W9-ABV-633

LIVING FORMS

Romantics and
The Monumental Figure

BRUCE HALEY

STATE UNIVERSITY OF NEW YORK PRESS

Published by
State University of New York Press, Albany

© 2003 State University of New York

For information, address State University of New York Press,
90 State Street, Suite 700, Albany, NY 12207

Production by Marilyn P. Semerad
Marketing by Anne M. Valentine

Library of Congress Cataloging-in-Publication Data

Haley, Bruce, 1933–
 Living forms : Romantics and the monumental figure / Bruce Haley.
 p. cm. — (SUNY series, studies in the long nineteenth century)
 Includes bibliographical references (p.) and index.
 ISBN 0-7914-5561-0 (alk. paper) — ISBN 0-7914-5562-9 (pbk. : alk. paper)
 1. English literature—19th century—History and criticism. 2. Art and literature—Great
Britain—History—19th century. 3. Literature and history—Great Britain—History—19th
century. 4. Architecture and literature—History—19th century. 5. Romanticism—Great
Britain. 6. Monuments in literature. 7. Sculpture in literature. 8. Statues in literature. I.
Title. II. Series.

PR468.A76 H35 2002
820.9'357—dc21
 2002017577

10 9 8 7 6 5 4 3 2 1

Contents

Illustrations

Acknowledgments

I am happy to have the opportunity to thank those people and organizations who—many without their knowing it—contributed to the writing of this book. The scholars whose ideas I have drawn on are listed in the Works Cited section, but especially important have been the writings of Ernst Cassirer, Francis Haskell, Nicholas Penny, and Martin Aske. I am indebted too to the staffs of the following collections for their kind assistance: the Victoria and Albert Museum library, the London Library, and the University of Utah's Marriott Library, Special Collections Department. *Modern Language Quarterly* has granted permission to use an expanded version of an article published in that journal: "Ohe Sculptural Aesthetics of *Childe Harold IV*," 44 (1983), 251–66. *Studies in Romanticism* (Trustees of Boston University) has permitted use of material from an article entitled "Shelley, Peacock, and the Reading of History, pp. 439–62, published there in the Fall, 1990, issue.

My research assistant, Jack Vespa, helped correct the manuscript, as did Martha Klein. My good friend Brooke Hopkins provided an enormous amount of editorial guidance during the writing of the book. The reviews by State University of New York Press's readers aided me substantially in the book's revisions.

Finally, I owe a debt of gratitude to those who helped provide time and funds for research and writing as well as for preparing the manuscript: the University of Utah Research Committee and College of Humanities Career Development Committee, as well as the English Department and its chairs, especially Stephen Tatum, Charles Berger, and Stuart Culver.

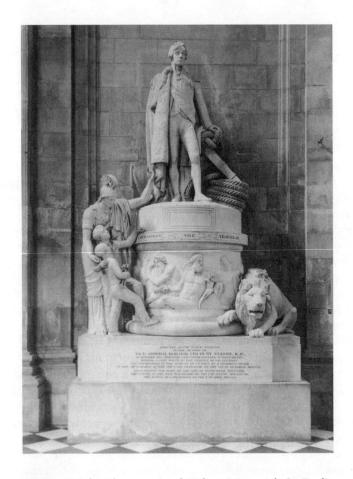

FIGURE 1. John Flaxman. Lord Nelson Memorial. St. Paul's Cathedral, London. Photo: The Conway Library, Courtauld Institute of Art.

INTRODUCTION

Thoughts on Nelson's Monument in St. Paul's

The artist's principle in the statue of a great man should be the illustration of departed merit.

—Coleridge, "On Poesy or Art"

During the Napoleonic War a Committee on National Monuments commissioned several memorials to military notables. Lord Nelson's was assigned in 1807 to John Flaxman and erected in the South Transept nave of St. Paul's Cathedral. It is dominated by an imposing, realistic, life-size figure of the man standing on a high plinth. Below and to his right Minerva encircles two young midshipmen with one arm while directing their attention to Nelson's figure with the other. Figures typifying the Nile, the Baltic, the North Sea, and the Mediterranean are pictured in relief on the pedestal. A lion reposes at the hero's feet.

Flaxman's naturalistic detail gives the face lifelikeness, while the staring eyes, fixed features, and cold, hard materiality suggest the rigidity of death. That is the ambiguity with which the monumental sculptor must deal: recalling a living person while marking his death. As Nelson is pointed to *as* figure by the others in the scene, he becomes a figure for the dead and they, by contrast, figures for the living. On the other hand,

while Nelson the person is felt to be absent from the scene, his effigy is seen to be an effective presence *in* the scene, a moral influence conveyed by the allegory's suggestion of life, purpose, and therefore import. Dividing itself into a portrait-figure—Nelson—and an iconic response to that figure, the work turns what in future times might be a dead relic into a living form: always readable, always being read. Enacting a public interpretation, it underscores the public nature of the man and the representation.

If, as a record, a monument is the historian's "object of investigation" or "primary material" and a document is something that can be used to read or investigate the monument,[1] Flaxman's work is both. His inscription announces that the monument was erected "to record [Nelson's] splendid and unparalleled achievements," the most notable of which it then mentions, but this record is also interpreted pictorially by the pedestal's allegorical figures. The living tableau above these recalls to life not only its human subject but, from the world of records, portraiture itself.

Flaxman may have drawn the idea for his allegorical scene from an anonymous eulogy published on Nelson's death in 1807.[2] In this example of notional or suppositional ekphrasis the poet envisions a real boy taking inspiration from some future memorial to the hero:

> . . . when autumn brings the shadowy year
> The circled urn shall drink her warmest tear:
> The mother there shall lead her child to con
> The deeds engraven on thy sculptur'd stone!
> The boy shall turn a hero from the pile,
> And rise the future Nelson of the isle!

In this the boy reads an engraved text: an epitaph to Nelson on a sculpted tablet. With Flaxman the boys gaze at, and read, not the epitaph but the figure alone, a form intended to express by itself.

Presenting the record as a living form was a common aim of sculptors of that time, who, like Flaxman, would sometimes use several complementary representational modes to dramatize the continuing interpretive act. A composition in Westminster Abbey by John Bacon the Elder (completed 1783) features, in addition to the figure of the first William Pitt, five others: Britannia, Prudence, Fortitude, Earth, and Ocean. Another excellent example by the same sculptor resides in Christ Church, Macclesfield.[3] A medallion profile of the industrialist Charles Roe (d.1781) is being held and contemplated by a Grecian allegorical form holding in her other hand a large cog-wheel. She sits atop three reliefs depicting buildings for which Roe was responsible: Christ

Church itself, a silk mill, and a copper-processing mill. Below these pictures is a eulogistic inscription. The symbolic wheel, the pictured buildings, and even the inscription may be regarded as the contemplative female's (or the artist's) interpretations of the medallion's significance: of Roe's life and works. Thus, as in Flaxman, the primary (portrait) figure records, while the other visual forms interpret that record, constituting in themselves a new text. So of course does the inscription. Portrait and its meaning are sundered, the meaning given its own figures, which are then juxtaposed with the portrait figure—side by side or one below the other.

Such elaborate semiotic reflexiveness—the lavish machinery of signs brought to bear on a simple effigy or portrait—might indicate the ease with which deceased persons are called to mind and their significance understood merely by viewing their likenesses. Though perhaps mute, the human form—focus of attention and subject of commentary in the Nelson monument—would seem to be the ideal monumental idiom: familiar and therefore always intuitively interpretable. On the other hand, such conspicuous explicating of Nelson's figure might itself be interpreted as the failure of portrait figures alone to express any *ideas* about the person beyond his death. With its several overlaid modes of representation, interpretation, and self-interpretation, the work may betray an anxiety about the life, not of its remembered subject, but of its own central figure and therefore of itself as record. Personal monuments, funerary or otherwise, are representations that offer to maintain a particular impression or memory of the subject itself only for a time. When viewed as monuments from the past, however, they are seen as replacing this memory *of* the subject with an idea *of or about or inspired by* the subject, generated *by* it, and this is what gives it its long life. The Nelson statue may be considered a series of commentaries on the idea-bearing capabilities of represented human forms.

In 1818, the year the Nelson memorial was completed and displayed, England was experiencing a period of tremendous popular interest in the visual arts—at home at heavily attended exhibitions, and, with peacetime continental travel now possible, abroad wherever famous masterpieces were housed and displayed. By this time a controversy had developed among historians, artists, and antiquarians over the adequacy of depicted persons as language: What can they alone, without text, express, and over what span of time? The focus was Addison's "Dialogues upon the Usefulness of Ancient Medals,"[4] which for a century had been regarded as the definitive statement on these questions. Through the reading of medallion portraits, declared Leigh Hunt in the periodical *The Reflector*, the essay had given to history a visibility, an

explanation, and even an ordering: "Virgil and Horace, the most elegant of the Roman poets, have been explained; many points in history, chronology, and the customs of antiquity, have been illustrated; and a regular history of the kings of France has been composed by the assistance of medals."[5] Addison's influence was acknowledged in the preface to a book that helped Keats gain his familiarity with Greek mythology, Joseph Spence's *Polymetis*. As poets and visual artists think so alike, wrote Spence (in a statement sarcastically attacked in Lessing's *Laocoon*) "they must be the best explainers of one another."[6] I will return to *Polymetis* in my last chapter.

Addison seemed to have demonstrated the unquenchable humanity of portraits from the past, their ability to express what the people depicted were really like. Commenting, however, on his method, which compared "the face of a great man with the character that authors have given him,"[7] the historian Gibbon doubted that the soul could often be read in the features without having some separate written account of the person.[8] At issue between these two men was whether a represented figure alone could express ideas or even personal character. Beyond this was the question of the figure's monumental efficacy: Whatever its significative power originally, to what extent could that power be retained over time without additional text? In the time of which I am writing, these issues were accentuated by a remarkable accumulation and public display across Europe of thousands of uncovered ancient artifacts—statues, urns, sarcophagi, memorial columns—from vanished cultures, many of these objects, certainly the most celebrated and conjectured about, bearing figural traces.

"The monument without a text is weak and helpless," observes Michael North; "no more proof against time than an ordinary stone."[9] Would this apply to the unmediated monumental figure? Does the mute image of Lord Nelson itself require those other verbal and iconic texts? Flaxman's Nelson points up certain questions central to the Romantic ideal of the "living form" that I shall be exploring: *How* do human forms in literature or art "express" themselves, and how does the passage of time affect their expressive life? What possible meanings are conveyed by the words of the king Ozymandias? By his sneer? By the sculptor's formal representation of these? By Shelley's sonnet form? If the expression on that statue's face still "tells" us something, does it in the same sense that Keats's Urn *as* figure (unravished bride, foster child, or sylvan historian) "can express" a tale? And what of the capacity of the forms on the urn—the bold lover, the mysterious priest—to express emotion *or* to tell their own tales? Most important of all, is their expression, if they show any, of the same kind as that of the work, the "Attic shape"? Like the figures on Keats's Urn, all those comprising the Flax-

man work lack the telling physiognomic expression that people have. They are of course voiceless, and their faces and stances convey little feeling or attitude. It is not as persons, however, but as representations—images—that they express. German critics promulgated the belief that visible form by its very muteness was equipped to express ideas with the most profound, hidden "source."

Images of persons, meant to have the power of recalling or calling to mind, are depictions first; therefore as soon as made they represent something past: a face, or an expression on a face; a naval battle; a dead child. In a metaphysical sense they stand for a past that has passed away. The following chapters will trace the attempt by Romantic critics and poets to restore damaged, faded, or unfamiliar figures to the status of living forms. The writers scrutinized figures in poetry, sculpture, or painting in what Coleridge called a "figurative" reading, one meant to discern not only what they were originally figures of, but what they now may be taken as figures for. Coleridge contemplated figures in the Bible, Shakespeare's plays, and other written stories; Wordsworth contemplated those—people and objects—from his own past. Byron and Felicia Hemans were especially drawn to sculptures from antiquity, as well as more recent effigies and other sepulchral works. Shelley was fascinated by portrait figures and Greek statues. So was Keats, but also by figures from old tales. All those monumental forms were reinterpreted as more than portraits, and therefore the works they belonged to as more than images of particular historical reference with meanings in danger of continually dimming or falling away.

Here I need to distinguish the two kinds of monuments whose figures or forms were of great interest to these writers. The first is the memorial work, the monument *to* someone or some occurrence—a grave sculpture, for example, something which "by its survival commemorates a person, action, period, or event" *(OED)*. Obviously all portraits have this documentary function. Depending on their quality, these may also be monuments in the other sense, highly impressive or significant works, as when Coleridge spoke of "the permanent monuments . . . *of* genius and skill," such as poems and paintings (emphasis added).[10] These works were deemed monumental in the sense that they *were* permanent. "Glorious monuments of genius," wrote the novelist and critic Alessandro Manzoni, "last precisely because genius has a way of perpetuating even things that by their nature are not otherwise certain to last."[11] The subject and its image are deathless because the work is expressively self-existent—not destined always to refer to some past moment.

Whether we mean by "monument" a work of significant human achievement, like Michelangelo's Moses, or a memorial object, like a

gravestone, or something that is both at once, like "Adonais" or the Flaxman work, it is an "impressive record" (Dorothy Wordsworth; see chapter 6), a durable representing presence. However, if it loses its power to impress, it no longer functions as a living record or text. If it loses its power to provide memory, it cannot long impress. The Nelson monument offers a tableau to remember and impress, thus to sustain the effect of its own central figure. It interprets more than its documentary signs; it interprets its own effect.

A permanently impressive object, to use William Wordsworth's own formulation (see chapter 7), must impress visually and immediately. To be—in the most familiar sense of the word—"monumental," it must convey presence, a sense of itself as being right here, remaining in our "midst," as the Grecian Urn does, or "with us" as *Endymion*'s "thing of beauty" must always be. With the Flaxman, Nelson's figure as object locates a site for the present viewing experience, one which underscores it as a presence. Naturally, the presence of the sculpted form as object was thought to play a large part in its aesthetic impact. Statues were not only "living" but "breathing" forms. Beattie's "Triumph of Melancholy" spoke of "the breathing bust"; Joseph Warton's "The Enthusiast" described the Pantheon in Rome as "The well-arch'd Dome, peopled with breathing Forms"; the sculptor Canova declared that everything about the Elgin Marbles "breathes animation."[12] The poet Samuel Rogers called the Belvedere Torso a "mass of breathing stone" (see chapter 1), suggesting not only that the form lives, but that it imparts something of its life to those nearby. More important, the paradox "breathing stone" emphasizes a spiritual or aesthetic existence and presence apart from the purely material existence and presence. The Grecian Urn's marble cold pastoral is "All breathing human passion far above," but the Belvedere Apollo in *Childe Harold* IV "breathes the flame with which 'twas wrought."

By necessity, artists depicting the dead must strive especially hard to make their *works* breathe life. Benjamin West, creator of the most celebrated memorial picture of its time, the *Death of Wolfe,* envisioned a similar painting that might honor Nelson. Such a work must offer such a charismatic presence, a theatrically "presented" image. "To move the mind, there should be a spectacle presented to raise and warm the mind, and all should be proportioned to the highest idea conceived of the hero. No boy would be animated by a representation of Nelson dying like an ordinary man; his feelings must be roused and his mind inflamed by a scene great and extraordinary. A mere matter of fact will never produce this effect."[13] Thus a "representation of Nelson dying" must itself "warm" and "animate" the mind of the viewer, whose feelings will be

"roused" and "inflamed." For the sake of this "effect" a monument may even need to lose something of its documentary accuracy. A "mere matter of fact," the undistorted image of the man, must subordinate itself to "the highest idea conceived of the hero." Perhaps West was thinking of those features disguised by Flaxman: the missing arm, the one sightless and patched eye.

The end of the eighteenth century marked a discernible shift in poetics away from the ideal of expression as a communication of feeling—an ideal epitomized by the natural body's array of stances, voice inflections, gestures, and changes in countenance. This was supplanted by the ideal of expression as a revelatory embodiment of "mind," "spirit," or "character" typified by the devised body—the body's representation. This shift in emphasis was to an extent inspired by the age's interest in antique figures, especially Greek ones. Forever decipherable because always recognizable, the image of man represents the victory of the monumental, of the intrinsically and perpetually significant. Whereas the body conveys the feelings or attitudes of the moment, the represented figure conveys the human spirit itself, and in a more lasting way. That is why form is, in Coleridge's words, "the ultimate end of human thought, and human feeling" (*LOL*1: 68). Originally articulated by Schlegel, Goethe, Schelling, Herder, and Hegel, a humanist archeology was developed at that time based on interpreting artifacts as "works" whose "form" or "forms" could be read as embodying spirit or soul. Thus to recover forms of the past and what they expressed was to recover purpose itself.

The ambiguous nature of "form," however, may be seen in the twenty-two principal definitions and dozens of subheadings given the word in the *OED*. In art or literature it can mean either the idea for a work or the work itself, "the structuring power and that which is structured."[14] Also, by "form" literary historians and theorists now mean either a type of work with identifiable characteristics, like the personal essay or the Pindaric ode, or an aesthetic principle of "unity" evident in a work as a whole. "Form operating as a structural principle and genre conceived of as a nexus of conventions and a frame of reference" (9–10) are the two relevant meanings in Stuart Curran's astute study of Romantic forms.[15] Neither "form" is usually visible. Little attention, however, has been paid to the historical relation between these various versions of form and visual forms in the arts, especially human figures.

Thus far I have been mainly using "form" to mean the human figure depicted in a visual medium. The German term *Gestalt* can mean a person's build, shape, or stature. "Form" (or *Gestalt*) can also refer to

any artistically realized visible configuration. When Kant referred to sculpture, painting, and architecture as the "formative arts," he meant— as English critics would in speaking of the arts of form—"those for the expression of ideas in sensuous intuition (not by means of representations of mere imagination that are excited by words)."[16] But more and more at this time artists, critics, and philosophers were using the word to mean an ideal, as well as a visible entity and presence, something communicated by what West called "effect." "Effect" was the artist's term for what Schlegel called "unity of impression" and Coleridge "Unity of Effect" (see chapter 3). A monument's unity of impression or effect was how its "living form" was grasped. Living form meant shape not merely as seen, but as felt or experienced. "A block of marble," declared Schiller's influential *Aesthetic Letters,* "though it is and remains lifeless, can nevertheless, thanks to the architect or the sculptor, become living form *[lebende Gestalt].* . . . Only when [a person's] form lives in our feeling and his life takes on form in our understanding, does he become living form; and this will always be the case whenever we adjudge him to be beautiful."[17] Schiller's *Gestalt* is essentially the concept in modern Gestalt psychology and aesthetics, that of experienced shape or form, which, I have been suggesting, is the subject of Flaxman's tableau. We must "spiritually melt" solid forms in nature or art, fusing their energy with that of our own sprits. "We must go beyond form," Schelling argued, "in order to regain it as comprehensible, living and truly felt."[18]

Thus to experience form is to grasp the idea of or for the work, not necessarily ideas in it. The ideal monumental work makes an indelible unified impression, in Kantian aesthetics called *Anschauung*—the immediate knowing of an object as a form or unified entity, "the living picture," as A. W. Schlegel called it, that "makes an impression on the imagination which can never be effaced."[19] Coleridge used the term "intuition," a "conscious presentation" of an object, "immediate and individual."[20] A thing "is known, because it is, and is, because it is known."[21] An act of the inner sense, a "realizing intuition," provides a "living contact" with something, giving an awareness of "the whole." The "whole" grasped by the imagination is the idea of the work, not any material shape. A painting, sculpture, or vase has an external aspect: its form can be seen and described directly, its meaning grasped directly in its phenomenal presence. It is brought before the eyes "all at once" (Herder: see chapter 5). Poetic form brings the work all at once before the mind's eye with what Coleridge calls a "joint impression of the *mind*" (emphasis added; see chapter 3).

Having the real or virtual object in the mind as one thing offers the possibility of reimagining and reconstituting it, as Flaxman may have, if

he read the Nelson elegy quoted earlier. Through this process a work from the past can be invested or reinvested with an ideal or virtual living presence.[22] An 1809 study by the antiquarian Society of Dilettanti concluded that all the best qualities of the Greek mind, "represented under human form," could be directly deduced in Greek sculpted figures, many of those traceable to Homer, where "the attitude, action, and expression of every figure, introduced or described, are so just, and brought so completely before the eye of the reader, that a picture or statue is spontaneously formed in the mind; and a wish to execute it, in some visible or tangible material, excited."[23]

This points toward a kind of experience especially important in early nineteenth-century aesthetics, one involving the feeling of having caught on to something by having caught hold of it in the mind's eye, of having grasped its form by framing and contemplating it as an image. Not only for Coleridge but for many others who found Kantian or Hegelian ideas less congenial, the nature and form of the art work were to be apprehended through its effect and by means of a mental picturing, analogic or metaphoric—a seeing as, or as if. For example, the impression, and therefore the monumental "effect," of a play or poem depends on its being imagined as a statue, a picture, a circle. As image in the mind and not in stone or on canvas, the visualized work is a formal potentiality. A portrait is imagined, then reexecuted as a poem on that portrait. The unified, ideal presence, a living form or image in the parlance of the day, is brought "completely before the eye of the reader" with more effect than either that of statue, picture, or written description. A vital medium between one figure made of words and another made of bronze or paint, it is so vivid and detailed that it may be itself an object of contemplation. Addison's contemporary Pope had praised the "Dialogues" for creating such an image from the "sacred rust" of the coins, one that "rises to view" brightly: "Touch'd by thy hand, again Rome's glories shine:/ Her gods, and godlike heroes rise to view,/ And all her faded garments bloom anew" ("Verses Occasioned by Mr. Addison's Treatise on Medals"). A medal or coin becomes an essay by Addison, then a poem in couplets by Pope. The envisaged thing, the image as image, can realize itself in different forms, as the Dilettanti treatise put it, "in some visible or tangible material."

Formal reproduction, then, is one way of displaying Gestalt, or comprehension of living form, if by reproduce we mean more than merely copy. When Shelley writes that poetry "reproduces all that it represents" (see chapter 2), he means it produces once more, creates anew. In this sense aesthetic forms live eternally: "Sculpture retains its freshness for twenty centuries: The Apollo & the Venus are as they were. But

books are perhaps the only productions of man coeval with the human race. Sophocles & Shakespeare can be produced & reproduced forever."[24] This idea that poetic forms may be forever reproduced is, as we shall see, a central one in the "Defence," as well as in Keats, who says that the thing of beauty's "loveliness increases" *(Endymion)* and for Byron, whose "beings of the mind" are "essentially immortal"—they "create/ And multiply in us a brighter ray" (see chapter 9). Ekphrasis, converting material forms to ideal or poetic ones, makes possible endless further reproductions.

To depict human forms, as Flaxman does with his Nelson figure, is to use a figural language. To imagine figures for thoughts, as he does with the Minerva form, is to use a figurative or notional one. The figural idiom of painting and sculpture is mimetic. The tendency is to imitate them, either with graphic reproductions or by emulation—in either case by copying. Figurative language, an embodiment of an idea, not a copy of a thing or person, can be endlessly reproduced. What I shall be calling "re-production," to distinguish it from the making of mere likenesses—painted portraits, engravings of such portraits, etc.—is what Coleridge meant by "imitation" when he would distinguish that from copying, the representation of nature as mere object.

It was Keats who spoke both of "fair living forms" and of "fixed shapes." Fair living forms *(Endymion)* are those susceptible to perpetuation through reproduction such as ekphrasis, which supplies not just a different form to the idea but a different mode of form. This very mutability constitutes the idea's vital principle. Under the sculptor's hand the animate human figure becomes a stilled stone one, which the poet can turn into a sonnet or other verse form. No forms thus changeable are really dead.

Monuments of whatever condition whose forms cannot be apprehended or mastered by reproducing them are "fixed shapes" *(Fall of Hyperion)*. These convey the sense of a dual identity: as signs, whose referent has been lost, therefore as signs of absence; and as objects, persisting in time as dense apparitional presences. In some works by Byron, Shelley, Felicia Hemans, Keats, Samuel Rogers, and others this oppressive shape necessitates a special kind of ekphrastic performance, one ultimately failing to refigure and restore the work, which falls into dense objecthood, where it serves as ideogram for the poet's own self. Living forms belong to the monument as a radiant expression of mind or spirit, fixed shapes more typically to memorials associated with death either originally (tomb sculptures, cinerary urns, grave markers), or ultimately (the ruins of cities or civilizations). Throughout this study I shall be concentrating on those literary genres that seek to reflect on or preserve the past: Shelley's retrospective poetry defence, Coleridge's historical Shake-

speare lectures, Shelley's elegiac meditations on Keats, Wordsworth's retelling of his own life, Keats's readings of old legends and old artifacts. Through these writers' eyes I shall look also at various painted portraits, sculpted effigies, and edifices meant to hold the fame of those who decreed their making.

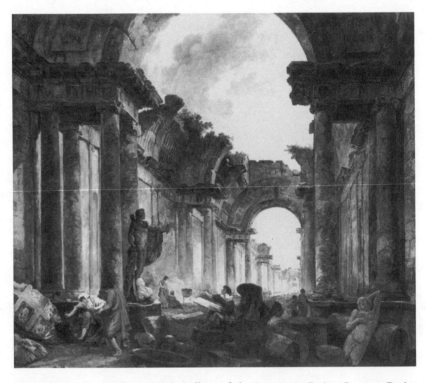

FIGURE 2. Hubert Robert. Long Gallery of the Louvre in Ruins. Louvre, Paris.
Photo: Lauros-Giraudon, Paris/Art Resource, NY.

CHAPTER ONE

Imaginary Museum

Pursue the road,
And beat the track the glorious ancients trod;
To those eternal monuments repair,
There read, and meditate forever there.

—Marco Girolamo Vida, *The Art of Poetry*

AN AGE OF MUSEUMS

André Malraux remarked that museums change the very nature of the items they house. They "estrange the works they bring together from their original functions and . . . transform even portraits into 'pictures'" (9).[1] When we recognize a portrait figure, painted or sculpted, less by its subject than by its maker—Reynolds, Lawrence, Flaxman, Chantrey—we can't help thinking of it as an art "work," as appropriate to a museum as to a dining hall or stairway wall of a home. Many such pieces in fact reside in art museums, while others, like the Nelson monument and the memorial tombs of Chaucer and Tennyson, have been given homes in buildings like Westminster Abbey and St. Paul's Cathedral, places looked upon by visitors and guidebooks more as museums than as burial sites. The museum space rescues artifacts not only from vulnerable objecthood[2] but from dead iconism, a semiotic bondage to the past. The visitor's concern is with their present effect, enhanced as much as possible by the way they are displayed. At sites where monuments have a significant referential setting—the

13

Roman Forum, or a necropolis—figures invite retrospective meditation. In the museum of art, itself a monument, they are viewed as forms, therefore as speaking of themselves, not of something that is gone.

"Every work of art is characterized by a deep structural identity," Ernst Cassirer observed, "an identity of form, not of matter."[3] Thinking of any work in terms of form always emphasizes certain things: 1) the mental or spiritual as against the merely physical or material; 2) the human and living as against the nonhuman and dead; 3) present effect as against past reference (forms are experienced, not merely understood); 4) ultimately, incorporating all of the above, the aesthetic as against the merely artifactual. During what has been called the Museum Age[4]—the latter half of the eighteenth century and the early part of the nineteenth—the concern with aesthetic forms in art and literature coincided with the spread of art museums, and especially of sculpture galleries, for as Hegel declared, the concern of the sculptor is "*Form* and *nothing more*."[5] The monumental figure came to embody form itself and all its possibilities. In the world of sculpture and painting, "form" meant outline or shape, especially the human shape treated artistically, and viewed as distinct from color, texture, and expression. Art museums were home to the arts of form; they housed human figures carved, molded, painted, drawn, or engraved.

Therefore, when the most celebrated displaced monumental figures in history were moved from the outside of a partially ruined temple—the Parthenon—to the inside of a new temple—the British Museum (by way of Burlington House)—they became reinterpreted as "the paragons of sculpture and the mould of form" (Hazlitt).[6] Transplanting such pieces— rescuing them, it was thought—from abandoned or neglected sites around the world replaced their meaning as relics or ruins with a new aesthetic significance that suggested man's transcendent spiritual life. Their new homes needed to reflect this. In 1816, as the British Museum prepared to house the Marbles, much interest was shown in just how they should be displayed. Complaining that the major continental museums were "wretchedly lit," and that by contrast the Townley Marbles in London were more effectively positioned below a twelve-foot-high skylight, a writer in Hunt's *Examiner* demanded that "England first shew, with her usual understanding, that she considers the beauty of the production as the first requisite, and that she will sacrifice all splendour and magnificence and height of apartment for the attainment of an object of infinitely more importance, viz. the exhibition of this beauty to the greatest effect."[7] The museum's project was to realize spatially the mental character of individual artists and their culture, and thus to express human purpose as visible form, the element of clarity and definition, as Benjamin Haydon said, in all the visual arts.[8] By emphasizing one kind of original intention, formal identity, over another, indication or reference,

the museum gave the monumental artifact a living humanity.

In thus being linked to the truly monumental—human greatness expressing itself intelligibly over the ages—rather than the merely memorial or historical, "form" came to symbolize man's conquest of time itself. A person may be beautiful "only for a moment," Goethe observed in his appreciation of Winckelmann, but the figural work of art, standing "before the world in its ideal reality . . . produces an enduring effect . . . and by breathing life into the human figure, it raises man above himself, completes the cycle of his life and actions, and deifies him for the present moment, in which the past and future are also contained."[9] To Goethe the classical mythic sculpture was the epitome of the pure figural, and therefore of pure form. It "divests man of all inessential elements," thus attaining "perfection," so that the viewer can attend only to the work. "A subject at rest presents solely itself, and therefore is complete by and in itself." That is, it need only present itself, not represent anything. Figures like the regally reposing Juno or the contemplative Minerva "have no contact with the outside world but are completely self-contained." They "reign in splendid isolation."[10] Such figures contain "the motion together with its cause." Even figures in groups are wholly involved in one another and wholly explainable by reference to one another. Goethe was really defining the aesthetic in terms of the image and designating the image as non- or anti-historical: ideal in origin and thus, like a figure in an art museum, creative of its own essential dramatic space. The figure in an art museum or museum-like space is *essentially* a "breathing" presence, not a representation.

Nonetheless, some early nineteenth-century critics, most notably those of Lord Elgin, held that dissociating works from what Malraux calls "their original functions" was murder or at least captivity. In a work published in England in 1821, the archeologist Quatremère de Quincy, who had himself visited Paestum in the 1770s, argued against the transporting and enclosing of such works, whose real influence derives "less from their beauty and perfection than from their antiquity, their authenticity, and their publicity." It was a "death" to this direct knowledge of the past to "withdraw its elements from the public, to decompose its parts, as has been done without intermission during the last twenty-five years, and to collect the wreck in depôts called *Conservatories*."[11] (He was referring especially to the Musée de Monumens Français.) The emotions attached to these artifacts in their native settings give that historical instruction a special potency when all is seen as a whole. Therefore, "To displace all these monuments, collect the scattered fragments, class methodically the remains, and compose from such an assemblage a practical course of modern chronology" is to deprive them of their sustenance (56).

Especially interested in what happens to the original meaning of monumental figures, Quincy conveyed the new monumental meaning with his own, distinctive figure:

> Who can now make us sensible of the meaning of figures whose expressions are only grimaces, whose accompaniments are enigmas? What emotion do we in reality feel from the contemplation of that disenchanted figure of a woman pretending to weep over an empty urn? What mean these images which retain nothing but their substance? What signify these mausoleums without graves, these cenotaphs doubly empty, these tombs which death animates no longer? (56)

The monuments' loss of their own historical context means the death of their "images," leaving only their "substance," their material identity. Without what "explained" them we are left to contemplate them as enigmatic objects. Quincy's model for the artifactual corpse is an emblematic tomb figure, lifeless as the body it is supposed to honor, an allegory arousing no "emotion" for the viewer. The viewer now is in the position of an allegorical figure of Grief, and the work itself is an "empty urn" not studied and understood archeologically, but mourned over.

Though Quincy laments the historian's effort to reimagine figures according to a modern scheme, the historical reading of figures, even the contextual kind he favors, is always a departure from the maker's intention. The original aim of the monument as a religious icon, an insigne of grief, or a bearer of personal fame (of the subject, the maker, or both) is always incompatible with its subsequent use as an indicator of historical situations. Monuments are usually made for the first, but ultimately read for the second. Quincy lamented the loss to monuments of a "publicity," which depended on their "antiquity" and "authenticity"—their true historicity—rather than on their "perfection and beauty." What a museum does, whether it is an institution of art or of archeology, is provide a new visible context, one imaging a modern or a transhistorical perspective. The assumption behind the museum of art, which underlay much literary and art history of the late eighteenth and nineteenth centuries, was that a work's grander historical significance was not to be found by learning its original social or even intellectual context, but by grasping its Gestalt, the impression it makes. In this Gestalt or experienced form may be grasped the work's true historical meaning: the character of the age in which it emerged. More than anyone, it was Winckelmann who has inspired museum curators to look for perfection and beauty, and thus to Greek art, as the standards for their collections. And it was from him that art historians and later literary historians inherited what I shall call a museum sensibility or consciousness.

IMAGINARY MUSEUMS: WINCKELMANN AND SCHLEGEL

Winckelmann, "the greatest antiquary of his time and the first modern art historian" (Bazin 164), supervised productive excavations in Rome as Clement XIII's Prefect of Antiquities and directed the building of Rome's Villa Albani, as well as the assembling and arranging within the Villa of a major collection of antiquities. Thus his relation to classical forms was personal and immediate, as his writings reflect. He developed a method of reading art objects that made cultural history possible, one based on drawing historical generalizations from the present character and effect of the individual work or art object.

The premise of his *History of Ancient Art* is that art began with the drawing of human figures and has always been centered on them. From his first chapter, "The Shapes with Which Art Commenced," he writes the story of the represented human form evolving toward its greatest perfection with the Greeks.[12] Here and in other writings he circumscribes and isolates the sculpted artifact, in many cases also providing an engraved version of it. He then muses upon it, emphasizing its aesthetic (often its erotic) expressiveness, which he then uses to interpret its period or phase of history. As Goethe's appreciative essay on him phrased it, he taught that great works of art exist "through their continuing reality as ineffable creations," and that we should "contemplate" each work "as an individual whole" ("Winckelmann" 236).

Starting from this close reading of individual forms and their separate parts, Winckelmann was the first to lay out an historical scheme of ancient art, based on the evolution of style or treatment. It has been argued that his work had a major influence on nineteenth-century European museums and indeed on all thinking about represented human forms as artifacts: "After the appearance of Winckelmann's *History* it became possible . . . for more and more people to arrange sculpture [chronologically] in their minds and eventually in certain publications."[13] The conceptual influence of Winckelmann can be seen in the imagery of many of the German writers who followed, particularly Schiller, Herder, Goethe, and Hegel. Schiller, like Winckelmann, saw civilization as the evolution of defined, forever expressive, forms from indefinite, by now inexpressive, ones. "The monstrous divinity of the Oriental, which rules the world with the blind strength of a beast of prey, shrinks in the imagination of the Greeks into the friendly contours of a human being. The empire of the Titans falls, and infinite force is tamed by infinite form."[14] Herder's *Outlines of a Philosophy of the History of Man* described the Near East as a mysterious ruin—"fables of fables, fragments of history, a dream of the ancient World." The Greeks, however, left "noble monuments, monuments that speak to us with a

philosophic spirit."[15] Their *monumental* articulateness is empowered by the "philosophic spirit" of the age, which penetrates both "letters" and "the arts." As the spirit of the artist then was in perfect harmony with that of the age, the same quality could be found in all remaining monuments of the time.

Nearly everyone credited Winckelmann's *History of Ancient Art* (1764) with effecting a true revolution in the reading of what he called "splendid forms," and by means of those, in the reading of literary works.[16] Winckelmann's contributions were, first, a definition and examples of pure beauty and, second, a truly historical approach to aesthetics: a history of art constructed of individual works alone, not biographies of artists—monuments, not lives.[17] And in his *History*'s gallery of Greek marbles he provided both a starting place for understanding our past and a standard by which to measure all post-classical achievements. Before passing to "the masterpieces of painting," Mme. de Staël's heroine Corinne (1808) commences her art tour of Italy with the Vatican Museum, "that palace of statues where you see the human countenance made divine by paganism, just as Christianity makes the soul's emotions divine."[18] It is in these halls that she embarks on reflections about the history of the human spirit, a history embodied not only in art forms representing the human body, but in the social forms discernible through these figures. "In our modern day, society is so cold and oppressive that suffering is man's noblest aspect, and any man who has not suffered has neither felt nor thought. But in earlier times, there was something nobler than pain; it was heroic equanimity, the sense of strength that could develop among unequivocally free institutions" (142). The whole climate of the age can be read, as Winckelmann and Corinne do read it, in the faces and postures of these antique forms.

Like the author of *Corinne*, Winckelmann was less interested in what the sculpture was once meant to depict than in the cultural character it embodies symbolically and forever. For example, the "character of wisdom" found in the father's face in the Laocoon group, its "noble simplicity and tranquil grandeur," he attributed to the characteristically "great and dignified" Greek soul.[19] This habit of "Physiognomic Perception," which the historian uses to "wake the dead" and to "unriddle the mute language of the monuments,"[20] underpins art and cultural history from Winckelmann on. It is a practice resisted in our own time by Foucault, who, unlike the humanist, insists that statements of the past be treated as "an incomplete, fragmented figure." He describes the aim of creating a total history as one of seeking to "reconstitute the overall form of a civilization . . . what is called metaphorically the 'face' of a period."[21] Foucault himself here disfigures history *with a figure*, thus rejecting the accepted practice of monumentalizing the past by humanizing it.

Foucault of course is arguing against such modern humanist philosophers as Ernst Cassirer, who insisted that the concepts of form were basic to the existence of the humanities.[22] While Foucault emphasizes the status of the monument as "relic," Cassirer sees it as a living symbolic idiom. The "true historian" must regard his material not as "petrified fact" but as "living form." "History is the attempt to fuse together all these *disjecta membra,* the scattered limbs of the past, and to synthesize them and mold them into new shape" (*Essay* 225). Perceiving an artifact as a "work" helps rescue it from the necessary oblivion of all material creations. Monuments and documents have an *objective* past that is "gone forever." They cannot be wakened "to a new life in a mere physical, objective sense." Humanist history, though, can give them an "ideal existence" (*Essay* 221) by interpreting them "not only as dead remnants of the past but as living messages from it, messages addressing us in a language of their own." Therefore, no matter what its nominal subject, the humanist reads every work of art as a monument to man generally, not to a particular person. "Beneath the temporal flux and behind the polymorphism of human life [historians] have hoped to discover the constant features of human nature" (*Essay* 208, 218–19).

The act of *converting* monuments from "dead and scattered" historical facts into living "forms" was central to Romantic cultural theory and art history, a tradition to which Cassirer belongs. It is a kind of archeology, the archeology of revivification. The mental reproduction of the monument to create the sense of a new, living form is what Cassirer and earlier historians referred to as an historical "palingenesis." Goethe praised Herder's historical descriptions as providing no simple "husk and shell of human beings" but as "regenerating the rubbish . . . to a living plant" (quoted by Cassirer, *Essay* 225).

Such regeneration, according to Cassirer, has been central to humanist thought for centuries and indeed underlay the humanist idea of the "Reformation."

> According to Ficino, the whole point of religious and philosophical *knowledge* is nothing other than the eradication from the world of everything that is deformed; and the recognition that even things that seem formless participate in form. . . . If redemption is conceived of as a renovation of the *form* of man and of the world, i.e., as a true *reformatio,* then the focal point of intellectual life must lie in the place where the 'idea' is embodied, i.e., where the non-sensible form present in the mind of the artist breaks forth into the world of the visible and becomes realized in it.[23]

Thus the basic act of reforming the "deformed" has focused on reimposing form on monumental works disfigured by time, especially those of the human figure: a "renovation of the form of man." Form, by

which the work expresses its character, is something concealed, to be unfolded or disclosed by viewer, reader, or, in the case of the ekphrastic poem, the poet. It is "a significant exterior," A. W. Schlegel observed, "the speaking physiognomy of each thing, which, as long as it is not disfigured by any destructive accident, gives a true evidence of its hidden essence" (*Lectures* 340). To the eye of the connoisseur, even disfigured works were integral in their form if not in their shape. When Shelley's friend Thomas Jefferson Hogg visited Florence, he was drawn like everybody then to the Medici Venus. He discovered that it had once been broken to pieces, then badly repaired: the head and hands he thought perhaps modern. The head was "insipid." Nothing about its expression could he admire, "but the form I praise."[24] Clearly the whole was greater than any of its parts when expression was subordinated to form. The Belvedere Apollo had also been mutilated and restored, but its state of repair mattered little to Byron, who declared that in its "delicate form . . . are exprest/ All that ideal Beauty ever bless'd/ The mind with in its most unearthly mood . . ." (*Childe Harold* IV, St. 162).

Rudolf Arnheim has more recently framed the matter in terms of Gestalt aesthetics. Although an artwork has a weak Gestalt as an object, it has a strong one as an experience. It is physically "an object of low organisation. It makes little difference to the marble of the Laocoon group that an arm is broken off, nor does the paint of a landscape revolt when a busy restorer adds a glaring blue to its faded sky." But "the *work of art defined as an experience* turns out to be a Gestalt of the highest degree" (emphasis added).[25] Form is the *visualized* whole of any "work," as shape is the visible whole. Thus form brings together the two aspects of monumentality: durability of the work as record and durability of the work as effect. In fact, it gives a work like the Belvedere Torso a monumental Gestalt and thus protects it from disfigurement. Long regarded as proof of the indestructibility of aesthetic identity, the Torso received its most celebrated reformation by Winckelmann. If Renaissance humanists sought the "renovation of the *form* of man," in Winckelmann's reading[26] we see a later example of such reformation. The process is one of reconstructing and reproducing the Torso form by imagining it: presenting it to his "inner eye." The passage, written in 1759, was later incorporated into his *History*.

> If it seems inconceivable that the power of reflection be shown elsewhere than in the [missing] head, you can learn here how a master's creative hand is able to endow matter with mind. The back, which appears as if flexed in noble thought, gives me the mental picture of a head filled with the joyful remembrance of his astonishing deeds, and, as his head full of wisdom and majesty arises before my inner eye, the other missing limbs also begin to take shape in my imagination. . . .

The manner in which our thoughts are directed from Hercules' feats of strength to the perfection of his soul constitutes one of the mysteries of art; and the perfection of that soul is recorded in the torso as in a monument that could not have been equaled by a poet who limited himself to celebrating the strength of the hero's arms. . . . The world of art weeps with me in seeing this work . . . half destroyed and cruelly maltreated. Who does not lament, on this occasion, the loss of hundreds of other masterpieces? Yet art, in wishing to instruct us further, recalls us from these sad thoughts by showing us how much might still be learned from this fragment, and how an artist should look at it.

Reading the torso (which he identifies as that of Hercules) as a record of its own composition, Winckelmann first invites us to imagine the "master's creative hand" in order to "learn" how to see a "work," matter endowed with mind. Supplied by the writer, the "hand" and arm so obviously missing in the thing become the power of the artist's expression and craftsmanship. The "head full of wisdom and majesty" rising before Winckelmann's inner eye is equally that of Hercules and of the creative "master." As it emerges, so then does the idea of the work itself, its form, taking "shape in [his] imagination" as the "missing limbs" do.

Figural works, especially those like sculptures or oil portraits, which are nothing but figure, have a presence, phenomenality, depending little on their being intact. As Arnheim says, the mutilated Laocoon may give the experience of wholeness more than an overpainted landscape. Perhaps mutilation itself, as has been surmised, "requires us to imagine that the work in question is sustained by an underlying, albeit sometimes invisible, ideal order."[27] Through its form the partial figure with a strong Gestalt is a language for the ideal order which generated it and which it embodies. That order as imagined is form, but imagining it is undoubtedly easier if the original shape of the object is a familiar one, a centered recognizable figure.

Partly owing to Winckelmann, the Belvedere Torso came to exemplify the monumental power of the "work of art"; it can be mutilated but never deformed: its formal presence belongs to the idea, its essence, rather than to the object, its material existence. "When a Work has Unity it is as much in a Part as in the Whole," Blake declared. "The Torso is as much a Unity as the Laocoon" ("On Homer's Poetry"). In its original state the Torso expressed the strength of the human body. Maimed, it imaged the comprehensive unity of the Greek mind. For Blake's friend and patron William Hayley, that unity, discernible to the tactile imagination, was the secret of classical sculpture's ability to reproduce itself in figures designed by later artists like Michelangelo: "The veteran, while his hand, with science fraught,/ Roved o'er the stone so exquisitely wrought,/ His fancy giving the maim'd trunk a soul,/ Saw,

in his touch, the grandeur of the whole."[28] Thus the monumental form's ultimate expressive power is that of keeping alive the idea of itself, not as historical object or artifact but art work (as "an artist should look at it," rather than as a mere antiquarian would). That was the essence of Samuel Rogers's sonnet "To the Fragment of a Statue of Hercules, Commonly Called the Torso":

> And dost thou still, thou mass of breathing stone,
> (Thy giant limbs to night in chaos hurl'd),
> Still sit as on the fragment of a world;
> Surviving all, majestic and alone?
> What though the Spirits of the North, that swept
> Rome from the earth, when in her pomp she slept,
> Smote thee with fury, and thy headless trunk
> Deep in the dust 'mid tower and temple sunk:
> Soon to subdue mankind 'twas thine to rise,
> Still, still unquell'd thy glorious energies!
> Aspiring minds, with thee conversing, caught
> Bright revelations of the Good they sought;
> By thee that long-lost spell in secret given,
> To draw down Gods, and lift the soul to Heaven!

Though mutilated in the drive of events and forgotten ("long-lost") by history, the Torso "remains," like Keats's unravished bride. "Still" intact as image, it sits on, yet apart from, "the fragment of the world," fitting Stephen Dedalus's description of the aesthetic image as "self-bounded and self-contained upon the immeasurable background of time and space which is not it"—a background, in Rogers, of night (or "night in chaos," depending on how we read the line). The darkness of formless time and shape claims as much of "Hercules" as can be thought of as either human body or stone object. What survives is the Torso as work. By identifying the figure as Hercules (as Winckelmann had) Rogers's title specifically supplants the idea of fragmented object with that of original integral meaning, one that can be reanimated to "breathing" life as a speaking image with which to "converse" and find "Bright revelations of the Good." Though physically a "ruin" like fallen towers and temples, it maintains its power of articulate expression. Rogers's rhetorical question "And dost thou still . . . ?" is mutely answered by the still, surviving work.

Of course the archeologist's task has been to revive discovered objects with scholarship, placing them within an explanatory—that is to say historical—framework. They are reconnected to their origin and their original role. That was the method of Quatremère de Quincy dis-

cussed above. Rogers's poem and other monument-readings of the time served the common Romantic aim of providing comprehension not by explaining, but by repicturing. As I have said, sculpture galleries like the Vatican's Belvedere, where Rogers viewed the Torso, frame and isolate their figures, creating new images of solitary objects. Similarly literary ekphrasis, the verbal reproducing of a real or imagined form, lifts the work from the setting in which it was or might be found and formally isolates it, recontextualizing it as art. Indeed, James Heffernan argues that the ekphrastic tradition has created a "museum of words," an imaginary place that started to gain a particular referentiality during the Romantic period with the new public art museums.[29] The reconstruction of an image attests to the power of the historical imagination to penetrate present situations—heaps of intact or mutilated remains—and grasp origins. Further, it attests to the artwork's power of surviving its own time.

The survival of the fragment shows that the artwork is more than object, form is more than shape. "A fragmentary torso still lives as a work of art," Herbert Read declares, no doubt with the most famous example in mind. "A work of art . . . and particularly a piece of sculpture, is not destroyed so long as a recognizable fragment of it survives. The fragment bears the artist's signature, the impression of his sensibility, and that quality we must isolate if in the end we would stand in the presence of the work of art." Such a work survives not only the "physical dismemberment of the statue but even the spiritual destruction of the body image."[30] *As* a fragmentary relic, a piece like the Torso has changed not just its condition or situation but its very nature and meaning. It began not as a monument in any documentary sense but as "an ideal of humanity." Now no longer that but not simply an aesthetic object either, it stands, according to Read, for the Aesthetic. Rogers's poem completes the meaning by making it stand for the triumph of the aesthetic over the historical or political. Released from its *past* signification it now has a strong phenomenal existence, a "presence" involving us as spectators.

However, when Read says we "stand in the presence of the work of art" I take him to mean it figuratively, a point I want to emphasize here. We may physically stand in the presence of an art object (or any other object or any person), but the "presence" of a poem, say, or a piece of music, is more in its effect than its physical nearness to us. So also is a sculpture *as* a work. We feel the presence of the grand *idea* of the "work of art" when we set up a kind of conceptual rather than perceptual space including the piece as work and us as audience or reader, with the relationship defined, as I have said, by having the work in the mind's eye. Thus Goethe reflected on Winckelmann's natural ability to appreciate

the beauty of forms in Greek literature, then confront it "face to face" in classical sculpture.[31] And as we have seen, Winckelmann then could reconstruct the work, as work, to his "mind's eye."

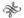

On returning from a survey of Paris museums, the *Champion*'s editor John Scott described their richness in "the imperishable parts that appertained to what has perished;—in the sole survivors of general wrecks and ruins." "In their present situation, looking back to their past history," the treasures of the Louvre were poignant monuments to the catastrophes of time.[32] Though these "survivors" are reminders of Time itself as ruined, in their new setting they were used to restore it, to shape it into eras or periods experienced in the various rooms, salons, or halls of the museum, a milieu of walls, frames, pedestals, and cases. Theatrically enlivening discovered figures from the past illuminates the darkened past itself. So history as a whole was given what Henri Focillon has termed "a really monumental quality," Time distributed among rooms and exhibition cases, "stable chronological environments."[33]

Concurrent with the recognition of "archeology" (in the early sense of a "systematic description or study of antiquities" *[OED]*) as a serious pursuit was a singular growth of museums and other public object-collections, such as literary anthologies. These developments testify, first, to an eagerness to explain the earliest role of works of art, and, second, to envisage them in a new way while recapturing something of their earliest force or effect. By isolating or grouping, museums tended to accentuate their dual nature—aesthetic and historical. As individually displayed aesthetic forms these artifacts were made literally to showcase the uniqueness of the monument of human genius. As grouped records they arranged history.

In short, the museum offered a vision of Time shaped by its most distinguished human works. When the English and Prussians captured Paris in July 1815 they found in the Louvre Palace, as tourists later would, an extraordinary collection of works, the Musée Napoléon. The vast Gallery, running the whole length of the palace and half the distance between the Pont Royal and Pont Neuf, contained nearly two thousand paintings; the various ground-floor Salons or Halls were home to statues and statuary remains "collected from every part of the world, being exhibited to the best advantage."[34] "The gallery was a magnificent sight," wrote the Irish poet and novelist the Reverend George Croly. "A vista of 1,300 feet, of pictures, pillars of precious marble, and massive gilding. The first sensation seemed to be the same to all spectators, a feeling of eager, uneasy wonder. It required days to be able to look upon this daz-

zling collection with the calmness necessary to enjoyment."[35] Although James Forbes, visiting the place a decade earlier during the Peace of Amiens, voiced dismay over the thefts that made possible such a collection, he too had been impressed with the "taste and judgment" of the decor and arrangements, the way the rooms themselves "correspond with the inestimable objects with which they may be said to be peopled."[36]

The Museum had opened to the public in 1793 and received its first consignment of looted works the following year, among them, from the Antwerp Cathedral, the middle panel of Rubens's *Descent from the Cross.* Then, from 1796 to 1799, one shipment after another from the cities of Italy arrived, including the Apollo Belvedere, the Laocoon, the Dying Gaul, the Belvedere Torso, and the Venus di Medici.[37]

Aside from moral and political questions arising from the confiscation, this museum provoked Europe-wide controversy about the ideal arrangement of artistic monuments. The aesthetics of viewing, of "effect," so vital an element of landscape or garden theory, was now applied to it and places like it. One tourist just after Waterloo was "struck with amazement" at the Gallery's more than quarter-mile length, its gilded and ornamented ceiling, the "nine noble arches abutted on pillars of porphyry and marble," its grand mirrors and vases.[38] Henry Milton by contrast thought the gallery with its semicircular ceiling resembled "a great interminable pipe." He could not imagine what the aim was of offering the visitor a view of so many paintings at once. He would find much to praise, however, in the different sort of drama of the sculpture salons, lined with dark marble effectively setting off the white figures in them. These rooms were, he noted, well lit, and many had marble floors.[39] For John Bell in 1817 the meagerness of the Tribune in Florence evoked by contrast the Louvre, where one could contemplate items "with sensations of heightened pleasure, when viewed in rich and noble halls."[40]

Obviously the gallery of paintings was intended to supply a panorama of human achievement, overwhelming in its richness and plenitude. To Sir Thomas Raffles in the summer of 1817 that aim was achieved: "It is like some splendid effort of enchantment—the mind is overwhelmed and bewildered by such sublime combinations of art—and the eye is lost in the vast and interesting perspective—and it is long ere you can recover from the impression of so much grandeur, to fix your attention on any individual portion of the stupendous whole."[41]

What the gallery did singly the ground-floor sculpture rooms did successively, showing "the noblest efforts of human genius," as Raffles referred to them, "wrested from the oblivion of long-departed years." And all of this in a visible historical scheme: "you pass from age to age as you move from room to room—and in the lounge of a morning, you seem to have communed with the greatest characters that have appeared

upon the busy theatre of the ancient world" (27). Even when the original collection was being assembled, the English engraver Valentine Green wrote to Joshua Reynolds that it would provide "at one view" all the "principles and systems" of the various eras of art in a "resurrection of their ancient spirit."[42] In the Great Hall the room itself dominated as an image of history, but of history rationally ordered, as opposed to the images of time disordered that Petra or the sands of Egypt provided. "The eye is tranced," Croly wrote, "and from the portal-arch/ Looks down the unmeasured length in dim delight,/ Piercing the radiant lines, the mighty march/ Of armies of the mind."

Whatever the opinions about the great picture gallery, there appeared a consensus that the Louvre sculpture salons achieved their intended purposes: to present single models for periods, and to define history in terms of individual expressions of mind. They encouraged focusing on one object or group, sometimes by creating visual contrasts to isolate it aesthetically as a presence. In the same way, the Townley collection of ancient marbles in London (soon to form a prominent part of the early British Museum holdings) positioned each object to stand alone and stand out: "The aim in the decoration of this room was principally to recal the eye in particular upon each of the marbles it contains," so objects were placed between dark red columns "to prevent the sight from wandering upon too many objects at once," and also to present a contrast to the lighter marble.[43] Travelling in Italy, James A. Galiffe expressed a preference for only one class of sculpture at a time in the visual field (for the "perfect enjoyment of works of art"). It is too jarring, he declared, after the contemplation of the ideal beauty of a Greek or Roman statue, to have the eye immediately fall on the narrative or "poetic" aspect of a bas relief.[44] And yet the strong formal presence of the great single work could overcome an unfortunate placement. Croly argued that although the Louvre's Venus di Medici, less favorably situated than the Apollo Belvedere, on first glance "disappointed every one," she "gained upon the eye, and admiration seemed to be at length won by her, not inferior to that which was given at once to the *dazzling* eloquence of the Apollo" (81).

In their larger schemes museums conveniently provided what visits to present sites of ancient cities did: visual equivalents of cultures or ages. Goethe said that Winckelmann in and about Rome "saw his ideas in corporeal form . . . as he wandered in amazement through the ruins of a gigantic age."[45] What we see with our eyes, of course, are monumental relics; what we can imagine is a past culture, an historical idea, an ideal world shaped around real objects. The word "museum" comes from the Greek *mouseion,* meaning a *place* or home for the muses. Like a church, cathedral, or temple the museum gave a sense of place to an

otherwise remote past, a place to view, study, and honor human achievement. Perhaps it was natural that the museum was often called a temple of art: *Tempel der Kunst.*[46]

In the early decades of the nineteenth century these attitudes were reflected by the exterior and interior architecture of new museums, especially those meant to frame and display antiquities. The buildings were temples, "meant to preserve the vestiges of human history" (Bazin199). The late eighteenth and early nineteenth centuries witnessed the spread of these museums of antiquity designed, very graphically, to accommodate "secular relics."[47] The British Museum, begun in 1823 and designed by its architect Sir Robert Smirke as "an Ionic temple with two wings" (Bazin 198), was in fact inspired by the Parthenon in Athens. In Munich Louis I of Bavaria commissioned the construction of the neo-Greek Glyptothek to keep and display his collection of antiquities, including the pediments from the Temple of Aphaia in Aegina.

The association of artifacts with art and then with these buildings of solemn importance—both the temples from which they might have come and those in which they were deposited—profoundly influenced the way art and cultural history were imagined. As we shall see, the temple played an important role for poets as well as historians in visualizing both the art work and art history in general. Winckelmann declared that during the fifty years following the Persian War "was laid a foundation for the greatness of Greece on which an enduring and splendid edifice could be erected. The philosophers and poets commenced the structure; the artists completed it; and history leads us to it through a magnificent portal."[48] In an ardent commemorative essay written in 1781 Herder spoke of "the edifice of his historical doctrine," describing it as a "simple Greek temple" with "supreme sanctuaries and vast perspectives" standing before us.[49] Schlegel praised Winckelmann as "the best guide to conduct us to this sanctuary of the beautiful, with deep and thoughtful contemplation" (48).

Those interested in relating periods or cultures to the forms they produced found a logical beginning in the sculpted forms from classical Greece as stationed in an ancient temple or a modern museum. Matthew Arnold, a later advocate for a monumentalist sense of the past, would quite naturally turn to Greek literature as a model for humanist formalism ("a model of immortal beauty") *and* to Greek sculpture as a visual model for true literary form. His 1853 Preface declared that the unifying element of a Greek tragedy, its "mythic story," was in the mind of the spectator as he entered the theater: "it stood in his memory, as a group of statuary, faintly seen, at the end of a dark vista." The strength of this self-configuring central idea gave to the classical artist—sculptor or writer—the power of architectonics, "that power of execution which creates, forms, constitutes," and which allows "the spirit of the whole" to be "seized."

Partly through the influence of Winckelmann, the museum curator and his audience saw the housed artifacts as materials for a newly constructed, comprehensible version of human progress and the "Rise of the Arts." Art history and art collecting grew up together and were part of the same phenomenon.[50] The novelist Lady Morgan wrote that the Gallery in Florence permitted the visitor "to read the history of man in the progress of his works," from the time the "dark rude animal" first exercises his imagination by "scooping his hideous idol in the rock" to the time when, as Phidias or Michelangelo, he leaves in the marble the record of his own and his god's divinity.[51] Likewise, in the Louvre one could trace "the progress of the art from its first beginning to the period of its greatest perfection."[52] However, as I have said, these visitors found only the paintings there organized to this end. The sculptures were treated as self-existent forms. The Louvre sculpture salons showed only "captive gods and emperors . . . imprisoned heroes and sages," the Reverend James Chetwoode Eustace complained, while the sparse windows allowed a few sunbeams to "just glare on the lifeless forms, as if to show the paleness of the marble."[53] "Statues, like pictures . . . ought to be arranged so as to form the history of the art," leading the spectator "from the first efforts of untutored nature, to the bold outlines of the Egyptians, to the full, the breathing perfection of the Greeks."

Graphically Winckelmann and his followers gave each historical period the faces and figures of its characteristic forms. The descriptions and engraved plates in his *History of Ancient Art* provided models for visualizing particular ages, most memorably that of classical Greece. But it was left to A. W. Schlegel to demonstrate the cultural unity of historical periods by devising, in terms of such models, the kind of inter-art analogies that have always been essential to concepts of cultural periodization.[54] Schlegel made sculpture a figure (in two senses of that word) for Greek drama, and painting for Romantic (post-classical) drama. Each style of drama, merged with its appropriate iconic form, became a model for the spirit of its age, bringing "before our eyes an independent and definite whole." Such a whole, perceived *as if visually,* is perceived as having monumental form. "The solidity and uniformity of the mass in which [the figures] are constructed" announces "a creation of no perishable existence, but endowed with a high power of endurance" (*Lectures* 76). Characteristic form, remaining a shape in history, analogically provides a shape to history, reconstituting it figurally.

Although the arts became the focus of Schlegel's interest in the later years of his life, a time when he superintended Berlin's Museum of Antiquities and delivered a notable series of lectures on the *Theory and History of the Fine Arts,* he is best remembered for his work on literature: his essays, his translations of Shakespeare, and above all a series of

historical lectures he gave in Vienna during the spring of 1808 on *Dramatic Art and Literature*. As we shall see, when published these were to have a major effect on the way English writers such as Hazlitt, Coleridge, and Shelley analyzed and, more importantly, imagined the history of poetic thought.[55]

Although the whole series shows the stamp of Winckelmann's perceptions, it is in the third lecture that Schlegel pays the most direct homage to the *History of Ancient Art* and the methods of "our immortal Winckelmann" (48). He begins this part of that lecture, a section on the study of the antique, by noting that although Winckelmann's subject was the plastic arts, he left many "hints" for the study of other aspects of Greek civilization, especially of literature. These hints, expanded to cover subsequent periods of literature and culture, become the basis for Schlegel's own historical method.

Throughout all the lectures, but especially in the third, Schlegel displays and defines what I have called museum consciousness, a way of thinking about cultural history to a large extent influenced by assumptions behind the philosophy and practice of art museums of the time. In a chapter on "The Essentials of Art" Winckelmann had indulged in a reverie in which he was an athlete in the Olympic Stadium. All around him he saw "countless statues of young manly heroes, and two-horse and four-horse chariots of bronze, with the figures of the victors erect thereon, and other wonders of art" (1–2: 190). This was his version of what Malraux would call our *"musée imaginaire"* or "museum without walls": the personal or cultural mental storehouse of images of the noblest works of art (13–16). Winckelmann argues that the critic-historian must try to collect and unite in the mind all the statues mentioned by ancient authors and all those whose fragments might be viewed. "When the understanding and the eye assemble and set the whole together in one area, just as the choicest specimens of art stood ranged in numerous rows in the Stadium at Elis, then the spirit finds itself in the midst of them."

Briefly, the assumptions Winckelmann and Schlegel shared in these matters were: 1) The culture of a nation is best grasped and displayed by the display of its monumental forms, the noblest productions of national genius. "The history of the development of art and its various forms may be . . . exhibited in the characters of a number, by no means considerable, of elevated and creative minds" (Schlegel 29). 2) When arranged or ordered historically these forms show the historical shape of a national or international culture. 3) Therefore, to make the presentation of forms publicly accessible either tangibly or verbally is to teach cultural history to the public. To these assumptions Schlegel, again following Winckelmann's lead, added three others, and by example showed how they

might be applied. 4) In *all* the arts each age has left behind characteristic forms by which it might be understood. 5) These historically characteristic forms in one of the arts have analogues in the others. 6) Therefore a new literary history is possible based on an understanding of the history of all these characteristic forms.

Schlegel's subject is drama, which he sees as essentially theater or spectacle, "visible representation before spectators." It follows, then, that the historian should give dramatic literature a "sort of theatrical animation" by offering to the mental view images of Greek statuary as conceptual models. Because every great cultural period is an organic whole, certain forms can be made to stand for that whole and give it a concrete presence. Winckelmann's investigation into early figural art had taught cultural historians to interpret periods by means of typical styles of representing the body. By using the inter-art analogy, Schlegel gave his own cultural history a broader perspective than Winckelmann's did. "We are yet in want of a work in which the entire poetic, artistic, scientific, and social culture of the Greeks should be painted as one grand and harmonious whole . . . and traced through its connected development in the same spirit which Winkelmann [sic] has executed in the part he attempted" (48–9).

Delivered the year *Corinne* made its appearance, Schlegel's *Lectures* used human forms in painting and sculpture this way to embody different styles of representation and effect for different periods. As Winckelmann did in his *History,* Schlegel offered a monumentalist view of cultural history, comparing and judging the "original and masterly works of art . . . the existing productions of the human mind" (18). This is very close to what the *History* tried to do, to show "the origin, progress, change, and downfall of art, together with the different styles of nations, periods, and artists, and to prove the whole, as far as it is possible, from the ancient monuments now in existence" (1–2: 3). Winckelmann's monuments are sculptures *by the side of which* we see Greek drama and "the other branches," making up a composite, a panorama of Greek culture (1: 3). Schlegel's are the otherwise lost figures in ancient drama restored by calling up sculptural models. Ancient Greece, the "consummation of form" (Schelling 336), was a natural starting place.

> What is the best means of becoming imbued with the spirit of the Greeks, without a knowledge of their language? I answer without hesitation,—the study of the antique; and if this is not always possible through the originals, yet, by means of casts, it is to a certain extent within the power of every man. These models of the human form require no interpretation; their elevated character is imperishable, and will always be recognized through all vicissitudes of time. . . . (47–8)

Although we have no other information about the artist's exact intention or even who the figures are supposed to be, the idiom of form is always comprehensible.

As a staged or presented aesthetic form, the monumental figure operates in Schlegel's lectures to provide insight into cultural periods, much as it was supposed to in a museum. As readers we can give a theatrical animation to the great tragedies by keeping the "forms of gods and heroes" such as the Laocoon or Niobe "ever present to our fancy" (48). This would be the basis of a grand historical vision not just of drama or sculpture but of cultures as a whole in a *musée imaginaire*. These are no doubt some of the "shapes of beauty" that Keats in *Endymion* says we must always have with us. Obviously if we do not, in Schlegel's terms, keep them present in our imaginations we lose much of our power to read other artifacts. If we do keep them present, we have a way of reading history by responding to the *aesthetic* power of individual works. This, as I shall presently show, is the technique proposed by Shelley's "Defence of Poetry."

Significant form is the principle in a work that makes us *visualize* a particular kind of unity and therefore feel a particular kind of effect. "It is only before the groupes of Niobe or Laocoon that we first enter into the spirit of the tragedies of Sophocles" (48). Of course Schlegel places us mentally, not physically, "before the groupes," positioning the figures in our minds as figures or emblems of thought. Using visual form, sculpture, rhetorically to convey the spirit of the nonvisual, drama, he advanced his most influential idea, that the "spirit of ancient art and poetry is plastic *[plastisch]*, but that of the moderns picturesque *[pittoresk]*" (22). Thus the essence of the classical work of art, sculptural or poetic, is a highly unified beauty, characterized by the single figure or group, that of the moderns a more complex and heterogeneous unity, as among the figures in a painting. The human form becomes a figure first for the spirit of the work and then for the spirit of the age.

The impulse, I believe, in identifying these two types of historical form is the humanist one of giving faces to historical periods to underline the endurance throughout history of something identifiable as human intentionality embodied in form. In its essential configuration the body, unchanging through history, stands for humanity and universal ideas about man. Among natural forms, Schelling declared in 1807, art should "seize directly" on what is "highest and most evolved, the human figure" (336). "The forms of sculpture are as uniform and eternal as simple, pure, human nature," Herder wrote; "the shapes of painting, which are a tablet of time, change with history, races and times."[56] The forms of sculpture can stand for the "simple" and "pure" in humanity, but as Hazlitt pointed out in some remarks on the Schlegel formulation, classic

and romantic are equally "founded in essential and indestructible princi-
ples of human nature" (*Works* 6: 348). This is certainly a dominant view
in Schlegel's *Lectures* as a whole, which attempted to restore the balance
that Winckelmann had tipped in favor of the classics.

What makes any "work" historically telling, Schlegel indicates, is
that point of contact between style and idea that we refer to as form
which can be interpreted by the metamorphosing trope that images the
work's effect. Through their signifying forms, therefore, preserved art
objects provide a unified conception for each individual period. In addi-
tion, the fact that even across centuries they can inspire "astonishment
and admiration" assures us of the universality of human response and
thus offers a sense of the unity of human history, providing a sense of
form for that as well. Such assumptions were basic to Friedrich
Schlegel's own lectures, which also made use of inter-art analogies to
convey the essence of historically significant aesthetic forms. As a liter-
ary historian Friedrich too sought to renovate old poems and plays by
reproducing them in analogous forms. Like old paintings they must
undergo a "process of restoration," so as to be rescued from the "dust
of ages." He believed that restoring works of post-classical periods
would help restore those periods in the eyes of historians. His discussion
of the "Gothic" works of Eschenbach and his contemporaries was
meant to help make the excellence of the Middle Ages "patent to all
eyes." To do so he must display the period in terms of its characteristic
forms, and like his brother he used one art form as a metaphor for
another. Past periods cannot be comprehended by analysis alone; each
must be known by its formal effect. Medieval German poetry in its con-
ceptual simplicity and its decorative style bears "a striking resemblance
to the monuments of Gothic art, which still impress the beholder with
mixed feelings of astonishment and admiration."[57] The act of reconsti-
tuting an age by graphically reproducing its most characteristic works
became an essential mark of these early literary histories.

Cultural and art historians from Winckelmann on sought to show
that recovered figures constitute a living language for the past—as Cas-
sirer put it, "messages addressing us in a language of their own," living
rather than dead. Any language should serve to make clear its subject,
but dead languages themselves need explaining or deciphering. Cas-
sirer's goal of discovering an "idiom"—a style of speaking that
expresses a style of thinking—is based on the idea, one I have been trac-
ing in this chapter, that types of figures—literary and plastic—are mutu-
ally referential, and that one can be used to restore the other. I will men-
tion one case briefly before turning in the next chapter to a literary
monumental history not usually remembered as such: Shelley's "Defence
of Poetry."

In the winter of 1819 Hazlitt delivered a series on *The Dramatic Literature of the Age of Elizabeth,* the eighth and last of which, "On the Spirit of Ancient and Modern Literature," was based on Schlegel's distinction between the sculpturesque and the painterly. In it he declared that Schlegel was right in having us contemplate the Greek dramatists while standing before the Niobe or Laocoon (*Works* 16: 349); to show the distinctive nature of modern literature (in this case Elizabethan) Hazlitt used an architectural model. His point was that classical art is that of immediate visual impact, romantic of imaginative association of images. "A Grecian temple, for instance, is a classical object: it is beautiful in itself, and excites immediate admiration. But the ruins of a Gothic castle have no beauty or symmetry to attract the eye; yet they excite a more powerful and romantic interest, from the ideas with which they are habitually associated" (348). The habit of using historical inter-art analogies became ingrained with Hazlitt after reading Schlegel and is a prevailing feature in *Lectures on the English Poets.* His introductory "General View of the Subject" in the Elizabethan lectures adopts and even elaborates on Schlegel's counsel to imagine art objects when thinking of literary works: "What is, I think, as likely as any thing to cure us of this overweening admiration of the present, and unmingled contempt for past times, is the looking at the finest old pictures; at Raphael's heads, at Titian's faces, at Claude's landscapes. . . . We begin to feel, that nature and the mind of man are not a thing of yesterday, as we had been led to suppose" (*Works* 16: 178). Hazlitt also observed that time has left only "the wrecks of taste and genius . . . from which we are only now recovering the scattered fragments and broken images to erect a temple to true Fame! How long before it will be completed?" Hazlitt's lectures were intended as a kind of temple of the arts, to restore and house the fragments and images, to "rescue" his subjects from "hopeless obscurity" and "do them right" (*Works* 6: 176).

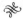

In the plastic arts "form" meant first of all significant shape or outline. In the museum age it came to signify or express both the work's own aesthetic essence and the essence of that age or civilization that produced it. Thus the Grecian Urn's "attic shape," read as form, spoke not only of its own character, but of the character of ancient Greece. Time, however, obscures or mutilates its forms. Writers could rescue or even restore them by visualizing them as other shapes or as figures in other media. In doing so, as we shall see in the next few chapters, they called upon another, centuries-old, idea of form: the shaping or reshaping force rather than the shaped thing.

FIGURE 3. Medici Venus. Uffizi Gallery, Florence. Photo: Alinari/Art Resource, NY.

CHAPTER TWO

History's Seen and Unseen Forms: Peacock and Shelley

> She, all those human figures breathing there
> Beheld as living spirits—to her eyes
> The naked beauty of the soul lay bare,
> And often through a rude and worn disguise
> She saw the inner form most bright and fair—
>
> —Shelley, "The Witch of Atlas"

Those museum visitors heard from in the last chapter could journey through Europe in relative comfort and safety because the Napoleonic wars had ended at Waterloo in June, 1815. No longer was there a French military presence in the cities of the Grand Tour, and for the most part the masterpieces looted by the Imperial Army had been restored to their original settings—private palaces or public museums. Tourism flourished, and so did guide books and travel memoirs. Some idea of the interest in the subject might be gained by a very partial list of publications from the decade or so following the war: W. A Cadell, *A Journey in Carniola, Italy, and France* (1820); Henry Coxe, *Picture of Italy* (1815); the Reverend George Croly, *Paris in 1815* (1821); Richard Duppa, *Miscellaneous Observations and Opinions on the Continent* (1825); the Reverend John Chetwoode Eustace, *A Classical Tour through Italy and Sicily* (4th ed., 1817); Joseph Forsyth, *Remarks on*

35

Antiquities, Arts, and Letters During an Excursion in Italy (2nd ed., 1816); James Galiffe, *Italy and Its Inhabitants;* A. and W. Galignani, *Traveller's Guide through Italy* (1819); Thomas Jefferson Hogg, *Two Hundred and Nine Days* (1827); Lady Morgan, *Italy* (1821); Thomas Raffles, *Letters during a Tour through Some Parts of France* (1820); W. S. Rose, *Letters from the North of Italy* (1819); Henry Sass, *A Journey to Rome and Naples in 1817* (1818); and Charlotte Waldie, *Rome in the Nineteenth Century* (1820).

Shelley's own remarkable contribution to the literature of aesthetic tourism was a series of letters from 1818 to 1820, mainly to Thomas Love Peacock in England, describing the architectural, pictorial, and sculptural treasures of Italy. To these may be added notes he took in 1819 (published posthumously) on statues mainly in the Uffizi, where he judged the Niobe figure the personification of beauty of countenance.[1] "I have seen a quantity of things here," he reported from Bologna, "— churches palaces statues fountains pictures, & my brain is at this moment like a portfolio of an architect or a printshop or a connoisseurs common place book." From Rome he wrote of viewing such treasures as the Belvedere Apollo, the Gladiator or Dying Gaul, the Laocoon, and the Capitoline Venus, drinking in "the spirit of their forms" (*Letters* 2: 84). Passages in *Prometheus Unbound,* explained Mary Shelley in a note to the play, were traceable to the "intense delight" he took in these studies: "The charm of the Roman climate helped to clothe his thoughts in greater beauty than they had ever worn before. And, as he wandered among the ruins made one with nature in their decay, or gazed at the Praxitelean shapes that throng the Vatican, the Capitol, and the palaces of Rome, his soul imbibed forms of loveliness which became a portion of itself."[2]

From Florence Shelley wrote to Peacock that one of his chief aims in Italy was "observing in statuary & painting the degree in which, & the rules according to which, that ideal beauty of which we have so intense yet so obscure an apprehension is realized in external forms" (*Letters* 2: 127). The impressions made on Shelley's mind by such forms during his various stays are very much part of the context not only of *Prometheus Unbound,* but of his response to Peacock's "Four Ages of Poetry." So also were his studies at this time. On his way to Italy in the spring of 1818 he was reading, to himself and to his companions, John Black's 1815 translation of Schlegel. This book helped develop in him what I have called a museum consciousness, as Schlegel had taught that a "study of the antique," of the "models of the human form," which required no interpretation, would enable one to grasp their "elevated character," and thereby the character of the Greek civilization. Schlegel had also credited Winckelmann for showing how to picture these figures

side by side with literary characters of the same period in order to understand the character of both. If mentally staged statues are "imperishable . . . through the vicissitudes of time," so are those in poetry. Especially after gazing at the classical statuary of Rome, Naples, and Florence, Shelley saw representations of the body as more powerfully human than the body itself. The experience must have been like Goethe's in his own journey to Italy: "Standing amid antique statues, one feels as if all the forces of nature were in motion around one. One is made aware of the multiplicity and diversity of human forms and brought back to man at his most authentic, so that the beholder himself is made more human and authentic."[3] For Goethe the human figure was "the alpha and omega of all things known to us . . . [it] has come to grips with me and I with it . . ." (374). Following the direction of Goethe, Winckelmann, and others, Schlegel chose Greek sculpture as his model for the spirit of that age, a spirit he viewed as pure and uncomplicated.

That December in Naples Shelley spent a week going through Winckelmann's *History* in a French translation.[4] The most immediate influence, Nathaniel Brown has argued, was on his 1818 "Discourse on the Manners of the Ancient Greeks Relative to the Subject of Love."[5] Among other subjects, this essay, written during the summer, treats androgyny and homosexuality in ancient Greece. It takes some of its evidence from classical sculpture, since Shelley believed, as had Winckelmann, that "the models which they have left" are "specimens of what they were" (*Prose* 221). The *History* and the museum presentations it influenced themselves offered models for the imaginative experience of historical periods through the visual experience of sculpted or painted forms. It was a method adaptable to the imagining of literary history as well. In this chapter I shall look in some detail at a notable example, Shelley's "Defence of Poetry."[6]

MIND AND FORM

For both Peacock and Shelley human history is one of man-made forms. For Shelley, however, forms lie hidden within the past; as form is often invisible, so are intention and influence, apparent only in their embodiments. "How evanescent are paintings & must necessarily be," Shelley wrote from the Continent. "The material part indeed of these works must perish, but they survive in the mind of man, & the remembrances connected with them are transmitted from generation to generation. The poet embodies them in his creation, the systems of philosophers are modelled to gentleness by their contemplation . . ." (*Letters* 2: 53). For Shelley and others, any modern "re-producing" of forms is also an act

of republication of past intention and an historical recreation. One aim of the "Defence" is to show how such forms, especially poetry's envisioned ones—literary characters—operate not simply to bind the work to reader or viewer, but to create a cultural history, binding age to age. By creating new forms for the future as well as records of the past, great poems or dramas unify history as a realm conformable to the mind, one "to which the familiar world is a chaos" (505).

The first issue addressed by the "Defence" is the way the mind creates form. Near the end of the "Four Ages" Peacock dismisses the poetic mind as lacking

> the philosophic mental tranquillity which looks round with an equal eye on all external things, collects a store of ideas, discriminates their relative value, assigns to all their proper place, and from the materials of useful knowledge thus collected, appreciated, and arranged, forms new combinations that impress the stamp of their power and utility on the real business of life. . . . (21)[7]

Peacock's "philosophic" mind, which his own historical method must surely be intended to show at work, acts sequentially: 1) it turns things into thoughts and collects the thoughts; 2) it assesses, or places "relative value" on, the thoughts; and 3) it "forms" the most valuable of these thoughts into "new combinations," which can influence "the real business of life." The most constructive part of this process, the rearranging of thoughts into new concepts, is always intention- and value-shaped, and those values, "power" and "utility," are mutually reinforcing: in life's real business utility is powerful and power is useful. The new intellectual form of most power, in Peacock's scheme, is the end product of a process of collecting, arranging, and combining.

The "Defence" begins by disputing this empiricist concept of form. Formation does not follow perception; it is intrinsic to it. Whereas *logizein* regards things "as the algebraical representations which conduct to certain general results," *poiein* "regards the relations of things . . . in their integral unity." It colors thoughts "with its own light . . . composing from them, as from elements, other thoughts, each containing within itself the principle of its own integrity." But whereas Peacock's philosophic mind first treats things as signs ("representations"), then separates those signs into categories ("assigning to all their proper place") in order to "discriminate" their "relative value" and then to reconstitute them, *poiein* "*is* the perception of the value" of its materials (emphasis added), as well as "the principle of synthesis." It is, then, at once all three phases of Peacock's conducive thought: perception, appreciation, and representation. How can it be? Only if it is a "class of mental actions" that includes both aesthetic perception—

the expression of taste—and creativity, the expression of the imagina-tion. As a "principle," then, ("a primary element, force, or law which produces or determines particular results" [OED]), poiein creates indi-vidual forms. As a principle of each of those forms—a poem, a statue, a law—it is form in the Scholastic sense ("the essential determinant principle of a thing" [OED]). Shelley will think of such a principle as inner form, invisible but powerfully and perpetually generative, since each form contains "within itself the principle of its own integrity." One might say that the "Defence" is about the relation of poiein to its forms (an in-dwelling, life-sustaining relationship), and of logizein to its forms (a purely external one).

Reflecting on all this, one might suppose that in the "Defence" Shel-ley would wish to "regard" a subject like poetry by poiein. In the first part, however, his method is dominantly (and I believe deliberately) ana-lytical. Following the example of Aristotle's Poetics, he carefully devel-ops a series of categorial distinctions, analyzing (as logizein does) "the relations of things, simply as relations." "Poetry in a more restricted sense" (483) is considered here not so much as one type of thinking but as one type of production among many. Poets are "not only the authors of language and of music, of the dance and architecture and statuary and painting: they are the institutors of laws, and the founders of civil soci-ety and the inventors of the arts of life . . ." (482). These different forms Shelley distinguishes and compares, always to the advantage of "lan-guage"; then he divides language into poetry, stories, philosophy, and history—to the advantage of poetry. He views his subject in a more and more "restricted sense," placing it within greater and greater "limits," and by making the "circle still narrower" (484) retreating from the con-cept of poiein he began with, a concept he referred to in a letter as a "more general view of what is Poetry" than Peacock's (Letters 2: 275).

This circumscription prepares the way for the next section. His "defence" of poetry must, by showing how the world of aesthetic expe-rience relates to the "factual" world of general history, deal with Pea-cock's charge that it has come to relate less and less, or in Auden's words, that it makes nothing happen. He sets out therefore to "estimate [poetry's] effects upon society" (486) and uses Peacock's own scheme, the literary history. Historical analysis, however, must regard its subject phenomenally, as something which having a particular existence may also have a particular history of causation. Because poiein, as a type of mental action, has no particular existence and thus no history, Shelley initially lays the ground for his own literary history by seeing "poetry," as Peacock does, as an historical fact, a developing body of writing. Then in the second part he moves to historical instances, and from cat-egorical to chronological and causal relations: he follows Peacock's lead

in dividing his subject linearly into ages or periods in order to trace what Gibbon calls "the natural connexion of causes and events."[8] It was the standard analytical way of perceiving historical value.

Approaching this task of chronicling, however, he includes two paragraphs that would seem to discredit that plan. First he casts a shadow on the adequacy of any kind of narrative to describe experience:

> A poem is the very image of life expressed in its eternal truth. There is this difference between a story and a poem, that a story is a catalogue of detached facts, which have no other bond of connexion than time, place, circumstance, cause and effect; the other is the creation of actions according to the unchangeable forms of human nature, as existing in the mind of the creator, which is itself the image of all other minds. The one is partial, and applies only to a definite period of time, and a certain combination of events which can never again recur; the other is universal, and contains within itself the germ of a relation to whatever motives or actions have place in the possible varieties of human nature. (485)

As this passage is crucial to understanding the essay's rhetorical structure, it may be helpful to discuss its central distinction. A story is "a catalogue of detached facts," but a poem is "the creation of actions." Unlike the story, the "poem" is both cause and effect, a working and a work. "The creation of actions" may refer to its being the product of the creative process, but it also defines the poem itself as an influence, a creator of new actions. (In a passage Shelley translated from Plato's *Symposium, poiein* is described as "a general name signifying every cause whereby anything proceeds from that which is not, into that which is; so that the exercise of every inventive art is poetry, and all such artists poets.")[9] That is why it is *the* creation, while the story is *a* catalogue. But a poem—*Comus* or *The Faerie Queene*—is also of course *a* particular creation, an effect or achievement. Obviously, then, poems in the limited sense are "forms" that might be catalogued or chronicled. As "detached" facts in a very transitory "combination," however, they will never coalesce into an "image" because the world of phenomena enjoys no natural unity: its connections are *merely* those of "time, place, circumstance, cause and effect."

"Men, even in the infancy of society, observe a certain order in their words and actions, distinct from that of the objects and impressions represented by them, all expression being subject to the laws of that from which it proceeds." Those laws are of the synthesizing or unifying power he speaks of in paragraph one; they can account for the "immortal *creations*" (emphasis added) of ancient Greece, the first historical age considered by Shelley. Any human perception or expression, therefore, has a form, an "order," to a degree distinct from the shapes of external objects and of transient emotive states. This order he sometimes refers to as "rhythm," a word that seems to carry for him the special meaning

given it by artists of his time, a "due correlation and interdependence of parts, producing a harmonious whole" *(OED)*. The rhythm discernible in human expressions, whose internal relations reflect those in thoughts rather than in things, is evidence of the mind's independent formative power (494). The principles of form are "equality, diversity, unity, contrast, mutual dependence" (481).

Poets *per se* do not appear in the "Defence" until halfway through the third paragraph. Whereas in the simple act of continuation described above, poetry is "connate with the origin of man," the poet and his public representations are connate with the origin of society and therefore of "language." With social man emerges the necessity, therefore the instinct, for a language of expressive forms. Figurative language "perpetuates" certain thoughts, and the pleasure the poet derives from certain impressions "communicates itself to others, and gathers a sort of reduplication from that community" (482). In short, the desire to "perpetuate" impressions and feelings, especially the feeling of pleasure, finds "expression" *as* it embodies itself in language for the purpose of communication. In fact it is only such an outward medium that enables the poet's *self*-expression, the revealing and recording for history of the self and its most prominent faculties (as distinct from the temporary revelation of some feeling or other). As we shall see, for Coleridge the most distinctive outward medium was the literary work, but also the character within the work. That is true of Shelley as well.

To summarize Shelley's argument, far from turning into "disjointed relics" as Peacock argued (20), spoken or written poetry *lends* form "to that which is most deformed" (505), and it is strong enough to give living form even to dead thought, impressing the imagination, as he has said earlier in the essay, "upon its forms." The works of Dante and Milton "have conferred upon modern mythology a systematic form; and when change and time shall have added one more superstition to the mass of those which have arisen and decayed upon the earth, commentators will be learnedly employed in elucidating the religion of ancestral Europe, only not utterly forgotten because it will have been stamped with the eternity of genius" (499). To some degree, then, Shelley's essay concerns the way poetry makes use of the past, even the unenlightened past. It shows that the poet does not, as Peacock says, merely wallow "in the rubbish of departed ignorance" (19)—but reforms and perpetuates the past.

THE POTENCY OF THE LIVING IMAGE

Unified by authorial perception and intention, a poem is "the very image of life expressed in its eternal truth." It has that advantage over the

story, which deals with the particular, not the universal, as Aristotle says of history in comparing it to poetry.[10] In Shelley's words, history concerns only "a definite period of time, and a certain combination of events which can never again recur." The "bond of connexion" that narratives don't have is the image of the author's mind. Forms in that mind—those, as Coleridge put it, of "the permanent in our nature, which is common and therefore deeply interesting to all ages" (see chapter 3)—are impressed on what it finds, making that intelligible for future generations. For these reasons, a results-measuring history of literary phenomena, like Peacock's own, or the one Shelley proposes, could hardly succeed in either understanding poetry or measuring its effects on society. So he turns specifically to historical narrative, whose structure, he says, is strong and durable only in the works of those historians who are also poets, those who have filled "all the interstices of their subjects with living images" (486).

With their chronological "plan," historical treatises cannot in their entirety be works of the imagination nor, therefore, images of life in its "integral unity." However, any "living" images within them are themselves poems or "forms." The next stage of Shelley's argument—poetry's effect on society—concentrates on one kind of living images, literary characters: "eternal truths charactered upon the imaginations of men" (501). Shelley sees such characters, "great and lovely impersonations," as having a dual historical function: to represent their age and, standing as "edifying patterns for general imitation," to act as moral influences on history itself. "Homer embodied the ideal perfection of his age in human character; nor can we doubt that those who read his verses were awakened to an ambition of becoming like to Achilles, Hector, and Ulysses" (486).

"Embodiment," *poiein*'s mode of formation, is opposed to "combination," which is *logizein*'s mode. The noblest literary characters are integrated embodiments of the ideals of the age, in this case of "friendship, patriotism, and persevering devotion to an object." As embodiments, they are characteristic forms with respect to the noblest qualities not only of their author but of their age. They are therefore mirrors in which "the spectator beholds himself, under a thin disguise of circumstance, stript of all but that ideal perfection and energy which every one feels to be the internal type of all that he loves, admires, and would become" (490). Shelley's placing such "living impersonations" as Philoctetes, Agamemnon, or Othello on his own shield would "put to flight the giant sophisms" of Peacock, who prudently sidesteps the effect of drama on "life and manners" (490).

Shelley's own Prometheus is "the type of the highest perfection of moral and intellectual nature" (133). Whether imaginary or historical,

such a personage is a human "type"—not a mere sign for ideas about human nature but a symbol and example of it. Hector, Achilles, and Ulysses, types of "human character" like Prometheus, are impersonations ("stamped . . . visibly with the image of the divinity in man" [488]). Such are "beautiful idealisms of moral excellence" (135), "the living impersonations of the truth of human passion" (490). An impersonation is "a person or thing representing a principle, idea, etc." *(OED)*, representing in the sense of manifesting or revealing. (Carlyle would speak of "Man the visible Manifestation and impersonation of the Deity.") It is a sign *of*. Although early poetic language is "vitally" metaphorical, in its decay it becomes "signs *for* portions or classes of thoughts instead of pictures *of* integral thoughts" (482; emphasis added).

Clearly, for Shelley impersonation is the product of synthesis, which "has for its object those forms which are common to universal nature and to existence itself." Forms common to universal (human) nature are ideal images, forms in the mind; those common to existence are real people. Synthesis embodies the forms of universal nature in the shapes of existence. Its most commanding poetic forms, "poetical abstractions," combine the observed and the archetypal, representing and analogizing "those sources of emotion and thought" and the "contemporary condition" of them (Preface to *Prometheus Unbound*). (The specific process he illustrates elsewhere [*Prose* 220] by a person's seeing figures in clouds or flames: the mind, seeking out a real form closely resembling its own archetype, "fills up the interstices of the imperfect image.")

A dramatic work leaves the most accurate reflection of its own age (491–2). The modern historical drama (like *The Cenci*) can profoundly interpret a past age when its ideal impersonations inter-react with historical circumstance, which "an epic or dramatic personage is understood to wear . . . around his soul, as he may the antient armour or the modern uniform around his body" (487). All of the circumstantial costuming of clothes, manner, or historical speech helps give history a human figure but not, as Foucault would say, a "face," not a living form at all. However, beneath the figure of, the figure taken from, is the form, the basis of the figure for. The modern reader's or writer's task is to discover the unseen form beneath the uniform. "The beauty of the internal nature cannot be so far concealed by its accidental vesture, but that the spirit of its form shall communicate itself to the very disguise, and indicate the shape it hides from the manner in which it is worn. A majestic form and graceful motions will express themselves through the most barbarous and tasteless costume" (487). The particular world of the character, however, and the historical action in which he or she is involved, will also help us read the character of that age. The "thin disguise of circumstance" constitutes a genuine historical identity, the

shapes of the time imposed on essential forms of beauty. To a poet, vices of his time are "the temporary dress in which his creations *must* be arrayed, and which cover without concealing the eternal proportions of their beauty" (487; italics added). Beatrice Cenci's "crimes and miseries" were "as the mask and the mantle in which circumstances clothed her for her impersonation on the scene of the world" (242). Likewise, though we see recorded even in Milton and Dante "distorted notions of invisible things," these are "merely the mask and mantle in which these great poets walk through eternity enveloped and disguised" ("Defence" 498). But poetry reanimates "the sleeping, the cold, the buried image of the past." It "redeems from decay the visitations of the divinity in man" (505).

Shelley's ideas on the dual nature of poets and their greatest literary characters—their historicity and their universality—are related to his distinction between stories, including histories, and poems. Whereas the story is a catalogue of time-specific "detached *facts*," the poem is compounded of "the unchangeable *forms* of human nature" (emphasis added). In a linear, narrative view of general history, as opposed to a synthetic, poetic, or cultural one, persons are facts. A linear view of poetic history also sees figures as facts: images of transitory realities. But as Coleridge insisted in *The Statesman's Manual,* they may be forms as well as facts, ideals and models as well as portraits (See chapter 3). A symbol "always partakes of the Reality which it renders intelligible; and while it enunciates the whole, abides itself as a living part in that Unity, of which it is the representative" (*SM* 30). This I believe is the sense, and perhaps a source, of Shelley's own statement that the poet's images "participate in the life of truth" (485).

And why do these ideal figures appear to the poet and not to the historian and novelist? Because only the poet's mind "is itself the image of all other minds." Each poet's mind is a collective and creative consciousness, composed of monumental forms left by each of the preceding ages. A synthesizer of present and past cultural history, the poet is a product of no one age. Because the poem in its universal representation of "human nature" will be understood by and influence future generations of readers and poets, it contains "within itself the germ" of a *future* literary history. While the "Defence" clearly emphasizes social changes and the corresponding moral state of society, Shelley clearly believes aesthetic pleasure to have been historically instrumental with respect to these things. Its instrumentality is usually obscure, however, as reflected in the unarticulated connection between this sentence's two main clauses: "The poems of Homer and his contemporaries were the delight of infant Greece; they were the elements of that social system which is the column upon which all succeeding civilization has reposed" (486). (I shall suggest below what I believe Shelley saw as the connection.)

Part of the difficulty of tracing *poiein* is the mysteriousness of creativity, which "acts in a divine and unapprehended manner" (486). Images arise "unforeseen and depart unbidden" (504), undirected by "consciousness or will," the "necessary conditions" of other "mental causation" (506). Nor do will and consciousness count for much in poetry's reception. The poet's auditors "feel that they are moved and softened, yet know not whence or why" (486). The immediate effect of poetry is entirely aesthetic, moral, and private. We know of it, but we are never conscious of its cause or of its considerable moral and social value. This was a common view of taste in Shelley's time and in the preceding century.[11]

What then of the poet's own causative power—his originative force? For Peacock the inadequacy of poets is not only their lack of influence on the future, but their totally passive relation to the past. His historical review in the "Four Ages" concludes that they are collectors, not creators. Poets and poems cause nothing; they are wholly caused. Having drawn upon the legends of the Age of Iron, poets of the Age of Gold are themselves succeeded and copied by the "civilized" versifiers of the Silver Age. In Peacock's own period, which ends the second cycle of four ages, poets are "a herd of desperate imitators, who have brought the age of brass prematurely to its dotage" (18). Their work, pretending to the originality of "a new principle," is only "disjointed relics of tradition and fragments of second-hand observation . . . woven into a tissue of verse" (20). Evidence of poetic imitation is reflected in the incoherence of the product, a heterogeneity that only too obviously reveals the originals. "New combinations" created by the philosophic mind are stable and coherent; those in the world of poetry become less and less so with each succeeding era.

Though it may not have been the intent, these words would have struck a personal chord with Shelley. For several years he had been battling the charge of trading in second-hand goods. In what was clearly a struggle to define the proper relation between tradition and originality, his preface to *Laon and Cythna* defended the poem, now on the basis of its daring originality, now on the basis of its observance of literary tradition. His claim that the poem "is properly [his] own" and that he imitated no one of his contemporaries is qualified by an admission that writers "cannot escape from subjection to a common influence which arises out of an infinite combination of circumstances belonging to the times in which they live, though each is in a degree the author of the very influence by which his being is thus pervaded" (*Works* 1: 242, 244).

These thoughts were to survive as the foundation of Shelley's theory of cultural progress as well as of periodization: the myriad "circumstances" of any age operate on all artists equally as a power, a "common

influence" accounting for the "resemblance" between cultural forms in that age. Although art is shaped by this power, works of art themselves help constitute the influencing conditions. The greater the number of elements making up the spirit of the age, the stronger and more necessary is the influence.[12] This last point had been argued by Hume in an essay that Shelley probably read (*Letters* 1: 342; M. Shelley 86–88). "The Rise and Progress of the Arts and Sciences" declares, "The question . . . concerning the rise and progress of the arts and sciences, is not altogether a question concerning the taste, genius, and spirit of a few, but concerning those of a whole people; and may, therefore, be accounted for, in some measure, by general causes and principles" (114).[13]

The paradox is that even persons of genius, or highly "original" thought, are the products of many determining causes, the more determinate the greater the number, and the more general the more discernible. This subject occupies much of his Preface to *Prometheus Unbound*, which details the kind of "infinite combination of circumstances" that produce an author. He allows "in candour" that his own writing might have been "tinged" by that of his contemporaries. With all great poets, however, "the spirit of their genius" remains their own and inimitable—"the uncommunicated lightning of their own mind"— while the forms they use are "the endowment of the age in which they live," the "peculiarity of the moral and intellectual condition of the minds among which they have been produced" (134). Thus it is cultural *forms* that are most historically significant, most historically determined, and of course most historically determinant. "Poets, not otherwise than philosophers, painters, sculptors and musicians, are in one sense the creators and in other the creations, of their age. From this subjection the loftiest do not escape. . . . [E]ach has a generic resemblance under which their specific distinctions are arranged" (135).

If, then, Shelley's emergent concept of literary history can be traced to *Prometheus Unbound*'s Preface, its basis is the primacy not of purely social and political influences, but of all cultural forms. These would include, of course, those legal and institutional ones that, according to him, embodied the spirit of Poetry in ancient Rome (494). Expressions of an "indestructible order" (482) in any age have a "generic resemblance" to one another, and so are the most historically revealing ones. They also have the strongest historical effect but one that cannot be historically *traced*. Shelley's survey of poetry in the "Defence" shows that the law of *poiein* operates historically much as it does in the individual creative act—as an inevitable synthesis of forms without consideration of purpose. An example is the Medieval period, which the "Four Ages," like many Enlightenment histories,[14] dismisses as an age of darkness, when all contact was lost with the cultural richness of Greece and Rome.

In this era, Peacock writes, the materials for poetry were "dispersed" or "scattered," and were only "harmonized and blended" again in the Renaissance (15). Shelley conceives of the same period as comprising one age of only temporary "darkness" and a succeeding one of chivalry in which "the poetry in the teachings of Jesus, and the mythology and institutions of the Celtic conquerors of the Roman Empire, outlived the darkness and the convulsions connected with their growth and victory, and blended themselves into a new fabric of manners and opinion" (495). Thus historical progress is not a matter of cultural expressions acting to produce different and better ones in the next age, but of their synthesizing to produce more complex ones. "The result was a sum of the action and reaction of all the causes included in it; for it may be assumed as a maxim that no nation or religion can supersede any other without incorporating into itself a portion of that which it supersedes" (496). The word "incorporating" suggests a true synthesis, a "result," no one of whose efficient "causes" can be determined, for they are really all material ones.

As the possible causes become more numerous, the effects become more complex and the relations among particular historical causes and effects more obscure. Since the cultural past is absorbed in the cultural present, important historical causes are discernible only as the Humean antecedent diffusions of "spirit and genius" in the culture of a period. And yet the process of evaluative synthesis, the "mental action" called *poiein,* must have underlain all the occasions of significant historical change. As I have noted, Shelley terms the poet's mind "the image of all other minds." He also speaks of "the invisible effluence" which "great minds" send forth and which, descending through "many men," "at once connects, animates and sustains the life of all" (493). Though unseen in its specific causative actions, it is a knowable *principle* of causation, the known power of the living image or impersonation. The effluence is identified as a *"faculty* which contains *within itself* the seeds at once of its own and of social renovation" (emphasis added). A poem, then, has no "cause" in the poetry of a preceding or contemporary poet, but may be traced to a universal feature of the human mind itself, one which represents a constitutive historical law. Reading Shelley's own poems we know that the world of poetic representation is one filled with intense "unseen" presences like the West Wind and the Skylark. By their nature these are influences for change and for good, for poetry "transmutes all that it touches, and every form moving within the radiance of its presence is changed by wonderful sympathy to an incarnation of the spirit which it breathes" (505).

What we witness in Shelley's criticism, and as we shall see in Coleridge's as well, is the development of the modern theory of literary

or artistic "influence," one framed in direct opposition to neoclassical theories of imitation and perhaps in the case of both writers a concept made to answer charges of plagiarism. Influence is not a conscious borrowing of particular aspects of a work, but an unconscious response to a work's presence. Paradoxically, by admitting to influence one shows oneself to be original—that is, an author with power, not to invent, but to "transmute" (a word Shelley favored; poetry "transmutes all that it touches").

For Shelley the recovery and transmutation of buried forms had a general cultural significance and played an important role in his concept of social reform. In Cassirer's words, reformation means "a renovation of man and of the world." A thesis of Shelley's "Philosophical View of Reform" is that times of political and social reform are also those in which inherited aesthetic forms are being made into new ones. At the essay's outset he speaks of "that imperfect emancipation of mankind from the yoke of priests and kings called the Reformation." Imbibing this spirit of freedom as it resisted Pope and Empire, Florence witnessed also a renaissance in literature and the arts, a "restlessness of fervid power which expressed itself in painting and sculpture and in daring architectural forms, and from which, and conjointly from the creations of Athens, its predecessor and its image, Raphael and Michel Angelo drew the inspiration which created those forms and colors now the astonishment of the world" (*Prose* 231).

Politically Shelley is concerned with the "forms into which society" is "distributed" (233), but these forms will have a bearing on those in the arts and vice versa. A daring movement in one area will be reflected in a like movement in the other. It is a theory of reform that, unlike Peacock's, does not depend on design or deliberation, but on the unseen effects of "inspiration." Since reasons or purpose have no part in *poiein*'s creative or receptive process, the historian who dwells on these can never discover the essential action of poetry. A larger issue, though, is the historian's necessary ignorance of causal relations between *any* particular facts or events. In ancient Greece

> written poetry existed . . . simultaneously with the other arts, and it is
> an idle enquiry to demand which gave and which received the light,
> which all as from a common focus have scattered over the darkest periods of succeeding time. *We know no more of cause and effect than a
> constant conjunction of events:* Poetry is ever found to coexist with
> whatever arts contribute to the happiness and perfection of man. I
> appeal to what has already been established to distinguish between the
> cause and the effect. (488–89)

If there is no "constant conjunction" of particular events, we cannot denominate any thing as a cause or as an effect. Poetry "in form, in

action, or in language"—the work—is one of those realized "facts" that Shelley argues belong to stories or histories. It is then, as I have noted, particular and time-bound, unlike unrealized or pure *poiein*. This uniqueness of the historical fact baffles the historian seeking either its cause or its effect in the realm of historical fact. Therefore it is an insoluble riddle whether in any age one art form or style caused the development of another. Equally impossible to determine is the influence of, say, painting in one age on the poetry or the moral climate of the next.

Because *poiein* is "the creation of actions according to the unchangeable forms of human nature," there is a kind of eternal present in its world. The distinction is like William Davenant's, between "Truth narrative, and past" and "Truth operative, and by effects continually alive."[15] What *has* happened may well be connected by cause and effect, but in an indeterminable pattern. What *does* happen (for example, *poiein* "turns all things to loveliness") may be read causally. We cannot "feel" Petrarch's poems "without becoming a portion of that beauty which we contemplate: it would be superfluous to explain how the gentleness and the elevation of mind connected with these sacred emotions can render men more amiable, more generous, and wise, and lift them out of the dull vapours of the little world of self" (497). In aesthetic matters our own experience of effect is immediate, direct, and necessary. Therefore it would be "superfluous" to "explain" it in the instance of Petrarch's poems. "Feeling" them ourselves, we know how others will. Shelley is opposing explanation to a tacit knowledge. We know, then, through our own direct experience of image, how the poetic mind gathers, combines, and expresses its images, and how the reader of poetry is affected or influenced by these images. In short, we know the aesthetic process from conception to reception. As to the cultural or "general results" of *poiein,* we know what they are, but it is an "idle enquiry" to seek to trace them.

The methodological question raised in the "Defence" is whether analytical thinking is adequate either to grasp the nature of this invisible *poiein* or to trace the history of its forms. For Peacock, the past clearly reveals a greater and greater rationalism in the evolution of institutions; the value of any one effort is its role in this progress. Therefore in assigning relative importance to past achievements the historian must himself be a reliable narrator showing real causes rather than depending on "fabulous incident and ornamented language" (9). In this way the method of the "Four Ages" is effectively if not intentionally self-validating. In fact, Peacock says that centuries ago history appropriated poetry's role as the one accurate interpreter of the past. Before that, when the past was little known, poets were "as yet the only historians and chroniclers of their time" (6). In the first Age of Gold, the first historically conscious period,

all thought including poetry turned "retrospective" (6). Satisfied to find its "materials" in the legends and fantasies of the Age of Iron, poetry yielded the realm of historical truth to specialists: "With the progress of reason and civilization, facts become more interesting than fiction: indeed the maturity of poetry may be considered the infancy of history" (9). At this time both poetry and history looked back, but poetry merely to scavenge, history to sift and judge—to uncover the real past in order to create new ideas: "While the historian and the philosopher are advancing in, and accelerating, the progress of knowledge, the poet is wallowing in the rubbish of departed ignorance . . ." (19).

According to Peacock, poetry begins fancifully as "a sort of brief historical notices, in a strain of tumid hyperbole, of the exploits and possessions of a few pre-eminent individuals" (4). Then, in the Age of Gold, this "traditional national poetry is reconstructed and brought like chaos into order and form" (8). Next this poetry is recast and polished in the Silver Age. Then follows a return to the "barbarisms and crude traditions" of the Age of Iron (13). In its inability to maintain its form it shows how deformed the poetic past is for us now, how "crude" and unformed it always was, never having contained either fact or rational thought.

Meanwhile, fact and rational thought continue to constitute the growing empire of civilization, giving whatever real form to life it has. Only when *society* acquires "stability and form" (7), when *states* "have harmonized into a common form of society," is a nation's poetry "brought like chaos into order and form" (8). "New forms" are then found, but soon all poetic forms "become exhausted" (9). In the first Golden Age the "comprehensive energy" of Homeric poetry imparts "the grand outline of things" in "a vivid picture" (13). But by the Renaissance, the second Golden Age, the picture that poetry assembles by harmonizing "scattered materials" is "a heterogeneous compound of all ages and nations" (15); and by the second Age of Brass, the modern period, poetry is made up of "disjointed relics of tradition and fragments of second-hand observation," a "heterogeneous congeries of unamalgamating manners" (20). Poetry gains *form* (becomes formed or orderly) as civilization does—up to a point. With each Age of Silver, thought becomes more rational and fact-based, as fact had become more "interesting" in the Golden Age: first the empire of fact detaches itself, then that of thought, and while civilized thought continues to gain form, poetic thought loses it. Only the philosophic mind can give form to history, which it does in Peacock's essay, giving an upward linear, ascending form to civilization, a cyclical, descending one to poetry: a series of distinct, repeated phases, with an overall pattern of deformation. The history of civilization is linear, connected, and progressive with an overall pattern of greater and greater formation.

Like Peacock and other Grecophiles of the time, Shelley always stressed the principles of order that gave Greek monuments their own form and thus their lasting impact. His "Discourse on the Manners of the Ancient Greeks" symbolizes these principles with that culture's most familiar model: "The wrecks and fragments of those subtle and profound minds, like the ruins of a fine statue, obscurely suggest to us the grandeur and perfection of the whole" (*Prose* 217). The assumptions here are the ones I have been tracing: first, that works of a highly unified conception, those with form in that sense, can be used in any period to "suggest" one another, and when they are analogically compared they suggest their culture; and second, that both form and effect survive disfigurement in such works. Any work of Greek poetry displays "harmonious and perfect form," "homogeneous," "a whole, consistent with itself": "The compositions of great minds bore throughout the sustained stamp of their greatness" ("Discourse," *Prose* 218; see also *Letters* 2: 73–4). As the mind of the Greek artist was itself a "whole, consistent with itself," so was the mind of the age. That quality, impressed indelibly on the work as form, imparted to it an intelligible identity, a single impression, without which it would be both incommunicable and short-lived. In the "Defence" Shelley declares, as Schlegel and Winckelmann had, that the greatest Greek dramatists and lyric poets "flourished contemporaneously with all that is most perfect in the kindred expressions of the poetical faculty; architecture, painting, music, the dance, sculpture, philosophy, and we may add the forms of civil life." Because all these "expressions" of *poiein* are "kindred," all are analogous, any one can be taken as a model for the age, and all together comprise the harmonious achievement of the culture. Poets (and Shelley in his history is a poet) "unveil the permanent analogy of things by images which participate in the life of truth" (485).

Shelley allows that because of the reduced importance placed on the "inner faculties of our nature" in succeeding periods (492), poetry after ancient Greece seems partial and limited by comparison. Even those incomplete works must not be seen, however, as "fragments and isolated portions" (493), but as "episodes of the cyclic poem written by Time upon the memories of men. The Past, like an inspired rhapsodist, fills the theatre of everlasting generations with their harmony" (493, 494–5).

The rhapsodists were the reciters of epic poetry who drew together ("stitched") various epic threads in one performance. The cyclic poets were those who followed Homer, combining his stories with theirs in one integrated cycle. Thus history in Shelley's view is "cyclic" but in an almost opposite sense of the word from what we might apply to Peacock's: for Shelley the Past (the personification is significant) builds up

as in one mind a *unified* image the way that poems do. Only the monuments to worldly achievement (such as the Ozymandias statue) fall victim to what he calls in *Hellas* "Cycles of generation and of ruin" (154). Today these monuments are the "melancholy ruins of cancelled cycles" (*Prometheus Unbound* 4: 288–9), and a past seen as recorded by them will itself be a cyclical ruin. Shelley's History, an "inspired rhapsodist," if not given a face is supplied with a voice, a form—a unified presence— and a figure (in the two senses of the word). The personification is only an extension of Shelley's enfiguring the past with the imagined characters from literature and with their authors. To Shelley the rise of Greek culture plainly showed that the development of original, beautiful forms was a sign of social and political progress: "For thou wert, and thine all-creative skill/ Peopled with forms that mock the eternal dead/ In marble immortality, that hill/ Which was thine earliest throne and latest oracle ("Ode to Liberty").

Shelley's literary model for Greece's complex but harmonious spirit is the early Greek stage, where "language, action, music, painting, the dance, and religious institutions" were "disciplined into a beautiful proportion and unity one towards another," creating "a common effect in the representation of the highest idealisms of passion and of power" (489). Schlegel had said (41) that in the theater, where "many arts are combined to produce a magical effect . . . the whole of the social and artistic enlightenment, which a nation possesses . . . are brought into play within the representation of a few short hours." The common, or magical, "effect," which a great historical period with its synthesis of forms can produce, is aesthetic. Unlike the "general results" that analysis seeks to know, this kind of effect is immediately revealed in the works that last to succeeding ages, though sometimes in incomplete form: "It is probable that the astonishing poetry of Moses, Job, David, Solomon and Isaiah had produced a great effect upon the mind of Jesus and his disciples. The scattered fragments preserved to us by the biographers of this extraordinary person, are all instinct with the most vivid poetry" (495).

Peacock's history seeks to reveal how causation operates from one age to the next. Initially this seems Shelley's plan as well, but having brought his readers as far as the dawn of the Renaissance, he abruptly stops:

> But let us not be betrayed from a defence into a critical history of Poetry and its influence on Society. Be it enough to have pointed out the effects of poets, in the large and true sense of the word, upon their own and all succeeding times and to revert to the partial instances cited as illustrations of an opinion the reverse of that attempted to be established in the Four Ages of Poetry. (500)

Implied here are 1) that in attempting to trace poetry's "influence on Society" Shelley *has* been engaging in a "critical history";[16] 2) that as a critical history is not a defence, it is a betrayal of the original purpose of the essay; and 3) that a "defence" of poetry really consists in describing the "effects" that artists have "upon their own and *all* succeeding times" (emphasis added). In other words, he has most directly defended when he has shown what poets do, not what they have done in particular cases.

This applies to all issues of poetic influence, whether affecting subsequent social and political, or subsequent literary, events. In Shelley, however, those mental actions characterized as *poiein* have their own independent mode of causality.[17] "There is no portal of expression from the caverns of the spirit . . . into the universe of things" (505). Therefore, apprehending poetic effect or influence requires a different kind of understanding from that appropriate to other historical events; because of the dual—phenomenal and nonphenomenal—nature of the subject, all questions of influence in the history of literature or the arts involve causal issues necessitating both kinds. As Claudio Guillén has observed, literary history must confront different "orders" of the real: composition represents a "displacement of experience" out of the order of historical reality into that of the poem, while the work's career represents "the replacement of the poem in history."[18] Shelley and Peacock both speak of dual realms, but Peacock's are not different "orders" in the sense in which Guillén writes. That is to say, the world of poetry and that of "fact" are constituted similarly, and both operate according to the laws of fact.

Failing in his own critical history to provide an "image of life" or more than a "catalogue of detached facts," Shelley abandons it. He then moves to his final section, which is manifestly a "defence" by means of *poiein*. Here tropic rather than analytic language prevails, as Shelley engages in a display of metaphoric virtuosity: a series of figurative transformations, the climax of which is the passage (503) that begins "Poetry is indeed something divine." In this paragraph and succeeding ones that idea not only takes on many formal embodiments but many types of forms—allegory, symbol, metaphor, personification, metonymy—vividly illustrating through the vitality of imagery his proposition that poetry reproduces all it represents (487). In J. V. Cunningham's definition of the term, *form* is "that which remains the same when everything else has changed. . . . Form is discoverable by the act of substitution. It is what has alternative realizations."[19] These forms, alternative realizations, are the only way of realizing, though not of knowing, *poiein* as a form.

"We have more moral, political and historical wisdom," Shelley declares, "than we know how to reduce into practise" (502). Yet as the letters and journals show, he and Mary read histories regularly,

continuing to do so during the period of the "Defence." Although his essay emphasizes the transhistorical "image" and insists that *poiein* has little connection with the circumstances of time and place, its over-all tendency is far from anti-historical or even ahistorical. After all, if "Poetry is the record of the best and happiest moments of the happi-est and best minds" (504), poets must also be the unacknowledged his-torians of the world. If the most significant past is made up of the highest "moments," then the best history writing is the representation of those moments.

The "Defence of Poetry" attempts to discredit a *particular* type of literary history, one which was to become standard in the nineteenth century and is still familiar in our own. Borrowing its method from political or social history, this type finesses questions of intrinsic value in favor of those of causation, specifically of genesis and influence. The question "Which works are the most valuable?" becomes absorbed into the question "Which works are most important?" Value is seen with ref-erence to generative power within the sphere of literature and ultimately within the general sphere of history. Because traditional literary history has followed the lead of Enlightenment and Positivist general history, its explanations have been genetic rather than aesthetic. As Taine remarked, the literary historian needs to gather the facts and then find the causes.[20]

Shelley offers a type of new literary history that avoids such tangles of historical causation while broadening both the context and standard of literary value. In his paragraph (discussed above) on the various arts in classical Greece, he draws on Hume to deny the possibility of know-ing which of these types or aspects of *poiein* "caused" the others, "which gave and which received the light." To speculate on that (as the traditional historian might) is an "idle enquiry" (489). And yet the "records and fragments" of the age are themselves a kind of cultural monument; taken as a whole they form a composite "image of the divin-ity of man" at that time. To recall that by envisioning the fragments as a formal unity is to do the historian's work of recreating the era.

Nietzsche writes that critical history will "bring the past to the bar of judgment, interrogate it remorselessly, and finally condemn it."[21] However, "monumental history" (of which Shelley's essay may be cited as an example) points to and preserves the heroic achievements of the past as models for the future. Its object is "to depict effects at the expense of the causes—'monumentally,' that is, as examples of imita-tion; it turns aside, as far as it may, from reasons, and might be called with far less exaggeration a collection of 'effects in themselves' than of events which will have an effect on all ages" (15). Events or achieve-ments are seen as monumental, then, if their "effect" is on future minds

rather than on contemporaneous situations. A monumental history is one that creates such monuments or focuses on their appearance in the past. In Shelley's concept of time (and within the essay itself) this series of mind-made forms comprises a magnetic chain that, descending through "many men," "at once connects, animates and sustains the life of all" (493). Shelley's history, beginning with the "immortal creations of Greek poetry" (486), constructs that chain with highly visual presentations of the forms or images that constitute its monumental links, pointing up though not tracing its invisible flow of influence.

What finally remains of Shelley's own literary history, the middle part of his essay, is not a tracing of poetry's "effects upon society" but a chronicle of successive cultural ages, each with its own spirit (508) whose historical meaning is read by responding to its most representative works. In two ways Shelley's essay anticipates the efforts of today's "new" historians to preserve literature's historical dimension while freeing it from the context of a too-narrow historicity. First, he identifies that dimension analogically in the formal rather than the causal relation of its particular "order" to others of its own time. Also, like those historians, he contextualizes the work in its future as much as in its present or past, refusing to limit its "history" to its genesis or its immediate influence on society *or* poetry. In each part of his history he not only links the work to the age in the way described, as its historian, but releases it *from* the age, from mere historicity, by emphasizing the eternality and therefore the eternally dynamic quality of its depicted human figures: Achilles, Hector, Ulysses, Dante's Beatrice, Milton's Satan, and even Camillus and Regulus, the "actors" in the poetic "dramas" of Roman history (494). The fine arts in the Homeric age ("Poetry . . . in form, in action, or in language") made that epoch "memorable above all others," and also "the storehouse of examples to everlasting time" (488). This places the arts in the category of those memorials that have a permanent exemplary influence without traceable impact on their age. In the way Hans Robert Jauss has described, the work evolves as it continues to be encountered, and its very reception is a "history-making energy."[22] Dante's epic, says Shelley, "bore a defined and intelligible relation to the knowledge, and sentiment, and religion, and political conditions of the age in which he lived, and of the ages which followed it, developing itself in correspondence with their development" (499). The history of the poem is its past and its "infinite" future; like an "ever overflowing" fountain, it creates "wisdom and delight" in generation after generation (500).

The dominant social issue in the "Defence" is the one Shelley had addressed three years earlier in his "Discourse" on the Greeks. That essay begins by calling the age of classical Greece, "whether considered

in itself or with reference to the effects which it has produced upon the subsequent destinies of civilized man, the most memorable in the history of the world" (217). However, how could the age influence future history when, as he allows, its "manners"—slavery, the degradation of women, and above all homosexual love—were better forgotten? How is it that the artistic or intellectual fragments of the age continue to astonish, while subsequent progress has left the manners of the period no more than historical relics? The "Discourse" ends rather inconclusively, but the theme is resumed in the "Defence," which supplies a definitive answer: the effect of any past age *is* its memory of the age as a whole, preserved monumentally through its forms. The "Discourse" argues that the Greek culture, while limited, achieved a wholeness, which was the secret of its effect on later, more complex but also less fully realized periods. Cultural records exist in their works of art, which express the highest ideals of the age. Those "images" act as monuments both to document and to influence—the way, for example, Greek monumental figures have done. (Similar statements about the influence of the cultural image or form are found at the beginning of his "Philosophical View of Reform.") Periods are made whole when their principles are embodied in forms that serve as conceptual historical models. A period shapeless in itself cannot produce integral monumental forms. The modern period has higher, more advanced principles (those of justice), but has not found the form to embody them.

Shelley argues that the monuments of any age are both records of an historical moment and memorials to moments of one poet's creative humanity. The *Vita Nuova* is "the idealized history of that period, and those intervals of [Dante's] life which were dedicated to love" (497). It is thus a personal monument as well as a public one; or rather, it makes the personal experience public by monumentalizing it. "The impersonations clothed in [poetry's] Elysian light stand thenceforward in the minds of those who have once contemplated them, as memorials of that gentle and exalted content which extends itself over all thoughts and actions with which it coexists" (487). The image is a "memorial" or "record" of poetic moment either of expression or reception. (I take "content" to be satisfaction or pleasure, as in "heart's content.") As Shelley goes on to say, readers then are internally changed as they are impelled to identify with these monumental figures which "stand" in their minds. The passage as a whole is complicated but crucial in showing how figures are both monumental and influential. One who described that influence on himself was Browning, whose lines in *Pauline* addressed to Shelley the "Sun-treader" seem almost a commentary on the paragraph in the "Defence," but show more specifically how living monumental forms beget new living forms:

> they stand—thy majesties,
> Like mighty works which tell some spirit there
> Hath sat regardless of neglect and scorn. . . .
> I have stood with thee, as on a throne
> With all thy dim creations gathered round
> Like mountains,—and I felt of mould like them,
> And with them creatures of my own were mixed,
> Like things half-lived, catching and giving life. (151–67)

The "mighty works . . . tell" the same thing and in the same way that the visage on the statue of Ozymandias does. As records they tell of the artist's spirit more than of the subject and thus offer a sense of the artist's presence. Like the fragments of the statue, they "stand" and thus *are* telling or impressive. They are striking, expressive presences. Shelley's "majesties" were ultimately derived from Greek forms used as models with which to envision the highest ideals. As the Preface to "Hellas" declares, "The human form and the human mind attained to a perfection in Greece which has impressed its image on those faultless productions, whose very fragments are the despair of modern art, and has propagated impulses which cannot cease, through a thousand channels of manifest or imperceptible operation, to ennoble and delight mankind until the extinction of the race."

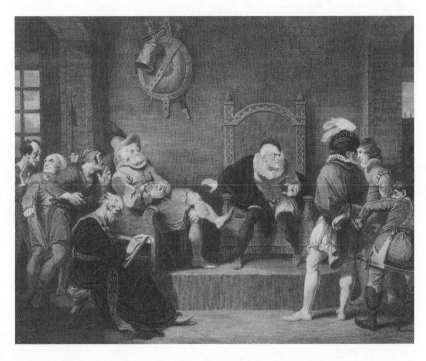

FIGURE 4. Robert Smirke. Shakespeare: *Much Ado about Nothing*, Act IV, Scene II. From *Boydell's Shakespeare Gallery*. Photo: Marriott Library, University of Utah, Special Collections.

CHAPTER THREE

Coleridge's Shakespeare Gallery

> The supremacy of the verbal over the monumental has something about it of the supremacy of life over death. Any individual form of life can be wiped out by the smallest breath of accident, but life as a whole has a power of survival greater than any collection of stones.
>
> —Northrop Frye, *The Great Code*

PORTRAITS AND IDEALS: THE *STATESMAN'S MANUAL*

In the "Defence of Poetry" works of art are the reflection of the form-making power of *poiein*, which "regards the relations of things . . . in their integral unity." Analogously, every great age presents an aesthetic synthesis of arts and institutions, best grasped by reimagining these works and the figures in them. Like the "Defence," Coleridge's Shakespeare lectures are exercises in historical restoration. Treating the Shakespeare corpus as a monument, they seek to restore its form, as archeological poetics was in the habit of doing. From this standpoint, our best introduction to these lectures is his treatise on form, figures, and the shape of history, the *Statesman's Manual,* which Shelley knew[1] and no doubt drew upon. A handbook on reading texts "in a figurative sense," it argues that, like any other authored work, human history will only be seen as shaped if one visualizes the idea of it and therefore feels the author *in* it. Then it is a story whose figures all play comprehensible symbolic roles. "Form," whether

59

natural or man-made, is not just design or shape but the particular exis-
tence given to an idea (or given by an idea to a thing) to make it intelligi-
ble. A shape is a living one when it is intelligible—when it is seen to
embody its constituting idea. "In every living form, the conditions of its
existence are to be sought for in that which is *below* it; the grounds of its
intelligibility in that which is *above* it."[2] In a mere historical record, events
are only explainable by ones preceding (below) them, as are the acts of the
historical personages. When history is treated as a design, figures and
actions are explicable and draw their life from the designer's creating idea.
Therefore, they are "living forms."

As a school boy, Coleridge recalled, "History, and particular facts,
lost all interest in my mind" (*BL* 1: 15–16). When he would later describe
the writings of modern historians like Gibbon and William Robertson as
"trash"[3] or as unphilosophical,[4] he meant that they narrowly focused on
immediate causes. Perhaps he had in mind the kind of explanation that
Robertson provided for the ending of the Dark Ages: "We . . . can trace
a succession of causes and events which contributed . . . to abolish confu-
sion and barbarism, and to introduce order, regularity, and refinement."
It is important "to show how the operation of one event, or one cause,
prepared the way for another, and augmented its influence."[5] In Enlight-
enment history a "showing how," which seeks causation in precedence, is
sufficient as an explanation, and a causally unified "succession" of events
will provide an integral view of history. Such explanations were natural to
the Understanding, Coleridge thought, a mode of perception depending
upon familiar perceptions of space and time. If space is a "*mode* or *form*
of perceiving," the necessary way by which "things are seen as outward
and co-existing,"[6] time is the way of seeing things as outward and sequen-
tial. Effects, to the Understanding, are things in a sequence.

Concluding, however, as Hume had, that immediate causes were
"infinitely complex & uncertain," Coleridge decided quite early (as
Hume never did) to "muse on fundamental & general causes—the
'causae causarum.'" (*Letters* 1: 397). "In the World we see every where
evidences of a Unity, which the component parts are so far from explain-
ing, that they necessarily pre-suppose it as the cause and condition of
their existing *as* those parts; or even of their existing at all" (*Aids* 75).
Therefore, an historical figure or event cannot be fully explained, its
"being" cannot be "evolved," by reference to a first cause or "origin,"
or efficient causes proceeding from that, but only a final cause or pur-
pose, an "antecedent Unity," which is also its potentiality.

In short, a true explanation not only accounts for a past occurrence
or situation but brings it to life, providing an intelligible "idea" of it, not
just linking it to a series of preceding situations or events. To use a dis-
tinction in his essay on Life:[7] for an Idea of a thing we need an account-

ing for it—a sufficient cause—which is also an explanation of it, a reason for its existence or occurrence, which must be Intelligence. "By reason we know that God is: but God is himself the Supreme Reason." Coleridge often, as here, uses "reason" to signify both the means of knowledge and explanatory knowledge itself. Thus Reason "is the knowledge of the laws of the *Whole* considered as *One,* and as such it is contradistinguished from the Understanding, which concerns itself exclusively with the quantities, qualities, and relations of *particulars* in time and space" (*SM* 59).

Now, the *Manual* insists that the Bible be viewed as not only an admonition and spiritual guide for the present but a reliable record of the past. However, as a record the "facts" of Biblical history are different from those in "all other history" in being subject to "divine interference" (9). Accepting the Bible provides a "faith . . . without which the fleeting *chaos of facts* would no more form experience, than the dust of the grave can of itself make a living man. The imperative and oracular form of the inspired Scripture is the form of reason itself in all things purely rational and moral" (18). In the first sentence here, "form" means to provide order and design: conceptual logic. But in the next two it is used to mean a manifestation of and then a model for, as in this passage from *Table Talk:* "The Father, supreme reason, identity. The son the realization of the reason—its *form,* as expressed by logos, word, light, wisdom."[8] Words, such as the four used to end that sentence, "express" ideas and therefore would be deemed forms of them in a way analogous to that in which the Son realizes or expresses supreme reason. When dealing with "works," Coleridge ordinarily used "express" to mean not merely show or make manifest, but embody: to turn an idea into a form.

In the Bible, therefore, one recognizes a living form only by keeping in mind that the great law of history is that man is "destined to move progressively towards that divine idea which we have learnt to contemplate as the final cause of all creation, and the centre in which all lines converge."[9] This law was perceived by the early historians, for whom "thought and reflection supplied the links of causation and formed while they explained the connection of events and their common relation as parts of one comprehensive scheme."[10] Newer historians merely *seek* explanations in discovered causative links.

> The histories and political economy of the present and preceding century partake in the general contagion of its mechanic philosophy, and are the *product* of an unenlivened generalized Understanding. In the Scriptures they are the living *educts* of the Imagination. . . . [The Bible's] contents present to us the stream of time continuous as Life and a symbol of Eternity, inasmuch as the Past and the Future are virtually contained in the Present. According therefore to our relative position on its

banks the Sacred History becomes prophetic, the Sacred Prophecies historical, while the power and substance of both inhere in its Laws, its Promises, and its Comminations. In the Scriptures therefore both Facts and Persons must of necessity have a two-fold significance, a past and a future, a temporary and a perpetual, a particular and a universal application. They must be at once Portraits and Ideals. (*SM* 28–30)[11]

As opposed to lifeless, retrospective modern chronicles, scriptural history is living because continuous, continuous because it is also prophetic. History by itself pertains to the past, the temporary, and the particular; prophecy by itself, like poetry, pertains to the future, the perpetual, and the universal. From a merely historical view, Biblical events and figures ("facts and persons") are "portraits" or likenesses; from a prophetic one, they are "ideals" to be realized. As he wrote in a note in one copy of the *Manual,* images *(eidola)* are "merely *formal*"; ideas are dynamic as well as formal (61). Thus the truest history provides not only a chronicle, account, or image of what has been, but an idea or model for what might be, one which to succeeding generations is both satisfying and broadly influential.

Figures or events that are mere memorials of an age past will constitute a merely memorial history, therefore a shadowy one. In Gibbon, for example, Coleridge found no "ultimate causes" set forth for the Empire's decline that would lend reality to the whole sequence of events. "I seem to be looking through a luminous haze or fog, figures come and go, I know not how or why, all larger than life, or distorted or discoloured; nothing is real, vivid, true; all is scenical, and, exhibited by candlelight as it were" (*Table Talk* 1: 419). "The Bible alone contains a Science of *Realities:* and therefore each of its Elements is at the same time a living GERM, in which the Present involves the Future, and in the Finite the Infinite exists potentially" (49). Divine law, revealed in the Bible, is also a promise; it is a necessity not of mere passing succession, but of an unfolding potentiality.

Any event or figure in history thus fits Coleridge's definition of the symbol, which we may now recall while stressing that the well-known passage occurs in a discussion of the historical meaning of "facts and persons" in the Scriptures: "A Symbol . . . is characterized by a translucence of the Special in the Individual or of the General in the Especial or of the Universal in the General. Above all by the translucence of the Eternal through and in the Temporal. It always partakes of the Reality which it renders intelligible; and while it enunciates the whole, abides itself as a living part of that Unity, of which it is the representative" (30). "Above all," then, the symbol has to do with the disclosure of the timeless within what belongs to time. Historically speaking, it functions monumentally by marking and representing what did happen while

expressing something of the "Eternal" needed to define that event now. That is why the symbolic occurrence or figure is always meaningfully alive to the philosophical reader. Coleridge's remark on the poem also applies to the historical account: it must "contain in itself the reason why it is so, and not otherwise" (*BL* 2: 12). Only phenomena viewed as symbols can signify the cause of their own effect, that is, their final cause or purpose, which *is* effect. They must be self-interpreting.

This of course is true not only of persons, things, or events but of representations of these, such as written histories. As history, the Bible presents a story whose form is internally determined by the will of its participants, though with a framework imaging the mind of an Author, whose authorial presence "predestinates the whole in the moral freedom of the integral parts": "every agent appears and acts as a self-subsisting individual: each has a life of its own, and yet all are one life" (*SM*, 31).[12] When the past is considered in relation to Law or Idea, it will reveal method; when it is seen as a means, and an evolution, it is seen as method itself, which "implies a *progressive transition*" (*The Friend* 1: 457). Thus might a historical text be "read in the spirit of prophecy" (*SM* 124, n.). To the extent that any history is Christian, it will be "Providential, and this a Providence, a Preparation, and a Looking-forward to Christ."[13]

Since history is "the great drama of an ever unfolding Providence" (*CS* 32), a retrospective explanation of any event is necessarily incomplete, unsatisfying, and ultimately destructive of our sense of *history's* wholeness. True history begins with a "prior purpose," a "previous act and conception of the mind" (*The Friend* 1: 475). The analogy between art and history depends wholly on a sense of God as artist, as both have the power to wed "the Past in the Present to some *prepared and corresponsive* future" (*The Friend* 1: 129).

Because history is a drama, Shakespeare's histories serve as models for interpreting the past. Their living form is provided by the mental life of the participants. Thus in *Macbeth* all of the protagonist's principal experiences find their source in his "moral will." That abandoned, he would be merely a creature of natural causes and effects (*LOL* 2: 306). From the beginning of *Richard II,* "the *germ* of all the after events" can be found in the king's "Insincerity, Partiality, Arbitrariness, Favoritism, and in the proud tempestuous Temperament of his Barons" (*LOL* 1: 559). Although the complex of social and political happenings "informs" the plot,[14] to be "properly" historical it must also be poetical—it must take

> the permanent in *our* nature, which is common, and therefore deeply interesting to all ages. The events themselves are immaterial, otherwise than as the clothing and manifestation of the spirit that is working within.[15] In this mode, the unity resulting from succession is destroyed, but is supplied by a unity of a higher order, which connects the events

by reference to the workers, gives a reason for them in the motives, and presents men in their causative character. It takes, therefore, that part of real history which is the least known, and infuses a principle of life and organization into the naked facts, and makes them all the framework of an animated whole. (*SC* I: 125–6; italics added)

The merely factual arranges itself historically as the merely successive. This is not what Coleridge calls living form. This principle in drama is the human soul and, moreover, the "defect" in it that makes the character resist God's design.

Form, then, is a means of seeing the Universal in the Individual, and like any symbolic language it is grasped by the pure Reason, not the Understanding. This mode of comprehension gives shape to time and an explanation for all events. It does this by focusing on significant monumental points of human experience and seeing history as proceeding from those points not merely forward, but bi-directionally (out toward circumference—idea or purpose—and in toward any other point). Modern historical thought represents events as in an epic, whose essence is "the successive in events and characters" (*SC* 1: 125). Schlegel had compared the events in ancient epic to the "infinite extension" of figures on bas-reliefs on vases and friezes, "where, while we advance, one object appears as another disappears"; this, thinking perhaps of the Laocoon, he opposed to Tragedy's "distinct outstanding group" presenting an "independent and definite whole" (*Lectures* 76). According to Coleridge, while neither chronicle nor epic has a "*rounded* conclusion," an "ethical tragedy" takes sequence, with its line of immediate causes, and encloses it spatially, so that it defines itself internally. As against the experiential line of the epic, it presents a conceptual circle. The circumference comprises the events of the story, the center is the self-consciousness of the protagonist, the radii the acts of free will that give meaningful shape to experience. *Paradise Lost,* based on a very brief passage of Scriptural history, is fundamentally a drama of human choice, and therefore has "the totality of a Poem or circle as distinguished from the ab ovo birth, parentage, &c or strait line of History" (*LOL* 2: 388–9).[16]

Again, form in Coleridge is less the shape of a work than that which enables us to picture its unity as a Gestalt. When a modern critic describes Aristotelian tragedy as a process of converting "a chronological line of development into a logical one" and sees that conversion as bending a line segment into a circle,[17] he reflects the Coleridgean approach of picturing essence as shape, as well as adopting Coleridge's favorite image for that shape, the circle. "Form, connection, and unity" were requisite to all individuality and life, and the "true poet" is one who supplies these "from his own mind" (*Logic* 28–9). Coleridge always maintained that what makes a work endure is unity, the formal

logic supplied by the presence in the work of the author's mind. This was as true of the author of *Hamlet* as of the author of providential history as revealed in the Bible.

COLERIDGE'S SHAKESPEARE MONUMENT: THE LECTURES

At the end of *The Prelude* Wordsworth predicted that his friend's own "monument of glory" would soon enough be raised (1805, 13: 430). Coleridge was not persuaded. When Wordsworth had read to him the 1805 version, including those lines, Coleridge was certain his own efforts to date were "but flowers/ Strew'd on my corse, and borne upon my bier/ In the self-same coffin to the self-same grave" ("To Wordsworth" 1807). He lamented to William Mudford in 1818 that financial exigencies had made lecturing a necessity, and hours given to poetry or philosophy—to "the PERMANENT"—had to be "stolen from others' as well as from my own maintenance" (*Letters* 4: 838). He had fought for Wordsworth's fame "with an ardour that amounted to absolute oblivion." He had also been sacrificing his own fame for the sake of Shakespeare's "monument of glory." As T. M. Raysor observed, however, those lectures had a considerable effect upon Shakespeare's fame (*SC* 1: xv). Nothing more could be expected of a monument.

A year or so after writing the poem to Wordsworth, he laid the foundation for a theory of living monumental form in a lecture his friend traveled down from Grasmere to attend.[18] It was the fourth of a series on "the Principles of Poetry" delivered in London in 1808. Its purpose was to demonstrate Shakespeare's living "glory." He complained that treating Shakespeare as a mere "wild, irregular, pure child of nature" had left him a kind of Tartarian Dalai Lama, "adored indeed & his very excrescences prized as relics, but with no authority, no real Influence" (*LOL* 1: 79). The lecture focused on the poems, and, with special appropriateness, on the sonnets, where Shakespeare alludes often to his own fame, as well as that of the sonnets themselves and of the person to whom they are addressed.[19] To illustrate Shakespeare's "own belief of his own greatness," Coleridge read aloud Number 107, which affirms that the poet will live in "this poor rhyme." As to the person addressed in the poem, "in this shalt find thy monument,/ When tyrants crests and tombs of brasse are spent." The sonnet had a particular significance for Coleridge, who would quote it to show the power of that "'*great, ever living, dead man's*' dramatic works." As he was to declare in a later series, Shakespeare's "glory must for ever increase wherever our language is spoken" (*LOL* 1: 208).

Coleridge advanced the argument that poetry is preeminent among the arts because a poet's words have a much surer "power of giving permanence" than materials other artists use, and thus a broader realm of

influence (*LOL* 1: 76). Recalling that while in Italy he had pondered the deterioration and wanton mutilation of paintings, he urged gratitude that writing does not suffer the same fate: "the great & certain Works of genuine Fame can only cease to act for Mankind . . . when they themselves cease to be men . . ." (77). He cited and probably read to his audience a passage from Bacon's *Advancement of Learning,* one he would return to in other lectures and writings. It is worth pausing over, not only for the light it casts on Coleridge's thoughts on the power of imaginative as against material forms, but for the sake of its echoes in Shelley's "Defence," which had declared that works of the past "generate still, and cast their seeds in the minds of others."

> We see then how far the monuments of wit and learning are more durable than the monuments of power, or of the hands. For have not the verses of Homer continued twenty-five hundred years, or more, without the loss of a syllable or letter; during which time, infinite palaces, temples, castles, cities, have been decayed and demolished? It is not possible to have the true pictures or statues of Cyrus, Alexander, and Caesar; no, nor of the kings or great personages of later years; for the originals cannot last, and the copies cannot but lose of the life and truth. But the images of mens wits and knowledges remain in books, exempted from the wrong of time, and capable of perpetual renovation. Neither are they fitly to be called images, because they generate still, and cast their seeds in the minds of others, provoking and causing infinite actions and opinions in succeeding ages. . . .

The *Biographia* (1: 31–6) compares two kinds of geniuses and the monuments they leave. "Commanding" geniuses, whose monuments record past achievements and events, "impress their preconceptions on the world without" in canals, temples, or aqueducts: works that attach a particular image to a particular object. By contrast, the minds of "absolute" geniuses are affected more by thoughts than things. As "ideal creations," their works remain in an "intermundium," as he elsewhere calls it, of words. The substance of their creations is their own "living spirit" and their "ever-varying form." A Shakespeare sonnet, a "monument" of "gentle verse," shows this kind of ideal or imaginative self-sufficiency, ensuring the immortality of its subject and its author alike. The difference between the two types of monuments is illustrated in "Kubla Khan." As a production of commanding genius, Kubla Khan's palace is vulnerable to "the shaping spirit of Ruin." An ideal creation, Coleridge's "dome" is built in air, the intermundium.

That poetry or other writing is less transitory than buildings and other solid monuments is of course a very old idea. The classic English discourse on memorials, John Weever's *Ancient Funerall Monuments* (1631), acknowledged that books may make their subjects and authors

immortal, yet sepulchres will only leave a record of a person and his station.[20] By the seventeenth century "monument" could mean either an *emblem* of eminence or an eminent *work* that creates, sustains, or revives the eminence of its maker ("a work . . . worthy of record . . . or of enduring" [Webster's Third International]).

That is Bacon's distinction in the passage Coleridge quotes in the sixth of the 1808 lectures. "Monuments of wit and learning" represent or stand in place of the minds of their makers. The "pictures or statues" of Cyrus, Alexander, and Ceasar ("Monuments of power") are different types of images: because they are "copies," images *after* their subject, they "cannot but lose of the life and truth" as they become distanced from the persons they commemorate. As the originals fade from memory, the copies lose their power and finally die as images. Likenesses can't last because likeness itself cannot. On the other hand, expressive and conceptual monuments contain their life and truth, Coleridge would say, in the form of "ideas," and therefore constitute true imitations, rather than copies, an important distinction first introduced in this lecture (83–4). The *Biographia* argues that in the New Testament "idea" means "the visual abstraction of a distant object, when we see the whole without distinguishing its parts." Therefore it is not a mere sense impression, a visual copy of a thing, but what we would today call a Gestalt, an integral conception of something shaped by a concept of it.

Coleridge considered ideas to be "mysterious powers, living, seminal, formative, and exempt from time" (*BL* I, 97 n.). His living "Ideas" are "exempt from time" as Bacon's "images" are "exempted from the wrong of time"; unlike objects in the world such as sculpture or things of nature, forms in the mind are themselves powers, and their chief power is to *be* "formative," to generate forms in other minds, achieving "perpetual renovation." "Every principle is actualized by an idea; and every idea is living, productive, partaketh of infinity, and (as Bacon has sublimely observed) containeth an endless power of semination (*SM* 23–4)." That ideas partake of infinity is Plato's; that they partake of their creator's mind, that they are monumental, and that they are seminal, is Bacon's. Coleridge would come to conceive of figures in drama as the most lastingly effective of such ideas.

Many of the 1808 notes, including those on the Bacon passage and on the vulnerability of art treasures, were used in the next series, three years later, for the London Philosophical Society. Among those attending at least one of those lectures were Byron, Hazlitt, Lamb, Crabb Robinson, George Dyer, and Samuel Rogers. Coleridge was then enduring one of his most miserable periods, struggling not only with his opium and alcohol addictions, but with his estrangement from Wordsworth. As a result, the thoughts expressed were often radiant but

chaotic, inspiring ridicule or concern in his friends in the audience. Robinson said they did "high honour to him as a man of genius, but are discreditable to him (perhaps I might use with[ou]t injustice a stronger word) as a man who has a duty to discharge" (*LOL* 1: 409).

Taken as a whole, however, the 1811–12 series constitutes the most complete record we have of Coleridge's views on Shakespeare and is one of the truly indispensable contributions to Romantic criticism. The rest of my chapter is an attempt to reconstruct, as with the "Defence" in the last chapter, his main line of thought and thus the form of the series. The scattered records include some autograph notes of his own, two sets of Collier transcriptions and another by J. Tomalin, plus newspaper reports and accounts by Henry Crabb Robinson. Although the reports and transcriptions (like the lectures) are uneven and fragmentary, we can discern the main argument to be the same as in the 1808 series: Shakespeare developed from a pure poet (that is, like Milton, a man speaking in his own voice and situation and "attracting all forms & things to himself" [the Wordsworthian or egotistical sublime?]) into a dramatist, a man speaking through others and their situations, "darting himself forth, & passing into all the forms of human character & passion" (Lecture Four, *LOL* 1: 244). Coleridge meant to show that not only "forms of human character" but dramatic forms memorialize their designer, whose presence is embodied in both, expressed through the work's form or design: the self-presentation that made all things in a work seem present and real to our minds. *One "feels" the work as a present influence, and therefore its author as a presence, by feeling its form, or principle of unity.*

A poet like Milton or Shakespeare was a type of divinity, Coleridge wrote in the *Biographia*, "all things, yet for ever remaining himself" (2: 28). Commonly, and especially with respect to Shakespeare's "thinking faculty and thereby perfect abstraction from himself," Coleridge saw a great creator of dramatic personages as a master of self-transformation. Shakespeare could "become by power of Imagination another Thing— Proteus, a river, a lion, yet still the god [is] felt to be there" (*LOL* 1: 69–70).[21] The import of this analogy itself has a protean elusiveness. Although in his disguises Shakespeare is "felt to be there," he shows "miraculous powers of conveying the Poet without even raising in us the consciousness of him" (Lecture Six, *LOL* 1: 290). He is a power most felt when least seen. "The Proteus Essence that could assume the very form, but yet known and felt not to be the Thing. . . ."[22] While standing for itself as a "form," a literary character stands *for* part of the author's own character. Coleridge's Shakespeare, therefore, is not Keats's chameleon poet, since his *own* "Essence" is evident to the reader in the experience of the work, which always retains as did Proteus "the awful character of the divinity" (Lecture Three, *LOL* 1: 231). Interpreting Bacon's monumental

"images of mens wits and knowledges" as dramatic characters, Coleridge saw them not as mere likenesses, but as representative or characteristic embodiments of a mind, the "results & symbols of living power," to be "contrasted with lifeless mechanism" in Classical drama (discussion of organic form, *LOL* 1: 494). As a symbol, a character would be a "representative form,"[23] "an actual and essential part of that, the whole of which it represents" (*SM* 79). In 1819 he speculated that the *"general truth"* developing in a poet's mind "proves itself" as a symbol "produced out of his own mind, as the Don Quixote out of the perfectly sane mind of Cervantes—& not by outward observation or historically" (*LOL* 2: 418).

Whether reading the Bible, a poem, or a play, we experience no authorial presence without a strong sense of design, and vice versa. Whenever we can see in some work how an "After" *fittingly* follows a "Before," we can "recognize the effective presence of a Father [or author], though through a darkened glass and turbid atmosphere" (*BL* 2: 234). This sense of a paternal, ordering, Presence is necessary for religious faith in life and for poetic faith when reading; just as important, it is that presence that gives the work an impressive or "effective" wholeness. In Coleridge's time two types of models were being used to indicate Shakespeare's own relation to his text and his subject. The first was portraiture. With this mimetic pattern (character is copied from nature) the artist is seen as standing apart from his achievement. Thomas Whately described the "picture" of Macbeth as more "highly finished" than that of Richard III, "for it required a greater variety, and a greater delicacy of painting, to express and to blend with consistency all the several properties which are ascribed to him. That of Richard is marked by more careless strokes, but they are, notwithstanding, perfectly just. Much bad composition may indeed be found in the part. . . ."[24]

"Express" here is the painter's term: convey accurately what is perceived. Like Shelley ("Defence," 481–2), Coleridge viewed aesthetic expression as something beyond either mimesis or emotive utterance. Early art evolved from expression as mimicry and display of feeling to expression as personal embodiment in an independent form. Shakespeare's own imaginative embodiment in his figures fitted a sculptural model familiar in late eighteenth-century criticism (Morgann 103). William Richardson distinguished the poet who "describes" (copies, in Whately's terminology) from the one who "imitates." Both "may *paint* the most beautiful imagery," but while the character of the poet who describes may be "judiciously *composed*," those of the one who "imitates" may be "judiciously *moulded* and aptly circumstanced." Thus the poet "in some measure becomes the person he represents, clothes himself with his character, assumes his manners, and transposeth himself into his situation. . . ."[25]

Another Shakespeare critic, Maurice Morgann, also turned to the sculptural analogy to express the poet's involvement in his characters, which he saw as "forms" in "groupes" with "roundness and integrity," forms into which he compressed "his own spirit." Shakespeare gave "alternate animation to the forms. This was not to be done *from without*; he must have *felt* every varied situation, and have spoken thro' the organ he had formed."[26] Reflecting this second tradition, Coleridge applies to Shakespeare the words of the Greek philosopher Themistius: "He that moulded his own soul, as some incorporeal material, into various forms" (*The Friend* 1: 454). The approach was useful in adapting sculptural monumentalism to characterization. Like three-dimensional figures, poetic forms had a dramatic presence, but they also served as self-embodiments. The artist "must out of his own mind create forms according to the several Laws of the Intellect . . ." (*LOL* 2: 222).

Appropriately, the topic of Shakespeare's characters is introduced in the sixth lecture by a discussion of monuments, fame, and influence. Once again, Coleridge cites the Bacon passage in observing that "the monuments of the greatest heroes" have been more vulnerable to "destruction and instability" than "the everlasting writings of Homer," which are "still present to us, acting upon us ennobling us by [their] thoughts & images . . ." (*LOL,* 1: 287). He takes Bacon's "monuments of power, or of hands" to belong to the domain of those with manifest influence in their own world, but "the mere actions of our bodily powers" are nothing to those by which "we are governed for ever." With our minds we may reach and affect not merely our contemporaries but "all who succeed us" (287). Those with most sway in their own age are destined to have their monuments fall victim to time. Those independent of time may leave lasting memorials to themselves.

In this light Coleridge considers Shakespeare within the context of the political, intellectual, and moral conditions of his age, a time when great intellectual powers were applied to individual and prudential purposes. Lesser writers are governed by the manners and expectations of their age: not so Shakespeare. He was "out of time" as his characters "might in truth be said to be of no age." "It is natural that he should conform to the circumstances of his day," Coleridge remarked in an 1813 lecture, "but a true genius will stand independent of these circumstances" (*LOL* 1: 516). Precisely because he did not depend for his materials on his age, its people, and its goings-on, Shakespeare could realize enduring characters embodying those truths his mind "had pronounced intrinsically and permanently good" (*LOL* 2: 114). A "Poet of all ages," he created virtually no "mere Portraits of Individuals" (1: 304). Mere portraits are mere facts because they merely record fact. They are "Masks only, not forms breathing life" (*LOL* 2: 222). A

Shakespearean character, with more of Shakespeare than of the Elizabethan or Jacobean world, does not strike us as a mere historical portrait; we "see however dimly that state of being in which there is neither past nor future but which is permanent, & is the energy of nature" (Lecture Nine, *LOL* 1: 356–7). Lecture Six declares that Shakespeare could render a great number of lifelike figures simply by "meditation," a kind of idealizing self-awareness: "he had only to imitate such parts of his character, or to exaggerate such as existed in possibility, and they were at once nature & fragments of Shakespeare."

How do these fragments coalesce into one organic whole in a play like *The Tempest?* They would not individually be "forms breathing life" were they not all "one life," all containing an "infusion of the author's own knowledge and talent" (*BL* 2: 43). They and the works have endured as what Bacon calls monuments of wit and learning. Some readers, unable to explain certain things in Shakespeare (such as Romeo and Juliet's sudden and apparently inexplicable love), had regarded the plays "as the sacred fragments of a ruined temple, every part of which in itself was beautiful but the particular relation of which parts was unknown" (*LOL* 1: 316). In those days Shakespeare's plays were commonly described as ruined, disfigured, or neglected monuments. Herder's essay on Shakespeare closes by observing that as the language, customs, and categories of the Elizabethan age grow more and more distant from us, so also will "these great ruins" (176). Soon, perhaps, the plays "will become the fragment of a Colossus, an Egyptian pyramid which everyone gazes at in amazement and no one understands." He encourages Goethe to raise a dramatic monument to Shakespeare.

With Shakespeare's death, a tradition had begun of poetic remonumentalization and reformation: depicting the works as monuments and building a new monument around them. "Thou art a Moniment without a tomb," Ben Jonson wrote, "And are alive still, while thy booke doth live,/ And we have wits to read, and praise to give" ("To the Memory of . . . William Shakespeare"). Milton's Shakespeare needed no "piled stones" or "Star-ypointing *Pyramid*": he had built his own "livelong Monument"—the *idea* that readers have in their minds of his achievements. That "deep impression" causes our own imagination, "of itself bereaving," to make *itself* into a marble monument; Shakespeare, "Sepulchr'd in such pomp [doth] lie,/ That Kings for such a Tomb would wish to lie" ("On Shakespeare").

By the nineteenth century the plays, with their corrupt texts and old-fashioned language, seemed in danger of becoming undecipherable, and no more than startling or awesome fragments of genius. For Coleridge, however, only inorganic things *fragment* over time, fall to ruin, like the ruined temple, and cannot as monuments be reconstructed. Because all

organic forms symbolized the one life (in one of his definitions a symbol is a living part of a living whole), organic forms are perpetually meaningful. Convinced that though "fragments" of Shakespeare each play was a human living unity, Coleridge directed much effort to scrutinizing its "organic" form as evidence of "a genial Understanding directing self-consciously a power and a wisdom deeper than Consciousness" (*LOL* 1: 495). He saw his task as restoring the monument's form, its integral unity, by discovering and explaining its "idea." While we can see only parts, each part (a character, for example) indicates the whole. This means that criticism must employ not merely analysis but imagination, which "struggles to idealize and unify. It is essentially *vital*, even as all objects (*as* objects) are essentially fixed and dead" (*BL* 1: 304).

The sixth lecture was delivered on Thursday, December 5. The following week and the succeeding Monday he gave lectures Seven, Eight, and Nine, on *Romeo and Juliet* and *The Tempest*. At about this time[27] he had secured a copy of Schlegel's recently published *Lectures*. The impact was immediate and long-lasting. He found, as R. A. Foakes relates, "everywhere echoes of his own thought, but well articulated and more coherently set forth" (*LOL* 1: lxiii). One idea in particular synthesized all of his thinking about dramatic form, characterization, and monumentality: Schlegel's comparison of ancient and modern drama as art forms. By means of it Coleridge was able now to answer those critics who saw the plays as disunited "relics . . . with no authority, no real Influence." He also had a model for the monumental *figure,* and more important the reader's relation to this figure and the play.

In thinking, as Schlegel had, of Sophoclean tragedy as sculpture and Shakespearean drama as painting, Coleridge was able to frame two related distinctions having to do with unity. First, unity may be either simple or complex: the homogeneity of the single form or group, as in nearly all sculpture, or the composed heterogeneity of a number of figures, settings, actions, or other elements, as in many paintings. Second, unity may be mechanic or organic. It may be that of a self-sufficient "perfection" (*LOL* 1: 347), "the perfect satisfaction in a thing as a work of art" (349), or it may be a continually developing wholeness, the never-completed wholeness of the living thing. For Coleridge as for others of his time, concepts of form as unity presupposed the idea of the "work of art." Like a statue or painting, the "work" came to be thought of as having the integrity, concreteness, and effective presence of a material thing (what Heidegger calls "an almost palpable reality"), but not, in itself, its cumbersome and vulnerable materiality.[28] The *visualized* work, then, has an immediate and lasting presence in the mind.

Coleridge's concept of "organic form," most clearly framed during the next series of lectures (1812–13), and borrowed in large part from

Schlegel, posits a wholly personal involvement (and investment) on the part of a writer: an in-dwelling, rather than a mere shaping according to an abstract idea, as he thought the early Greek sculptors did. Schlegel had prefaced his discussion of organic form by calling the human body the highest form in nature (340). After reading these pages, Coleridge began to think of literary works analogously as forms, but with not merely the unified, inanimate shape of a statue but the functioning, heterogeneous, growing form of a live being. The spirit of poetry, he declared in his lecture on *Romeo and Juliet*, "must embody in order to reveal itself; but a living Body is of necessity an organized one—& what is organization, but the connection of Parts to a whole, so that each Part is at once End & Means!" (*LOL* 1: 494). Organic works are not mere objects, matter shaped *according to* some abstract idea, but living forms.

Influenced by Nature Philosophy and biology—the new study of vital processes in plant and animal forms—Coleridge always saw form as a disposition of parts or elements giving something a particular configuration. This is as true of *The Tempest* as of a birch tree. Organic form embodied and reflected its inner principle. (By contrast, Shelley came to see the inner form as often masked by the outer shape.)

> The form is mechanic [Coleridge wrote] when on any given material we impress a pre-determined form, not necessarily arising out of the properties of the material—as when to a mass of wet clay we give whatever shape we wish it to retain when hardened—The organic form on the other hand is innate, it shapes as it developes itself from within, and the fullness of its development is one & the same with the perfection of its outward Form. Such is the Life, such the form—Nature, the prime Genial Artist, inexhaustible in diverse powers is equally inexhaustible in forms—each Exterior is the physiognomy of the Being within, its true Image reflected & thrown out from the concave mirror—& even such is the appropriate Excellence of her chosen Poet, of our own Shakespear. . . . (*LOL* 1: 495)

This may be applied equally well to the form of a play or to figures within it. (In context the passage could refer to either or both.) A classical sculpture is less "natural" because less the creation of a living consciousness.[29] It cannot grow the way a character or a play can. In fact, as Coleridge uses the word, "form" often indicates the representation of the human body. While his organic form is a mode of expression, an outward representation of something inside, what it expresses is not an inner state or situation—attitude, emotions, or passions—but "the Being within." The appropriate model is physiognomy, the body's revealing the person's character or dominant temper.

He brought these ideas to bear on *Romeo and Juliet*'s apparent incongruities. His preceding lecture had granted what most Shakespeare critics

were saying—that the play had "all the crude materials of future excellence . . . but the various parts were not blended with such harmony as in . . . his after writings . . ." (*LOL* 1: 297). Now he continued the theme. Although "to borrow a phraze from the Painter the whole work is less in keeping" than other plays, "there was the production of grand portions: there were the limbs of what was excellent" (*LOL* 1: 303). The form of the work is experienced in the mind's eye first as a painting, then as an unarticulated body. If "limbs" suggests sculpture, the "phrase borrowed from the Painter" would indicate that he wished to reconcile two-dimensional and three-dimensional forms as models for the play. The particular phrase he has in mind had become a favorite of his. "Keeping" denoted pictorial congruity or harmony resulting from a skillful use of color or tone. Elements in a picture were said to be "in keeping" or "out of keeping" with the picture as a whole. It was on a picture's keeping that the spectator's sense of a unified scene depended, as in Coleridge's description of the town of Ratzeburg, Germany:

> I saw the town perfectly beautiful, and the whole softened down into *complete keeping,* if I may borrow a term from the Painters. The sky over Ratzeburg and all the east, was a pure evening blue, while over the west it was covered with light sandy clouds. Hence a deep red light spread over the whole prospect, in undisturbed harmony with the red town, the brown-red woods, and the yellow-red reeds on the skirts of the Lake. Two or three boats, with single persons paddling them, floated up and down in the rich light, which not only was itself in harmony with all, but brought all into harmony. (*The Friend* 2: 238)

Keeping, then, is pictorial unity. However, in considering the *analogous* effect in literary works Coleridge adopts Schlegel's term, "picturesque" unity. The difference to him would have been significant. Pictorial unity is a feature of the painting itself. Picturesque unity is an *experience* of integrity or form that occurs in the audience's imagination: "Unity of Effect" (*LOL* 1: 241). (To him, "effect" always carried the usual associations with painting.) As he elsewhere defined the phrase, "Where the parts by their harmony produce an effect of a whole, but where there is no seen form of a whole producing or explaining the parts of it, where the parts only are seen and distinguished, but *the whole is felt*—the picturesque" (*BL* [1907] 2: 309; emphasis added). In Greek drama "the great Rule was the . . . separation, or the removal of the Heterogeneous—even as the Spirit of the Romantic Poetry, is Modification, or *the blending of the Heterogeneous into an whole by the unity of the Effect*" (emphasis added; 1812 series, 1: 439).

Because the Greeks did not understand mankind's "indefinite Progressiveness," their works are complete in their outline but consequently limited in their effect (1: 438–9). "Indefinite progressiveness" is a key term

in the concept of picturesque unity. Growth or life must involve hetero-geneity, and the organic reconciliation of contraries. Thus, while the art of the ancients is characterized by "whatever is capable of being definitely conveyed by defined Forms or Thoughts" (1: 492), in the Christian Mid-dle Ages arose "the distinguishing yet . . . combining Spirit, that excludes nothing yet harmonizes all—and in which as its distinctive character, the finite derives its *effect* . . . from being the symbol or, were . . . it even by contrast, the remembrancer of the infinite" (2: 54; emphasis added).

We have seen that to Coleridge the Understanding was one means to reducing "the manifold of the impression from without into unity, and thus contemplate it as one thing." The formative Imagination was a higher means. Apparently, in reading the *Lectures* he came to understand what A. W. Schlegel termed *Romeo and Juliet*'s "unity of impression," a unity that "blended" all of its contrasts into a harmonious effect (401). Schlegel had devoted a lecture to the subject of unity in tragedy, arguing that while the eye or ear perceives in an object "only an indefinite plurality of dis-tinguishable parts," the mind, referring the object to some "aim," may grasp a real but intangible principle of wholeness. Behind the mechanic unity of a watch is the "aim of measuring time"; behind the organic unity of a plant or animal is "the idea of life." For any work of art, the aim or idea is to have all parts make "a joint impression on the mind" (*Gesamt-Eindruck auf das Gemuth; Lectures* 244). We receive this impression by our faculty of "feeling" *(Gefühl)*, "our organ for the Infinite," which is "not merely sensual and passive." Now although the principle of unity in a literary text is itself not visible as a "defined Form," it can be mentally embodied in some figure (like a watch, a plant, or an animal) that becomes the model for the text's form. By calling classic drama sculpturesque and modern drama picturesque Schlegel was providing a form of and a form for the ideas of unity underlying these types. Further, *Romeo and Juliet,* he wrote, achieving its "unity of impression" by harmonizing contrasting elements, was consistent with its character as a picturesque drama. Coleridge agreed with Schlegel in Lecture Seven that while the play lacked what critics call "unity of action," it had instead what he would call some years later its "totality of interest," evidence of the "creative Life-power of inspired Genius," as opposed to a mere "Shaping skill of mechanical Tal-ent" (*LOL* 2: 362). Even so, a creative life-power offers a less conspicu-ous unity than a mechanical shaping skill does.

In the eighteenth century, as I have said, aesthetic form was mainly thought to be the visible form of the visual arts. The emphasis in dis-cussions of these arts was on the arrangement, positioning, and presen-tation of "figures and colors."[30] In his *Critique of Judgment* Kant listed the "formative *[bildende]* arts*"*: sculpture and painting, as well as archi-tecture and landscape gardening. These use "figures in space"—painting

by visual intuition, the others by tactile as well (185–6). Kant located the aspect of figural development in the reader's imagination rather than on the page. By means of the form-giving imagination, Poetry, the highest of the arts, gives a free play to the representation of figures in the mind (184–5, 191ff.).

In Lecture Nine, delivered December 16, Coleridge laid out his concept of "Picturesque unity" as a feature of romantic drama. His focus this time was *The Tempest*. Toward the beginning he introduced (without giving credit) Schlegel's distinction between the sculpturesque and the picturesque. The former is the unity of reduction and abstraction. In the Niobe group or in some Greek drama, few figures occupy the stage. To introduce an old nurse in the midst would be an absurdity. In a painting by Raphael or Titian "an immense number of figures might be introduced"—a beggar, cripple, dog, or cat. It is left to our imaginative, unifying power to supply an intuited harmony (*LOL* 1: 348–49; 351). In *The Tempest* what we often "see" are parts or fragments of a ruined temple; what we feel or sense is a whole that our reading constructs. Reading passages in Shakespeare, Coleridge had told his audience a couple of weeks earlier, "You feel him to be a poet inasmuch as, for a time, he has made you one—an active creative being" (Lecture 4, 1:251). As an artifact the work sustains itself by empowering the reader, thus manifesting the poet's "Picturesque power," which can "produce that energy in the mind as compels the imagination to produce the picture" (1: 361, 362). Shakespeare's art was not vividly graphic in itself; it did not supply pictures, but it conveyed the power of picturing. In this, such a work as *The Tempest* might be contrasted with highly "dutchified" word-painting of the sort that made one lady of his acquaintance "cast her eyes on the opposite page for coloured prints" (*LOL* 1: 362). Had she been reading Shakespeare, presumably Prospero and Ariel would have emerged engraved in her own imagination.

The critical imagination must struggle to discern a deeper form than neoclassical criticism demands. In Shakespeare it can perceive "that *unity of feeling*, which runs through all his characters to the very close of the play," and of which *Romeo and Juliet* is the most conspicuous example (*LOL* 1: 513). This unity of feeling was the result of strong imagination, "that capability of reducing a multitude into unity of effect, or by strong passion to modify series of thoughts into one predominant thought or feeling" (1: 249; see also *LOL* 1: 86–7). As I have noted, Coleridge was to apply these ideas to the multitude of figures in the Scriptures, where the effect is "all . . . one life." R. J. White links that passage to some remarks on *Romeo and Juliet* in *The Friend*: "In all his various characters, we still feel ourselves communing with the same human nature . . . that just proportion, that union and interpenetration of the universal and the particular, which must ever per-

vade all works of decided genius and true science" (1: 457).

In *The Friend* Coleridge remarked that "throughout the whole of [Shakespeare's] splendid picture gallery . . . we find individuality every where, mere portrait no where" (1: 457). R. A. Foakes conjectures plausibly that Coleridge had Boydell's Shakespeare Gallery in mind (*LOL* 2: 121n.). If true, this would help explain Coleridge's manifestly pictorial way of envisioning the arrangement of Shakespearean characters within a play. In an 1818 lecture he declared that the characters of Cervantes and Shakespeare, "at once individual and general," "stand cut [engraved] in the pictures of the imagination" (*LOL* 2: 165).

Alderman John Boydell and his nephew Josiah had opened their Shakespeare Gallery of original paintings in Pall Mall in 1789, enlisting the talents of such eminent artists as Reynolds, Romney, West, Opie, and Fuseli. The exhibit began with thirty-four paintings, and more were added from time to time. (The Gallery was to turn into the British Institution, constituted to display and promote British artists). When in 1802 the total of pictures had reached nearly 170, Alderman Boydell, a London printer, published his two-volume edition of *The Shakespeare Gallery, A Collection of Prints from Pictures Painted for the Purpose of Illustrating the Dramatic Works of Shakespeare by the Artists of Great Britain*. This, however, was only one of many collections of engraved Shakespeare illustrations during Coleridge's lifetime.[31] Not only Coleridge but also his London auditors and readers would have had good reason to envision Shakespeare's figures as those in a picture gallery, illustrated volumes, or decorated rooms. As with the assembled paintings or engravings themselves, one could see, as Coleridge says, "individuality everywhere," but Shakespeare's authorial personality in all.

In the seventh lecture Coleridge had observed that the budding dramatist created a different *kind* of form in *Romeo and Juliet,* but form nonetheless, by entering into his forms, the characters, the result being what he called in an 1813 lecture that play's "unity of impression." The critic must reconfigure it from each "fragment in the history" of Shakespeare's mind (250). As Coleridge insisted in the *Tempest* lecture, however, great dramatic art like Shakespeare's produces the "picture" with the reader in it: "every man sees himself without knowing that he sees himself as in the phenomena of nature, in the mist of the mountain a traveller beholds his own figure but the glory round the head distinguishes it from a mere vulgar copy" (1: 352). The effect, that is, was like that of the "Brocken Specter," in which the spectator sees himself mirrored in the mountain mist as a larger, separated figure. Shakespeare gives the reader the sense of being projected into the story (presumably into its main figure), but with "elevated dignity." The plot develops about him like a unified picture in which "all forms" are "dressed in the gorgeous colors of prismatic imagination and with magic harmony uniting them and producing a beautiful whole in

the mind of the Spectator." Paintings, though not producing the "perfect satisfaction" of statuary, give "an effect equally harmonious to the mind" (1: 349). The whole, an apparently disunified work, unifies itself around the spectator's reflected (and now reflective) person. Like a picture, then, a Shakespearean drama is not a monumental "thing," an object shaped and closed, but a monumental experience. The form of the Shakespearean play is made by the spectator's own participation in it. The spectator must involve himself in the work, *witness* himself inside it, to "feel" its unity, a unity that can be conveyed to others by satisfying models or analogies.

For this communing to occur the reader must experience no temporal distancing from a story's characters. They must be living ideals as well as historical portraits. The greatest of Shakespeare's characters are "permanent, in as much as the passion on which they were founded" did not depend on "accidental circumstances," that is, circumstances of any historical period (1: 317). The *Tempest* lecture enlarges on this thought, showing that though Shakespeare's characters did mirror their own age, they spoke, and in themselves represented, timeless Shakespearean truths, thus not only recording the past but transcending it. He wrote not for his own but "for all ages" (*LOL* 1: 313). Coleridge read aloud a eulogy to Shakespeare from the Second Folio (2: 518):

> death may destroy,
> They say, his body; but his verse shall live,
> And more than nature takes our hands shall give:
> In a less volume, but more strongly bound,
> Shakespeare shall breathe and speak; with laurel crown'd,
> Which never fades. . . .

In connection with this sense of Shakespeare's timelessness Coleridge chose the *Tempest* lecture to develop his theory of characters as "ideal" realities, "not [the] things but the abstracts of the things which a great mind may take into itself and naturalize" (*LOL* 1: 351). As he remarked some years later, Shakespeare "shaped his characters out of the nature within" (*LOL* 2: 148).

Several lectures earlier Coleridge had given a distinctly religious or moral cast to this process of character-making. If we are poets we take "the purest parts" of people we observe and "combine [them] with our own minds, with our own hopes, with our own inward yearnings after perfection, and being frail & imperfect, we wish to have a shadow, a sort of prophetic existence present to us, which tells us what we are not, but yet, blending in us, much that we are, promises great things of what we may be" (*LOL* 1: 224). What we observe in another person, therefore, we purify into a better version of ourselves. An "intuition of absolute existence" fills us with "a sort of sacred horror." However, sensing a potentiality within us "ineffably greater than our own individual nature" ele-

vates what we observe to "an ideal distance" from our self (*The Friend* 1: 514). A dramatist like Shakespeare in this way provides objectified versions of his moral self. Because the Shakespearean figure is no mere likeness or copy, the work comes home to all audiences. In the Shakespearean character "every man sees himself without knowing he sees himself." Coleridge wanted his listeners to contemplate these shadows or prophetic existences. Personally, as a reader, he may well have been aware of the degree to which he identified with characters like Hamlet or Richard II.

In the series' last lecture (the twelfth) of which we have any adequate record[32] he revealed how his own "meditation" of the figures of Richard and Hamlet helped both animate and unify their dramas. Though he stated at the outset that he would show the two tragic heroes as "totally distinct" (1: 378), his own subjectively grasped moral being would recognize their similarity—to each other and to him. Instead of facing up to their personal situations, both Richard and Hamlet throw up verbal screens. Hamlet's is a screen of resolutions, Richard's of metaphors—and in this Coleridge's Richard resembles the lecturer himself: "In the play from beginning to end he pours out all the powers of his mind: he seeks new hope, anticipates new friends, is disappointed & at length makes a merit of his resignation: he scatters himself into a multitude of images and in the conclusion endeavours to shelter himself from that which is around him by a cloud of his own thoughts" (1: 382). Like Hamlet, as T. M. Raysor has observed, Richard may be interpreted "as a romantic hero whose inner emotional life paralyses his power of action" (*SC* 1: xliii–xliv).

Hamlet is of course the much more famous case of the lecturer's identification with his subject. Lecture Twelve ended with what Henry Crabb Robinson recorded as the play's "moral": "Action . . . is the great end of all. No intellect, however grand, is valuable if it draw us from action and lead us to think and think till the time when action is passed by and we can do nothing." When a companion commented to Robinson, "This is a satire on himself," the shrewd reply was "No, it is an elegy" (*SC* 2: 181–2). Remarking also on Coleridge's "striking observations on the virtue of action and the futility of talents that divert from rather than lead to action," Robinson opined, "I doubt whether he did not design that an application should be made to himself" (*SC* 2: 173). Certainly if this was Coleridge's design it has succeeded. His Hamlet is "a man in certain respects like Coleridge himself," A. C. Bradley commented, "on one side a man of genius, on the other side, the side of will, deplorably weak, always procrastinating and avoiding unpleasant duties, and often reproaching himself in vain. . . ." Bradley complained that Coleridge's reading "degrades Hamlet and travesties the play."[33] Surely Coleridge did not mean to degrade Hamlet and travesty the play, whatever we might think about his wanting to degrade himself and travesty his own life. Why then would he wish the application to be made?

In his reflections on the twelfth lecture Robinson goes on to say that Coleridge may have been willing to suffer personal censure "for the sake of the reputation of those talents apparently depreciated. . . ." Whose talents? Not Hamlet's, of whom he is sharply critical, or his own, which, as Robinson observed, he had exposed to censure. As Coleridge liked to point out, all of his lecturing on Shakespeare was meant to advance the proposition that Shakespeare's judgment, the laying out of a unified plan and then executing it, was equal or even superior to his genius (*LOL* 1: 142). This ability Hamlet lacks, as we know that Coleridge himself did. But all the lectures are filled with evidences of *Shakespeare's* admirable "preparation" of intention and careful execution. For example, to counter one of the "general prejudices against Shakespeare," Coleridge makes "preservation of character" a thread running through both halves of the twelfth lecture (1: 385 and n.). The two subjects of the twelfth lecture behave throughout in total accordance with a discernible center of personality: "The same character Richd. had shewn in the commencement was preserved through the whole" (381–2). And *Hamlet* is not, as alleged, "a heap of inconsistency" (385 n.); its hero is in fact an "admirable and consistent character" (388). "Anything finer than this conception & working out of a character is merely impossible" (390).

It is necessary to see that in this series of lectures, as in most of the others, Coleridge is discussing two kinds of unity or form in the plays: that of judgment and design—the play as a fashioned artifact—and that of genius and meditation—the subjective, organic unity of the play as an experience, which he defined in the ninth lecture as picturesque unity. The first is the executed unity of the author's preconception, the second of his imagination or intuition. If Hamlet seems to be a whole person, that is traceable to Shakespeare's genius. If he seems to be a whole character, we can thank the author's judgment. It is what Wordsworth, in the 1815 "Essay Supplementary," called Shakespeare's power of selecting his materials and *making* them, "heterogeneous as they often are, constitute a unity of their own, and contribute to one great end."[34]

Coleridge's method was to show the wholeness of each play in the uniformity of its principal figures. At the same time he wanted to assure his audience that his own apparently scattered observations held together in one design.[35] It is likely that with his discovery in Schlegel of the concept of picturesque as opposed to statuesque unity he found a way of justifying not only modern (Shakespearean) drama but modern (Coleridgean, post-neoclassical) criticism. The first of his 1813 lectures developed at length Schlegel's analogy, offering the speaker's own comparison of types of monumental unity:

> The Greeks reared a structure, which in its parts and as a whole, filled the mind with the calm and elevated impression of perfect beauty and symmetrical proportion. The moderns, blending materials, produced

one striking whole; this may be illustrated by comparing the Pantheon with York Minster or Westminster Abbey. Upon the same scale we may compare Sophocles with Shakespeare;—in the one there is a completeness, a satisfying, an excellence, on which the mind can rest; in the other we see a blended multitude of materials; great and little; magnificent and mean; mingled, if we may so say, with a dissatisfying, or falling short of perfection: yet so promising of our progression, that we would not exchange it for that repose of the mind, which dwells on the forms of symmetry in acquiescent admiration of grace. (1: 517)

This may not answer Lamb's dry remark that Coleridge had fulfilled his promise to discuss *Romeo and Juliet* by delivering his lecture in the character of the Nurse (1: 283), but it does explain how one auditor of the seventh lecture who grumbled that "he cannot subject even his pen to any order or arrangement in his subject" could allow by the sixteenth that "there is a peculiar intelligibility in that awkwardness, which appears as though it were content to sacrifice grace to enable the image of his mind to escape unmutilated" (*LOL* 1: 321, 402–3). In both *The Friend* (2: 16) and the *Statesman's Manual* (43) Coleridge confessed that his own writing wanted "regular Form." About the 1811–12 lectures he observed to Beaumont, "Several of my Friends join to take Notes—and if I can correct what they can shape out of them into any tolerable Form, I will send them to you" (letter 12/7/11, q. *LOL* 1: 160). In the Shakespeare lectures as in the *Statesman's Manual* he makes claims for the enduring form of a literary monument while confessing his own deficiency in form.

Coleridge's own mind needs to be reconstructed by the reader, partly because of the scattered nature of the discourses themselves and partly because of the imperfect records we have of them. He was to argue that, despite the seeming formlessness of the *Statesman's Manual* as a text, the imaginative reader could discern the unity of an active consciousness. In fact the "imperfection of form" may be "the means of presenting with greater liveliness the feelings and impressions under which they were written" (*SM* 43).[36] The least perfected form is the most effective expression. Throughout the lectures Coleridge is at least as concerned that his audience would see the real self under the disorganized one as that they will see the real Shakespeare beneath the disunified one (without judgment). The audience, he admits in his chaotic sixth lecture, will see his whole skeleton, but the bones mis-arranged (1: 286–8).

Though Wordsworth could not have anticipated it, the lectures on literature may well constitute Coleridge's "monument of glory." It is one of those monuments Bacon calls the "images of mens wits and knowledges," a monument of mind that continues to sustain fame while generating new ideas, new images.

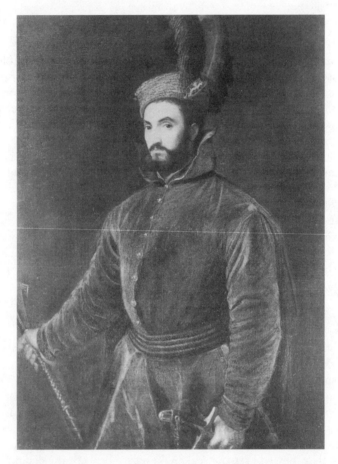

FIGURE 5. Titian. Portrait of Cardinal Ippolito de' Medici, Palazzo Pitti. Florence. Photo: Alinari/Art Resource, NY.

CHAPTER FOUR

Hazlitt's Portraits:
The Informing Principle

I had rather leave a good portrait of myself behind me than have a fine epitaph. The face, for the most part, tells what we have thought and felt—the rest is nothing.

—Hazlitt, "On the Knowledge of Character"

"A likeness pleases every body," observes Jane Austen, referring to Emma Woodhouse's collection of desultory, half-finished "miniatures, half-lengths, whole-lengths, pencil, crayon, and water-colours" of her family. Those pictures themselves are likenesses; a likeness too is their perceived resemblance to identified living originals: "There is my sister; and really quite like her own elegant figure!—and the face is not unlike." As with the novel of contemporary life, recognizing and admiring the accurate picture are part of the pleasure of viewing painted portraits. However, to his audiences Coleridge would insist that a likeness be more than a mere "copy." The arts "are ideal, and not the mere copy of things, but the contemplation of mind upon things. " Copies were short-lived, if they lived at all. Portrait-ideals were living forms, figures whose life did not depend on memory.

Of all the major Romantic poets and essayists Hazlitt brought to his writings the most distinct artist's vocabulary and sensibility. A talented

painter of likenesses himself, he thought of "form" and "expression," the dominating concepts then in the visual arts, the way a portraitist would. "Form" to a painter meant configuration—in a portrait, the face, its outline, and its molding. "Expression" was what gave life to the form. It included the artist's expression as well as the sitter's. As artists did in those days, Hazlitt gave considerable attention to the relation of one to the other with respect to the question, "What is it that makes some figures endure and others fade?" After looking into his (and the age's) interest in this question and in portraits generally, I shall explore what many have seen as Romanticism's partiality toward expressionism as opposed to formalism. I shall try to show how in the concepts of Characteristic Form and the Informing Principle, Hazlitt articulated a theory of expressive formalism.

LOOKING AT PICTURES

In December 1798, twenty-one-year-old William Hazlitt visited the Orleans Gallery in London's Pall Mall, a six-month exhibition and sale of Italian masters during which total receipts exceeded 70,000 guineas. Deemed by many at the time to be a major cultural landmark, belying claims of those like Montesquieu and Winckelmann that British taste was limited to Dutch and Flemish pictures,[1] the event was to prove a turning point for Hazlitt as well. "It was there I formed my taste, such as it is; so that I am irreclaimably of the old school in painting" (8: 14).[2] Throughout his life he was to favor not only painters of the high Renaissance, but writers of that age as well.

When in 1802, owing to the Peace of Amiens, he was able to cross the Channel in safety, he went immediately to the Louvre, then the temporary home not only to French royal acquisitions but to Napoleon's confiscations. For four months he "strolled and studied," visiting not only the celebrated marbles—the Laocoon, the Apollo, the Dying Gladiator—but the pictures by Raphael, Veronese, Poussin, and Correggio, and above all Titian, "who painted the mind in the face, and unfolded the soul of things to the eye" (6: 148–9).

Twenty years later, with a financially helpful marriage, Hazlitt was again able to return to the continent. Traveling through France and Italy and noting carefully the manners and characteristics of the people, he also toured the most celebrated galleries. His observations were published first as a series of pieces in the *Morning Chronicle,* then collected in 1826 as *Notes of a Journey Through France and Italy* (10: 85–303). In this volume, published only four years before his death, may be found

some of Hazlitt's most developed and suggestive thoughts on the endur-
ing power of the human form in art and literature.

 On this trip his first major destination was again Paris and the Lou-
vre. For two decades that gallery, the paintings it contained, and the
figures in those paintings had all been to Hazlitt like Wordsworth's
"spots of time": deeply impressed image-memories linking his present
to his past. They were personally important, in other words, not as
originally seen, but as imagined, remembered, and revisited. These
"lasting works of the great painters," he declared in one lecture, recall-
ing his first visit to the museum, remained with him "from youth to
age; the stay, the guide, and anchor of [his] purest thoughts" (6: 149).
They had formed "in one chamber of the brain" a *musée imaginaire:*
"There, in that fine old lumber-room of the imagination, were the
Transfiguration, and the St. Peter Martyr, with its majestic figures and
its unrivalled landscape background. There were also the two Jeromes,
Domenichino's and Correggio's—there 'stood the statue that enchants
the world' [Venus di Medici]—there were the Apollo and the Antinous,
the Laocoon, the Dying Gladiator, Diana and her fawn, and all the glo-
ries of the antique world . . ." (10: 107). The king who first assembled
the works was dead and Hazlitt "no longer young," but the works
themselves were vital as ever.

> Look at the portrait of a man in black, by Titian. . . . It is still; but the
> hand seems to have been just placed on its side; it does not turn its
> head, but it looks towards you to ask, whether you recognise it or not?
> It was there to meet me, after an interval of years, as if I had parted
> with it the instant before. Its keen, steadfast glance staggered me like a
> blow. It was the same—I was altered! I pressed towards it, as it were,
> to throw off a load of doubt from the mind, or having burst through
> the obstacles of time and distance that had held me in torturing sus-
> pense. (112)

Old works and figures in them—bright, venerable survivors, had this
feeling of immediacy to Hazlitt, especially portraits with their dramatic
gaze. And they also endowed the past itself with a sense of a familiar
human presence. The sculpted portraits he saw at Florence's Uffizi were
"an extension of the idea of humanity; and 'even in death there is ani-
mation too.' History is vague and shadowy, but sculpture gives life and
body to it; the names and letters in time-worn books start up real peo-
ple in marble, and you no longer doubt their identity with the present
race. Nature produced forms then as perfect as she does now" (221).

 Hazlitt wrote at a time of enormous interest in the likeness as a
genre. A remarkable chapter in British art history was the portrait's

success in achieving status within the art world, where it had long enjoyed an uncertain position, as had the portrait painter. Though the artist's most profitable effort might be a portrait commission, the loftier one, most had believed, was the idea-shaped "history" painting: one with a mythological, religious, or historical subject. In the Regency period critics and connoisseurs became aware of the portrait's ascendancy in England. Wordsworth regretted that Reynolds had avoided the path to distinction as the first Englishman in "the higher department of painting" (Letter to Beaumont, 20 July 1804). Even Boydell's Shakespeare Gallery, intended by its owners to show the British artist's capacity for imaginative history painting, was reviewed favorably as a product of the portrait-painting school.[3] "Portrait! portrait!! portrait!!! intrudes on every side," a writer in the 1817 *Annals of the Fine Arts* complained of the current art scene, "while history, poetry, fiction, fade before the overwhelming invader."[4] That same year the February issue of the *Literary Gazette*'s "Fine Arts" column argued against "uprooting" the "indigenous" forms like portrait and landscape in favor of "exotic" Italian grand pictures. In April, however, that same periodical was lamenting the lack of patronage for historical painting. Then at the Royal Academy opening a year later it was criticizing the number of likenesses: "Where a large picture occurs, it is garnished round the edges with faces like a turbot with smelts, and has even a whimsical effect; along the top of Mr. West's Treaty between the Grand Mogul and Lord Clive, there are six or eight portraits a-row, resembling a battalion, or at least a grenadier company in line."[5]

Increasingly, while history, or story, painting such as Benjamin West's India scene was more and more featuring portraits of real people, the portrait itself was becoming a vital kind of *historical* painting, a respected genre of public monument. Early nineteenth-century England could read its past in its heritage of portraits, of which major exhibitions were being presented in London. One of these in 1820, occupying three rooms at the British Institution, featured Kneller's Dryden and Robert Walpole; Gainsborough's George III and Princess Charlotte; Lely's Duke of Monmouth and James II; Hogarth's Coram; Van Dyck's Thomas Howard, Earl of Arundel; a Roubillac bust of Pope; and 174 other oils and busts. This was the "famous exhibition in Pall Mall of the old English portraits" attended in June by Keats who, noting to his correspondent that "pleasant countenances predominate," proceeded to mention several unpleasant ones: James I, the young George II, Lord Burleigh, the young Devereux.[6]

From Holbein and Van Dyck to Gainsborough, Reynolds, and the great Regency talent Lawrence, portrait painting was coming to be val-

ued as a peculiarly English tradition. Visitors took great pride in the lavish portrait shows at the newly formed British Institution. The 1813 Reynolds show, like others there, was to exhibit the excellence of modern British art, not old masters. In what the *True Briton* referred to as "the elevated character of the historical portrait" an artist like Lawrence could take his place in the dignified ranks of the Titians or Raphaels.[7] Martin Archer Shee, a portrait painter himself, praised the latter as attaining "the dignity of history."[8]

Exceptionally popular by the Regency period were published collections of portrait reproductions, including *The Biographical Magazine* (1819), *Woodburn's Gallery of Rare Portraits* (1816), John Adolphus's *British Cabinet* of illustrious personages (1799, 1800), *Boydell's Heads of Illustrious Persons* (1811), and, for the sake of collectors, John Morris Flindall's *Amateur's Pocket Companion; or, a Description of Scarce and Valuable Engraved British Portraits* (1813). Before the London museum of portraits with the same name there was William Jerdan's *National Portrait Gallery* in five volumes (1830–34), starting with Lawrence's Princess Charlotte and moving on to Wellington, Byron, and others. The purpose was to "preserve and transmit to posterity, the features and the memory of those who have earned greatness in the present age, in all the paths that lead to distinction or to glory."

This "fascination" with historical portraiture from about the turn of the century[9] coincides with a more general interest[10] in painting historical events and situations, and also with the eighteenth-century historian's interest in representing history accurately, rather than using it didactically. Since the first important collections during the early Renaissance, much of what was presumed to be known of the classical world had been drawn from close study of portrait figures on statues, coins, and medals. Painted portrait figures were now serving the same purpose.

However, as a contributor to the *Magazine of the Fine Arts* observed, though history might claim portraits as "important records," their chief purpose was as "memorials" assisting private memory; their appeal was to "the absent lover—the affectionate orphan—the desolate widow."[11] We value them, Dr. Johnson had insisted to Reynolds, for "diffusing friendship . . . renewing tenderness . . . quickening the affections of the absent and continuing the presence of the dead."[12] These remarks point up a central paradox about the painted likeness: it depicts a living figure, but as a "memorial" it must one day be associated with memory, death, and the dead. Surveying all the figures in the 1813 Reynolds exhibition, the poet Martin Archer Shee meditated, "But who shall gaze upon the gorgeous train?/ And think how few around him— now remain, / . . . How few survive to show the picture's truth."[13] The

truth of a likeness must be shown in comparison with the original. Like effigies, which depict dead persons, portraits may be termed retrospective images: they are drawn or sculpted "after" the person, to whom, in their monumental character, they refer back. The monumental likeness, bound to the past, begins to die when its subject passes on. In the words of the Earl of Shaftesbury, it loses its "character"; it "dies and becomes thoughtless, devoid of meaning."[14] As Byron's Don Juan gazes at the family portraits in the Amundeville mansion's long gallery (16: Sts. 17ff.) they are, ranged in their gilt frames, monumentally impressive as works. However, though the pictured figures "Look living in the moon," their eyes do not. "Death is imaged in their shadowy beams./ A picture is the past; even ere its frame/ Be gilt, who sate hath ceased to be the same." "Portraits of the dead" must image only what has passed or will pass. Then like the past itself it will always be "the same." In this scene the pictures are the same, seeming not to change, unlike the depicted evolving consciousness of the hero who muses on them, then hears a mysterious noise, then sees a monk in cowl and beads, stands transfixed "as stands a statue," then reviving his "energies," goes on to live out his part.

Must a portrait, recording the past, itself only *be* "the past"? Must its "character" pass with the remembrance of the person pictured? These questions have to do with the adequacy of the monumental figure itself. Although Hazlitt referred to the genre as a "clue to history," he objected when some "blockhead" member told the House that the works in the British Institution's 1820 eye-opening portrait retrospective were "strictly *historical*." He responded curtly, "There was nothing historical in the generality of those portraits, except that they were portraits of people mentioned in history—there was no more of the spirit of history in them (which is *passion* or *action*) than in their dresses" (12: 115–16).

To be itself a living image or form, the portrait must convey the person's character, the essential, continuously existent self. More than skill in copying, capturing character requires, as Hazlitt wrote, "a comprehension of the whole, and in truth a moral sense," to guide him through "the labyrinth of shifting muscles and features" (12: 288). In "On the Knowledge of Character" (8: 303–17) he argues that faces are less likely to deceive than words or actions; a man may hoodwink his contemporaries his whole life, but must leave a true account of himself in his portrait. Contemporaries differed about Charles V and Ignatius Loyola, but whoever has seen Titian's pictures of them "judges of them at once, and truly." The countenance is the best index of a man's real self: "A picture painted of him by a great artist would probably stamp his true character on the canvas, and betray the secret to pos-

terity" (303). What a recent historian has surveyed as "the addition of character" in the later eighteenth century was supposed to endow the depicted face with an interest transcending that of his personal circle.[15] To Fuseli only the "characteristic portrait" (by Reynolds and some others) "takes its exalted place between history and the drama."[16] "Ennobled by character," a portrait "rises to dramatic dignity." Without it, it "sinks to mere mechanic dexterity, or floats, a mere bubble of fashion."[17]

Just as the concept of character in literature was changing to favor the particular person or the personal over the type or the typical, so was it in painting, most prominently in discussions of portraiture. Generally acknowledged to be "the grand vehicle of expression," in the words of Elmes's *Dictionary*, the face must be viewed by the painter as expressing the "actual character of the individual."[18] This of course meant that he must pay less attention to the face's expression of feeling or attitude than to its expression of the whole person. The catalogue to the British Institution's 1820 portrait exhibit argued that it would be possible for a viewer of any of the pictures to "trace the character of a man in the expression of his countenance."[19] In fact, the portrait was the characteristic *form* of the person: "Historical character consists in those proportions and forms which history has transmitted to us of persons who have existed in former times, and made themselves celebrated by their actions. The characteristic forms or portraits of these celebrated persons can only be procured from the authority of statues, busts, coins, medals, and other authentic representations" (Elmes, *Dictionary*, "Character").

Characteristic form, moreover, may be said to belong not only to the subject but to the portrait itself, embodied in the artist's performance. The painter imparts his own artistic character to the work and to the portrait figure. The work's form is apprehended in a cognizance of the figure. Two portraits that appear and reappear in Hazlitt's writings, a Titian and a Van Dyck, were to him the ultimate embodiments of characteristic form.

Titian's *Ippolito de' Medici*, showing the Cardinal in hunting costume, was one of those works he copied in the Louvre in 1802. Except for a four-year period when he was obliged to give it up for "hard money" (8: 16), the copy was always in his possession, and Ippolito's image always in his imagination. His first published mention of it came in 1814, in the course of a series of *Champion* essays on Sir Joshua Reynolds's *Discourses*, remarks repeated three years later in an *Encyclopaedia Britannica* essay on the fine arts (18: 62–84, 111–24).

"All the lines of the face" of the *Ippolito*—"the eyebrows, the nose, the corners of the mouth, the contour of the face,—present the same

sharp angles, the same acute, edgy, contracted expression." Form and expression in this case operate together to comprise the face's (and thus the picture's) "general character," the "aggregate impression" of the whole countenance. The artist must be able to "comprehend" the sitter (to grasp him or her *comprehensively*) in order to convey that aggregate impression in the work. With a portrait, the face's "character" is also the picture's, and Titian's portraits had the highest degree of character, that is, of "expression." A portraitist himself, Hazlitt always maintained that a work need not depict some action, event, or narrative situation to be historical and belong to the highest class of painting. In the Reynolds piece, and again in the "Fine Arts" essay, he tried to show that Titian's faces were "the most historical that ever were painted" (76). The reason was their "consistency of form and expression." A portrait with *characteristic* expression is historical; "that is, it carries its own internal evidence of truth and nature with it" (75). The importance of these remarks for Hazlitt's criticism, as I shall presently try to show, is twofold. It gives his Shakespearean criticism, with its emphasis, like Coleridge's, on individual character *and* on overall impression, a theoretical grounding in the visual arts. It also helps explain what he means by "gusto" ("On Gusto," 4: 77–80).

"Gusto in art is power or passion defining any object." By "defining" Hazlitt here means characterizing, making a thing's identifying form, and therefore its life, known as felt. A work's gusto is its power of expressing ideas and passions, but above all the character of its figures, by means of color or form. The flesh tone in a Van Dyck portrait "wants gusto. It has not the internal character, the living principle in it." Titian's figures express that principle through their power of color, Michelangelo's through the power of their forms, which "are full of gusto. They everywhere obtrude the sense of power upon the eye. His limbs convey an idea of muscular strength, of moral grandeur, and even of intellectual dignity." "On Gusto" is less concerned with how the figures portray expression—for example, what sort of expression their faces have—than with the figure as form, and with the qualities that make that *form* expressive. Any use of colored form could have gusto. For example, whereas Titian's landscapes "have a prodigious gusto," every object possessing an "appropriate character," Raphael's gusto "was only in expression; he had no idea of the character of anything but the human form."

Thus, with a visible depiction of a visual world, gusto is the expressive character, given it by an artist, of a "thing" or "object," or ultimately of the work as a whole. It is what painters of the time meant by a *picture's* expression (though Hazlitt puts uncommon stress on the tactility of its depicted objects). As the very end of the

essay insists, the world of a poem also may have this supplied quality, though there the objects are visualized, not viewed, and what supplies gusto is the imagination.

"On Gusto" was first published in the *Examiner* in 1816. Hazlitt had then begun to think more and more of the expressive character of a work as, first, belonging to the very texture, coloring, and form of the depicted object, especially if that object is the human figure, and second as a power which that object projected, a power of impression. For Hazlitt, as also for Keats—to an extent because of Hazlitt—the represented face had this projected intensity that fixed the visual attention rather than inviting an imaginative voyaging, as landscapes like Claude's "Enchanted Castle" did.

A depicted figure was thus historical in the sense of being alive, of having a living presence. The picture was historical if its style and surface had the same kind of tangible presence as the figure. The painter Hazlitt aimed to capture and preserve the human figure. As a critic he aimed to convey to his readers the nature of figures in paintings and literary works conceived centuries ago. The *Ippolito de' Medici* became his touchstone. It showed how intimately involved were the character of the pictured person, the character of the work, the person's expressive power, and the work's. In his *Journey through France and Italy* he recalled the picture once more as one of the "gorgeous jewels" to be found in the Pitti Palace, some of which he had seen decades earlier at the Louvre.

> Among these . . . is Titian's Hippolito di Medici (which the late Mr. Opie pronounced the finest portrait in the world), with the spirit and breadth of history, and with the richness, finish, and glossiness of an enamel picture. I remember the first time I ever saw it, it stood on an easel which I had to pass, with the back to me, and as I turned and saw it with the boar-spear in its hand, and its keen glance bent upon me, it seemed 'a thing of life,' with supernatural force and grandeur. (10: 225)

During his 1802 visit to Paris another portrait resided at the Louvre, a picture by Van Dyck of a woman and her daughter. At the time he gave it little notice: "After Titian's portraits, there was a want of interest in Vandyke's which I could not get over" (10: 111). Years later it was to share a place of honor with the Titian in his "lumber-room of the imagination." During his second visit to Paris and the Louvre he composed "On a Portrait of an English Lady, by Vandyke" (12: 280–94). His most extensive treatise on his favorite art form, this piece consolidates many of his ideas on the representation of figures by focusing on the essence of the portrait.

That essence involves the highly personal relationship between artist and sitter and also between the represented figure and viewer. Near the essay's end he declares that he has seen four or five pictures he would be contented to own—originals or even good copies: Van Dyck's Woman and Child, Poussin's Adam and Eve, Guido Reni's Presentation in the Temple, and Rubens's landscape called The Rainbow. He adds the two Titian portraits he had already copied, the Ippolito and one other. On these six the essay as a whole centers, working, I believe, to explain in what sense they already belonged to him.

Each of the six has its own gusto, its characteristic expressiveness. As usual in his art criticism, "character" and "expression," then familiar terms in the world of painters and connoisseurs, are central to his attempt to convey his experience of the picture. He begins with Van Dyck's *Lady and Her Daughter,* noting especially how an "habitual gentleness of the character seems to have been dashed" by the expression of a transient feeling, "a look of timid attention . . . some anxious thought or momentary disquiet." The effectiveness of this portrait is most apparently the *sitter's* natural expression, not the painter's. "You have before you a real English lady of the seventeenth century, who looks like one, because she cannot look otherwise; whose expression of sweetness, intelligence, or concern is just what is natural to her." The same natural expressiveness is found in the daughter, "who turns her head round with a certain appearance of constraint and innocent wonder; and perhaps it is the difficulty of getting her to sit (or to sit still) that has caused the transient contraction of her mother's brow. . . ."

This is a reading of the portrait that concentrates on the subject's frame of mind to explain the picture's expressive power. Presumably that is where Van Dyck began, and it is where Hazlitt's prose version begins. But in exploring the mood or attitude of mother and daughter he discovers something else: the mother's character or essential nature. This is possible because of his confidence that in the face Van Dyck has captured something permanent in the person, and also because it seems clear that the woman's countenance, displaying "a mother's tenderness, a mother's fear," is a "genuine text of nature without gloss or comment" (281).

Shown, then, is the unself-conscious naturalness of the English gentlewoman. "I have said that it is an English face; and I may add (without being invidious) that it is not a French one." (In fact, scholars describe the two subjects as belonging to a well-to-do Antwerp family.)[20] If Van Dyck's characters are English, Titian's are typically Italian: "They have not the clear smooth skins or the even pulse that Vandyke's seem to possess. They are, for the most part, fierce, wary, voluptuous, subtle,

haughty" (285). While the Englishwoman is modest and absorbed, the Italian Cardinal Ippolito is bold and aggressive. Again the expression reflects the person's nature.

> All its faculties are collected to see what it can make of you. . . . It is this intense personal character which, I think, gives the superiority to Titian's portraits over all others, and stamps them with a living and permanent interest. . . . [W]henever you look at Titian's portraits, they appear to be looking at you; there seems to be some question pending between you, as if an intimate friend or inveterate foe were in the room with you. They exert a kind of fascinating power; and there is that exact resemblance of individual nature which is always new and always interesting, because you cannot carry away a mental abstraction of it, and you must recur to the object to revive it in its full force and integrity. (285–86)

If the object to be recurred to was the portrait itself, Hazlitt could not have done that as he wrote these words. He had not yet reached Florence where it again hung, and of course he did not have his own copy with him. Even the Van Dyck, though he was in Paris when he wrote the essay, was not physically before him. What the essay shows, however, is how thoroughly he mentally possessed the paintings in the essay, how for him these countenances, and these pictures, were living forms.

The essay advances a democratic ideology of aesthetic involvement. A painting merely purchased and hung does not belong to its owner. It is only possessed if the imagination owns it. Hazlitt offers a method for achieving that kind of ownership, a method the painter himself has of discovering expression in the sitter and *thus* giving to the painting an expression that, unlike the subject's, is unchanging. If you are a portraitist, "in the course of a day the whole expression of the [sitter's] countenance undergoes a change, so the expression which *you gave* to the forehead or eyes yesterday is totally incompatible with that which you have to give to the mouth today" (287–8; emphasis added). If Titian's people, and his paintings, have expression it is because the figures are Titianesque, "characteristic specimens" of the master.

This is the kind of painting, Hazlitt makes clear at his essay's end, that wealthy British patrons and collectors, "the Great," could never appreciate. The Duke of Wellington "cannot enter into the merits of Raphael" (293). Such men will pay the "highest price" for the "highest finishing," and the portraits they order for purchase have that sort of competence, but little real expression. To the "great and exalted in station," art "must be servile" (293). They will tolerate nothing ambitious or truly original. The subjects of their paintings must be "the little and elaborate," the pictures themselves "mechanical," "*done to order*." By contrast, the "mighty masters of the Italian school" *are* masters of their

own work. Artist or viewer, the man of imagination has an independence directly reflected in the expression he *gives* to the work. In his continuing feud with the Royal Academy, the British Institution, and all partisans of contemporary British art who deprecated the Italians and other masters, Hazlitt declared that the moderns "cannot paint with *gusto,* or high expression." They "do not go out of their way in search of character and expression—their sitters come to them in crowds; and they come to them not to be painted in all the truth of character and expression, but to be *flattered* out of all meaning; or they would no longer come in crowds" (18: 107). As a result, the figures in such paintings are drab and lifeless, whereas Titian's heads have a singular "keen, sharpened expression": they exercise a "discretionary power" over the viewer, partly owing to the "personal appeal" of the faces, their "point-blank look." Hazlitt keeps returning to the fact that these portraits stare boldly at the viewer, projecting their own determined character. The faces are as unrestrained and independent as Titian was.

As Elmes's dictionary says, "character" in the arts "is figuratively applied to the adventitious qualities which are or may be conferred by any external or internal means; and determine in a distinctive manner the qualities, whether good or bad, of any person or thing. . . ." The character of the portrait's subject, to an extent "given" by a painter, is merged with and enhanced by the character of the work. Thus Titian's *pictures* had "expression in the highest degree." *Ippolito de' Medici*'s "look goes through you" because the painting conveys a "united impression." Everything is "acute," pointed, "wedge-like." The sense of definite, unified character makes the work endure for ages. The "intense personal character" in Titian's portraits, Hazlitt argues, "stamps them with a living and permanent interest. Of other pictures you tire, if you have them constantly before you; of his, never." A portrait's pictured expression belonged once to the person, therefore now it belongs to remembered impressions and to the picture as reference and record; artistic expression belongs to a form given an aesthetic existence by an artist and therefore forever to the picture as embodiment or symbolic self-presentation. As expressions by the human face or figure are manifold and transient, so therefore are the impressions they make. The expression of a work, like the impression it is intended to leave, is unitary and permanent: monumental.

THE MEANINGS OF "EXPRESSION"

What Hazlitt calls Ippolito de' Medici's "keen sharpened expression" is, to use one *OED* definition of "expression," the "aspect (of the

face) . . . as indicating a state of feeling." But when he declares in the same essay that the greatest portraitist is the one who "can *put* the greatest quantity of expression *into* his works," and when he speaks of the artist's desire to "*give* expression *to* a face" (12: 290, emphasis added), he refers not to something observed in the sitter by the painter and then copied, but something the painter invests in the "work." Gusto, the "highest degree" of expression, is the artist's "*giving* [the] truth of character from the truth of feeling" (emphasis added). The function of all the fine arts, James Elmes observed, was to "impress upon objects a striking and distinguished character."[21] Concepts long used by Hazlitt and others—character, expression, and even form itself—to explore the aesthetics of effect in paintings, sculptures, and buildings were now being adapted to the poetics of the imagination, the poetics of visualization and transformation. As I shall be tracing various attempts to uncover and interpret living expression in represented human forms, I need to devote some time here to ideas of expression itself, particularly with respect to two questions: 1) Do representations of human beings in literature and the arts "express" differently from live people? and 2) What *kind* of thing might the expression be meant, and later invited, to "reveal"?

First, to review briefly some points covered. When painters used to speak of a portrait figure's expression they could mean either of two things, in both cases something recorded in the work for posterity: first, the sitter's own mood as directly shown in the face, and second, the permanent aspect of the sitter, the "actual character," as expressed by the painter. Reflecting on the Reynolds show at the British Institution, Prince Hoare wrote that the portraitist should exclude the transient and paint the mind.[22] In the "air and attitude" of a Van Dyck portrait P. G. Patmore found "a mixture of conventional nobility, and conscious natural power, which is finely characteristic."[23] It is, he added, "not the *accidental* but the *prevalent* and *genuine* characteristics of the face that are to be seized and perpetuated." Whereas the sitter's face may at any time offer signs of the feelings within, the portrait, the representational work, must be typical, standing for something more enduring. Artists, critics, and connoisseurs believed that only in the portrait was the person's character "seized" and "perpetuated." A work's expression differs in kind from expressions seen on its figures.

The concept of "characteristic form," it has been argued, was effecting a revolution in the aesthetics of the time.[24] Expression as characterizing or characteristic form began to define itself in its difference from, or even opposition to, expression of feeling or attitude, the expression a portrait face may have, or the human body. We interpret both the body

and the represented form as expressing life by expressing mind, intention, consciousness. However, only form in art is monumentally enduring. John Dewey, the most influential modern spokesman for what in aesthetics is called expression theory, wrote that by resulting in a work, aesthetic expression must be distinguished from more ephemeral kinds of expression such as talking or scowling. "Where there is . . . no shaping of materials in the interest of embodying excitement, there is no expression."[25] The "work" is "the deliberate creation of something which 'embodies' or 'objectifies' the feeling, unlike merely giving vent to or betraying" it.[26] Purely natural, bodily expression is an imitation of impressions; formal expression is a kind of idealization of them and an embodiment of the ideal.

The connection between expressive mind and expressive form has been assumed by such twentieth-century aestheticians as Dewey, Reid, Ducasse, Santayana, and Collingwood. In a trenchant "critique" Alan Tormey sums up their shared position this way: "the artist, in creating the work, is expressing something, which is then to be found 'embodied,' 'infused,' or 'objectified' in the work itself."[27] Unlike what Dewey calls "emotional discharge," the shaped object, the work, endures as the product *of* work: "To discharge is to get rid of, to dismiss; to express is to stay by, to carry forward in development, to work out to completion."[28]

How the two "expressions" are related emerged as a visible issue at a crucial moment in the history of criticism, when in the first part of his *Laocoon* (1766)[29] Lessing disputed the assumptions of Winckelmann's "Thoughts on the Imitation of Greek Painting and Sculpture (1755)."[30] According to Winckelmann, in the Laocoon group the father's pain "expresses itself *[äussert sich]* in the countenance and in the entire attitude without passion" (Lessing 60). The point of the paragraphs quoted by Lessing, including that sentence, is that Greek sculptural form suppresses the intense feeling manifested by persons under stress in their faces and bodies. Other statements in the passage indicate that this is done in order to *embody and reveal* loftiness of spirit—something, Winckelmann continues, that the artist must have felt in himself and stamped in his marble. The "expression *[Ausdruck]* in the figures of the Greek artists shows under all passions a great and steadfast soul"; and "the expression *[Ausdruck]* of so great a soul goes far beyond the fashioning which beautiful nature gives." This is the expression of "character" discussed above. It is consequently the unifying nature of the work "under all passions": that identity which accounts for the *work's* integral impression. According to Winckelmann, the arts began by communicating the passions directly, as does music, and by depicting passionate expressions, as does some painting.

With Greek sculpture evolved the expression of spirit as form, a quality giving it an enduring power of self-expression, as it has to later reproductions of Grecian forms like those in Raphael's Dresden Madonna. Although time has dimmed that painting's colors, "the soul which its creator breathed into his handiwork animates it to this day" (45). Of course Lessing agreed that figures in the visual arts are unsuited to conveying pain and joy directly, representing as they do a single moment. "As this single moment receives from art an unchangeable continuance, it must not express anything which thought is obliged to consider transitory" (67). Therefore "the artist is obliged to set bounds to expression and never to choose it for the supreme moment of an action" (66). The very unity and permanence of the form, both as object and image, argues against its being a medium for living expression of feeling. It can express "soul" but not "passions." In the conclusion of his reply to Winckelmann, Lessing remarked that "Our pity is always proportionate to the suffering which the interesting subject expresses [äussert]":

> And now I come to the inference I wish to draw. If it is true that outcries on the feeling of bodily pain, especially according to the ancient Greek way of thinking, can quite well consist with a great soul; then the expression [Ausdruck] of such a soul cannot be the reason why, nevertheless, the artist in his marble refuses to imitate this crying: there must be other grounds why he deviates here from his rival, the poet, who expresses [ausdrücket] this crying with obvious intention. (63)

The two principal meanings in English of "to express" are conveyed in the German of both writers by äussert and ausdrücket. For Winckelmann the art work, a formal totality, is the vehicle for the artist's embodiment of his own soul. Because Lessing's orientation is toward art as mimesis, these remarks I have quoted, like Laocoon as a whole, primarily concern what things a work of visual art can accurately reproduce or "imitate" [nachahmen]. The display of feeling is one of them. But for Winckelmann the whole art form is what most vitally expresses. The idea of the work, largely ignored by Lessing, is central to monumental form, the means by which an artist's achievement might last through the ages. The work expresses itself longer than expressions depicted in or on it. In this sense the sculpture (more so than, say, the portrait) is the exemplary monumental form, for as Hegel insisted, it will ignore momentary changes in countenance and body reflecting transitory emotive states. Instead it will concentrate on "permanent traits of spiritual expression, and retain and disclose such in the posture and configuration of the body no less than in the face."[31]

Observing that classic monuments, with their consummate form, conveyed such "permanent traits of spiritual expression" while modern works depict figures displaying temporary mood or emotion, writers came to think of forms in art as something *different from* transient physiognomic display and its depiction. As Richard Duppa remarked in his widely read life of Michelangelo, the Greeks, valuing the beauty of the body in repose more than the lively depiction of displayed passions, "made expression and animated feelings subservient to form."[32] Again and again, as Winckelmann did, writers would describe the nature of a *work's* expression by showing it wasn't the other kind. Whereas ancient Greek sculpture could "embody the conceptions of divine perfection" and "realise the expression" of a certain "character of mind," modern French and Italian paintings sought "the expression of *passion and violent emotion*."[33]

Shelley's Uffizi Gallery notes tend to focus first on the work's form as impersonating (to use a favorite word of his) some idea of beauty, and then on the figure's expression as manifesting strong feeling. The Venus Anadyomene's "form is indeed perfect" with its "roundness and perfection of the limbs" (*Prose* 348), while her face "expresses . . . at once desire and enjoyment and the pleasure arising from both." In a statue of Minerva "the head is of the highest beauty." He describes the "perfect form" of the neck and the "beautiful moulding" of parts of the face, while noting that the countenance is "invested with the expression of grief because it must ever plead so vainly" (349).

Instructive here is his entry on that Romantic tourist magnet, the Niobe group. When he speaks of the "number of the infinite modes of expression of which any form approaching ideal beauty is composed" (352), he means by "expression" something other than when he adds that Niobe's face "expresses . . . a sense of the inevitable and rapid destiny which is consummating around her as if it were already over." The second reading is psychological, the first aesthetic, an interpretation of form as "the most consummate personification of loveliness."

Other writers as well found perfectly compatible formal and physiognomic expression (by convention called, respectively, "form" and "passion"). Though believing that "All depends on Form or Outline," Blake disputed Reynolds's claim that the passions, producing "distortion and deformity," are irreconcilable with the purest beauty in art. "What Nonsense," Blake's marginal commentary snorted. "Passion & Expression is Beauty Itself—The Face that is Incapable of Passion & Expression is Deformity Itself."[34] The question of course was to what extent figures in art were like those in life. Romantic aesthetics sought a way of presenting figures whereby beauty and character were expressed in form, and the passions, as they are with a living body, in the features. Sir Thomas Lawrence admired

Flaxman's use of form to convey the subject's personal dignity while also depicting "the gentler feelings and sorrows of human nature."[35] Flaxman himself quoted Xenophon: "Statuary must represent the emotions of the soul through form."[36] Coleridge's favorite sculptor, Francis Chantrey (see next chapter), studied Raphael's paintings for their combination of grandeur of outline with pathos and force. Henry Fuseli spoke of the "grand principle of *form and expression.*"[37]

To summarize, artists, poets, and critics came to seek not a combination of form and expression, as Chantrey, Flaxman, and Lawrence did, but, following Winckelmann's lead, a concept of form *as* expressive. If, by their own forms, human figures in the work—say, faces in a portrait—can express both physically and spiritually, might not the formal work do the same, permanently conveying its "actual character" as forcefully and directly as a countenance transitorily conveys a mood?

Readers accustomed to thinking of them as opposed concepts will likely identify expressionism with the Romantic period and formalism with later and perhaps earlier periods. In fact, an expressive formalism lies at the heart of Romantic poetics, traceable to a change occurring at the beginning of the nineteenth century. As poetry came to be regarded as akin to the "arts of form," its own expression, like that of the well-known monuments of sculpture, came to be regarded as embodiment, the presentation of an expressive object, both more forceful and more lasting than the human body's various expressions. Wordsworth, Shelley, Hazlitt, Coleridge, and others share a focus on enduring expressive objects and especially on figures associated with them, a focus, we have seen and shall see, reflected in the best known Romantic documents, particularly of the period 1805–25: *The Prelude,* the "Defence of Poetry," Coleridge's lectures, Hazlitt's essays. As more stress was laid on the poet as artist, more was laid on symbolic form as a making, an embodying, and a representing, more on the "object" and on "materials" as constituting a medium; less emphasis was placed on the poem as a display of passions. In his comprehensive analysis of ideas of artistic expression, Guy Sircello speculates that once Hume had cast doubt on the reality of personal identity or unified self, poets and artists found a new understanding of Descartes's definition of personhood, which became, "I express myself, therefore I am." Only artistic expression makes known the person as a unity. For example, the painter looks for some means "to express not simply this or that feeling or attitude to this or that person, place, thing, or event, but some basic attitudes, feelings, sensitivities, or qualities which characterize his whole person and affect his whole outlook."[38]

Hazlitt's interest in the language of human forms centered on these issues. The artist's purpose, he wrote in the *Journey,* was to express the

soul of objects, and thereby his own soul. The painter, then, seeks above all to *"express"* an object like a human face (16: 348), not merely to copy it. His style is itself the expression of his own nature and signifies his own freedom in revealing that nature. Hazlitt himself in his best criticism, with his rich personal involvement in the paintings he studies, follows his injunction to painters to express the object "by a closer and continued observation of the thing itself," rather than subjecting the thing to traditional standards of assessment (349).

If plastic arts concentrate on expressing the object and its form, poetry or the verbal arts concentrate on the imagination's expression of new forms, as Shelley said. With the visual arts, Hazlitt wrote, "the object itself is given entire without any possible change of circumstances, and . . . though the impression is momentary, it lasts for ever" (20: 305). Poetry, no "mere delineation of natural feelings" ("On Poetry in General"; 5: 3), is the most vivid *"form* of expression" that can be given to "our conception of any thing," by means of the poetic imagination's power to *"shape* things" (emphasis added). The imagination "gives an obvious relief to the indistinct and importunate cravings of the will" by "embodying and turning them to shape" (7: 8). Giving definition to an apprehension or desire, a visualized form not only lets us contemplate it ourselves; we can also "shew it to others as we feel it to exist," and poetry becomes *"in all its shapes the language* of the imagination and the passions, of fancy and will" (8; emphasis added). Emotions are transitory: revealed or displayed as they occur. The language of the imagination comprises the lasting shapes of poetry.

PORTRAIT POEMS: THE INFORMING PRINCIPLE

The characteristic expression of a painting or sculpture was thought to be grasped as the form struck the eye, that of a poem or play as it struck the inner eye. But forms in both poetry and the visual arts were thought to be alive insofar as they were directly experienced as convertible into other forms. Even images become dead forms without a continuing existence in the imagination. A portrait maintains its expressiveness only if its "character" is clear enough to inspire people to visualize or imagine the picture, then reimagine it in a different form, one constituting an additional or alternative text. "Painting gives the object itself; poetry what it implies. Painting embodies what a thing contains in itself: poetry suggests what exists out of it, in any manner connected with it. But this last is the proper province of the imagination" (5: 10). To that province belong Hazlitt's prose forms of paintings he saw. To it also belongs the

small portrait poem, then a favorite genre of occasional poetry that sought to uncover and sustain the picture's character, therefore its iconic life, by turning a monumental object into a living memorial utterance. Poet and reader alike learned to "gaze on every feature till it lives!" (Samuel Rogers, *The Pleasures of Memory*). The ambiguity of "it" here (in his poem, the portrait or "every feature"?) reflects the uniqueness of the portrait as art form: the expressive character of the work merges with that of the subject. Poets focused on the portrait's iconic power of recalling to life its subject and thus also itself. The picture was a "sweet memorial shrine" that could "give us back the dead" (Thomas Campbell, "Stanzas to Painting").[39] The figure thus recalled, the portrait as a work was recreated in the mind, as a Wordsworth sonnet ("The imperial Stature, the colossal stride") recreated a likeness of Henry VIII seen at Cambridge. The King's features "are yet before me; yet do I behold/ The broad full visage. . . ."

The octave of another little-known late sonnet of his, on the portrait of Isabella Fenwick ("We gaze—nor grieve to think that we must die"), laments that Wordsworth's own death would mean the loss to "human memory" of the love inspired by the woman. The sestet continues: "Yet, blessed Art, we yield not to dejection;/ Thou against Time so feelingly dost strive./ Where'er, preserved in this most true reflection,/ An image of her soul is kept alive. . . ." Because the "blessed Art" is not only the painting's but the sonnet's, "this most true reflection" may mean, sequentially, the portrait, the image of the picture in the poet's mind and his poem, and his own meditation upon picture, poem, and person. The sonnet converts a privately owned likeness and a personal mental image of it into a more publicly accessible memorial.

What enables the translation of viewed possession to published poem, of icon of personal remembrance to one of general remembrance—the public monument—is the awareness of both painting and poem as art forms, not mere memorials. This is manifestly the case in the best-known portrait poem at that time, Cowper's 1798 "On the Receipt of My Mother's Picture out of Norfolk."[40] In it the poet, addressing first the likeness as private memento—"Faithful remembrance of one so dear"—uses it to "weave a charm for [his] relief." As a "charm," his "Elysian reverie" calls up his mother's living person, to whom the prosopopoeia is then addressed. He recalls her many kindnesses, but as the focus shifts from the painting, "the mimic show of thee," to his own poem, "frail memorial, but sincere," the link is not merely portraiture, but art form itself: "Blest be the art that can immortalize,/ The art that baffles Time's tyrannic claim/ To quench it." As James Elmes wrote of portrait figures in his *Dictionary of the Fine Arts,* "if the expression on their countenances is still and

unchanging, it is at the same time perpetual, and subject neither to the accidental dimming of angry and unworthy passions, nor to the fading touch of time. It haply remains young while we grow old, and constitutes a charm whereby our earlier and later years are linked together" ("Portrait Painting").

Although those words could well have been chosen for the epigraph of Felicia Hemans's "The Charmed Picture,"[41] she adapted instead the first lines of Cowper's poem: "Oh that those lips had language!—Life hath pass'd/ With me but roughly since I heard thee last." At the beginning of her own piece the portrait's "spell" is the conveyed personal character of her deceased mother. Soon, however, this unchanging "image of the dead" is replaced by a changing image of the viewer. "Whence are they charm'd—those earnest eyes?/—I know thy mystery well!/ In mine own trembling bosom lies/ The spirit of the Spell!" Memory, conscience, love—those things embodied in the image—are now elicited from the speaker. First the picture, then the poem, become mirrors for the remembering, visualizing self. Coleridge makes the fascinating speculation that a portrait might "partake of the person" if that person were the one contemplating it, and the picture could change "with the changes in the person produced by the contemplation" (*Logic* 96). This effect turns out to be the talismanic power of the contemplated picture in Hemans's poem (as perhaps in Cowper's): it can call to the speaker's mind an image of the mother, then to the reader's mind an image of the poet. It was commonly held at the time that through the image of the portrait's subject the viewer gained a lasting image of the portrait's maker. As Elmes declares, quoting Cowper's poem, the viewer "beholds a sketch on canvass which appears almost animated with life. . . . He views, or imagines, in the curve of the lip and the play of the eyes, the germs of those characteristics which distinguished the living person, and feels the painter by his 'so potent art' effectually bids defiance not only to time but mortality."

As a final example of the ekphrastic portrait poem I shall give some attention to Wordsworth's "Lines Suggested by a Portrait from the Pencil of F. Stone" (1834). A meditation on death, the visual imagination, and the portrait as "charm," it begins by reading a likeness of its female subject, whom Wordsworth had known personally for over a decade. Jemima Quillinan was the daughter of Edward, a friend and neighbor of the Wordsworths at Dove Cottage who was ultimately to wed Wordsworth's own daughter Dora. In 1822, shortly after their moving to the vicinity of the Cottage, Edward's first wife suffered a nervous breakdown and was fatally burned when her clothes caught fire. The likeness, which must have been taken soon after that, hung for many years in the Wordsworth's main sitting room.

Wordsworth invites the reader to visualize what the poet sees on his wall: "from Imagination take/ The treasure,—what mine eyes behold see thou." Sitting "beguiled" into inactivity by the appealing natural scene outside his window, Wordsworth notices the portrait first as tranquil presence, with its "mild gleam of beauty," its motionlessness, and silence. It "charms the air,/ Or seems to charm it, into like repose." There "seems" nothing about the picture or the room to suggest the past, or death or mourning, or any emotion. The whole is a composition, with an "atmosphere . . . broad, clear, and toned harmoniously"; the "fair scene" outside seems at one with that within.

The poet's first survey of the painting's figure continues that motif. Her hair is a "golden harvest," her eyes "Soft and capacious as a cloudless sky." The painter might well have learned his skill "from nature . . . in the hour/ When the lone shepherd sees the morning spread/ Upon the mountains." In the girl's hand, along with "a few pale ears/ Of yellowing corn" is a blue wildflower, such, the poet speculates, as Ceres might have worn in her own garland. That this flower was her mother's favorite as a girl, however, gives a new, more serious import to the vision and to the poem: "the orphan Girl,/ In her own dawn—a dawn less gay and bright,/ Loves it, while there in solitary peace/ She sits, for that departed Mother's sake."

The poem explores the two kinds of "expression"—"truth/ In character, and depth of feeling" (99–100)—"dearly united" in the painting. The girl's character is indicated by her "posture," the "humble grace" of her head's "inclination towards earth," which in the painting casts a shadow on the whiteness of her neck. The character is caught, stilled, embodied in form. The expressed sentiment, what the girl is thinking about and feeling, is also fixed in the painting, a "quiet pensiveness/ Caught at the point where it stops short of sadness." It is, the poet discerns, a "look of filial love." The poem, like the painter Stone's spatial, "Godlike" art, "both creates and fixes" the two kinds of expression "in despite/ Of Death and Time."

Contemplating Stone's work, moving from the figure's expressed mood to its expressed character and to the picture's character, Wordsworth does more than recall a time-bound image from the past; he provides it with a consciously redemptive transformation to another medium, securing it in a sort of ideal, permanent realm, that of aesthetic influence ("My Song's Inspirer") as opposed to particular historical reference. Somewhere between art and fact are words, which "have something told/ More than the pencil can." The pictured face, in short, may be a living image if it records more than the expression of a moment. It is literally a still life, the features fixed in one unchanging position. Therefore, while it may serve as history, as a document, there is a real

question as to whether it can be, in the sense of the term then, a history painting. Can it represent movement and living experience?

The ekphrastic portrait poem sought to grasp the painting's form, what Hazlitt called gusto, the "internal character, the living principle." This was the informing and therefore *trans*forming *poetical* principle. The reading or viewing imagination first sees a work's form or wholeness, and therefore its character. Like Coleridge, Hazlitt considered a work's "principle" to be not only an original but an originating essence, one, moreover, to which a thing's form or wholeness can be traced. To cite examples we have already encountered, Shelley spoke of *poiein*'s composing new thoughts, "each containing within itself the principle of its own integrity." Coleridge argued that the explanation of any thing is the "principle of its possibility," and referred to the unity of a Shakespeare play as its "principle of life and integrity."

Therefore to grasp a work or a figure in it poetically, one must grasp its form-generating principle: its character. In his *Edinburgh* review (1816) of Schlegel's drama lectures Hazlitt set out to "explain" the currently familiar analogy of classical poetry with sculpture and modern poetry with painting (16: 62–4). Though more Hazlitt than Schlegel, the explanation is consistent with his source and with the general line of thought I have been tracing. Underlying his own discussion is the most central of his tenets: in poetry the imagination, under the influence of passion, moves the mind forward from form to form. A classical work is directed toward the imitation of things: it "seeks to identify the imitation with an external object,—clings to it,—is inseparable from it,—is either that or nothing." This is the art of "form"; the modern work is that of "effect," and therefore of originality and imagination. The most austerely formal art has no "informing principle"; it does not create new forms or images for itself. "For the imagination is that power which represents objects, not as they are, but as they are moulded according to our fancies and feelings." So the "poetry of form," like the sculptor's art, depended for its unity on the unity of the thing represented. "In order to identify the imitation as much as possible with the reality, and leave nothing to mere imagination, it was necessary to give the same coherence and consistency to the different parts of a story, as to the different limbs of a statue" (16: 63).

The informing principle of a poetic work not only speaks to a reader of the sort of thing, aesthetically, the work *is* (and originally was), but conveys a power by which the defining element of one form ("principle" in one sense) becomes the defining cause ("principle" in the other) of a new form. Antique sculptures and their literary analogues offer nothing for the imagination to grasp. They are "specious forms," self-sufficient, "marble to the touch and to the heart. They have no informing princi-

ple within them" ("On Poetry in General"; 5:11). To "inform" can mean 1) to shape, mould, or put into some form; or 2) "to be the 'form' or formative principle of, to give a thing its essential quality or character, to make it what it is; to pervade as a spirit, inspire, animate" *(OED)*. In other words, to use a phrase I have been tracing throughout this study, Hazlitt sought in each portrait figure a living form. For him as for Coleridge and Shelley, however, forms that live give both life and character to, they "inform," *other* forms. The figurative language of poetry translates the object "into some other form" (20: 305). Poetry therefore "represents forms chiefly as they suggest other forms" (5:11). Portrait figures are poetic to the extent that they do this.

This helps explain why, arriving in Florence in 1825, Hazlitt was so enthralled by the paintings in the Pitti Palace but so dismissive of that city's most celebrated work at the time, the Venus di Medici: "an exquisite marble doll" (10: 222). It did not "express," as he would say, a single object, a real woman. It was only an abstraction "embodied to the senses," a mere personification of an idea. So it did not have the informing principle. It could not, for example, be converted or reformed in living description. In his review of Flaxman's Royal Academy lectures Hazlitt asked why sculptured figures should be so much more severe and abstract than other kinds of representations. The answer was that the primary idea of sculpture is *"tangible form,"* something of "solidity and permanence." But this idea itself "becomes an exclusive and unsociable one," distancing rather than involving the viewer. In short, most sculpted figures were not living forms because they did not, like those in the most effective portraits, involve the viewer's tactile and visual senses, or involve the reader's creative imagination, as did those in literature.

Hazlitt's writings on art should be seen as a kind of intense, sustained ekphrasis, an attempt to turn the object of tangible form into what Susanne Langer calls a "virtual 'object.'" This feature was commented upon insightfully by Edmund Gosse. Hazlitt's aim, Gosse said,

> was nothing more nor less than a spiritual reproduction of a physical impression. He describes, but with the design of producing, on the mental retina, an image which shall create a like enthusiasm in the mind as the sight of a picture does when the physical eye regards it. Hazlitt writes, to be short, not so much for those who are about to see the picture, as for those who will never have the chance of seeing it. . . . Hence his rich and sometimes over-luscious descriptions can hardly be read side by side with the paintings they deal with.[42]

Certainly that method of art criticism, the spiritual or mental reproduction (to the mind's eye) of a physical impression, presented its own kind

of challenge to an essayist like Hazlitt. No less challenging was his attempt as a literary critic to spiritually reproduce what was essentially a spiritual impression of a poem, novel, or play. His major efforts in this regard occurred in 1817–20, at about the time Coleridge was giving the last series of his own lectures on literature. He delivered at the Surrey Institution three series of lectures: on the English poets, on the English comic writers, and on Elizabethan literature. He also collected and published two series of essays, *Characters of Shakespear's Plays* and *A View of the English Stage*. All these show two related influences on his ideas of living form: Schlegel's lectures and his own thinking about the arts.

SHAKESPEARE'S FIGURES

Characters of Shakespear's Plays, on which I want now to focus briefly, begins by paying tribute to Schlegel and then attacking Dr. Johnson for a rigid, unimaginative reading of the plays. Dr. Johnson "retained the regular, habitual impressions of actual objects, but he could not follow the rapid flights of fancy, or the strong movements of passion. That is, he was to the poet what the painter of still life is to the painter of history" (4: 175). A critic himself must be a painter of history, Hazlitt implies (and we must remember that for Hazlitt the great portraitist was such an artist) in order to convey the essence of historical paintings like Shakespeare's plays. While Dr. Johnson's mind had a strong grasp of motionless things, it lacked the "informing principle" and could not understand how the imagination evolves forms from other forms. As I have argued, Hazlitt's pictorial writing, highly metaphoric, analogical, and allusive, itself might illustrate how the informing principle works.

Since all significant forms in the fine arts express their own age, they may be understood experientially, as Schlegel had demonstrated, with interart analogues. This is why in his own writings and lectures on literature Hazlitt tended to make abundant use of examples from the visual arts. "For it is certain," he wrote, commenting on Schlegel, "that there are exactly the same powers of mind displayed in the poetry of the Greeks as in their statues. Their poetry is exactly what their sculptors might have written. Both are exquisite imitations of nature; the one in marble, the other in words" (6: 349). Because for Hazlitt the most characteristic Renaissance form was the portrait, that is what he uses to convey the nature both of a Shakespeare play and of its protagonist. "The character of Henry VIII is drawn with great truth and spirit. It is like a very disagreeable portrait, sketched by the hand of a master. His gross appearance, his blustering demeanour, his vulgarity, his arro-

gance, his sensuality, his cruelty, his hypocrisy, his want of common decency and common humanity, are marked in strong lines" (4: 305). The artist here might be Titian (or Hans Holbein, whom he then mentions), rather than Shakespeare.

For Hazlitt all the unifying elements in each Shakespeare play—plot, settings, language, imagery—can be accounted for in the nature of the ruling passions of the protagonist or by the emotive relationships between and among characters. Thus it is from the main characters that the character of the play evolves. *Othello* is an elaborate expression of Othello himself. Form expresses feeling. In a note on the Elgin Marbles in his *Journey* he speaks of a great sculpture's "logic of form" as distinct from the "logic of passion" in Shakespeare, where "one part being given, another cannot be otherwise than what it is. There is a mutual understanding and re-action throughout the whole frame" (10: 69). The logic, that by which we can account for its being what it is, of the play *King Lear* is the logic of Shakespeare's "subject," Lear's own passion. Thus Hazlitt's title, *Characters of Shakespear's Plays,* may be read as referring to two related elements: the form of the play and the figures in it. (John Kinnaird has observed that in each of the Shakespeare essays Hazlitt writes a "character" of the play itself.)[43]

The logic, then, or form of a play, while not of course visible, should be able to be imaginatively experienced as if it were. For Coleridge, Shakespearean logic was that of "picturesque unity," a phenomenon of effect much like that experienced in looking at a picture. Not surprisingly, this is true for Hazlitt as well, who of course had accepted and adopted Schlegel's description of Shakespeare's plays as picturesque. "The Moor Othello, the gentle Desdemona, the villain Iago, the good-natured Cassio, the fool Roderigo, present a range and variety of character as striking and palpable as that produced by the opposition of costume in a picture. Their distinguishing qualities stand out to the mind's eye, so that even when we are not thinking of their actions or sentiments, the idea of their persons is still as present to us as ever" (4: 200).

A work's characteristic form stands out not to the eye, but in the "mind's eye." This gives both the work and its figures their lasting life. "Present to us as ever," their "idea" becomes reenvisioned in different forms. The imagination, Hazlitt wrote elsewhere, "seeks to identify the original impression with whatever else, within the range of thought and feeling, can strengthen, relieve, adorn, or elevate it" (16: 63). In a lecture on the comic writers he spoke of the writers' *"instinct of the imagination,"* by which he meant an "intuitive perception of the hidden analogies of things." In *Don Quixote,* for example, "this indistinct keeping and involuntary unity of purpose gives to all the characters and

parts of the work "something of the same unsettled, rambling humour" (6: 109). In his mind's eye Hazlitt sees each play as he would an historical painting containing several believable portraits. The psychological "keeping," consistency, in each character, gives the play "an affinity and harmony, like what we may observe in the gradations of colour in a picture." *Cymbeline* as a whole is shaped out of the play's dominant passion, "the unalterable fidelity of Imogen to her husband under the most trying circumstances" (183, 184).

In his discourses both on historical literary topics and on the older European painters Hazlitt sought to defy what he viewed as a national modernist prejudice. The "lengthened perspective of human intellect" is clouded by present-day myopia, which neglects the "loftiest monuments" of the past (6: 176, 177). Like old plays, old paintings have an intrinsic expressiveness rarely found in the moderns:

> Painting of old was a language which its disciples used not merely to denote certain objects, but to unfold their hidden meaning, and to convey the finest movements of the soul into the limbs and features of the face. They looked at nature with a feeling of passion, with an eye to expression; and this it was that, while they sought for outward forms to communicate their feelings, moulded them into truth and beauty, and that surrounds them with an atmosphere of thought and sentiment. . . . The moderns are chiefly intent on giving certain lines and colours, the *mask* or material face of painting, and leave out the immortal part. (10: 111)

As I have noted, Hazlitt would often reiterate that recent art and literary works could never be as alive, could never have the same power with those who encountered them, as those of the masters of the past. Two early fragments, included in *The Round Table* and drawn upon for the Milton-Shakespeare part of *Lectures on the English Poets,* developed some ideas on "Why the Arts Are Not Progressive." The argument (18: 7–9) anticipates Peacock's in "The Four Ages," but is also a defence of creative work, at least that of the past, that parallels Shelley's. The old poets and painters show the "full possession of their subject," "an increasing force and impetus, which moves, penetrates, and kindles all that comes in contact with it, which seems, not theirs, but given to them." (Echoes of Wordsworth in this section, especially of "Tintern Abbey" are, I think, unmistakable.) When Hazlitt comes to discuss the inadequacy of living poets he merely says that their works lack the same "atmosphere of sentiment" (5: 145) and declares that he cannot speak of these poets with the same reverence as for Shakespeare or Milton "because I do not feel it." His sense of any period, and of the works in it, was entirely of what he could feel. If he could not feel it he did not

think it was worth conveying to his audience. He needed to be, like those old painters and poets, in full possession of his subject. For him, as for Shelley and Coleridge, that shaping or "informing" principle which gave an art work its stable identity as a thing—its characterizing, unifying, form—was paradoxically also the dynamic principle that allowed it to flourish in the viewer's or reader's imagination, to make it felt or experienced, and to inform other works. To Hazlitt only the older monumental achievements had this power.

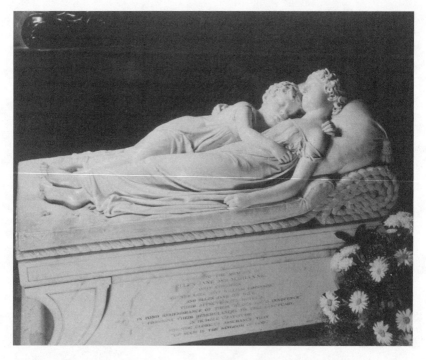

FIGURE 6. Francis Chantrey. The Sleeping Children. Lichfield Cathedral, Staffordshire. Photo: Pitkin Unichrome.

Symbolic Forms:
The Sleeping Children

Molded by powerful hands, but also by instruments that
are no longer apt, these monuments say, in effect, to those
who look at them long and carefully enough: admire me, but
do otherwise.

—Alessandro Manzoni, *Del romanzo storico*

The solid, stationary object—the framed portrait, the stone effigy, the
marble divinity, even the church tablet or graveyard headstone—has
always fascinated poets, partly because it recalls or resembles a person
but is not one, partly because it offers a model of undying remem-
brance and expression. For both reasons poets have tested the power
of language to make these things speak. According to Jean Hagstrum,
this exercise has particular importance in the Christian era. "The
statue or painting has, in spite of official pronouncements against idol-
atry and in spite of powerful iconoclastic movements, become a kind
of intermediary between the divine and the human. Spoken to,
entreated, implored, it speaks in return."[1] But since these efforts at
prosopopoeia are also efforts at ekphrasis or transmutation, they test
the object's "informing principle," as Hazlitt called it, its innate power
of generating new versions of itself. For Hazlitt figures in Renaissance

paintings had this energy. Greek and Roman statues lacked it: they were fixed shapes, "marble to the touch and to the heart." Coleridge too, and many of his German contemporaries, saw post-classical forms as constituting a new, living, symbolic language, unlike the dead language of antique sculpture.

Based on one of his 1818 lectures, Coleridge's essay "On Poesy or Art" takes uncharacteristic notice of contemporary art. "[A] new field seems opened for modern sculpture in the symbolical expression of the ends of life, as in Guy's monument, Chantrey's children in Worcester Cathedral, &c." (261).[2] To Coleridge most effigies, indeed most sculptures, were no living "educt of the imagination," but cold, immobile signs for dead persons or dead ideas. A figure such as Shakespeare's Hamlet or Richard II, by contrast, was a symbol, a "translucence of the eternal through and in the temporal."

One of the two "symbolical expressions" recognized in "On Poesy or Art" is a memorial to the founder of Guy's Hospital, probably Peter Scheemakers's completed in 1734; the other is Francis Chantrey's "The Sleeping Children" (in Lichfield, not Worcester, Cathedral). The relief on the monument to Thomas Guy shows the philanthropist helping to raise an afflicted man from the ground where he has fallen. Its novelty at the time, Nicholas Penny has observed, was that "the deceased and not the Good Samaritan, or Christ, is made part of the narrative."[3] Though conventional allegorical figures (Charity, Industry, Wisdom, and Prudence) appear in medallions below, the chief scene is a symbolic language in the sense that a figure from life is made to "express" dramatically those four attributes.

Chantrey's "Sleeping Children," whose subject had unusual appeal for Coleridge, also uses a mute, symbolic language. It depicts the two small daughters, Ellen Jane and Marianne, of the widowed wife of the Reverend W. Robinson. They are lying in each other's arms, uncovered on a mattress and pillow. One of them holds a lily in her hand. Although as sleeping (or dead) figures they have no expression of face, voice, or gesture, as "expressions" in themselves they exemplify what Catherine Gallagher has called Coleridge's concept of "synechdochal representation," a mode that "establishes an absolute continuity between meaningful facts and their eternal values."[4]

Like nature, the sleeping child symbolizes the unfallen and fallen self at once, and more important the Divine Idea as the nexus between the two. "The mind . . . looking abroad into nature finds that in its own nature it has been fathoming nature, and that nature itself is but the greater mirror in which he beholds his own present and his own past being . . . while he feels the necessity of that one great Being . . ." (*BL* lxxxi; quoted from *Philosophical Lectures*). The "reality" of any

human work must reveal Christ's promise of redemption and immortality conveyed not merely *in connection with* figures, as in allegory, but through them directly, as living persons display feelings and attitudes in their physical demeanor. When idea and form originate separately, the monumental figure is what Coleridge would call an object "as an *object*"—not living (experienced) form at all, but "dead, fixed, incapable in itself of any action, and necessarily finite" (*BL* 1: 279). Of course, belief in the power of the symbol depends on a strong conviction of the power of general ideas such as "the ends of life," ideas working in the world through persons and things alike. The monument must be more or less talismanic; otherwise it and its subject can be neither identical nor coeval: the subject precedes the monument, the signified the sign. Chantrey's symbolic monument evidenced to Coleridge a tendency away from the popularity of "allegorical figures on monuments and elsewhere." The same point was made in an 1820 *Blackwood's* article that characterized Chantrey's work as marking "the return of English sculpture from the foreign artificial and allegorical style, to its natural and original character—from cold and conceited fiction to tender and elevated truth."[5] Perhaps that writer saw in this depiction an emblem of its mode of representation; both subject and language are "natural and original."

"Tender and elevated truth" describes the symbolic realism of "The Sleeping Children," whose figures were famous at the time for being extremely true to life, presented, like Scheemakers's, as real people in a believable situation. They imparted a noble meaning or truth without resorting to allegory's "cold and conceited fiction." (In fact, Chantrey incorporates a traditional emblematic motif, the broken flower, symbolically into the scene itself rather than allegorically applying it to the monument's base.) Coleridge affirms that this living aspect marked many modern sculptured forms: "thoughts, emotions and images of profounder interest and more exalted dignity, as motherly, sisterly, and brotherly love, piety, devotion, the divine become human." (261). More than remembering the end of two lives, the Robinson memorial expresses the "ends" or purposes of life mutely through its figures, answering the concept of the portrait/ideal enunciated earlier in the *Statesman's Manual*. Like Biblical personages, they have "a two-fold significance, a past and a future, a temporary and a perpetual, a particular and a universal application."

First displayed at the Royal Academy in 1817, "The Sleeping Children" may be the most acclaimed English sculpture ever.[6] It attracted much notice, including verses by William Lisle Bowles. Felicia Hemans called it "one of the most affecting works of art ever executed."[7] Some responses, like one submitted to the *Annals of Fine Arts* of 1817,

focused on its grimmer aspects: "Cold—Cold—and silent as this icy stone!" (1: 294). But Hemans, like Coleridge, read the figures not as mere memorial images of Mrs. Robinson's children, but as living symbols: "fair images of sleep,/ Hallow'd, and soft, and deep" ("The Sculptured Children"). The mother in her "voiceless home," as well perhaps as the poet's reader, might hear from the forms' "calm profound/ A still small voice, a sound/ Of hope, forbidding that lone heart to sink!"

Schelling called the visual arts "mute poetry" not because they are silent but because their ideas are not verbally enunciated. Like poetry with its "spiritual thoughts," painting or sculpture "should express ideas whose source is the soul, not, however, by means of speech, but, *like silent nature,* by configuration, by form, by sensuous works which are independent of it" (emphasis added).[8] Coleridge's "Of Poesy or Art" offers its own version of these remarks: the fine arts convey their ideas "not by means of articulate speech, but as nature or the divine art does, by form, color, magnitude, proportion, or by sound, that is, silently or musically" (255). Like Schelling, Coleridge wanted to identify the basis of the fine arts as forms in nature, a language not "articulate." That poets were eager to reimagine Chantrey's work would have evidenced its presence as living, or experienced, form, expressive despite its apparent silence.

COLERIDGE'S SLEEPING CHILDREN

An appendix to the *Statesman's Manual* explores the language of symbolic forms in a "figurative" interpretation of people and events in the Bible, a text recommended as the "end and center of our reading and meditation" (*SM* 70). Reviewing Coleridge's book Hazlitt singled out this part to illustrate its author's "laborious foolery." He assailed Coleridge on specific political and theological grounds, but was most critical of his mode of thinking, the way he went from idea to idea, from image to image. "Clouds do not shift their places more rapidly, dreams do not drive one another out more unaccountably, than Mr. Coleridge's reasonings try in vain to 'chase his fancy's rolling speed'" (*Works* 16: 100). It is the imagination's rolling speed, however, that is generated by what Hazlitt called the informing principle present in certain perceived forms.

Recalling passages earlier cited in this study reminds us that Hazlitt's informing principle is merely a principle of suggestion. Poetry "represents forms chiefly as they suggest other forms"; poetry "suggests what exists outside of it[self]." Hazlitt was no transcendentalist; his way

of reading forms was metaphoric, not symbolic. For Coleridge, forms symbolically *contained* other forms and other meanings. In the Bible Time is "a symbol of Eternity" because past and future are "virtually contained" in the present.

In the *Statesman's Manual* we can see how forms are naturally (spiritually) embodied within other forms. Coleridge begins by observing "before" him a "flowery meadow." The evinced feeling calls up a "similar" one, along with an imagined, not viewed, scene: "when we gaze at a beautiful infant that has fed itself asleep at its mother's bosom, and smiles in its strange dream of obscure yet happy sensations."

> The same tender and genial pleasure takes possession of me, and this pleasure is checked and drawn inward by the like aching melancholy, by the same whispered remonstrance, and made restless by a similar impulse of aspiration. It seems as if the soul said to herself: from this state hast *thou* fallen! Such shouldst thou still become, thy Self all permeable to a holier power! thy Self at once hidden and glorified by its own transparency, as the accidental and dividuous in this quiet and harmonious object is subjected to the life and light of nature which shines in it, even as the transmitted power, love and wisdom, of God over all fills, and shines through, nature! . . .
>
> But further, and with particular reference to that undivided Reason . . . I seem to myself to behold in the quiet objects, on which I am gazing, more than an arbitrary illustration, more than a mere *simile,* the work of my own Fancy! I feel an awe, as if there were before my eyes the same Power, as that of the REASON—the same Power in a lower dignity, and therefore a symbol established in the truth of things. (71–72)

Gazing with spiritual needs on a natural, living scene evokes first nostalgia, then a sense of capability, with respect to that simpler, more natural world. To us, nature's language of silent forms seems effortless expression like an infant's smile. Seeing that, we both regret the loss of such power and grasp the personal possibility of regaining it.

Coleridge's method was to interpret symbolically natural *beheld* forms (on which his eye was "now reposing") by allowing the scene to become, "figuratively" or suppositionally, some envisaged human form, a child. Thus transfigured, it stands for what one of the 1811–12 lectures referred to as our "moral being," showing us and driving us toward "what we might be hereafter" (*LOL* 1: 279). These feelings are also evoked, however, about the symbolic language thus created: totally expressive and unpremeditated signs, which Coleridge finds in the mute, eloquent figure. When gazing at things in nature we seem to be "seeking, as it were *asking,* a symbolical language for something within . . . that already and forever exists . . . a forgotten or hidden

Truth of my inner Nature" (CN 2: 2546). By his symbolic reading, he makes himself—the self now writing—*into* a symbol, a transparent object, a sleeping, smiling infant, mysterious but readable, and "permeable" by truth; he then sees the world filled with such figural transparencies. He manifests his ideas through the presented self, as divine light does through natural objects. That light is the "transmitted power, love and wisdom, of God." The object that transmits it also provides the form by which it is known. As he declared at the end of the *Statesman's Manual,* the Idea, the God-like within us whose symbol is light returns to its parent mind "enriched with a thousand forms, itself above form and still remaining in its own simplicity and identity!" (50). He would later use the example of a pure crystal "lost in the light, which yet it *contains, embodies, and gives a shape to*" (emphasis added).[9] Thus form is only known by the light it transmits and the light by the form that transmits it.

Coleridge explicitly develops the symbol of the child-figure as religious *ideal.* But he also makes it an effigy or *portrait* of his own lost or dead self. Poems like "Frost at Midnight" show those traces of nature leading back not only to childhood, but to the child as the figure or image of perfect expression. "An under consciousness of a sinful nature" is indicated in all Christian literature, he says in a lecture on Milton, "a fleeting away of external things."[10] The Fall, repeated most recently with modern empiricism and sensation psychology, was caused by a desire to know general, even ultimate, truths by the sensuous and cognitive appropriation of natural, external objects; the punishment has been, for the Christian, this sense of sin, symbolized by the loss of Eden. Therefore, recognizing the object merely as object (meadow as meadow) is a necessary spiritual act expressing one's sinfulness, as is the subsequent spiritualization of the object through an infusion of idea (a self-consciousness, a listening to oneself, as was not done in Eden). The "symbol" conveys the "*want*" of, the desire for, "that absolute Union, which the soul sensible of its imperfection in itself, of its *Halfness,* yearns after . . ." (CN III, 3325).

The Romantic conception of symbolic form was much influenced by a fascination with figures sculpted by ancient Greeks who, wrote Hegel, conceived the "astounding project of making Spirit imagine itself in an exclusively material medium."[11] It was no coincidence that the motionless person often served Coleridge as an example of both the symbolic and the monumental. One of his 1812 Lectures on Drama saw the transparent figure as a feature of the poetry of the ancient Greeks, but also of their Statuary, where "The Perfection of Form is an outward Symbol of inward Perfection, and the most elevated Ideas—where the Body is wholly penetrated by the Soul, & spiritualized even to a state of Glory—

Like a perfectly transparent Body, the matter in its own nature darkness becomes . . . a vehicle & fixture of Light . . ." (*LOL* 1: 457).

This is a rephrasing of Schlegel, who had maintained that in antique sculpture "the perfection of form is merely a symbol of mental perfection and the loftiest moral ideas, and where the body is wholly pervaded by soul, and spiritualized even to a glorious transfiguration" (*Lectures* 148). Coleridge's own contribution, giving these thoughts a definitely religious cast, is the theme of holy transparency. Both Schlegel and Coleridge reflect the romantic concept of aesthetic "expression" which, according to Guy Sircello, involved "the picture of something inside coming out" (5). As I have noted, the model for this idea is physiognomic expression, in which the inner soul, mind, feeling, or attitude is displayed by the body's exterior. Physiognomic expression, never divorced from act, is therefore always a part of what it is a sign *of*. A frown is the act of frowning and a sign of present displeasure. But as I have also shown, the idea of expression the Romantics developed was really that of the independent aesthetic form as a sign *for* certain ideas while still being a sign *of* some inner state. Schlegel's version uses sculpture as the model for "perfection of form," a "symbol of mental perfection and the loftiest moral ideas." From 1812 Coleridge's model for symbolic form was the "spiritualized" living body, the "vehicle & fixture of Light." Chantrey's memorial sculpture of the two children depicted for him just such a spiritualization.

SYMBOLIC EXPRESSION AND THE ANTIQUE FORM

If, as Hegel and many others thought, man's own body is that natural "fusion of significance and form" sought in vain by the symbolists,[12] its carved or molded image in Greek art came as near as artifice could to the symbolic ideal. Unlike those earlier Egyptian and Indian figures that reflected man's shadowy groping after truth, the poised Greek sculpture was expressively self-sufficient, "adequate" as language: "the inward and the outward . . . are no longer distinct. . . . The manifesting and the manifested are resolved into a concrete unity."[13]

Winckelmann's writings on classical sculpture have been credited with inspiring these theories of the symbol. One disciple, Friedrich Creuzer, called the symbol a "child of sculpture."[14] If it was, one may say that the modern idea of what Coleridge, referring to the Chantrey monument, called "symbolical expression" was born in Winckelmann's meditations on a mode of art that sought to suppress the expression of passion in favor of this higher language of the body at rest, a language that *embodied* "spiritual ideas."[15]

It became a convention to observe that the Greeks *saw* things steadily and saw them whole. The renowned aesthetic unity of the classical work was thought to be less a matter of style and design than of natural perception. Return to Greece's childhood, Herder cried, when dramatists expressed a "simple whole" without "the least labour or art": "the artificiality of their rules was—not artifice at all! it was Nature!"[16] Many in Herder's time ascribed the consummate form of Greek sculptural and literary monuments to the intimacy of history's "children" with forms in nature. Viewing the "Greek city" of Pompeii and its airy, light temples open to the sky, Shelley concluded that the residents must have "lived in a perpetual commerce with external nature and nourished themselves on the spirit of its forms." Nothing else could explain the natural-seeming harmony, unity, and perfection of Greek poetry (*Letters* 2: 74). The same point—the elements of beautiful form were a natural part of Greek perception—was made by Hazlitt in the Schlegel lecture. At home in nature, the Greeks expressed a natural unity in their art. All they needed for a unified representation in their art was to set down a simple and accurate record of an impression. This way they could give "the same coherence and consistency to the different parts of a story, as to the different limbs of a statue" (*Works* 6: 350–1).

Thus the Greek statue exemplified the perfect symbolic form. While acknowledging this achievement, however, Romantics tried to show that the visualized or imagined figure—the character in dramatic or poetic literature—incarnated more of the true interior self with all its contradictions. The spirit, soul, or consciousness, "the actuality of self-aware subjectivity in the knowing and willing of itself,"[17] had to find another, more versatile language of forms. The sense of simple joy and self-satisfaction found in the countenances and attitudes of the old stone gods and goddesses would always be missing from the modern arts, for the modern spirit was destined to be marked by regret, yearning, and above all a sense of spiritual inadequacy and of the expressive inadequacy of all language. Whereas the antique artist's perception attained "an original and unconscious unity" of content and form, wrote A. W. Schlegel, modern expression must "struggle to unite" the two; by means of the searching *imagination* the soul must try to convey its "forebodings, or indescribable intuitions of infinity, in types and symbols borrowed from the visible world" (*Lectures* 27).

The modern mind creates its own unity by combining kindred impressions into integrated forms such as paintings or poetry rather than by employing homogenous ones like sculpture. With poetry, the reader's (or writer's) imagination can modify one image by preceding or following ones, achieving the effect of "combining many circum-

stances into one moment of thought to produce that ultimate end of human Thought, and human Feeling, Unity . . ." (Coleridge, *LOL* 1: 68). This power of imaginative coalescence is the counterpart of the ancient's natural, unified perception. It is what Shakespeare and Raphael had but Sophocles and Praxiteles did not need or want. It is also the effort of the viewer or reader when discovering a work's form by mentally uniting all its elements, or by contemplating, as Schlegel and Hazlitt do, "hidden" interart analogies in an earlier age to disclose its principle of unity.

The ancient's natural, unlearned achievement of expressive, integral form was thought to inspire in modern artists or poets a great cultural envy, or at least admiration. Friedrich Schiller's "On Naive and Sentimental Poetry,"[18] of which Coleridge's sleeping child passage in the *Statesman's Manual* is clearly a poetic elaboration, opens by declaring that as "sentimental" viewers, either in the countryside or before "the monuments of ancient times," we "dedicate a kind of love and tender respect" to the things of simple nature. "*They are what we were;* they are *what we should once again become.* We were nature just as they, and our culture, by means of reason and freedom, should lead us back to nature. They are, therefore, not only the representation of our lost childhood, which eternally remains most dear to us, so that they fill us with a certain melancholy. But they are also representations of our highest fulfilment in the ideal, thus evoking in us a sublime tenderness" (181).

As with forms in nature, we regard the artifacts of those Grecian "children" the way we remember our own childhood, that is with a moralized nostalgia for what they symbolize: creativity, spontaneity, unity of being, and existence in accordance with one's own laws (180–1). They are naturally expressive; we are not. And their form signifies their perfection. We have lost more than the moral innocence represented; gone is the power of a certain type of representation itself, the power of making known either concepts or the impressions of things directly and concretely. Thus as sentimental viewers or readers we regard an early artifact as we might an effigy—as either recording something passed away and silent or as symbolizing something always present and mutely eloquent. Its first identity and mode of "representation" fills us with melancholy, the second with sublime tenderness. Absence is obscured by presence, a past signification supplanted by a present one.

Like Coleridge's meadow/infant, Schiller's image of formal simplicity functions both to depict the past and to stand for the future, what has been lost and what might be attained. Therefore in the passage, "representation" *(Darstellung)* has a slightly but crucially different

meaning in its two occurrences. A consciously sentimental viewing converts a memorial image of what was ("what we were") into an image of the ideal operative thenceforward. This interpretive process reempowers the work as text and the viewer or reader as interpreter of form. A "sentimental" meditation on monuments elegizes them by embodying the viewer's "living" feeling of regret or loss.

"Naive" thinking, writes Schiller, necessarily produces "naive expression in word as well as gesture." School children, however, are taught to abandon their plain and direct "customary expressions" in favor of an idiom of the Understanding, in which the relation of signs to things is that of reference; "the sign remains forever heterogeneous and alien to the thing signified." Only genius captures something of the lost grace of the child. It "expresses itself in its works of the spirit[;] its innocence of heart is expressed in its social intercourse." Genius

> delineates its own thoughts at a single felicitous stroke of the brush with an eternally determined, firm, and yet absolutely free outline. . . . [It] springs as by some inner necessity out of thought, and is so at one with it that even beneath the corporeal frame the spirit appears as if laid bare. It is precisely this mode of expression in which the sign disappears completely in the thing signified, and in which language, while giving expression to a thought, yet leaves it exposed (whereas the other mode cannot represent it without simultaneously concealing it). . . . (187)

Painted or sculpted figures are at one with things, but the language of poetic genius, like the child's "naive" use of "word" and "gesture," is "at one with thought," employing signs seen simultaneously both as themselves (forms) and as what they represent (thoughts): as both "corporeal frame" and "spirit." The idiom of the painted figure merely replicates its subject's own corporeal frame; poetry's (Schiller's) figurative language lays bare its spirit (as Shelley says that poetry "lays bare the naked and sleeping beauty which is the spirit of [the world's] forms"). A figurative (or tropic), though still arbitrary, idiom of literary expression, it "delineates its own thoughts" (as, again, Shelley was to say that poetry "has relation to thoughts alone").

The poignant nostalgia of Schiller's sentimental viewer of natural objects or early monuments is for this lost adequacy of expression. Unlike children, we cannot ourselves (with our bodies) be symbolic forms, but must create or discover them. Schiller does this by verbally picturing. He begins by grasping the essence of early monument or natural form, then transforms it into a direct, symbolic language, as Coleridge would in his version of this part of Schiller's essay. "Our childhood is the only undisfigured nature that we still encounter in

civilised mankind, hence it is no wonder if every trace of the nature outside us leads us back to our childhood." Because we cannot "be nature," we seek an undisfigured "lost nature," including an adequate figurative idiom (190, 191), which, like an image of a child or "artifact of remote antiquity" affords us "a retrospective view of ourselves" and what is now unnatural in us. That is how such representation can be at once what we were and what we can be, and how it can be two different sorts of signs at once. "The child is . . . a lively representation to us of the ideal, not indeed as it is fulfilled, but as it is enjoined" (180, 182).

Observing a centuries-old iconologic tradition,[19] eighteenth-century writers on language described the "natural" language of imitated forms—sculpted or painted figures, for example—as constituting a *necessary* near identity of meaning and sign and of idea and thing. "Among the different Kinds of Representation," observed Addison, "*Statuary* is the most natural, and shews us something *likest* the object that is represented."[20] Writing or speaking is an "arbitrary" idiom, using signs consciously adopted to represent ideas of things. The "imperfection of words," Locke had maintained, is "the doubtfulness of their signification," since the sounds they employ "have no natural connection with our ideas, but have all their signification from the arbitrary imposition of men." Therefore they constitute a language whose meaning "must be learned and retained."[21] (Frankenstein's creature, spying on the cottagers, is "baffled" by their words and "the mystery of their reference." He must work to learn this arbitrary language.)

Romantic critics asked how it is that poetic expression can consist of something like natural correspondences when most verbal language is an arbitrary medium. The most common answer was its kinship with both painting and music. As Lessing and Mendelssohn had argued, poetic metaphor offered "the possibility of a *formal naturalness* in signification,"[22] as did painting. It presents its objects "as it were, visibly before the soul; that is, it gathers together as many characteristics as it needs to make the impression all at once, to lead the object before the eyes of the imagination. . . ."

Because consciousness is not a thing but an activity and a sequence of moments, it is poetry's musical, not its pictorial aspect that best captures it. Hazlitt described music as "*answering to* the music of the mind" (*Works* 5: 12; emphasis added). Though "arbitrarily produced by the imagination," wrote Shelley, poetry is a "direct representation"—not of things, but of thoughts ("Defence" 483). Paradoxically, despite sculpture's strong gallery or courtyard presence, for Coleridge it usually had little presence within the imagination. Its "mental

expression" is circumscribed "to the ideas of power and grandeur only" ("On Poesy or Art" 260)—circumscribed, that is, to what is externally monumental, theatrically impressive—its outward aspect. Lacking this material presence, music addresses the memory with the intuition of something absent; it is thus "a proof . . . that man is designed for a higher state of existence" (261). Therefore it invokes and expresses, is a natural language for, a highly present *feeling*. In intensely felt situations, the Spirit actively seeks in nature "every where/ Echo and mirror . . . of itself" (as it does at the beginning of "Frost at Midnight"). With nature as its "reflex," the imagination contemplates itself in "symbolic forms."

What, finally, is the connection between the language of nature and the (arbitrary) language of literary symbols? Addison and Locke's "natural" language—painting and sculpture—is natural only in that it effectively reproduces or copies real objects. For Coleridge, nature's own language of symbolic forms—like music or the highest language of poetry—is expressive, not mimetic. "The mind of man in its own primary and constituent forms represents the laws of nature" (*SM* 79). Therefore, any language for the constituent forms of the mind is itself natural. Perhaps through familiarity with Coleridge's remarks, Shelley was to argue much the same thing. The forms that any true expression takes are "distinct from that of the objects and the impressions represented by them, all expression being subject to the laws of that from which it proceeds" (see chapter 2). Expression is not of objects to be represented, but of forms within the mind. For Coleridge, symbolic expression is more natural than, say, a direct description or depiction of a swallow or a cliff because man's mind and its constituent forms represent the *laws* of nature. Thus the dramatic poet like "Our myriad-minded Shakespeare," one whose characters and works result from a "process of self-transformation," is a "genuine naturalist," as the natural forms in or of the mind are transformed to those in the plays (*SM* 79).

Coleridge's meadow/infant passage, which precedes these remarks, is such a recreation of the mind's "primary and constituent forms." While the language of poetry, like all discourse, is arbitrary in its designation of things, it approaches a natural resemblance to what it essentially *stands for:* thoughts and feelings. It is therefore not only a mode of representation but what Schiller calls a "mode of expression." Hegel described the symbol as "no purely arbitrary sign, but a sign which in its externality comprises in itself and at the same time the content of the idea which it brings into appearance."[23] That is why for Coleridge a flowery meadow envisaged as a sleeping child is "more than a mere simile," more than an "arbitrary illustration"; as a speak-

ing figure or true symbol, it is as naturally expressive as the child's smile. A landscape might be compared to a figure of a sleeping child. As they merge, however, the figure becomes conspicuous as sign, and the viewer feels a sacred "awe" at his own and nature's personifying power. To see nature as "the poetry of all human nature, to read it . . . in a figurative sense, and to find therein correspondencies and symbols of the spiritual world" (70) is to read it also in a figural sense: to see personification as the very essence of trope. The hermeneutic project of interpretive reconstruction and commentary is only necessary because of our own blindness to the Bible's natural language and to nature's. Coleridge would have thought of that "beautiful infant" in his metaphor, or the ones in Chantrey's work, as more expressive, more accessible to modern readers, than the figures of adult male and female bodies seen in museums.

Michael North observes, "Because it is so easily stripped of explanations, the statue is a convenient example of nonreferential art, of language halted and therefore preserved."[24] Like any living form, it achieves its identity in one sense—what it is—by being an identity of sign and signified. Likewise, the sleeping infant cannot mean anything but itself; therefore, it is wholly itself. But for adults there is something dead in such a signifying body. In fact, it is our "struggle" to achieve adequate expression that constitutes our spiritual life, and we use articulate speech to carry on the struggle. "The seeming Identity of Body and Mind in Infants, and thence the loveliness of the former—the commencing separation in Boyhood—the *struggle* of equilibrium in youth—from thence onward the Body first indifferent, then demanding the translucency of the mind not to be worse than indifferent . . ." (*LOL* 2: 224). In other words, like any symbolic language the infant's body is a sign containing and therefore perfectly expressing its meaning without speech. With speech the adult seeks a translucency, the power of adequately expressing "ideas" that have their origins and being beyond the individual consciousness—words which, like symbols, are the translucence of the eternal "in and through the temporal."

If, as it has been argued, the Enlightenment "desacralized" language by making signs "entirely external to the ideas they represent,"[25] Coleridge is really attempting to resacralize the linguistic sign. The modern mind (or the adult mind) strives for self-expression, hopelessly pursuing embodiment in adequate forms, representations not only of our particular selves but of "our highest fulfilment in the ideal" (that is, our selves as idealized). "Frost at Midnight" dramatizes a contrast between

the distinctly recognized sleeping form of the infant and the fluttering "stranger," a "companionable form" for the speaking poet. The child belongs to the world of nature, one of those

> lovely shapes and sounds intelligible
> Of that eternal language which thy God
> Utters, who from eternity doth teach
> Himself in all, and all things in himself.
> Great universal Teacher! He shall mould
> Thy spirit, and by giving, make it ask.

The inquiring spirit searches for, among other things, form: a molding of itself. The distinct form may express the object of the yearning, but only the indistinct gazing form can express the searching or the searcher.

Perfect classic forms, by contrast, express no power of self-knowledge. Like sculptors of the time, the ancient poets were victorious "in the simplicity of forms and in whatever is sensuously representable and *corporeal*. The modern, however, can leave them behind in richness of material in whatever is insusceptible of representation and ineffable, in a word, in whatever in the work is called *spirit*" (Schiller 195). The ancients had discovered an idiom wholly adequate only to what was susceptible of representation. Thus the graceful poise of the antique form must no longer be sought, nor the simple joy of its spirit. Although Winckelmann had claimed that the "true character of the soul" is revealed when the figure is in "the state of rest,"[26] most Romantics believed it to be manifested only in its passions and its exigencies. The soul rests only in death or sleep. Even the Grecophile Pater in his essay on Winckelmann was to allow that while man's idea of himself was first perfectly embodied in sculpture, it was the arts that predominated in later times, those of music and painting (and presumably poetry) that showed human experience as living and active.[27]

No wholly defined or known figure, however, can be a vehicle and fixture of light. Coleridge concurred with Wordsworth's opinion that Greek and Roman "anthropomorphitism" led to a "bondage of definite form" in their sculpted figures, excluding them from the "grand store-houses of enthusiastic and meditative Imagination" (*Prose* 3: 34). This was a common view at the time. Schiller wrote that the ancients were clearly superior to the moderns in sculpture but not poetry: "a work addressed to the eye can achieve perfection only in finitude; a work addressed to the imagination can achieve it also through the infinite" (195). In the same vein Coleridge defined the Ancient as "whatever is capable of being definitely conveyed by

defined Forms or Thoughts" and the Modern as the "indefinite as the vehicle of the Infinite—hence more to the Passions, the Obscure Hopes & Fears—the wandring thro' infinite—grander moral Feelings—more august conception of man as man—the Future rather than the Present—Sublimity—" (*LOL* 1: 492–3). The Greeks were satisfied by the "complacency and completion" of statues in which divinities were "placed before them . . . shaped . . . and presented." Such achievements, however, must always distance themselves from us. The natural environment gave the northern European's mind "a tendency to the infinite, so that he found rest in that which presented no end, and derived satisfaction from that which was indistinct." In a Homeric epic ("a poem perfect in its form") the descriptions "are pictures brought vividly before you, and as far as the eye and understanding are concerned, I am indeed gratified. But if I wish my feelings to be affected . . . if I wish to melt into sentiment and tenderness, I must turn to the heroic songs of the Goths . . ." (*LOL* 2: 79–80).

Thus the attention to visible form in classic art gave it too strong a position in the phenomenal realm, too weak in the phenomenological. Classic poems or statues are "present" as objects alone—before the eyes theatrically, like figures on a stage, but they have no living presence to our consciousness, as figures in a poem or play we are reading. In a note to his Oxford prize essay on the visual arts, Henry Hart Milman remarked that painting, and any post-classical art, impels the spectator "irresistibly . . . to meditate on what is dark and mysterious; on eternity, on the nature of his own soul, on an omnipresent and incomprehensible God."[28] The figure in modern painting or poetry is undefined, unfixed, mobile—"shadowy." The distinct Grecian form cannot engage our imaginations this way because in its "positive and determinate outline" the imagination is "fully gratified."

For a century or more, sculpture had been deemed an intellectual art of outline: distinct bodies standing for clear ideas; painting was an art whose figures depicted and recalled lived experience. On this subject the painter Benjamin Haydon wrote of the Elgin Marbles (most of which were nearly featureless or even headless) that form was an aspect of the body, which "can only express action or repose. . . . When it must show the refinement of passion how little can it do without the features."[29] By contrast, "the end of painting is to express the feelings of men." Note that Haydon uses "express" here differently in the two instances. The sculptor embodies the ideas of physical action and repose by representing what he has seen; the painter communicates inner experience: "feelings." Although physically a sculpted figure, having volume, mass, and weight, resembles the human form more closely that a painted one, expression in any sense except what might

be called semiotic was deemed inappropriate to it, as Lessing had argued. An essay in Leigh Hunt's *The Reflector* spoke of the "frigid monotony of the Grecian cast."[30] P. F. Tyler and Archibald Alison's popular *Travels in France* described sculpture as "an abstraction of character" and painting as "expressive of the living form" in imitating "all the fleeting changes which constitute the signs of present emotion" (1:137–9). The sculpted figure is "cold, pale, and lifeless marble," the fire of its gaze "quenched in the stillness of the tomb." Sculpture could incarnate spirit, idea, and character; painting could both depict and incarnate life, emotion, and activity.

Thus Coleridge's "On Poesy or Art" contends that any imitation of antique sculpture, unlike the Chantrey work, "speaks in a language, as it were, learned and dead, the tones of which, being unfamiliar, leave the common spectator cold and unimpressed" (261). The difference between Coleridge's passage and its source is most revealing. Antique marbles "leave you yet colder" than the works of nature, Schelling had written in "The Relation of the Plastic Arts to Nature," "if you do not bring to bear upon them the spiritual eye that penetrates their husk and feels the force at work within them" (327). Criticizing Winckelmann for thinking of form and spirit separately and for failing to "teach the manner in which forms can be generated from the idea" (327–8), Schelling maintained that forms in art are like those in nature. One must feel the "operative principle" within, or they are cold, hard, foreign to the mind: mere bodies in space. Even with ancient art one could see the idea in the form and "feel the power" of that generating idea. Coleridge would agree that this is possible with natural forms, and even poetic or dramatic ones, if, like Shakespeare, the writer "infuses a principle of life and organization into the naked fact" (see chapter 3). That informing principle, as Hazlitt called it, when deeply spiritual or psychological, is personal to each reader and experienced immediately. In poetry or the arts it is equivalent to *forma formans,* "the inward principle of whatever is requisite for the reality of a thing, *as existent*" (*The Friend* 1: 467n.). The thing as existent, the completed form, is *forma formata.*

The antique figure, though a strong presence as formed form, lacks, at least for the modern perceiver, the potent energy of the inner, forming form (similar to Shelley's *poiein*). In the first of his 1818 lectures on European literature Coleridge declared that whereas a Grecian form "excites a feeling of elevated beauty, and exalted notions of the human self," Gothic "impresses the beholder with a sense of self-annihilation; he becomes, as it were, a part of the work contemplated. An endless complexity and variety are united into one whole, the plan of which is not distinct from the execution" (*LOL* 2: 60). Whether one walks into York Minster, reads a Shakespeare play, or looks at history, one com-

prehends form by being a part of it, not by seeing it as a separate thing. Mechanic form is a contour in the mind and the "expression of "ideas," organic an experience of the mind, and the expression of "feelings" (260). With characteristic terseness Blake put it this way:

> Mathematic Form is Eternal in the Reasoning Memory. Living Form is Eternal Existence.
> Grecian is Mathematic Form
> Gothic is Living Form[31]

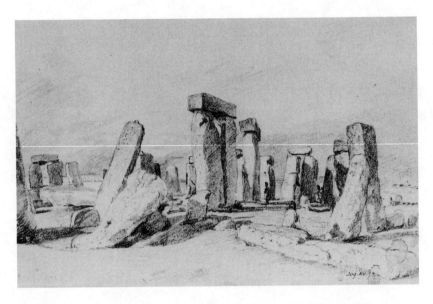

FIGURE 7. John Constable. Stonehenge, 1820. Photo: V&A Picture Library.

CHAPTER SIX

Wordsworth's Prelude: Objects that Endure

> In these my lonely wanderings I perceived
> What mighty objects do impress their forms
> To elevate our intellectual being. . . .
>
> —Wordsworth, *The Borderers*, Act IV

One of Wordsworth's "Itinerary Poems of 1833" is a sonnet on a monument in Wetheral Church, Corby, Cumberland. He had first viewed the sculpture in the studio of its eccentric creator, Joseph Nollekens. Proclaimed by Fuseli to be better than anything by Canova, the work honors Maria Howard, who died in childbirth at twenty-three. Wordsworth's own memorial opens by briefly describing the Nollekens figures: "Stretched on the dying Mother's lap, lies dead/ Her new-born Babe; dire ending of bright hope!" At first the work is painful in its rigid horizontality. But further notice records the mother's head raised heavenward to greet an angel, her hand reaching with "a touch so tender for the insensate Child." Ultimately, the poet's response is not lamentation for the mother but "reverence." And reverence also for Art, which, "triumphant over strife/ And pain, hath powers to Eternity endeared." Thus the sonnet turns on the difference between two kinds of memorial expression: as historical record, an image of death; as symbolic form, a mute embodiment of living truth.

THE IMAGINATION'S "MIGHTY OBJECTS"

The only solid objects that spoke to Coleridge symbolically were those he could convert immediately into mental pictures, turning them into virtual objects. For Wordsworth the symbol had to retain a strong sense of its original solidity or objecthood. For example, among the "types and symbols of Eternity" he encountered in the Alps, symbols of "first, and last, and midst, and without end," were the very rocks along the road, "Black drizzling crags that spake by the way-side/ As if a voice were in them (*Prelude* 6: 639–40, 631–2).[1] Those crags, present then and presumably still there, must be experienced by the reader in their absolute materiality in order that their ideal identities may also be experienced. Wordsworth was more interested in the significance of stone memorials than was Coleridge[2] and always much more interested in material monumentalism generally, in objects substantial and enduring, meaningful in the visual memory. Most often these were the impressive forms of nature. A little-known sonnet first published in 1817 ends with these lines:

> Grove, isle, with every shape of sky-built dome,
> Though clad in colours beautiful and pure,
> Find in the heart of man no natural home:
> The immortal Mind craves objects that endure:
> These cleave to it; from these it cannot roam,
> Nor they from it: their fellowship is secure.

("These words were utter'd in a pensive mood")

If natural shapes find no "natural home" in the human heart, which ones do? What are those "objects that endure," satisfying the immortal Mind? The 1815 Preface as well as some other poems in that collection indicate that these are not the shapes of nature but the forms of human expression—specifically, forms of the imagination. This, I believe, is made explicit in the Dedication to George Beaumont, where Wordsworth hopes that "this Work . . . may serve as a lasting memorial" of his friendship with the painter.

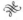

As he thought more about the endurance of poetic forms, Wordsworth had altered his idea of artistic expression, which for him had come to be less an outpouring than a making, like Coleridge's *forma formans* or like Shelley's *poiein*, by which "the imagination is expressed upon its forms." In the 1802 Preface, poetry is a spontaneous overflow of powerful emotions, the poet someone with "greater readiness and

power" than most men "in expressing what he thinks and feels" (*Prose* 1: 138). The 1815 Preface, really an essay on the poetic imagination, emphasizes concepts more than feelings or emotions, concepts that are first made visual to the inner eye by the intermediary, the form-making power, the imagination, then embodied in some medium. The poet's "spiritual attributes body forth what his pen is prompt in turning to shape." Thus the materials of poetry "are cast, by means of various moulds, into divers forms." (*Prose* 3: 30, 27).

Introducing "Poems of the Imagination" in the 1815 volumes, "The Boy of Winander"[3] shows a person acquiring this power of expression. The boy delights himself at first with "mimic hootings" that, unheard, have no permanence. Then the whole "visible scene" enters his mind at once as it might be "received into the bosom of the steady lake." Immortalizing the experience, the poet's public act of representation completes an imaginative process that begins with the boy's mimicry entering "unawares" into his mind. It continues with the emergence, before the "clear eye" of the poet's mind, of that scene together with a view of the graveyard where the boy is buried. It concludes with the poem itself, a "shape" given by the pen to what the imagination could "body forth" from what was "planted" there. (Wordsworth of course actually transplanted the passage in Book Five of *The Prelude*.) The 1815 Preface cited this poem as illustrating the "commutation and transfer of internal feelings, co-operating with external accidents, to plant, for immortality, images of sound and sight in the celestial soil of the Imagination" (1815 Preface; *Prose* 3: 35 n.). Without the imagination there can be no formal embodiment, no mighty object for "immortality." The subjects of poetic fame and influence were very much on Wordsworth's mind at this time, as is shown by his survey of later fortunes of the major English poets that occupies most of the 1815 Essay Supplementary.

Among the "Poems on the Naming of Places" in the 1815 edition is a relatively early one titled "To Joanna."[4] It tells how the poet, "like a Runic Priest, in characters/ Of formidable size, had chisell'd out" Joanna Hutchinson's name on an immense rock overlooking the Rotha, where the two had come during a walk in the summer of 1800. That rock, which had at first seemed a single impressive object, was disclosed as bearing a complex but unified, memorable scene, the surface of the "living stone" revealing a variety of stones, flowers, shrubs, and trees: "That intermixture of delicious hues/ Along so vast a surface, all at once,/ In one impression, by connecting force/ Of their own beauty, imaged in the heart." The inscriptions (first her name, then his poem) were in memory of that scene, of Wordsworth's astonished gaze, and of Joanna's response, an echoing laugh. The poem inscribes the visualized object as he himself had inscribed the real one.

"To Joanna" has all the features of Wordsworth's monumentalizing of "mighty objects" in *The Prelude* and elsewhere. The imagination takes a singular natural form, which, like a sculpted work, has its own unified impact, and incorporates it into a complex pictorial "image," offering a more highly elaborated, and therefore more lasting, unity of impression. The rock and its surroundings constitute a "scene" remembered and memorialized both for its unified aesthetic character (in this case "beauty") and for being the locale of a substantial human experience and thus connected with a human figure. To allude once again to the sonnet quoted at the outset of this chapter, the natural shapes alone have no "natural home" in a mind whose nature is immortal. They are "enduring objects" only when, coalescing with living human forms, they come to belong to the mind itself.

"ENDURING THINGS": *THE PRELUDE*

The Prelude's first two books depict the power over a child's mind of "high objects," "enduring things" (1: 409). In Book One especially, but in the poem generally, "object" has two significantly related meanings. First, as the book's beginning shows the poet's heart becoming attached to "rural objects" (2: 199), the word refers to (often) sizable natural forms—lakes, mountains, vales. But all the books also explore human aims or purposes: how they are formed and carried out. "Mean/ Our object and inglorious" (328–9), the poet says of his boyhood nest-robbing adventures. Thus "high objects" and "enduring things" are directly opposed to the "mean and vulgar works of man." Against the backdrop of sublime things the poet, beginning this autobiographical work, measures his own aims and works to that point in his life. Book One focuses on his own "determined aims" (115), but the poem will more and more concern the objects—both plans and accomplishments—of others. It will demonstrate how, historically, human design has been monumentalized in objective form.

The first few hundred lines show him casting about for some medium to "temperately deal forth/ The many feelings that oppressed [his] heart" (122–3). He contemplates various poetic forms in his desire to write "immortal verse" (232), a desire, we learn later, traceable to his university days, that he "might leave/ Some monument behind . . . which pure hearts/ Should reverence" (6: 55–7), and traceable also, perhaps, to thoughts of the immortals like Milton and Newton who passed through Cambridge and did leave such monuments. The poet may possess naturally a greater power of expressing his feelings, but how does he make them (and him) "immortal"? Of course from the outset readers of *The Prelude* are made cognizant that in one aspect the poem is the story of

a man writing a poem. But it is from Books Five and Six that the project is specifically framed in terms of creating an enduring object.

Like Coleridge and Shelley, Wordsworth sought a living form, a kind of poetic monument both expressing immediate feeling and embodying the maker's character forever. He poses the problem early in Book Five: although the mind has "powers to send abroad/ Her spirit," that spirit must lodge in books, frail "shrines" (5: 45–9). Even a volume of Shakespeare seems a "Poor earthly casket of immortal verse" (5: 164). As object, a "book" may bear the personal "image" of its creator (for example, on the frontispiece or title page or, metaphorically, throughout its contents), but Wordsworth seeks the true impression of creator's self-embodying power. The appropriate model for this kind of expression is given at the beginning of Book Five, just before the passages mentioned. As with Coleridge, it is the "speaking face" of nature, the "bodily image" through which the sovereign Intellect has diffused a "deathless spirit." The spirit—breath or *life*—is immortal because diffused throughout nature's enduring form, and therefore expressed forever. In the course of Book Five Wordsworth comes to think of books as language, and language itself as "power," embodied less in the (printed) book than in the (spoken) word. The "works" of man, therefore, even of men who sleep "nameless in their scattered graves," should be deemed "Powers,/ For ever to be hallowed; only less . . . Than nature's self, which is the breath of God,/ Or his pure Word by miracle revealed" (213–22).

In short, Books Five ("Books") and Six ("Cambridge and the Alps") are not just about volumes written, published, and read, but about the link memory makes between these and the language of nature. Like the *Statesman's Manual,* they offer a guide to the practice of reading both languages. As with nature, whatever is of lasting value in volumes held in our hands comes from the spirit or breath expressed in them, not from what they literally say or depict. J. Hillis Miller has argued that Wordsworth anticipates the modern "deconstruction of metaphysics" by putting in doubt the dichotomy between form and substance, language and meaning. In the poems "meaning is generated by the interplay of elements rather than by the copying of some pre-existing sense. Form itself constitutes meaning, in both senses of 'constitutes'" (298). However, using "Composed upon Westminster Bridge," Miller argues that Wordsworth not only declines to have his forms (in this case the sonnet and the language that constructs it) convey some external and antecedent meaning, he allows an "indeterminateness" to pervade the apparently meaning-creating form. The "boundless breath" blowing through these poetic forms remains an "undifferentiated wind" (310).

I would reply to this that in Wordsworth, as in Shelley and Coleridge, forms (and form) do convey meaning, but not an external and antecedent

one. The meaning, unarticulated but clearly meant to be *experienced*, is authorial presence and ultimate influence, an informing form that perpetually creates new forms. In a poem this undying energy is derived

> from the great Nature that exists in works
> Of mighty Poets. Visionary power
> Attends the motions of the viewless winds,
> Embodied in the mystery of words. (594–7)

Though lacking the physicality of monumental objects, words house "forms and substances," which, "circumfused" with a spiritual light, "present themselves as objects recognized/ In flashes, and with glory not their own." Thus they confer an emotive power to things they signify, and the things give form and substance to words and an incarnation to thought.

To embody their visionary power in the mystery of words poets can use the "speaking face" and "bodily image" of nature. *The Prelude*'s second half tells of discovering this countenance by looking on Man as "an object of delight, of pure imagination, of love" rather than of observation, logic, or speculation. Thus conceptualized, Man himself is among the "objects that endure," of "kindred permanence" to those in nature (13: 32, 37). *The Prelude*'s most visually memorable human forms—the discharged soldier, the girl with a pitcher on her head, the poet himself as a boy—are things that "stood most prominent" in his life, things whose depiction, the poem's conclusion states, might itself have succeeded in "building up a Work that shall endure" (14: 302–11).

However, neither the remembered form of man alone nor the remembered forms of inanimate nature alone—those that "impress their forms/ To elevate our intellectual being"—are sufficient as enduring objects. Images of both kinds must be "brought into conjunction" by the "conferring, the abstracting, and the modifying powers of the Imagination" (1815 Preface; *Prose* 3: 33). Like Coleridge, Wordsworth viewed the imagination as having the power of "modifying" things seen and/or remembered. Coleridge associated modification with the imagination in two ways. First, the imagination modified ideas into particular forms: mental shapes. The idea *homme generale*, for example, was not "an abstraction of observation" from a number of instances, but a substance "capable of endless modifications" (*LOL* 2: 148). This is the "philosophical" use of the term as defined by the *OED*: "The bringing of a thing into a particular mode of existence, determination of a substance into a particular mode or modes of being." This concept, so important to Coleridge, does not seem to have been the one adopted by Wordsworth.

A second meaning of "modification," however, is—again to quote the *OED*—"the action of making changes in an object without altering its

essential nature or character": in other words, reshaping or *trans*forming. Thus for Coleridge, imagination is the "power of modifying one image or feeling by the precedent or following ones" (*LOL* 1: 68). This underlay his idea of unity of feeling or impression in the Shakespeare lectures. For Wordsworth, our imaginations conjoin *remembered* images so that they "modify each other": one image "is endowed with something of the power of life," the other is "stripped of something of its vital qualities" (1815 Preface; *Prose* 3: 33). The poet can achieve this common effect by juxtaposing images on the page: by analogy or otherwise. Wordsworth's well-known example in the Preface is taken from "Resolution and Independence." The old leech-gatherer is visually compared to a "huge stone" atop an "eminence," and that in turn to a sea-beast sunning itself on a shelf of rock or sand. The result is the "intermediate image," something between rock and living thing. In "The Thorn," one of the "Poems of the Imagination" in editions from 1815, the tree "stands erect, and like a stone/ With lichens it is overgrown." These lichens as well as mosses threaten to "drag it to the ground" and "bury" it (20, 22), just as grief threatens to drag down the seated figure of Martha in her scarlet cloak (whom the narrator on first spotting mistakes for some rocky crag). This way the "forms" of objects, abstracted as *idea*-figures by visually associating them with other object-shapes, are "impressed" forever on the reader's mind. Wordsworth's note to the poem (dictated in 1843) declares the hope of making the tree by some invention "permanently an impressive object," as the storm made it to his own eyes in the Quantock Hills.[5] This he does by enfiguring it with poetic characters. The tree will only "stand" as a presence if it is made to stand for lived experience.

"Processions," one of the "Memorials of a Tour on the Continent, 1820,"[6] shows the co-operating functions of the memory and the imagination in creating monumental, or permanently impressive, imaginative forms. "That the past might have its true intents/ Feelingly told by living monuments," man has devised "Rites such as yet Persepolis presents/ Graven on her cankered walls, solemnities/ That moved in long array before admiring eyes." After briefly describing various sacred processions of the past, the poet dwells at length on a Christian pageant he remembers seeing in the Vale of Chamounix of hooded figures carrying aloft the Cross. That vision "haunts" him "as it met our eyes!/ Still, with those white-robed Shapes—a living Stream,/ The glacier pillars join in solemn guise/ For the same service, by mysterious ties. . . ." A note recalls "the Glacier-columns, whose sisterly resemblance to the *moving* Figures gave it a most beautiful and moving peculiarity." The ice columns and the column of figures merge in one lasting, and living, unified impression, memorializing both the historical persistence of man's faith and Wordsworth's Alpine experience.[7]

In such remembered moments the mind merges as forms what Wordsworth tends to call "sensations," objects and events visually registered. The construction of such impressive images throughout *The Prelude* results in monumentalizing and honoring the human frame as well as animating natural objects. The intermediate image also enables the reader to see one key form in the work in terms of another, while endowing both with a sense of living monumentality. In Book One's rowboat-stealing episode, the mountain peak "Like a living thing/ Strode after" the frightened young thief. From that time on, "huge and mighty forms, that do not live/ Like living men, moved slowly through the mind/ By day, and were a trouble to my dreams" (1: 398–400). These presences that haunt the poem are often intermediate images, a status suggested by the polysemous word "forms." They represent the "impersonating power," as Wordsworth calls it in a rejected draft, "The faculty that gives sense, motion, will" (*Prelude* 502).

At the end of Book Four Wordsworth recalls coming upon an "uncouth shape" one night on a lonely road. Like the "grim shape" of the mountain in the earlier episode, one "growing in stature" as it is watched, this human "ghastly figure" is "of stature tall." Then in London (7: 639–49) he comes upon a blind beggar with "upright" and "steadfast" face, recalling the soldier's "upright" posture and "awful steadiness" and maybe also the reproving mountain's "upreared" head. Both beggar and soldier when encountered are physically connected with some stone object, the soldier "propped" by a mile-stone, the beggar "propped against a wall." Both therefore recall for us Michael and the stone sheepfold he is building as well as the Cumberland beggar seated "on a low structure of rude masonry." The stone-works serve to make more statuesque the at-first motionless figures, but they also visually recall other, natural, stone forms in the poem. In the third of the River Duddon sonnets, Wordsworth pictures himself seated on "this naked stone" to paint the river for the reader. The image is not a sculpted stone man, but like the other figures discussed, a stone-and-man. In such a pose he would be "Pleased could my verse, a speaking monument,/ Make to the eyes of men thy features known." One may regard both the sonnet and his own seated figure as speaking monuments to the Duddon, one an icon, the other an inscription. Because the icon provides a graphic form for the inscription, both are visualized and therefore essentially monumental.

Perhaps *The Prelude*'s most elaborate merging of human and inanimate forms to create the intermediate image, the picture before the mind's eye, involves the Chartreuse cross and the Shepherd. In his *Descriptive Sketches* (1793)[8] the Grande Chartreuse was a place not of religious quiet but of desolate silence, its inmates then being expelled by the armed might of the Republic. The scene is dominated by the sort of ghostly personifi-

cations that I shall discuss in the next chapter: "Ev'n now I sigh at hoary Chartreuse' doom/ Weeping beneath his chill of mountain gloom./ Where now is fled that Power whose frown severe/ Tam'd 'sober Reason' till she crouch'd in fear?" (53–6). The Chartreuse sections of *The Prelude* (6: 414–88) recall the *Sketches* but I believe do much more than that.

The focus is the same in the two poems: the desecration of a noble monumental building, of its religious atmosphere, and of its natural setting. Both passages mention crosses fixed, as if by angels, atop apparently inaccessible peaks near the monastery. The soldiers' weapons, the sword of Justice, and the purging fires of "new-born Liberty" are all emblems of the power of reason and of "sense" (458) in its several meanings. In *The Prelude,* however, the monastery and the cross are monumental symbols of "mystery" (451), specifically of the symbol itself, and of the mysterious power of the imagination to connect things seen when they are later remembered: "But oh! if Past and Future be the wings/ On whose support harmoniously conjoined/ Moves the great spirit of human knowledge, spare/ These courts of mystery. . . ." Quoting this passage, the 1815 Essay Supplementary affirms that good poetry survives because the People do. Poetry is "the embodied spirit of their knowledge, so far as it exists and moves, at the present, faithfully supported by its two wings . . ." (*Prose* 3: 84).

Chartreuse appears again in Book Eight (264–81), where the poet recalls himself as a boy feeling the presence of a shepherd "in his own domain." It is a man whose "form hath flashed upon" him, one who seemed "a solitary object and sublime,/ Above all height! like an aerial cross/ Stationed alone upon a spiry rock/ of the Chartreuse, for worship." This analogy could not have occurred to the boy Wordsworth; the connection is literary and anachronistic. *As* monumental form, a sublime and solitary object abstracted to its essential shape, this man became (perhaps consciously only after visiting Chartreuse, but intuitively at the time) "an index of delight,/ Of grace and honour, power and worthiness." "Index" here is an emblem or symbol: thus the image in his memory is monumental not merely in recording the past but in visually registering in the mind an idea as an "imaginative form." Through symbolic form man and cross are mysteriously conjoined in the *Sketches* and Books Six and Eight of *The Prelude* and both are "modified" in the way I have described.

Wordsworth memorializes human beings and inanimate objects by having them evoke each other both as living (mental) forms and as *objects* that endure. Linking themselves analogically, they literally create a continuous memory, defining themselves as monumental as they unify remembered time. When Wordsworth actually saw the Chartreuse aerial crosses they seemed in "the rage of one State-whirlwind, insecure," but they became secured in the memory by their imaginative association

with a human figure, the shepherd, which they did later in *The Prelude*'s composition. Wordsworth's shift from the dominantly allegorical mode in the *Sketches* scene to the emphasis on cross as symbolic form in *The Prelude* signals a different way of perceiving time and monumental works. Because to him monuments had a specifically symbolic nature, I must explore briefly this difference and its implications.

According to Murray Krieger, the Romantic symbol was seen as "a form-making power that could break through the temporal separateness among entities, concepts, and words to convert the parade of absences into miracles of co-presence." Allegory was "the modest device that permitted no pretension on the part of the signifier to exceed its self-abnegating function of pointing to an earlier and fuller reality outside itself. It is this cursed principle of anteriority that governs the chain that links events to one another, that links events to the language that seeks to represent them, and that links the elements of that language to one another."[9] With "the cursed principle of anteriority" two issues are necessarily linked: 1) the necessity for events within time's domain to be seen as sequential and therefore as discontinuous; and 2) the necessity for language to be seen as existing in time, and therefore as signs to become detached from things signified. By contrast, in its transparency the Romantic symbol was supposed to achieve a "co-presence" both of moment and moment and of language and meaning.

Romantic theorists saw the miracle of co-presence as a triumph of human expression, and with it the triumph of the mysterious, living "idea." Allegory, Creuzer declared, "signifies merely a general concept, or an idea which is different from itself." The symbol is "the very incarnation and embodiment of the idea." In allegory a process of substitution takes place: "in a symbol the concept itself has descended into our physical world, and we see it itself directly in the image."[10] All symbol theory, including Coleridge's, begins by opposing the perishable abstract thought or "concept" to the enduring concrete idea. As *The Prelude* shows, for Wordsworth most monumental forms with a personal reference were transparent symbols of this kind, speaking "as if a voice were in them" (6: 632), giving the past an immediacy and a humanity.

The imagination's "ennobling tendency" is a power, not shared by fancy, of showing us objects "worthy to be holden in undying remembrance" (1815 Preface; *Prose* 3: 35). The visual juxtaposition of aerial cross and shepherd "ennobled" man "outwardly" to Wordsworth's sight. A kind of test of this ennobling occurs later in Book Eight (543–616), where he recalls his stay in London the year after his walking tour in the Alps. One day, riding atop a coach, he was scanning an urban spectacle of "vulgar men" around him, "trivial forms/ Of houses, pavement, streets, of men and things,—/ Mean shapes on every side."

Suddenly this superficial, scattered scene gave way to a sense of the past, and he felt "a weight of ages" descend on his heart. The city was a monument in itself, as the stilled past was felt *in* the present, and all forms seemed monumental ruins. The experience lasted only an instant, but "with Time it dwells,/ And grateful memory, as a thing divine." Throughout this part of *The Prelude* the poet is intent on relating how he learned to see, as the final version reads, that

> The human nature unto which I felt
> That I belonged, and reverenced with love,
> Was not a punctual presence, but a spirit
> Diffused through time and space, with aid derived
> Of evidence from monuments, erect,
> Prostrate, or leaning towards their common rest
> In earth, the widely scattered wreck sublime
> Of vanished nations, or more clearly drawn
> From books and what they picture and record.

In the 1805 version the aid provided by books is augmented not by man-made forms but by natural ones, those in "the external universe" (766). Certainly one purpose of Book Eight in both versions is showing how natural and literary forms work together for the "Love of Mankind." Books as they "picture and record" human experience through time bestow a specifically human face on natural objects. But in the 1850 passage, solid monuments in their various postures give a much more vivid idea not only of people but of human works as "punctual presences." (Another reference to stone circles—those at Swinside, near the River Duddon—was added in the 1850 version of Book Two, ll. 101–2: "Some framed temple where of yore/ the Druids worshipped.") Insofar as they stand only for particular things, people and activities, they give a sense of the past as a corpse-like "weight of Ages." However, they can also constitute evidence of and aids for knowing the omnipresent human spirit as it connects periods of time spatially to one another and itself to all of time. This knowledge imparted a sense of "Power growing under weight" (555), as the objects "weighed *with*" him, not on him (628; emphasis added). By revealing their own significance they supported and unified the past. Books, for example, when recalled as reading experiences, took on a monumental weight and power. Relevant here is Wordsworth's late sonnet "The Monument Commonly Called Long Meg and Her Daughters," first published in his *Guide to the Lakes*.[11] The effect on Wordsworth of the Druid circle, and of things "cast/ From the dread bosom of the unknown past," is "A Weight of awe, not easy to be borne." It has silently survived the years,

a symbol of the unknown but not unknowable. Wordsworth wants the principal stone to speak but speaks for it, saying it foreshadows an "inviolable God, that tames the proud!" What is literally the burden of a mystery is lifted, as is the "weight of Ages" conveyed in *The Prelude* by monumental London.

The Prelude establishes and presents a poetic model for time itself. Like the aerial cross or any other monument, a book may record what once happened. So Wordsworth often speaks of his poem as a "record" or as a linear "history." But a monument may also "picture": "figure" or "represent symbolically" *(OED)*. The "spirit diffused" through a place, "with aid derived/ Of evidence from monuments," his own authorial memory, makes those monumental objects more than punctual presences. In crucial *Prelude* scenes the monumental object seems first subject to time and change, then, as an image contemplated or meditated upon, impervious to them. The Carthusian monastery is seen first as a victim of sweeping historical forces, then as a locus of "mystery," of "faith and meditative reason." The same thing happens in "Michael," where the aged shepherd "left the work unfinished when he died," but both his own form and the form of his "work" (the sheepfold and his life's accomplishments) are interpreted symbolically and monumentalized in Wordsworth's work as a kind of Druidical mystic stone circle.

Monuments, then, are not merely memorial objects, dependent for their power on recalling or referring to a dead past: "leaning toward their common rest"; as symbols they have a present power of advising, warning, or teaching (L. *monere*). To use the title of one of Coleridge's works, they are "Aids to Reflection." Wordsworth was led to find such monuments not a burden but a help in feeling "the unity of man" (668). With a kind of *general* seeing or interpretation, an "amplitude of mind" (606), any particular man is seen as *l'homme general.* In the part following the monumental "evidence" passage, the amplitude is made to extend back in time. Just as in "Tintern Abbey" the deeply interfused divine spirit is only evident in the particular forms of nature, the human spirit broadly diffused through time and space cannot be known except through the particular man-made forms and the punctual presences, as *figures,* of men and women.

Ultimately it is the "Wisdom and the Spirit of the universe" that gives to "forms and images a breath/ And everlasting motion" *(Prelude,* 1: 401–4). The "works of God" (7: 742) teach us to fix our attention on things, view them comprehensively, and therefore secure them in the memory as symbols. Further, because people have lived and are living among them, natural forms such as rocks and streams are "speaking monuments" of real episodes of local history (8: 172), "passions of men . . . incorporated with the beautiful and permanent forms of nature" (Pref. to *Lyrical Ballads, Prose* 1: 125). Historical London, the

London of monumental forms, is not merely the "burial-place of passions" but "their home/ Imperial, their chief residence." It is a Wordsworthian example of expressive form: form that expresses passions, and thus carries the living power of that kind of expression, but that also "incorporates" them, not just in the body's transitory way but with monumental weight.

Coleridge admitted being unable to see history in natural and man-made physical objects. "Dear Sir Walter Scott and myself were exact but harmonious opposites in this," he recalled:

> that every old ruin or hill or river called up in his mind a host of historical or biographical associations. . . . I really believe I should walk over the plain of Marathon without taking more interest in it than any other plain of similar features. Yet I receive as much pleasure in reading the account of the battle in Herodotus, as any one can. Charles Lamb wrote an essay on a man who lived in past time; I thought of adding another to it of one, who lives not in *time* at all, past, present or future.[12]

"Coleridge was not under the influence of natural objects," remarked Wordsworth on hearing this. "He had extraordinary powers of summoning up an image or a series of images in his own mind, and he might mean that his idea of Marathon was so vivid, that no visible observation could make it more so."

Present objects lacked life and monumental resonance for Coleridge because he did not experience past periods as realities. In this sense he did not live "in *time* at all, past, present or future." To use Wordsworth's phrase, he was "under the influence" not of physical shapes but of ideal forms, which illuminate history without being subject to a purely historical definition. Also, as an historian he was primarily interested in "assimilating the events of our own age to those of the time before us" (*SM* 9). This meant reading works of the past for the present, and both as part of an *encompassing,* living whole. For Wordsworth, always conscious of living in a present that only pointed to a future by recalling a past, monumental markers revealed the past's continuity with the present, not merely its parallels with it. Because he, unlike Coleridge, had a spatial sense of time (moments in time were spots or spaces), he saw the human "work" within time as being what Cassirer calls "a solid and permanent shape" occupying a specific place. *The Prelude* itself was one of these. The past must be experienced in relation to such shapes, but also with that circumfusing light that makes them more than dead shapes.

In *The Prelude* any real form, natural or man-made, has a memorial aspect because memory itself, consciousness of time as a unity, is built up by linking such forms analogically with ones they visually suggest. Therefore, like Scott, Wordsworth found historical value in *any* "visible cre-

ation," any "ruin or hill," the plain of Marathon as much as any human artifact that might be found or put there. If the central problem of *The Prelude* is being able to see the forms of man—both human figures and human works—as noble and ennobling, the answer is most clearly artic- ulated near the end of Book Thirteen. To those with "eyes to see," nature has the power to consecrate "The outside of her creatures, and to breathe/ Grandeur upon the very humblest face/ Of human life" (285–7).

"Things . . . may be viewed/ Or fancied in the obscurity of years/ From monumental hints." This, at the end of *The Prelude*'s Book Thir- teen, refers to Wordsworth's visiting Stonehenge in 1793 and seeing "our dim ancestral past in vision clear." The hints evoking that vision were not merely the stone circle and the "monumental hillocks" of Salisbury Plain but the very landscape of road and down. The "forms/ Of Nature have a passion in themselves,/ That intermingles with those works of man/ To which she summons him" (290–3).[13] *The Prelude* episode extends and revises the dark Stonehenge scene in "Guilt and Sorrow" (finished by 1794), which depicted in the "monuments and traces of antiquity" (Pref- ace to poem) dread emblems of the ravages of modern war, much as had the Chartreuse cross. In the earlier version the monument's "mysterious form" is "proud to hint yet keep" its secrets (XIV). With its allusion to wicker cages the poem hints of sacrificial agony but is silent on any redeeming truths. *The Prelude*'s counterpart records its vision of history as Time flees "backwards" to reveal the past: early Britons first as sav- ages, then as groaning sacrificial victims. If a monumental work like Stonehenge is designified by time, it becomes a deformed, oppressive object standing only *for* the past. What happens to it stands for history: what happens *to* the past. Those recalled by it are so many dead individ- uals, dissociated from the present-day viewer. However, Stonehenge then becomes more than historical. Like Chartreuse it becomes a court of mys- tery and a symbol of eternity. The grim figures are supplanted by others, evoked where the plain is "figured o'er with circles, lines, or mounds,/ That yet survive." Now the poet sees early magi pointing to the starry sky and to eternal truths figured in constellations. Now the past consists no longer of dead forms but of living, universal ones, from which one can "divine" that the "work" was "Shaped by the Druids, so to represent/ Their knowledge of the heavens, and image forth/ The constellations." The poet reads the monument "with believing eyes" (344), for as he declares at the end of Book Thirteen, there must be "an ennobling inter- change" between the "best power/ Both of the object seen, and eye that sees." The power in the object was, as he learned at the time (13: 278–94), that of nature to "consecrate" the "works of man" no matter how "mean" they were or have become. The object (here the monumen- tal object) is empowered by the figuring eye, and the eye by the figured

object. In this way the monuments become the means of recovering the
lost human figures, and those figures become the way of animating mon-
uments. The episode as a whole is included at this point in *The Prelude*
to show that the poet's strength is like the prophet's, "a sense that fits
him to perceive/ Objects unseen before" (304–5). As sages the Druids see
in the heavens something of the "mighty scheme of truth" (302); as a
poet Wordsworth sees figures in a landscape dominated by monumental
objects. Out of such experiences emerged *The Prelude* itself, "a work of
his,/ Proceeding from a source of untaught things,/ Creative and endur-
ing . . . like one of Nature's."

Since configuration gives expression a permanent visibility, the form
given to a poetic work remains the most lasting image of the poet's own
person. But what form should an enduring expression take? For
Wordsworth the question really had to do with the two meanings of
"form" covered in Stuart Curran's book: design or shape and type or
genre. Wordsworth appears to have pondered this when composing *The
Prelude*'s earliest version. In some lines written between 1798 and 1800
he recorded an early conviction that his versification of various thoughts,
expressing "in passion many a desultory sound," would constitute a suf-
ficient "memorial" of his own mind, one expressed in "a universal lan-
guage." However, the result had been only a "monument and arbitrary
sign." What then was missing to turn a lifeless monument into a living
memorial? "Considerate and laborious work . . . doth impart to speach/
Outline and substance even, till it has given/ A function kindred to organic
power—/ The vital spirit of a perfect form" (*The Prelude* 1979, 495). The
artist's long, dedicated involvement in the work's formation affords that
combination of energy and design that turns even words, arbitrary signs,
into a universal, symbolic language—the mind's permanent memorial.

Earlier I discussed Coleridge's use of "organic" and "mechanic"
form to describe two different modes of artistic creation and self-repre-
sentation. *The Prelude* tends to use organic metaphors to convey the long
unconscious evolution of Wordsworth's own spirit: "Fair seed-time had
my soul, and I grew up . . ."; "The immortal spirit grows/ Like harmony
in music" (1: 301, 340–1). The poem *about* that natural growth, how-
ever, is "an arduous work" (1: 147). Certainly he wrote it from a desire
to have it express himself, to stand for, represent, and thus make known
his *writing* self. As *The Prelude* ends, he declares that it "will be known"
and its reader will feel "that the history of a Poet's mind/ Is labour not
unworthy of regard:/ To thee [Coleridge but probably all other readers as
well] the work shall justify itself" (14: 411–14). The "work," the
wrought and finished thing, justifies itself by being also seen as a "his-
tory," a process taking place. When in 1814 he published another por-
tion of this major project, *The Excursion,* its Preface (*Prose* 3: 5–6)

recalled the original wish "to *construct* a literary Work that might live" (emphasis added). This "history of the Author's mind," comprised "Works" of "arduous labour" in a definitely architectural arrangement, with *The Prelude* as an ante-chapel to *The Excursion*'s "gothic church," his shorter poems being as "little cells, oratories, and sepulchral recesses, ordinarily included in those edifices." Perhaps this is as graphic an example as can be found of the work as embodiment in its monumental form. Although *The Excursion* is meant to "convey," among other things, "strong feelings," clearly the Preface emphasizes what it embodies or represents permanently. Coleridge speaks of *The Prelude*'s containing "the foundations and the building up/ Of a Human Spirit," but also "vital breathings secret as the soul/ Of vernal growth" ("To Wordsworth"). What is most evident and monumental is the architectural. The organic is invisible. Perhaps because of a greater confidence that the secret processes of the mind would result in a finished body of work of some reputation, he had as much interest in the *object* that endured as in the process of creating that object. For Coleridge there was no product, only an "educt," and the (never-ending) growth was what mattered. It was that which belonged to "genius," not to "judgment."

To return to the sonnet quoted at the beginning of this chapter: what does the "immortal Mind" have to do with material objects, those that may endure but not forever? I believe this is answered in Wordsworth's 1815 Essay Supplementary: "The concerns of religion refer to indefinite objects, and are too weighty for the mind to support them without relieving itself by resting a great part of the burthen upon words and symbols. The commerce between Man and his Maker cannot be carried on but by a process where much is represented in little, and the Infinite Being accommodates himself to a finite capacity" (*Prose* 3: 65). A poet lifts the burthen of the mystery by representing it in words that are monumental and have to do with vast time, but not, except symbolically, with timelessness. That is, a monument is made for duration, but "objects that endure" are our only symbols of immortality. In the first "Essay on Epitaphs," published in Coleridge's *The Friend* (1810), Wordsworth explains why expressions of grief are inappropriate on tombstones, and why "the thoughts and feelings expressed should be permanent":

> The very form and substance of the monument which has received the inscription, and the appearance of the letters, testifying with what a slow and laborious hand they must have been engraven, might seem to reproach the author who had given way on this occasion to transports of mind, or to quick turns of conflicting passion; though the same might constitute the life and beauty of a funeral oration or elegiac poem. (*Prose* 2: 59–60)

Wordsworth's qualification at the end is significant, suggesting as it does that emotive expression is more fittingly conveyed in language than in some art of material "form and substance." (In subsequent chapters, particularly with respect to *Childe Harold* and "Adonais," I shall discuss the representation of monuments *within* elegies.)

De Quincey astutely connected that whole section of Wordsworth's "Essay" with the central issue raised by Lessing,[14] which I considered at length in my fourth chapter: is evanescent expression, expression of emotion, suitable for stationary objects? De Quincey maintains that in an epitaph "we look for an expression of feeling, which is fitted to be acquiesced in as final."[15] Thoughts of immortality are thoughts of finality, but lamentations are both transitory thoughts and thoughts of transience. This was a common idea at the time. The *Magazine of Fine Arts* pointed out in 1821 that sculpture, because of superior durability, is the principal form for the monumental, and it lets us "indulge a feeling that is sacred, pure, and consolatory; and calculated to relieve the oppressed and overcharged heart of the mourner. . . ."[16]

De Quincey focuses, as Wordsworth does, on two related aspects of monumental inscription: the arduousness of the effort and the solidity and intractability of the medium: "For the very nature of the material in which such inscriptions are recorded, stone or marble, and the laborious process by which they are chiselled out, both point to a character of duration, with which everything slight, frail, or evanescent, is out of harmony" (593). Both Wordsworth and De Quincey suggest that the monumental form itself symbolizes—that is, expresses by embodying—ideas of "duration." The monument does as much as human works can in representing "final" ideas of immortality. For Wordsworth, the making of a lasting object was itself a worthy object, unlike the mean and inglorious ones he describes in *The Prelude*'s Book One. It was an object worthy of the craftsman's sustained labor.

Wordsworth had a very strong sense of poems as *things*—objects— just as he had a strong feeling for the objecthood, the sculptural presence, of natural forms. Therefore his use of the word "form" usually indicates more physicality and materiality than it does with Coleridge, who, as Wordsworth pointed out, "was not under the influence of natural objects." When Wordsworth speaks of the "beautiful forms of nature" or says that the Shepherd's "form hath flashed upon" him, the word denotes something between an image, an idea in the mind, and what is imaged. What Coleridge somewhat dismissively called the thing as thing, though certainly in Wordsworth meant to be perceived as an image, is also meant to be experienced by the reader in its original solidity, something concretely and enduringly monumental.

FIGURE 8. Michelangelo. Lorenzo de' Medici, detail. Medici Chapel, S. Lorenzo, Florence. Photo: Alinari/Art Resource, NY.

CHAPTER SEVEN

Fortune's Rhetoric:
Allegories for the Dead

> Wonder not, Mortal, at thy quick decay—
> See! Men of Marble piece-meal melt away;
> When whose the Image we no longer read,
> But Monuments themselves Memorials need.
>
> —George Crabbe, *The Borough*

MONUMENTAL ALLEGORY

Figures like Wordsworth's Shepherd, Cumberland beggar, and discharged soldier are living forms because they are not simply memorial ones—portraits of persons once known, now gone. They are intended to live permanently in his (and our) memory by their identification with the lasting forms of nature. Their life is the "intermediate" image in the poet's, then the reader's, imagination. These forms are symbolic, and the symbol, Goethe wrote, "remains forever active."

Noting Goethe's remark, Tsvetan Todorov adds: "In allegory meaning is complete, final, and thus in some sense dead."[1] The completeness, or definitiveness, of the allegorical message is its finality, which gives it the aura of death. Walter Benjamin's *Origin of German Tragic Drama* argues that whereas the ultimate use of the Romantic symbol was to idealize history's destruction and to "redeem" nature from time, "in allegory

the observer is confronted with the *facies hippocratica* [the withered image of a dying body] of history as a petrified, primordial landscape. Everything about history that, from the very beginning, has been untimely, sorrowful, unsuccessful, is expressed in a face—or rather in a death's head."[2] The passage, like Benjamin's essay as a whole, conveys "a relentless sense of history as death," as Denis Donoghue comments.[3]

Monumental allegory—popular, we have seen, in the eighteenth century and into the nineteenth—dignified the deceased subject by representing her or him in terms of abstract universals and in the company of rank and privilege. As when on opulent tombs, it bespoke power and conferred power. But poetic rhetoric often employed it ironically to depict the *passing* of traditional power and privilege. In the new, leveling age in politics and literature, Hazlitt remarked, "capital letters were no more allowed in print, than letters-patent of nobility were permitted in real life" (*Works* 5: 162). The same scorn for rank and its didactic imagery is reflected in Gray's "Elegy," where the poet asks rhetorically if Honor and Flattery on prominent church monuments can "provoke the silent dust" or "soothe the dull cold ear of Death." Allegory or personification is most appropriate to convey the semiotic emptiness of certain monumental shapes, those honoring or flattering power and privilege.

A funerary monument itself signifies the dead. To allegorize it poetically, as Gray does, emphasizes the position of that sign as subsequent to its signified. That is, it denotes the new, overlaid personified figure as existent after the original memorial sign, which has now become a dead, silent object. In this way it comments on "the biographical historicity of the individual" (Benjamin 166). Because it constitutes a language, or carries it in the form of figures or inscriptions in which the sign refers *to* the signified, sign and signified are destined to become more and more alien to each other with time. (An emblem of this is the disjoining of inscription and figure in "Ozymandias.")

"The connection between a monument and what it stands for—or is believed to stand for—is peculiar and intimate," writes Philipp Fehl in *The Classical Monument.*

> It is almost as if the monument had a double identity: its own, as a man-made object, and, in a shadowy and yet more immediately striking manner, the identity of the event or person it recalls. This is evident in the relation between tombstone and tomb: the immediate effect upon the sensibility of the viewer of the stone erected over a tomb is more compelling than the one it may have in the museum or in the stone carver's workshop.[4]

This divided impression probably belongs only to memorials of persons. Without an extraordinary imaginative exertion, people are not likely to

sense any identity at all for a plaque commemorating the establishment of a town's first schoolhouse. The "double identity" is the envisaged presence of a signified person contending with the viewed presence of the object-shape. I suggested in the last chapter that something like this often occurs in Wordsworth's poems, but with the imagination successfully merging human figure and stone object in a new living form, more impressive than either of those alone. With sepulchral monuments the impressions exist side by side as competing presences. The stone imparts its lifeless character to the dead, the dead person lends his spectral character to the stone.

Some of these memorials, like the standing, sitting, or semi-reclining effigies of the living figure, so popular in the eighteenth century,[5] or the kneeling or sleeping ones popularized by Chantrey in the nineteenth, enforced this effect. Even more did the representation of the dead person's corpse or the skull-and-crossbones motif, both long found on gravestones throughout England and Scotland.[6] In the early nineteenth century the corpse-effigy was also featured in the carved deathbed scene, a tableau of mourning representing the surviving family grouped around the deceased.

These were all especially appropriate to the monument located near the person's remains. William Godwin's *Essay on Sepulchres* argued for the erection of memorials at the precise spot of burial. "Portraits may be imaginary; the scenes where the great events have occurred are the scenes of those events no longer: but the dust that is covered by his tomb, is simply and literally *the great man himself*."[7] A significant development in burial sites occurred in the nineteenth century when the tomb was made to correspond to the position of the body. In English graveyards the footstone and headstone marked the exact position of the corpse.[8] Within the church or cathedral the memorial might be grander, as Gray reminds us, but it still marked the burial site itself. "Oh, let me range the gloomy aisles alone," wrote Thomas Tickell: "Sad luxury! to vulgar minds unknown;/ Along the walls where speaking marbles show/ What worthies form the hallowed world below."[9] To the solitary viewer the marbles (effigies, medallions, urns) "speak" both of themselves and of what they "show": the buried worthies. In the ecclesiastical aisle that is possible only because of the sense of dead presences in the vicinity. However, that second identity may be "more immediately striking," in Fehl's terms, because of, not despite, its "shadowy" character. We cannot be unaware of the physical presence of the dead who "form . . . the world below." On the other hand, their once-living persons are felt as absences. The monument "recalls" the person only in the sense of calling to mind, not calling back to life.

A figure-making figure of thought, personification "consists in representing an absent person as present," Cicero says, "or in making a

mute thing or one lacking in form articulate, and attributing to it a definite form and a language or a certain behavior appropriate to its character. . . ."[10] While *representing* the absent person as present, it also *records* the real passing of the person and the voice. It acknowledges the empty space and fills it with a figure. If the original figure is seen as itself a "mute thing or one lacking in form," refiguration or remonumentalization is possible. Graveyard poets like Blair and Gray provided personified figures like Ambition hanging down her head ("The Grave," 206–7), or Flattery or Chill Penury ("Elegy," 43–4, 51) as monumental representations of the felt but unseen dead.

This spectral effect is strikingly achieved in Samuel Rogers's lines on the Medici tomb in Florence. In Michelangelo's composition two personifications, Night and Day, face two portrait sculptures across a room. That we not "forget" the monument or its figures, Rogers memorializes them while exploring the cryptic essence of the monumental *and* the figural.

> Nor then forget that Chamber of the Dead,
> Where the gigantic shapes of Night and Day,
> Turn'd into stone, rest everlastingly;
> Yet still are breathing, and shed round at noon
> A two-fold influence—only to be felt—
> A light, a darkness, mingling each to each;
> Both and yet neither. There, from age to age,
> Two ghosts are smiling on their sepulchers.
> That is the Duke Lorenzo. Mark him well.
> He meditates, his head upon his hand.
> What from beneath his helm-like bonnet scowls?
> Is it a face, or but an eyeless scull?
> 'Tis lost in shade; yet like the basilisk,
> It fascinates, and is intolerable.[11]

What "dead" does the monument itself enchamber and remember? First, "gigantic shapes of Night and Day,/ Turned into stone," not standing but resting "everlastingly." Coleridge would have seen them as once living ideas of the infinite "turned into Finites, and these into Finites anthropomorphic" (*LOL* 2: 399). In time, even images *for*— ideal images—become images *of*: depictions of things now absent. Facing these allegorical figures in the chamber are effigies of Lorenzo and Giuliano de Medici (the other "dead"). The ideas of night and day— death and life, mystery and truth—are incorporated in those forms, along with their "two-fold influence."

The two effigies are made to personify directly, symbolically, the ideas enfigured allegorically across the room from them, but as a

Michelangelo scholar has observed, all the figures stand for paradox itself: "The *Capitani* are effigies, dead men honored by memorial statues. The *Times of Day* are rather, as Pope Hennessy expressed it, 'living figures turned to stone.' But this still does not quite express the full force of the paradox, for we feel strongly that Michelangelo deliberately kept the head of *Day* in its inchoate state—vastly unlike a petrified man—because he found it more expressive."[12] Everything in the room is "Both and yet neither": even in noon's clear daylight (suggested by the uncompleted face of "Day"?) we feel the duality of monuments and monumental figures: "In the central niches we see seated figures of consummate grace and elegance—Giuliano and Lorenzo—without any identification whatsoever. Michelangelo imagined them not as dead men, or Christian, but alive and clad in antique armor. This is only the most obvious novelty in these staggeringly original and iconoclastic tombs" (Hibbard 182).

The Medicis are "ghosts" enigmatically "smiling." But also under the helmet of Lorenzo something "scowls"—a face, an eyeless skull? (The eyes are carved without pupils.) "Ghosts" could equally well be the forms of Day, Night, Dawn or Eve, or the Medici figures, but could also be some other presence, since in Michelangelo's work none of these is smiling. They have no expression; what is expressed by the work? As idea, conveyed by images and/or inscriptions, a monument may be a reminder of death, a tribute to a dead person, and a marker of an historical event or place. But "monumental" also suggests pure objecthood, sculptured form giving the effect of impressive or perhaps oppressive mass, whose shape overwhelms any figures or writing on it.

As I have remarked, in the ekphrastic process living forms, those with an informing principle, are translated into different modes of form. When statuary is the focus, a human form has already become a stone form: 1) inanimate object, with 2) aesthetic contour. Thus perceived by the poet it becomes a mental form, an image in the mind, often alluded to *as* such. Finally, it is turned into a literary form: poetic lines or prose description. For Wordsworth and others this process illustrated the living imagination, which merges and harmonizes images or turns them into other ones. But in Rogers, with the competing presences of allegory and effigy, sign and signified, idea and object, the absent dead and the present monument, the emphasis is less on growth and harmony than on irony, paradox, ambiguity, and indeterminacy. The effect is unsettling. Which "forms" are real and which not?

Finally, all we know of the room and of Michelangelo's intention is that they have staged and enclosed men and ideas turned into stone; Rogers makes no attempt to recover the lost meaning. The stones have more presence as objects than as symbols. The work's influence is only

to be felt, not understood. Michelangelo expresses nothing clearly about man's fate or fame. Night and Day, Death and Life, are too effectively balanced in the work. The poem itself disfigures and dehumanizes all the figures: Night and Day are "gigantic shapes"; Lorenzo and Giuliano are "ghosts"; Lorenzo's features, perhaps those of a skull, become through simile those of a basilisk.

Significantly, Rogers provides no standing place for reader or speaker, no spot from which to view, to organize, to construe. This means that the forms may be regarded as either projections, involved intimately with our selves, or things wholly external, past and remote. Either they are the *objects* of historical meditation, always there to be contemplated "from age to age," or they symbolize to Rogers his own meditation, "his head upon his hand," on forms belonging to an inner world.

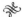

Philipp Fehl's observation about the sepulchral form—that as object and reference it has a double identity and a double effect—may be applied equally to gravesites and to places of monumental ruin: Petra, the Acropolis, the Roman Forum, the Colosseum. For obvious reasons, the viewer of any of these is conscious of a scene that points to an encompassing semantic situation. They "speak of something that is gone": a particular person in the case of the graveyard, a past civilization and way of thinking in the case of ruins. In both, the outdoor situation enhances our sense of their exposure to the elements and to time, and therefore our sense of their objecthood. Jay Macpherson has argued that Romantic lamentations like the beginning of the "Immortality Ode" have to do with the loss to us of things from "a subjective realm of divinely creative powers" as they pass to "an object realm of a nature cruel, mindless, or dead."[13] The world of things is the realm of the uninterpreted. In both graveyard poetry and the poetry of ruins, exposure is a symbol for dead referentiality, for the loss of a human signification. What is really desired is the termination of all the referential processes involved in multiple identity and the gaining of the fixed symbolic single identity of living form (such as, for example, the museum environment provides).

While antiquaries were scanning private and public collections of Greek and Roman figures for clues to the mind of those eras, travelers to India, the Near East, Mexico, and Africa were coming upon other figures, more impressive but more disturbing. Usually for these forms

there was no legible documentation. Rather than providing answers, they invited conjecture. In London the adventurer Giovanni Belzoni set up an "exhibition of Egyptian antiquities" from a dig made near Thebes. Supposedly the 5,000–year-old tomb of King Psammis, the excavated building "was 309 feet in length, divided into several chambers, of which the walls are covered with figures in relief." "The subjects are theological and historical; but, we apprehend, their precise meaning is lost beyond the hope of recovery."[14] Other travelers and antiquaries were asking, could "Pompey's Pillar" have been a "sepulchral monument"?[15] Was the massive sarcophagus transported to the British Museum from Egypt that of Alexander the Great?[16] Were the pyramids built for "astronomical observations"? Were they temples? Tombs?[17] Was the massive figure at Memnonium "the great Colossus of Memnon, or Sesostris, or Osymandias, or Phamenoph, or perhaps some other king of Egypt"?[18] Did the figures on ancient cinerary urns depict "heroic exploits" or "heathen mythology"?[19] What men or gods were these? As Byron's Sardanapalus says of the Egyptian pyramids: "none know whether those proud piles/ Be for their monarch, or their ox-god Apis;/ So much for monuments that have forgotten/ Their very record!" (*Sardanapalus*, 5: 483–6). Herder pondered the fact that while the Greeks had left "monuments that speak to us with a philosophic spirit," our most authentic information about ancient Egypt comes from "those vast pyramids, obelisks, and catacombs; those ruins of canals, cities, columns, and temples; which, with their hieroglyphics, are still the astonishment of travellers, as they were the wonder of the ancient World. . . . There stand, there lie, all those relics, which, like a sacred sphinx, like a grand problem, demand an explanation."[20] The original significance of these relics, the "sacred" meaning that gave them their origins as images in the first place, has been supplanted by a different kind of expression, a sublime aesthetic "effect" ("astonishment"). The power of monumental objecthood they gain; the power of ideas, of telling about themselves, they lose. Their language was never integrated into the work as form, but applied to the object as hieroglyphic. Now *that* language, like the object itself, is no more than a silent relic. Only by turning to written sources can the historian understand these figures and other images.[21] Herder himself reimages and resignifies his mysterious figures by representing their present effect with a highly familiar iconic figure (the Sphinx), which had come to be linked with hieroglyphics to represent lost meaning.

Herder reflects a rhetorical tradition of recording the death of the monument's iconic intention—its remembrance of events, persons, or periods—and its present persistence as silent relic now standing for Time as a whole. Romantic poetry of ruins deals with mute, dis-figured forms,

refiguring them in a high rhetorical mode. The poet, an *un*sentimental viewer, superimposes on the witnessed scene a newly pictured allegorical one, impressive in originality and eloquent in admonition. He sees not as Wordsworth in *The Prelude* saw Stonehenge, with believing eyes, but skeptically, standing apart from the ruined or indecipherable objects and writing as an agent of omnipotent Time or Fortune itself. Unwilling to credit the original meaning of the work or to lament its loss, he displays his moral comprehension of what he beholds by merging it with figures in his mind's eye, turning the designified object into an emblem of failure. He thereby gives it a new form and a renewed life: personality, articulateness, and theatrical animation.

FORTUNE'S RHETORIC

Thirty years after visiting the Grande Chartreuse, Wordsworth once more negotiated the Simplon Pass, this time (1820) with his wife and sister. They came upon an "immense" granite column resting on the rotting sledge that had carried it from its quarry. The column itself was "as fresh and sparkling as if it had been hewn but yesterday." William called it the "Weary stone," after "that immense stone in the wilds of Peru, so called by the Indians, because after 20,000 of them had dragged it over heights and hollows it tumbled down a precipice, and rested immoveable at the bottom, where it must forever remain." Dorothy hoped this object would "lie prostrate" there for eons as an "impressive record of disappointed vanity and ambition."[22]

A monument *is* an impressive record. No doubt this one was originally designed to impress and record, but quite differently in both from what Dorothy meant. Her brother's response was the following sonnet, titled "The Column Intended by Buonaparte for a Triumphal Edifice in Milan, Now Lying by the Way-side in the Simplon Pass."

> Ambition—following down this far-famed slope
> Her Pioneer, the snow-dissolving Sun,
> While clarions prate of kingdoms to be won—
> Perchance, in future ages, here may stop;
> Taught to mistrust her flattering horoscope
> By admonition from this prostrate Stone!
> Memento uninscribed of Pride o'erthrown,
> Vanity's hieroglyphic; a choice trope
> In Fortune's rhetoric. Daughter of the Rock,
> Rest where thy course was stayed by Power divine!
> The soul transported sees, from hint of thine,

> Crimes which the great Avenger's hand provoke,
> Hears combats whistling o'er the ensanguined heath:
> What groans! what shrieks! What quietness in death!

In the last chapter I discussed passages in two earlier poems where Napoleon's troops are seen desecrating the Chartreuse monastery. The *Descriptive Sketches* tell of the "groaning" river and the jay screaming in alarm, and also of a "death-like peace." In *The Prelude* the voice of nature calls out to the invasive military force, "Stay, stay your sacrilegious hands!," anticipating the later sonnet with its uninscribed column's course "stayed by Power divine." In the sonnet the column recalls Napoleon's crimes: "groans," "shrieks," and finally "quietness in death." The last lines seem meant to recall as well Wordsworth's 1790 experience and reflections as recorded in both earlier works.

The poem's title indicates first the column's silence even about itself. Its original idea lost, it now remains conspicuous in its featureless materiality, a "prostrate Stone." Its "intended" function—as part of a triumphal arch at the scene of one of Napoleon's victories—must be determined from some written or oral source. Its intended mode of signification has been "o'erthrown," as was Napoleon himself as Emperor, and as was the column as thing. Recognizing the political demise of the monument's subject, and therefore the death of its original iconic function, Fortune in "admonition" has supplied it with an equally conspicuous new rhetorical figurality, construing it as a "trope." Although Wordsworth's own normal bent was hardly allegorical, here he liberates the scene from its silent, objective particularity by turning persons into emblems (Napoleon as Pride, all future invaders as Ambition) and abstractions into persons (destiny as the Avenger), and the whole into a high moral truth. Situating both the onlooker and the monument historically, the allegory of Fortune's rhetoric insists not only on the individual's "biographical historicity," to use Walter Benjamin's phrase, but on the historicity of signs. It directs attention to the monument's failure to represent permanently either the person memorialized or the ideas about the person. Meant as a record of achievement, the column is rhetorically transformed into a "memento . . . of Pride o'erthrown."

This perception of some thing as both remembrance and emblem is central to the iconic tradition I am discussing. The rhetoric further subverts the iconography by blurring the distinction between sign and signified. "Rest where thy course was stayed by Power divine" is addressed both to the fallen Napoleon and to the column standing for him (now no longer standing). Thus Fortune's rhetoric offers visualized versions of dramatic irony: the initial iconic expression of one intention, Napoleon's, is overridden and supplanted by another intentional expression, that of

Providence, with its own congregation of forms and overall form. (And here the sonnet form itself must be taken into account as expressing this purpose.) Nominally the new design is that of Providence; actually it is the present author's.

Foucault remarked that the Romantics aspired to the condition of history by restoring a voice to the silent monuments of the past.[23] In *The Prelude* and elsewhere Wordsworth did just that, taking forms from his own life and reading and assimilating them into a present remembering consciousness expressed in a distinctive narrative voice and scheme. He thus gave shape (as memory) to time, and distinctive form to the remembered human, natural, and man-made shapes. This sonnet, however, rejects that episode of history commemorated by the column while giving voice and figure only to the present, belated viewing of the past, empowering it to speak and teach in "future ages," like Keats's Urn.

To summarize, finding the monument, as well as its original expression, irrecoverably obscured or fragmented, what I will call the poetry of Fortune's rhetoric comprehends the scene with a new didactic expression of its own, one appropriate to the idea of ruin. Conventional personifications replace absent figures from the past. The Romantic version of this rhetoric adds the poet's own figure to the scene as well.

Meditations on ruins had long since adopted the style of didactic emblematizing, the reader indirectly admonished to shun vanity by being shown how flattering icons die into relicdom. The image or inscription on a monumental object tells what the object itself means. When that image is unreadable—a favorite example of this situation was Egyptian picture writing—so also is the object. When in Blair's "The Grave" (1743) "The Mystick Cone, with Hieroglyphicks crusted,/ Gives Way" (196–7), he appears to connect the giving way of the object and of its inscripted message.[24] He describes (ll. 182 ff.) a series of dilapidated structures and obliterated records: a crumbling pyramid ("hideous and misshapen length of ruins"), fallen sepulchral columns, a moldering bust, tarnished brass. Ambition, the personification of shamed powerlessness and impotent iconography, "Half convicted of her Folly,/ Hangs down the Head, and reddens at the Tale." With the monument of power or fame, the deaths of the tyrants and vandals are inevitably followed by the fall of their memorials and thus of the original embodied themes of those memorials. Blair's lines are "the grave" of both the object and its expression: "The *Grave* gainsays" the monument's "smooth-complection'd Flatt'ry,/ And with blunt Truth acquaints us what we are" (ll. 235–6). Bluntly pointing out the failure of the "far-fam'd *Sculptor* and the laurell'd *Bard*,/ Those bold Insurancers of Deathless Fame" (87–8), Blair, like Wordsworth, creates the figure of Ambition to remark the scene, allegorically and didactically remonumentalizing the monument.

To use another example from the same period, Thomas Warton the Younger's *Pleasures of Melancholy* (1747) describes a scene of human works whose original iconography of "Elegance" and "Art" has faded as the objects have moldered, and all is now translated into an assemblage of rhetorical figures (ll. 258ff.).[25] Like Napoleon's column, as things the monuments have "fallen" to the ground; as images they have fallen from their intended purpose:

> Yet feels the musing Hermit truer joys,
> As from the cliff that o'er his cavern hangs,
> He views the piles of fall'n Persepolis
> In deep arrangement hide the darksome plain.
> Unbounded waste! the mould'ring obelisk
> Here, like a blasted oak, ascends the clouds. . . .
> Far as the sight can pierce, appear the spoils
> Of sunk magnificence: a blended scene
> Of moles, fanes, arches, domes, and palaces,
> Where with his brother Horror, Ruin sits.
> O come then, Melancholy, queen of thought!
> O, come with saintly look, and steadfast step,
> From forth thy cave embower'd with mournful yew. . . .

The stones are a "blended scene": first the "deep arrangement" (actually a profound or solemn disarrangement) of the ruined Persepolis, then a new silent allegorical arrangement, among whose characters are Horror and Ruin. In the central transformation, occurring within the passage, the observed figure of the hermit and his cave turns into the rhetorical figure of "Melancholy" and her cave, a trope-making trope, an original, originating, authorial presence (or author-surrogate, "queen of thought"), creating figures in a live situation of high poetic feeling.

"Melancholy" is certainly meant to be envisaged, with her traditional dress, posture, and countenance, but how melancholy is this figure and whose melancholy does she represent? As we shall see especially in the poetry of Byron and Keats, scenes of ruin can inspire or evoke the real heaviness of depression. That, I believe, happened to Wordsworth on his first sight of the fallen stones and lost symbolism of Stonehenge, an occurrence transpiring at a time of political and personal distress for him. But as a work, the poem on Napoleon's column, while depicting what might be called a melancholy scene, expresses not so much personal sadness as indignation. It *embodies* the concept of melancholy. The scene and the history it recalls are lamentable, but do not excite lamentation—they are deplorable, but no tears are shed. In fact, by their elaborate public, conventional figuration, personifications of Melancholy or Sorrow

and their moral stance are ways of displacing any expression of personal remorse, loss, or defeat that might be aroused by "melancholy" scenes. Literary Melancholy is more or less equivalent to Wisdom, with whom she sometimes shares the stage.

The Romantics, as I have tried to show, tended to think of the body's own language as a sort of original, naive expressive idiom. "In her homely way the Body tries to interpret all the movements of the Soul," Coleridge wrote, referring to the flow of tears and the rapid beat of the heart (*Letters* 3: 305). Although pictorial allegory (Dürer's "Melancholia," for example) also relies on facial expression, gesture, and posture, it does so in a confected display, using the human figures in a patently figurative, literary way. As a *figural* language, personification uses representations of the human form. A palpably *figurative* or notional language, the forms it uses convey nothing of the body's natural expressiveness. Their signals tend to be highly conventional and theatrical: the furrowed brow, the pointed finger, the wild stare. Peacock's *Palmyra* features Time, a "mystic form, uncouth and dread," with his insignia of hourglass, scythe, and wings, casting "a burning look around" while scowling and waving his "bony hand." And Oblivion is pictured "frowning in the dust" (Sections 10, 11). Such mystic forms, representing the actual deformation of the "noblest works of human pow'r" (St. 1), not only stand for but stand in place of the figures of those who once lived there, the "feeble forms" of those whom Fancy unsuccessfully attempts to picture (St. 10). The allegorical Minerva in the Nelson monument, motioning toward Nelson's figure while looking down at the two young midshipmen, expresses in a different way from that figure itself. The effigy's stern, resolute face and figure are meant to express directly (bring to view from inside) certain feelings both of the person and, once that is viewed, of the audience. Minerva's gesturing itself may be taken, in fact, as a sign of the difference between formal and natural expression. Wordsworth's 1802 Preface called personification a "mechanical device," one that does not make up "any natural or regular" part of the language of men (*Prose* 1: 131). The language of the earliest poets was "daring and figurative," but those very figures have since become conventionally and mechanically adopted and applied to thoughts and feelings with which they have had "no natural connection whatsoever" (*Prose* 1: 160). Thus for Wordsworth, the conventional trope stood for that "poetic diction" which, reflecting a distance from linguistic origins, also reflects a lack of original freshness and power.

Personification's manifest artificiality has been noted by Michael Riffaterre, who argues that one type of it, prosopopoeia, "by a mere convention" provides a voice to something that has become silent and perhaps always was (108).[26] Like any "figural sign," it is "an index of

convention. As such, it testifies to its literariness, and proclaims the text that it generates to be an experiment, a conscious substitute for a recognizable equivalent in accepted usage, in the sociolect. As an index of convention, it also points to the author's intention, a first, very general way of asserting the self, of putting its mark on the external world" (110). Personification is a "trope," a "form of expression which deviates from the normal" *(OED)*. Fortune's rhetoric deviates manifestly from the language it interprets, the failed language of the original figure, shape, or image whose remnants conspicuously occupy part of the total scene. Riffaterre calls prosopopoeia "a figure of figurality itself" (110). Following Paul de Man's earlier analysis in "Autobiography as De-Facement,"[27] he contends that overlying the figurative or suppositional may be the author's inscriptive act. Inscription "refers to the real," writing the present authorial self into the text (111) as an "intention." We may assume that the person authorizing, though not of course authoring the column that Wordsworth saw, was Napoleon. The column as found is authorless; there is no separate artistic intention, as there is, say, in the "Ozymandias" statue. Also, having lost contact with its original subject, it has lost its own originality. "Whereas the symbol postulates the possibility of identity or identification," remarks De Man, "allegory designates primarily a distance in relation to its own origin, and, renouncing the nostalgia and the desire to coincide, it establishes its language in the void of this temporal difference."[28] De Man quite rightly points out the time distance in allegory between the sign and its originary idea. Wordsworth's own (original) inscription, the sonnet, should be seen as belonging to the world of present authorship or present speaking (calling the column a "trope" is itself a trope, after all, a conspicuous sort of *verbal* maneuver). The scene referred to in the title is so conventionalized by personifications as to be consigned to a dying historical and rhetorical world of, to use Riffaterre's phrase, "mere convention." The "hieroglyphic" or *dead* image of Vanity thus becomes the "trope" or live image of Fortune.

Like any allegorical monument, Fortune's rhetoric is an appropriate way of meditating on the departed event, the failed hope, and ultimately on pastness itself. As a figurative language highlighting historical sequentiality by commenting on an already existing language, it is a strong affirmation of secular time. The use of an applied as opposed to an incarnated language suggests the impossibility of temporal union or even of immediacy with the signified. When it is contemplated, symbolic form, as Coleridge and others viewed it, expresses and contains the personal situation of the interpreter, who lends his own intimacy to it, often through the medium of a new or restored figure. For Coleridge this was true of Shakespeare's characters, and for Wordsworth of the figures who

populate his poems. As the allegory of Fortune's rhetoric offers figures for the subversion of intended form, the interpreter is distanced from what is seen, a spectator and reporter of historical refiguration. The "scene" viewed is of time past, in which the onlooker feels uninvolved. In short, allegorical reading supplants the form in a conspicuously elaborate and impersonal artifice; symbolic reading sustains the form with the involvement of a living self. Todorov writes: "the symbol represents and (potentially) designates; the allegory designates but does not represent" (201).

Krieger emphasizes the way the symbol was supposed to triumph over time's semiotic ruptures, which in other modes of discourse separate the sign from that "reality outside itself."[29] Allegory is unpretending, content with merely pointing—designating, as Todorov says. But *was* it "modest," to use Krieger's word? A rhetorical tradition going back to Cicero and Quintillian associated personification with "boldness" and the mode of the sublime.[30] By tradition the living form or image, as I have shown, was supposed to be one actively imaged— "before the eyes"—as opposed to one merely on canvas, in stone, or on the page. As it happened, the art of personification in the eighteenth century was regarded as the rhetorical power of giving live form to ideas, which in Joseph Warton's words could be brought "before our eyes, as on a stage." John Hughes spoke of Spenser's "Power of raising Images or Resemblances of things, giving them Life and Action, and presenting them as it were before the Eyes." And Erasmus Darwin included allegory and personification among those tropes that could bring objects "before the eye."[31] In their mute rhetoric, Warton's "Ruin" and Gray's "Death" do not merely rise from the world of historical fact to point to it. They rule and operate on it, potently reconstructing it, transporting the soul sublimely, as in Wordsworth's sonnet. The symbol, on the other hand, postulates its own independence not merely from some signified other, especially signified fact, but from any authorial activity. Its power is the idea's ability to embody itself by itself, thereby creating its own means of expression; allegory's is rhetorical—that of the poet or painter to express ideas with figures that conspicuously have the semblance only of natural expression.

Whereas the figures in Fortune's rhetoric may signify authorial power, specifically the power of abstraction, they may also convey a sense of concepts as spectral presences: vivid but unreal; here in this mind, but not in that place. Figural abstractions are noticeably separated from, inscribed or imposed upon, things or objects, a cold fiction, as *Blackwood's* described allegorical tomb sculptures (see chapter 5): object and image are connected but neither integrated nor reconciled.[32] A standard rhetoric of the time noted that abstract qualities "considered

as in a state of separation from the subjects to which they belong, have been not unfitly compared by a famous wit of the last century to disembodied spirits."[33] As with Roman personification, eighteenth-century and early nineteenth-century allegories of ruin feature figures that are not living characters in a drama but static emblems: as Dr. Johnson put it, meant not to act but merely to stand for.[34]

Probably more than any other, the work that gave Fortune's rhetoric a sustained life in the Romantic period was Constantin François Volney's *Les ruines, ou méditations sur les révolutions des empires,* first published in 1791. Volney's contribution to the meditation on ruins was a radical social ideology, one reflected in the pages of Mary Shelley's *Frankenstein* as well as in her husband's poetry. What is also striking about Volney is the way viewing and meditating figures merge with those that spectrally haunt the scene itself. In the Fortune's rhetoric tradition ghostly idea-figures attend fallen objects they represent and interpret. The viewed and the fancied contend with and then dissolve into each other. In Volney's *Ruins,* and in those works influenced by it, a third shadowy presence, the onlooker, is there to identify with the other two.

At Palmyra, as Volney's speaker climbs to the heights above the Valley of Sepulchres, "Darkness now increased, and through the dusk could only be discerned the pale phantasms of columns and walls."[35] He thinks of how life might have once gone on there, "And now behold what remains of this powerful city: a miserable skeleton! What of its vast domination: a doubtful and obscure remembrance" (6). In Chapter Two these object-specters appear to coalesce with the ghostly protagonist himself, who covers his head with the flap of his own garment and sinks into "gloomy meditation on human affairs" (8). Then, in Chapter Three, that man becomes visually identified with, yet separate from, a figure he meets, a "Genius of tombs and ruins." This being is "clothed in large and flowing robes, such as specters are painted rising from their tombs" (13, 9). The Genius, who also dispenses mournful discourses on human history, plays a similar role to that of Warton's musing hermit, or "Melancholy, queen of thought."

The first substantial work to show the influence of these scenes was Peacock's *Palmyra* (1805), which took its locale, subject, and themes from *The Ruins* and combined it with the traditional meditative allegory. "'Mid Syria's barren world of sand,/ Where Thedmor's marble wastes expand,/ Where Desolation, on the blasted plain,/ Has fix'd his adamantine throne. . . ."[36] Here again a monumental site whose image has been disfigured *with* time is pictorially refigured and verbally inscribed, as an allegory *of* Time—that is, of a history which, like Cronos, devours its own eras and civilizations. It fixes that imaging at a

particularized, though not a particular, time by introducing a presumably historical self into the scene. "Desolation" can easily be pictured as being part of the scene of "silent wrecks" or apart from it, ruling over it as an enthroned figure and an agent of destruction. As with Volney, Peacock emphasizes the viewer's situation:

> I mark, in silence and alone,
> His melancholy reign.
> These silent wrecks, more eloquent than speech,
> Full many a tale of awful note impart;
> Truths more sublime than bard or sage can teach
> This pomp of ruin presses on the heart.

The phrases "in silence" and "silent wrecks" identify the desolation of the scene with the desolation of the heart. The speaker is of the scene and apart from it. Later in the poem he again describes himself as standing alone, "Mid wasting domes,/ And mouldering tombs,/ The wrecks of vanity and pow'r":

> How oft in scenes like these, since Time began,
> With downcast eye has Contemplation trod,
> Far from the haunts of Folly, Vice, and Man,
> To hold sublime communion with her God!

The viewer himself is universalized with personification. The effect is to suggest a line of such viewers through history, as in Arnold's "Stanzas from the Grand Chartreuse," where the speaker, feeling himself "Wandering between two worlds, one dead,/ The other powerless to be born," meditates on the monastery's ghostliness as "a Greek/ In pity and mournful awe might stand/ Before some fallen Runic stone."

In Shelley's *Queen Mab* (1813), also directly influenced by *The Ruins*,[37] and perhaps by Peacock as well, there is a counterpart of Volney's Genius: the Fairy who describes to Ianthe's Soul the story of one perished culture after another (Cto. 2, ll. 109ff.), beginning with "Palmyra's ruined palaces." Though the objects have fallen into decay, the remnant of Palmyra "stands" as a scene. What "tells" is the silence of the presently observed place, an emblem for human achievements receding from memory but morally resignified as spectral presences: "Behold! where grandeur frowned;/ Behold! where pleasure smiled." Dominating these is the allegorical "Oblivion," who "will steal silently the remnant of [Palmyra's] fame." And yet while Shelley's Palmyra "stands to tell/ A melancholy tale, to give/ An awful warning," commanding the whole picture is his faery spirit, who "seemed to stand/

High on an isolated pinnacle." The ruins stand only in the sense of remaining. The spirit-commentator, in another sense one who stands, tells the tale, gives the warning. Therefore the voice of Fortune's rhetoric is not that of the ruined objects but of the present author and the present poem (or his surrogate) heard in a milieu of silence and absence. Although the monuments are said to impart "many a tale of awful note," in fact it is Peacock and Shelley who do (partly by means of extensive footnotes in their own voice). Thus the apparitional viewer/speaker is both a spirit in the place and the spirit *of* the place, much like Volney's Genius or Gray's elegist. These shadowy standing figures become identified with the partly fallen, partly standing ruins.

On the surface, the remaining live reality is not the ruined monuments—object- and icon-corpses—*or* the fictionally imposed figures, but the personalized lonely situation of the onlooker. The authenticity of the scene depends on its arising from a present meditative situation. However, this "real" (by comparison) situation is really fictive, without historical grounding. Peacock's poetic "I," standing "Where Thedmor's marble wastes expand," has no more basis in fact than Warton's contemplative hermit or his "Melancholy, queen of thought." This too makes the scene apparitional.

In the following chapters we shall see a still more obvious merging of self and stone structure, a response to a paralyzing experience of personal grief. In Byron's elegiac "Stanzas for Music" (1816), as the poet feels a "mortal coldness of the soul," wishing he could "weep as I could once have wept, o'er many a vanished scene," his words are "but as ivy-leaves around the ruin'd turret wreath,/ All green and wildly fresh without, but worn and grey beneath." Mourner and mourned, he becomes his own monument.

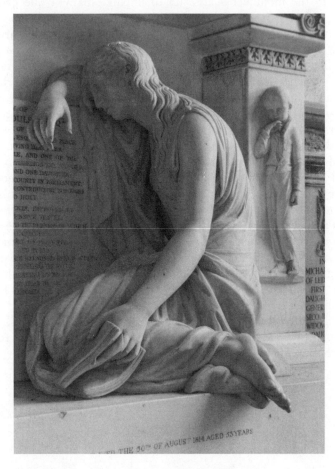

FIGURE 9. Richard Westmacott. Monument to Robert Myddle-
ton Biddulph. Ledbury, Herefordshire. Photo: Rev. John Lowe.

CHAPTER EIGHT

The Mourner Turned to Stone:
Byron and Hemans

> He stood—some dread was on his face—
> Soon Hatred settled in its place—
> It rose not with the reddening flush
> Of transient Anger's hasty blush,
> But pale as marble o'er the tomb,
> Whose ghastly whiteness aids its gloom.
>
> —Byron, "The Giaour"

MONUMENTS AND ELEGIES

According to Freud, a person with hysteria is like someone standing weeping before London's Charing Cross or the Monument to the Great Fire. A public monument is meant to evoke feelings of public pride, not private grief or regret.[1] It declares itself a work, a completed effort or achievement, signifying and publicizing its subject's own achievements. A private monument, on the other hand—the headstone for or photograph of a lost friend or sibling—provides a place and an occasion for the processes of remembering and mourning.

Fortune's rhetoric is a manifestly public response, treating its public monuments in a highly public way. It is conspicuously unelegiac. Allegorizing a scene of ruin, impersonally republicizing the remembrance of

165

once-known, now missing or forgotten, figures de-famed by Time, it signifies the poet's refusal to mourn these people or their monuments. Creating a persona and other personifications in fact suppresses or screens any private response. In "Adonais" Death keeps court over the ruins of Rome in a scene unlamented by the poet.

Shelley's lines, however, are embedded in a true elegy, a genre in which the finished work, concluding a personal mourning process, stands as both a public and a private memorial. Like some other Romantic elegies, "Adonais" focuses on the neglected, ruined, or dis-figured public site as an emblem of the dead subject's person and his loss to public memory. But monumental Rome in Shelley also functions as a locale for the poet's ongoing despair. Identifying his own fate with Keats's results in an elegiac work constituting a new monument to the public memory of both.

"But O the heavy change, now thou art gon," says Milton's "Lycidas," like all elegies a poem about change. Monuments are markers of change, and the nineteenth century became fascinated by their instability. When Matthew Arnold revisited the Cumner Hills ("Thyrsis"), both the familiar signboard of the Cross Keys Inn in South Hinksey and the "haunted mansion" in North Hinksey had disappeared. "How changed is here each spot man makes or fills!" Whereas in Fortune's rhetoric the viewer stands like Time or Fortune apart from mutability, in Romantic elegy poetic text and author become involved in it, themselves subject to the fate of monuments and their subjects: "wind-dispers'd and vain," as Arnold puts it. One product of discontinuous history, with its conspicuous gaps or shifts between periods, is the indecipherable monument of the type I have been discussing. Meditating on it, the elegist is naturally reminded of his own text; then both texts, intended as permanent messages, become emblems of personal as well as social and political impermanence. The mysterious words and figures of Hallam's tomb inevitably make problematic the legibility of *In Memoriam* itself, monument of Tennyson's own mind as well as to Arthur's person. At the very point where Gray's "Elegy" touches on the crude memorials of the village poor, the word "these" gives the poem a self-reflective turn. The dead and their monuments become tropes for the poet and his own "uncouth rhymes": "Yet ev'n these bones from insult to protect/ Some frail memorial still erected nigh,/ With uncouth rhymes and shapeless sculpture deck'd,/ Implores the passing tribute of a sigh."

Wordsworth's meditation on Stonehenge in *The Prelude* is juxtaposed with the confession of his own hope that "a work of his . . . may become/ A power like one of Nature's." This itself follows his declaration that nature consecrates the "works of man," however mean. Identifying with a solitary, forbidding artifact is one way of both defining

and presenting the self. As any meditation proceeds, the "I" that begins as a private, featureless, undefined presence (Gray's "me" left in darkness) becomes defined, while the work of the I—the poem—is gaining its own knowable form. With the kind of Romantic elegy being considered in this chapter, the spectral stone "form" assumes a number of identities, including that of the somber poet. Wordsworth's "Elegiac Stanzas Suggested by a Picture of Peele Castle" may serve to illustrate before I move on to discuss the theme in some poems by Lord Byron and Felicia Hemans.

At first the castle in the Castle of Beaumont's painting seems to be depicted with a cool distancing, a "Form . . . sleeping on a glassy sea," like William's own recollection from the time he "dwelt in sight" of it "at distance from the Kind." That naive, purely visual, and therefore "blind" perception of life and death dissipates in the painting's "sea of anger" and "dismal shore"—a scene now memorializing John Wordsworth's drowning—and the aestheticized "form" is transformed into a "Hulk" dressed in "unfeeling armour." This new sense of the castle's shape and stance embodies Wordsworth's initial stoic response to the loss: "I have submitted to a new control." That Peele Castle then becomes a figure for his poem as well as a figure in Beaumont's painting (a "passionate Work") may be the force of "here" in the final stanza: "But welcome fortitude, and patient cheer,/ And frequent sights of what is to be borne!/ Such sights, or worse, as are before me here.—/ Not without hope we suffer and we mourn."

Addressed in the first line as "thou" and as Wordsworth's one-time "neighbour," the edifice is to an extent personified, but by the line's end it is a "rugged Pile," a troubling lone figure-object, or lifeless form, standing for corporeal death: a possession or person lost. "Standing here sublime" in the thirteenth stanza, it has been restored, not as a human figure but as a trope, a now pictorialized but no longer picturesque figure in painting and poem, "standing" *for* a noble truth. The truth can involve both author and reader, as suggested by the pronouns in the last line. The elegiac situation converts the monument from a symbol of a lost other to one of the grieving self. In this role—no longer the remembered "Form . . . sleeping on a glassy sea"—it now stands with "fortitude, and patient cheer," elevated from a private to a public symbol. "Peele Castle" shows the inner self striving to achieve symbolically through words the iconic adequacy of expression of the sea and the painting. Perhaps it also seeks to show it can match Beaumont's "passionate Work" as a form and a personal record: a memorial of both his brother and his own experience.

Romantic elegies dwell on images of and from the poet's past—perhaps, as here, on retrospective monumental forms: those taken as recalling

or recording. Turning these into symbolic forms dissolves the world of the particular, personal past into that of universal human experience, now represented by the poem as monument, a work which, standing alone, provides a closure to mourning and retrospective reflection. At first too weakened by grief or bewilderment to reinterpret and sustain the monument, the poet gains the necessary insight and interpretive authority to reproduce the retrospective image as a timeless symbol, as something *seen* as itself while being *interpreted* as something else. In different ways the fourth canto of Byron's *Childe Harold* and Felicia Hemans's *Records of Woman* engage in a sort of ekphrasis with public monuments, reading them symbolically to represent a personal view of their public or published selves. The Form becomes an "intermediate image" in the sense that Wordsworth used the term—something mediating between the inanimate and the human—but also mediating, as Peele castle does, between the poet and the deceased, and between the monument and the poem.

DIM FORMS, BRIGHT MOMENTS: *CHILDE HAROLD*'S CANTO IV

For readers in Byron's day, a defining aspect of *Childe Harold* IV was its lack of pictorial "effect" ("the sensation or sentiment with which [a picture] inspires the spectator" [Elmes, *Dictionary*]). Mainly on the strength of the first two cantos, and later the Oriental tales, reviewers commonly used painting as the standard of an evaluation that was usually favorable. The *Gentleman's Magazine* found in "The Giaour" "the wild scenery of Salvator Rosa" and "the glowing contrast of earth, water, and sky of Loutherbourg," as well as reminders of Fuseli and Michelangelo. On the "bold outline" of that poem's story, the *Eclectic Review* declared, "Lord Byron . . . has laid the strongest and most brilliant colouring. The poet sees every thing himself, and so rouzes the feelings and enthusiasm of the reader, that he seems to see it too." The *Quarterly Review* attributed the "distinct and glowing" quality of the images in "Lara" and "The Corsair" to Byron's "magic of colouring." The *Critical Review* recognized in "The Giaour" the same "powers both of natural and moral description" as were evident in the early cantos of *Childe Harold*, powers "of presenting to the mind's eye by a few rapid touches of a strong and vigorous pencil, a clear, bright, and distinct image," and of "guiding the imagination through all the intricacies of human thought to the very sources of human conduct."[2]

The fourth canto of *Childe Harold* seemed to lack this clear painterly vision. It called to one reviewer's mind "a remarkable optical phenomenon which has been witnessed in Bohemia. . . . The spectator beholds his shadow thrown upon the clouds, dilated to a more than

gigantic stature. Lord Byron seems to have permanently impressed upon his inward sense, a spectral illusion of analogous origin . . . his own shadow immensely magnified, is seen reflected upon all the objects which surround him."[3] The reference was to the so-called Brocken specter, the seeing of which, according to Coleridge, was much like encountering genius: it either delighted or repelled, depending on how the image was identified. "The beholder either recognizes it as a projected form of his own Being, that moves before him with a Glory round its head, or recoils from it as a spectre."[4]

The issue here is the loss of psychological perspective, giving the effect of a loss of visual perspective. The result is a "spectral illusion" rather than the illusion of substantiality that a painting might provide. William Roberts argued that Byron's descriptions frequently are "mere expansions of himself." A poet may "transfuse something of the colouring of his own mind into his representations of natural objects," but cannot be allowed, "still borrowing our image from the painter's art, to present himself in the foreground of every landscape. We should enjoy Lord Byron's poetry much more if it were not for Lord Byron himself: he obstructs others and himself also: he stands full in his own light. . . ."[5]

Also, owing to the disconnectedness of events or scenes, the poem was thought to lack the harmony of a well-composed painting. Although one reviewer found the result delightful, like a magic lantern show,[6] Hazlitt, using much the same comparison, found it merely provoking. He likened it to a "phantasmagoria," a type of magic lantern show treating spectators to a series of projected figures that, shrinking or growing, would seem to advance on the audience, or recede, or merge with one another. "The general reflections are connected together merely by the accidental occurrence of different objects—the Venus of Medici, or the statue or Pompey,—the Capitol at Rome, or the Bridge of Sighs at Venice,—Shakespear, and Mrs. Radcliffe,—Bonaparte, and his Lordship in person,—are brought together as in a phantasmagoria, and with as little attention to keeping or perspective, as in Hogarth's famous print for reversing the laws of vision" (*Works* 19: 36).

Hazlitt required the poetic equivalent of pictorial illusionism—the depiction of solid-seeming objects in familiar-looking spaces—a mode that since the Renaissance has served to symbolize reality and order. His aesthetic is one that turns the reader into a spectator provided with a particular kind of visual experience. In Byron's fourth canto objects and people are given more or less equal status and every thing is separated from every other thing. The poem, however, has its own model for picturing the past: the emergent, self-sufficient art object, the sculptural or architectural form, whose essence is anti-picturesque—antithetical to the non-emergent, compositional nature of the picture.

As Hazlitt was himself a painter who (unlike Byron) responded keenly to picturesque poetry,[7] it is not surprising that he preferred painting to sculpture. His reasons cast some light on his evaluation of *Childe Harold.* Figures in paintings were living forms, he wrote; sculpted figures were dead ones.

> Painting is more like nature. It gives one entire and satisfactory view of an object at a particular moment of time, which sculpture never does. . . . A picture is as perfect an imitation of nature as is conveyed by a looking-glass; which is all that the eye can require, for it is all it can take in for the time being. A fine picture resembles a real living man; the finest statue in the world can only resemble a man turned to stone. The one is an image, the other a cold abstraction of nature. It leaves out half the visible impression. (*Works* 10: 163)

A painting represents and has the comprehensiveness of a total visual field, and thus creates a visual environment, as our eyes do. It is therefore lifelike and offers a life for the imagination. With sculpture, the "sense of perfect form nearly occupies the whole mind, and hardly suffers it to dwell on any other feeling" (*Works* 4:79).

For Byron sculpture, not painting, presented living forms, monuments of genius rather than monuments to glory or power. It was "the noblest of the arts because the noblest imitation of Man's own nature with a view to perfection" (*L&J* 8: 53). Sculpture, he told a visitor in 1817, was "vastly superior to painting."[8] In Milan only one picture of a thousand he saw pleased him; from Venice he wrote that he could not stand a painting "unless it reminds me of something I have seen or think it possible to see" (for that reason he hated most religious pictures); and he "utterly detested despised & abhorred" the Flemish school.[9] Although he evidently could not easily be drawn into a pictorial scene, he did respond to dynamically represented individual figures. The pictures capturing his attention were usually vivid, single-figure compositions, such as the copy of Titian's *Ariosto* he saw in Venice; or paintings of small groups, like the Guercino *Abraham and Hagar* in Milan, where the principals occupy most of the frontal plane and the setting is of little importance; or those in which, at least for him, a single figure stood out as paramount. Among these were Titian's Urbino *Venus,* Giorgione's *Tempest,* and even the crowded *Massacre of the Innocents* by Guido, from which Byron selected for comment the figure of one woman.[10]

No pictures are mentioned in Canto IV, only buildings, statues, columns, and other stone works. Nor are there many "picturesque" scenes.[11] The non-pictorial "effect" of the canto was observed not only by Hazlitt but by John Wilson,[12] who described the poem using (though not acknowledging) the visual terminology employed by Schlegel to dis-

tinguish Romantic or painterly modes of presentation from classical or sculpturesque modes. Wilson's remarks are worth quoting at length (especially in light of the fact that Byron himself attended the lecture in which Coleridge dwelt on these concepts (*LOL* 1: 344):

> Modern poets, in general, delight in a full assemblage of persons or ideas or images, and in a rich variety of effect, something not far dissimilar from which is found and admired in the productions of Painters. Byron alone seems to be satisfied with singleness, simplicity and unity. He shares, what some consider to be the disadvantages of Sculpture, but what we conceive to be, in no small degree, the sources of that power, which, unrivalled by any other productions, save only those of the poet, breathes from the inimitable monuments of that severest of the arts. His creations, whether of beauty or of strength, are all single creations. He requires no grouping to give effect to his favourites, or to tell his story. His heroines are solitary symbols of loveliness, which require no foil; his heroes stand alone as upon marble pedestals, displaying the naked power of passion, or the wrapped up and reposing energy of grief. (103)

What Hazlitt and other pictorialists looked for in a poem was "rich variety of effect"; what Canto IV of *Childe Harold* offered was "singleness, simplicity and unity," not a unity *among* objects, but a unified presence in each object. His heroes, like the poet, and like the "inimitable monuments" of sculpture, stand "alone." I believe that the "power" mentioned twice by Wilson is that of the isolated form or figure identified with the form of the poet himself. If Wordsworth hoped "a work of his . . . may become/ A power like one of Nature's," confident that nature empowers human achievements, Byron's work was recognized as drawing its force from his own familiar figure.

Like Wordsworth's Peele Castle, the canto's stone forms gather into them, and provide a focus for, a variety of impressions, seen or recalled. Picturesque poetry, like illusionist painting, furnishes the mind with an emblem of a mentally accessible world: stable, vivid, and comprehensible—the "picturesque unity," for example, of Coleridge's Shakespeare. Although potentially enveloping, Byron's sculpturesque poetry offers an emergent, theatrical facticity, with, as the last of Wilson's comments suggests, the Byronic presence appearing as one more of "the inimitable monuments of that severest of the arts." Hazlitt's criticism indicates the same by including Shakespeare, Napoleon, Mrs. Radcliffe, and Byron himself among the "different objects" juxtaposed in the canto. Obviously these are not objects in the sense that "the statue of Pompey" is, but they give the effect of being so.

Visiting Rome in 1817, Byron found the city "quite indescribable."[13] Largely untutored in art, architecture, or antiquities, depending on a

couple of standard guidebooks, he was bewildered by a succession of images foreign to his experience: "But I can't describe because my first impressions are always strong and confused—& my Memory *selects* & reduces them to order—like distance in the landscape—& blends them better—although they may be less distinct" (*L&J*, 5: 221–2).

Throughout much of the canto the poet's attempt to objectify his vision results in no general or comprehensive view. In the earlier cantos, especially the first, the separate images are sometimes elaborated into allegorical set pieces. In one of them, presented within the context of musings about "Time's ungentle tide," The Convention of Cintra (1: Sts. 24–7) is personified as a small demon robed in parchment, the English as Folly, the French as Policy. As is typical in Fortune's rhetoric, while the specific moral interpretation occurs in the vastness of "Time" ("Scorn" points her finger at the spectacle "through many a coming year"), the satiric scene is also witnessed and registered at a particular time by a meditating persona with his own melancholy idea about it ("So deem'd the Childe, as o'er the mountains he/ Did take his way in solitary guise").

In Canto IV some mysterious forms connote ruined intention, making them appropriate focuses for this type of historical irony in the mode of Fortune's rhetoric. An example is the shaft in the Roman Forum, whose pedestal had been uncovered in 1816 and which Byron addresses in Stanza 110. The lines recall Wordsworth's on the Napoleon column: "Tully was not so eloquent as thou,/ Thou nameless column with the buried base!" Such memorials, Byron continues, are today no longer tributes to their subjects but to "Time," whose eloquence they now possess. On the commemorative aspect, the subject's fame, there is silence and "nameless"-ness.

At the fourth canto's beginning, Venice is depicted as Cybele, "Rising with her tiara of proud towers/ At airy distance." It is an image not only of the city's power in the past, but, as a composition, of the present unifying and personifying power of the witnessing and writing poet ("I stood in Venice"). In the next stanza, however, her "palaces are crumbling to the shore," introducing what will be the dominant image of Italy as a "marble wilderness" (St. 79) or, as Byron called it in his dedicatory letter to Hobhouse, a "labyrinth of external objects." If features in a landscape are perceived as mere objects, without life, contextual meaning, or spatial relation to each other, the place will indeed seem labyrinthine.[14] In Canto IV there are no living people, only memories of dead persons and dead eras embodied in isolated, apparently lifeless, stones, many of them fragments: tombs, prisons, or memorial statues—reminders of the buried, the confined, the once-powerful. St. Mark's lion and horses, the tombs of Dante and Ariosto,

Tasso's prison room, the "nameless column with the buried base" (St. 110)—all are haunted by undisclosed spirits, *genii locorum* imprisoned by time. They thus suggest impotence, muteness, isolation, and spiritual deadness. "Alas, for Earth," Byron laments, "for never shall we see/ That brightness in her eye she bore when Rome was free!" (St. 82). Antiquity here is a non-emergent figure, a spirit whose vividness has been veiled by centuries.

In this last stage of the pilgrimage (which Hazlitt described as "a mass of discordant things" [*Works* 19: 41]), the poet seeks a way through the marble wilderness of man's history by discovering in its aspect evidences of an enduring spirit, a "being": evidences of vividness and permanence. They are occasionally found, but most of the canto simply proceeds from one historic attraction to another, plodding over "steps of broken thrones and temples" (St. 78) without map or compass: "Chaos of ruins! who shall trace the void,/ O'er the dim fragments cast a lunar light,/ And say, 'here was, or is,' where all is doubly night?" Just when we believe we can make sense of this chaos, "some false mirage of ruin rises near" (St. 81). The "dim fragments" studied by the poet are cities, sites within cities, and especially structures erected on those sites: pieces less of once whole objects (the focus is not much on ruins as such) than of time and civilization. Though often referred to or addressed directly as persons, they are generally unresponsive to questions posed. They have, for example, "nought to say" about the unmarked remains of the land's greatest writers (St. 56). Thus their "dimness" is their inexpressiveness and thus their resistance to being apprehended as realities. Like the phantom of Astarte in *Manfred,* they appear and disappear without revealing their secrets, and the promise of a "being" or spirit of the place is only a "false mirage." The tomb of Caecilia Metella, the "stern round tower of other days," can delay "an army's baffled strength" (St. 99) or, in this case, the baffled strength of the inquiring spectator. Byron asks the tomb a series of unanswered questions, discovering little about its history or purpose.

So, failing to invoke the spirit of this vivid but lifeless form, he withdraws into the formless subjectivity of his own inner life: "other days come back on me/ With recollected music, though the tone/ Is changed and solemn, like the cloudy groan/ Of dying thunder on the distant wind" (St. 104). He lets his memory, as Byron's letter from Rome reported, reduce his impressions to a subjective order, blending them better though leaving them less "distinct." The very blankness and dimness of the monumental objects makes them easily translatable into the imagination's own structures, the "heated mind" envisioning "Forms from the floating wreck which Ruin leaves behind" (St. 104). Thus the "woes far heavier" than Caecilia's "ponderous tomb" (St. 102) are

Byron's, belonging more to his now accessible but suppressed past than to Caecilia's inaccessible one. Unlike Fortune's rhetoric and the personifications employed in earlier cantos, the imagination does not use its figures to objectify loss and create a distancing perspective.

The principal images of the canto, according to Bernard Blackstone, are a special kind, the ideogram, "the product of a fusion of Byron with his environment." By "environment" Blackstone means everything present for the poet: feelings and memories as well as external, material things like the Bridge of Sighs or Petrarch's tomb. "All are felt as projections of an inner situation, an indivisible union with it, so that 'inner' and 'outer' are no longer antitheses, but co-exist in the artistic construct, and only there."[15] If it is true, as Blackstone says, that objects in the poem are first made into "inner situations," then given symbolic projection, the status of all events in the poem is uncertain. Pictorialism indicates a clearly perceived relation between oneself and what one sees. This distinction is of course blurred with the ideogram. Partly because of this, the famous passage that begins, "The beings of the mind are not of clay" (Sts. 5–7) is a maze of possible meanings, as shown by the number of widely divergent readings.[16] So is the immediately preceding passage, where Byron describes the personal significance of Venice,

> and her long array
> Of mighty shadows, whose dim forms despond
> Above the dogeless city's vanish'd sway;
> Ours is a trophy which will not decay
> With the Rialto; Shylock and the Moor,
> And Pierre, can not be swept or worn away—
> The keystones of the arch! though all were o'er,
> For us repeopled were the solitary shore. (St. 4)

These "dim forms" reflect what Hazlitt would call "the accidental occurrence of different objects," a juxtaposition of forms that arrive in the mind from being seen (the Rialto), that are called up in the mind as remembered image (characters from Otway and Shakespeare), and that the mind brings to the scene as feeling (Byron's own melancholy sense of himself). The three aspects merge, representing one another. Further, the "mighty shadows" cannot safely be assigned to any of the three categories. Although the dim forms that make them are most obviously the many sculptured figures both on the Doge's Palace and the facade of San Marco Basilica—including the mosaic of the translation of the body of St. Mark to the Basilica—it is possible to conceive of them as memories or phantoms of historical persons such as the Doges. In the fourth canto poet and reader experience a closed perceptual world consisting of

things seen, which are mainly stone forms; things known, which are usually memories of the dead and the defeated; and a continuing implied image of the authorial self. The three are analogous and therefore mutually referential. A disorienting effect results by which all events seem phantoms or reflections of the self,[17] rather than projections, for example, of that happy state in Wordsworth wherein inner and outer merge in the expanded concept of self as all-inclusive. In the Wordsworthian Alpine section at the end of Byron's Canto III, the poet as a "part of being" (St. 89) belongs to an undifferentiated whole. He is a soul in a spiritually defined world, not an object among objects or, as Byron says in Canto IV, a "ruin amidst ruins" (St. 25). In moving into the last canto the poet leaves behind his absorption in a "life intense" and seems to enter a landscape of lifeless, isolated, non-emergent or semi-emergent Brocken specters.

Childe Harold IV makes the traditional elegiac connection between lamented deaths of others and the death of the poet's own power, and also between the fame of the dead and the death of his own fame (Sts. 9–10). However, the dead he laments are not people but things: objects recalling people who once lived. Many of the country's monuments have been disfigured, either by having their figures removed (the St. Mark's lion and Trajan on his column) or by having the figural representations worn down (the Doges) or damaged (Egeria, Ariosto, the she-wolf). Thus the object remains, but like Wordsworth's Napoleon column, uninscribed. Often in the canto the ashes or relics of those memorialized have been displaced, turning their tombs into cenotaphs, memorials to those whose remains lie elsewhere. Even the Gladiator, who belongs with the Colosseum and is *its* figure, is elsewhere; like the others it must be recalled.

Still the poet affirms that his mind can re-people the solitary shore with figures he has read about in stories set in Venice, "a trophy which will not decay/ With the Rialto." Shylock, Othello, and Otway's Pierre "cannot be swept or worn away." These ideal, living forms are more durably monumental than those on stone monuments. *Growing* within us, such beings of the mind "create/ And multiply in us a brighter ray/ And more beloved existence," freeing us temporarily from our "mortal bondage." That, at any rate, is the "worn feeling" that "peoples many a page," including perhaps "that which grows beneath mine eye" (his poem), a feeling of refuge from hope or vacancy. The first part then is about the sense of Venice's bondage and vacancy and of the poet's own authorial consciousness. However, involving oneself in the necessarily dying past arouses personal melancholy. *His* and the Empire's pasts merge, making "the sun like blood, the earth a tomb,/ The tomb a hell, and hell itself a murkier gloom" (St. 34).

Byron's is a quite different Italy from that described by the art historian Heinrich Wölfflin: "To the traveler arriving in Italy from the North, the world appears all at once more tangible, simpler, and more definite. . . . Everything, down to the single column, is firmly self-contained; and the forms seem set apart from one another in more explicit contrast than in the North."[18] *Childe Harold*'s world is one of separate forms, but dim ones, neither tangible, simple, nor definite. The reason has to do with perspective. The poet conceives of his own record as so paralleling Italy's—one of undeserved injuries and public neglect of talent—that there is always a strong element of projection, blurring the distinction between the mind and its environment and leaving, as we have seen, individual images unclear in their outline.

An ideogram, as André Malraux originally used the term in *The Voices of Silence,* is a kind of artist's signature positioned within the world of the work rather than on its surface—Van Gogh's painting of the straw chair with the artist's pipe on it, for example. Such objects were signs of the painter's power of "subduing all things to his style" (119). Like any signature, it signifies the publicly known self and may be, as it is in Gray, the work itself conceived of as existing within the very world represented in it. The elaborate eloquence of Fortune's rhetoric conceals the poet's personal self, as the public self stands apart from the monumental scene that it views, marks with its own inscription, and judges. It is this imperial detachment, the fiction of objectivity underlying the figuration, that characterizes that allegorical convention. The monument's loss of its original public iconography leaves room for a new, publicly imposed one, an iconography denying to the artifact its original embodied meaning. Byron's ideographic signature is of an artist not succumbing to his world, but neither able to reorder it pictorially, as Van Gogh and his contemporaries did. In the first two cantos, as his preface to them explained, the figure of Harold was introduced "for the sake of giving some connexion to the piece," though the poem has "no pretension to regularity." The episodes and observations in Canto IV are just as disconnected, but there is, through the ideographic reordering of the monumental landscape, the strong unity of effect noted by reviewers.

With the disappearance of Harold as form and voice, the figure of Byron's viewing consciousness grows megalithic—that is, assumes the aspect of an isolated, deteriorating featureless "object," as Hazlitt and John Wilson both observed. The process begins as early as Canto III:

> By a lone wall a lonelier column rears
> A grey and grief-worn aspect of old days;
> 'Tis the last remnant of the wreck of years,

And looks as with the wild-bewildered gaze
Of one to stone converted by amaze,
Yet still with consciousness; and there it stands
Making a marvel that it not decays. . . . (St. 65)

The succeeding stanzas tell the story and describe the nearby tomb of
Julia Alpinula, a priestess of Aventicum, the Roman capital of Helvetia.
Unable to save her father when he was accused of treason, she died soon
after him. "Their tomb was simple, and without a bust,/ And held within
their urn one mind, one heart, one dust." The column was a monument
at first to an empire, later to those empires that the earth forgets "with
a just decay," and ultimately to "old days" and "the wreck of years."
The act of viewing converts it to a monumental effigy, not of the two
who died but of the one who witnesses those deaths retrospectively
through their common tomb. Paralyzed but conscious, he "stands" only
as a vertical object does, and yet while unable to act expressively, still
able, as he says, to know. It is the speaker's posture and situation
throughout *Childe Harold*.

The passage is in the long poetic tradition of the mourner made into
a monument, perhaps the most notable example of which is Milton's
tribute, mentioned earlier, to his famous predecessor. Shakespeare's
"live-long Monument," the lines go, has built itself "in our wonder and
astonishment": "Then thou our fancy of itself bereaving,/ Dost make us
Marble with too much conceiving;/ And so Sepulcher'd in such pomp
dost lie,/ That Kings for such a Tomb would wish to die." Punning on
"stone"/"astonishment," Milton's fancy grieves not over Shakespeare's
death but over its own weakness in the present poem, "the shame of
slow-endeavouring art" compared to the other's "easy numbers." Thus
by his paralysis the speaker, as elegist, becomes his own effigy *and* a
monument to Shakespeare at the same time. In this kind of monumen-
talization the speaker is represented, as on tomb-allegory, as a sculptural
embodiment of motionless (and powerless) grief or memory. In "Auto-
biography as De-Facement" Paul De Man notes that Wordsworth's
"Essay on Epitaphs" quotes the first part of Milton's sonnet (about
Shakespeare's not needing a pyramid or some such form to mark his
memory), but omits these lines. For De Man, Wordsworth's omission
indicated his desire to evade the "sinister connotation that it is not only
our own mortality but our actual entry into the world of the dead" that
a speaking epitaph, or any prosopopoeia, accomplishes (78). I would
respond that the marble man has not entered the world of the dead but
stands above it, as a helplessly conspicuous funerary monument. Byron
employed the trope in his early "Epitaph on a Friend": "No marble
marks thy couch of lowly sleep,/ But living statues, there, are seen to

weep;/ Affliction's semblance bends not o'er thy tomb,/ Affliction's self deplores thy youthful doom" (ll. 11–18). Byron himself ("Affliction's self") is the monument, taking the place of the personified, allegorical image ("Affliction's semblance"). He is, then, a human actor in the scene, his monumental self a performer.

Byronic stoicism in *Childe Harold's Pilgrimage* creates a special kind of self-monumentalization, a reduction of the self, not to an emblem of grief and awe as in the above lines, but to a standing object, "a ruin among ruins," in the face of the spectacle of Time's dominion: "I stood and stand alone,—remembered or forgot" (3: St. 112). Unlike Fortune's rhetoric, whose figurative conversion of the monumental image asserts power over the "world" and its role in creating history, this is an admission of defeat by one who cannot act creatively in the *world,* but who must only witness and endure ("a life within itself"; 3: St. 12). Byron's self-image is that of an unhonored corpse: "I stood/ Among them, but not of them; in a shroud/ Of thoughts which were not their thoughts" (3: St. 113). As long as he is obsessed with these memorials he only reconstitutes the image ideogrammatically or solipsistically with reference to his present effort.

Carolyn Springer has argued that the Romantic treatment of ruins, especially the Byronic treatment, was anti-archeological in not really seeking to recover the past but to use it to express present loss and vacancy. "By inscribing the names of Titus and Trajan—among the most familiar points of reference in Roman topography—only to erase them, Byron subverts the very notion of archeological attribution." Ultimately, Byron's desire, Springer says, is to build a monument for himself at the expense of such as these, one "more lasting than marble or bronze."[19] We cannot be sure about Byron's intentions, but I suggest that the poem erases only some old monuments for the sake of his own new one to himself. These are the "dim," ultimately ideographic, forms that appear mainly in the first half of Canto IV. Especially in the later sections, there is the effort to sustain the monument in one of two ways: either by presenting a vivid reading of the present figure (the Laocoon and the Apollo), or by imaginatively enfiguring the figureless object. All of these are instances of repeopling the solitary shore by bodying-forth brilliant "Forms" (St. 104). The forms themselves possess charismatic presence, brilliance, physicality or bodiliness, beauty of shape, expressiveness, and a majestic isolation. The Venus, which "loves in stone, and fills/ The air around with beauty" (St. 49),[20] is the sort of work that retains its aesthetic presence. It is neither mimetic nor memorial, but conceptual and expressive: "What Mind can make, when Nature's self would fail" (St. 49). Things cannot live, but minds can—while in the act of

poetic expression or manifestation, taking form as gods do ("Glowing," they "become as mortals"); man in *his* form-creating as artist or imaginative spectator has fleeting "moments like their brightest" (St. 52). The canto's brightest moments, an almost uninterrupted sequence of which occurs in the climactic Rome section, are dramatically exemplified in the Venus passage: they inspire or are inspired by works memorializing living ideas rather than dead persons.

"Beings of the Mind" in poetry are "essentially immortal" and "multiply in us a brighter ray." But might not Byron be thinking of the Venus, the Apollo, and the Gladiator when he declares that although the poet might people "many a page," "there are things whose strong reality/ Outshines our fairy-land; in shape and hues/ More beautiful than our fantastic sky"? Those "things . . . in shapes and hues" have a tangible reality and permanence not enjoyed by verbally represented figures, which come like truth and disappear like dreams (4: St. 7). Byron's "Prophecy of Dante" calls the poet "the new Prometheus of new men." The line of great poets, however, "which peoples but the air/ With Thought and Beings of our own thought reflected,/ Can do no more" and "The kindled Marble's bust may wear/ More poesy upon its speaking brow" (Cto. 4). Venice's desponding "dim forms" at the beginning of *Childe Harold* IV merely recall those Venetian Doges, Trajan, and other once-living men. Like Byron's Pilgrim, whose "breathings" at the end of the canto "are his last," they are what Hazlitt and Coleridge call "cold" forms. The Apollo statue, however, has not "caught/ A tinge of years, but breathes the flame with which 'twas wrought." The bright forms of the last part of the canto are emblems of a mind dynamic, assertive, aspiring, self-sufficient. They emerge and stand out theatrically, defining themselves and focusing the viewer's feelings.[21] This emergent quality is perhaps their most important: by individuating themselves, separating themselves from the general scene of chaos and loss, they become vividly apprehended images that can ultimately constellate into a significant pattern.

Like most of the other works mentioned in *Childe Harold,* the Medici Venus and the Belvedere Apollo belonged to a select group of several dozen so well known that writers could depend on readers' visual memory of them.[22] The knowledgeable reader carried to the poem images of objects—buildings as well as sculptures—gathered from prints, paintings, drawings, and travel-book descriptions. Thus the naming of or alluding to such works would evoke a picture that could be developed or vivified by dramatizing the figure. Byron does this and gives to the stone form what it never had for Hazlitt, a human aspect. Of her own visit to the Capitoline Museum, Lady Blessington wrote, "One object riveted my attention—the Dying Gladiator. Its own

transcendent merit would have achieved this, but the poetry of Byron has invested it with increased interest. . . . Never will English eyes at least, dwell on the Gladiator without Byron's description recurring to the memory. Glorious privilege of genius! thus to identify itself with the beautiful and sublime."[23] Byron does identify his "genius" with those beautiful and sublime forms, successfully enough that those like Lady Blessington, viewing them after having read the poem, merged the images she personally viewed and those Byron pictured for her. So the sculptures in Italy and the figures in the poem were equally, to use John Wilson's words, Byron's "creations . . . of beauty or of strength." But it was his "genius"—his creative self alone—that effected the identification. His personal self, as I have said, identified with the failed, "dim" forms.

Canto IV's Promethean effort of giving all these stone bodies life is only briefly effective. Immediately after the Apollo, the "poetic marble" of "eternal glory" (St. 163), Byron records his own hero's disappearance: "And he himself as nothing" (St. 164). All things "grow phantoms" and "the cloud/ Between us sinks and all which ever glowed,/ Till Glory's self is twilight . . ." (St. 165). Any form's reality resides in its conspicuousness, its individuality and intensity. But things glow into reality only as they are experienced. The more splendid monuments of Italy's artistic genius are viewed by the poet of *Childe Harold* in a way that, certainly for many of his time, brought them to life. For Byron the meaning of a work of art depended not on its faithfulness to life, but on whether, in its emergence, it became real; and that meant whether the aesthetic experience involved in its contemplation awakened the viewer to a genuine, if brief, awareness of his own inner life. The design of the fourth canto can be found in the pattern of these awakenings.

Ultimately, the only imperishable form is, to use Byron's term, "Affliction's self," the formal elegy's dramatized image of the repining authorial consciousness. In fact, it is toward elegy that the poem moves. Near the end, just after the section on the imperturbable Apollo, Byron wonders if his Harold has been one of the "forms which live and suffer" (St. 164). By then that figure has pretty much vanished, its place taken by the composing poet himself, contemplating forms, some dim, some bright, none of them either living or suffering. The "external objects" in *Childe Harold,* as the dedicatory letter calls them, ideograms for a monumental authorial self, stand for the poet's limited but conspicuous power, that of endurance—of being there and remain-

ing there. However, they screen his formless, melancholic personal inner world; to the extent they are read as monuments of public history they serve him in stoically suppressing images from his own past. Thus the canto seems to refuse involvement in the elegy's inevitable aspects of introspection and personal memory. Standing in the Colosseum, invoking the spirit of Time, the poet becomes "a part of what has been,/ And grow[s] unto the spot, all-seeing but unseen" (St. 138). Both the canto's structure and accompanying apparatus emphasize the historical aspect of a poem that moves from place to place, monument to monument, fixing its attention on things, uncovering or failing to uncover *their* history. These objects were given a particular kind of identity—as an historical, not an autobiographical, text—by Hobhouse's copious notes, which Byron said would serve as an "elucidation of the text" (*Works* 2: 122).

Very early in the canto the poet declares that melancholy bosoms must "strive with demons, who impair/ The strength of better thoughts" (St. 34). Immediately, the poem takes a turn that sets the direction to the end: a move away from the melancholic and private self to public, historical places and things. Freud tells us that in melancholia the ego is diminished, whereas in mourning the world is (246).[24] But as we have seen, and as reviewers did not fail to notice, Byron's ego and the objects in the world are scarcely distinguishable, so that at any point we cannot tell whether a lament for lost objects amounts to historical commentary or personal reminiscence. Though "All suffering doth destroy, or is destroy'd," griefs inevitably return, striking the electric chain that darkly binds us (Sts. 22–3). These memories of "the mourn'd, the loved, the lost" he dispels at once by demanding his soul "back/ To meditate amongst decay, and stand/ A ruin amidst ruins." Later, after a similar spell brought on by Metella's tomb, he urges himself to the Palatine Hill: "Upon such a shrine/ Where are our petty griefs?—let me not number mine" (St. 106). This journey among cultural relics and away from the sources of his own despair is punctuated by conventional diatribes against kings and their ambitions and by bitter reflections on imperial ruins.

Illegible monuments in *Childe Harold* bespeak a cultural discontinuity symbolized by the imagery of displaced remains, mourning parents, and lost or dead children. But whatever of worth has been lost, disfigured, or mistreated is not lamented for long: lamentation for the victims is supplanted by sustained scorn for the oppressors, identified by the train of erect or once-erect monumental forms representing the now-petrified fame of male historical figures. Scattered here and there, however, are emblematic female figures, objects of authorial pathos. There is Italia, with her "fatal gift of beauty" and "tears of [her] distress" (St. 42).

Rome, "Lone mother of dead empires," is figured as the Uffizi's Niobe (Sts. 78–9). These grieving maternal figures, familiar both in graphic illustration and sculpture, represent the most definitive monumental figuration in the work. Florence, who "vainly begs her banish'd dead and weeps" (St. 59), may be taken also as a feminized version of Byron, who had without success attempted to keep his wife and in-laws from sending his daughter Ada abroad: "My whole hope—and prospect of a quiet evening (if I reach it) are wrapt up in that little creature . . ." (L&J 5: 110). It is also an emblem for Byron's poem, which statuesquely monumentalizes private griefs the way elegies do, turning the process of grief into a public form or unified achievement.

Near the canto's conclusion these female weepers introduce the most prominent monumental figure, Princess Charlotte. News of the death of the immensely popular daughter of the Prince Regent, Heiress Presumptive to the throne, reached Byron in Venice at the end of November as he was finishing the canto. She had only briefly survived her newly born child. This was a little over a year after her marriage to Prince Leopold of Saxe-Coburg. Having begun with the imagined figure of Venice as a tiaraed Cybele and then moved to Rome as Niobe, "Childless and crownless, in her voiceless woe," the poem ends with another discrowned mother. Shelley's own prose essay on Charlotte observed that she "loved the domestic affections" (*Prose* 168). Byron is interested in the wife and mother, not the royal personage. "Those who weep not for kings shall weep for thee," he proclaims, in what now becomes a formal elegy (Sts. 167–72). The canto has left its famous monuments to mourn the recently dead Princess, who as yet of course had none. However, one passage, with suggestions of various Holy Family motifs including the Pietà (connected with the image of her son as Christ in St. 170), serves as a kind of effigy while fitting the canto's pattern of mourning regal females: Charlotte "Seems royal still, though with her head discrown'd,/ And pale, but lovely, with maternal grief/ She clasps a babe, to whom her breast yields no relief" (St. 167). The canto has moved alternately between "forms which live and suffer" and those wrought masterpieces that are above feeling but expressive of beauty. One kind of figure is all too human in its expression, the other kind all too remote. Now, with Charlotte, "grief" *becomes* "beauty," and the mourned and mourning become monumentalized.

Although he shows her subjects mourning her death, that seems a very personal lamentation. Byron himself is the monumental mourner, the "Affliction's self" that "deplored" his young friend's death in the earlier elegy.

HEMANS'S *RECORDS OF WOMAN*

By 1820 Felicia Hemans was to Byron no more than one of the inadequately educated "*He*-mans and *She*-mans" littering the poetic landscape with artificial verse. Pleased with the pun on her name, he referred to her in letters as "Mrs. Hewoman" and a "feminine *He-man*" (9/17/20, 8/12/20, 9/28/20). But there was a work of hers he traveled with, "a good poem—very," an 1816 effort with the prosaic title *The Restoration of the Works of Art to Italy*. It celebrated the return to their former homes of those "Forms of sublimity" looted by Napoleon and installed at the Louvre.[25] Since Byron had penned his assault on what he regarded as Lord Elgin's cultural theft ("The Curse of Minerva"), it is not surprising that an attack on the transportation of monuments would interest him greatly, enough in fact, to inspire a little borrowing, as one can see by comparing Hemans's poem with his own fourth canto, as the two of them extol the Medici Venus, the Belvedere Apollo, and especially the Laocoon. Like Byron, Felicia Hemans was always fascinated by stone figures, whether monuments of art or monuments to the dead. She found them as expressive as books: inextinguishable records of individual lives or of the spirit of past ages. Toward the end of Canto IV Byron announces, "In this page a record will I seek./ Not in the air shall these my words disperse,/ Though I be ashes" (St. 134). Both he and Felicia Hemans leave records of themselves in elegiac meditations on the records of others.

Byron's note on his Santa Croce church section raises the question of how women of achievement might be remembered. It cites the case of Madame de Staël, author of an admired passage on that building (in *Corinne*). Because her only personal memorial was one supplied by reputation, a "picture embellished or distorted, as friendship or detraction has held the pencil," Byron uses the extensive commentary to honor and "mourn" first the author, then the friend and mother, "tenderly affectionate and tenderly beloved." Hemans, also wondering about the public image of herself a woman might leave, came to think that it must be a direct impression (or expression) of her affections. The poet's "Image in Lava" (307–10)[26] contemplates a "thing of years departed," a solidified impression reported at Herculaneum of a mother clasping her infant. I believe this "rude monument,/ Cast in affection's mould" (and perhaps recalling Byron's Charlotte) became her model of female monumentalization—not an edifice, like "Temple or tower," the "proud memorials reared/ By conquerors of mankind," but the "trace" of a "woman's heart." Her distinction is between male pride, which builds forms to record achievement, and female "affection," which impresses

its own form *as* a record. The poem too is such an impression, not only of the mother but also of the poet, as indicated by the ambiguous "these" in its final stanza: "Immortal, oh! immortal/ Thou art, whose earthly glow/ Hath given these ashes holiness—/ It must, it *must* be so!"

The piece appeared in the same volume as *Records of Woman,* an 1828 collection of twenty poems, mostly about traces of themselves left by women. That book's reprint editor, Donald H. Reiman, somewhat harshly concludes that she is now unread and unremembered because "she spoke only from the past to her age and not, as well, from her age to the next" (*Records,* xi). The volume's purpose, however, is to ask what sort of monumental form women—she and those she writes about—can use to speak from their own age to the next. Notably, she views and provides records of "woman," not women, her title emphasizing her topic's universality. "Mens wits and knowledges," according to Bacon, may be monumentalized in their works. Hemans shows how difficult that is for women, whose "records" are ignored by the world at large. The collection deals with various original memorials, none of them adequate by themselves either to memorialize the subject or to objectify the viewer/poet's own personal feelings. To gain these ends, her poems seek to remonumentalize the record. Like most of Hemans's work, they are severely objective, especially compared to Byron's, fixing on their subject and seldom admitting mention of the poet as person. Maybe for this reason Reiman finds no evidence in her work of a "struggle toward self-discovery" seen in *Childe Harold* and poems of other male contemporaries (xi). As in *Childe Harold,* I would argue, the stone forms that dominate the significant landscape of *Records of Woman* are ideographic signatures of the poet's public self.

The early poems in *Records* treat women who owe whatever imperfect record they have to some man. The various stories Hemans recounts she only knew through books she read, a fact made conspicuous by her quotations from sources. For her, the places, people, and events had never been directly experienced, only visualized. (Byron dismissed her 1817 *Modern Greece*[27] as a poem "written by some one who has never been there"; *L&J* 5: 262). For the opening piece, "Arabella Stuart," she found a source in a passage in D'Israeli's *Curiosities of Literature:* "What passed in that dreadful imprisonment, cannot perhaps be recovered for authentic history,—but enough is known. . . . Some effusions, often begun and never ended, written and erased, incoherent and rational, yet remain among her papers." Hemans meant her own work as "some record" of the woman's fate, and the "imagined fluctuations of her thoughts and feelings" (4): a way of giving, through the medium of dramatic monologue, a more coherent though still partial view. Her

"records" are both personal traces—impressions of herself left behind—
and records made *of* a person, as with *Curiosities.*

Perhaps the most ambitious piece in the volume is "Properzia
Rossi," whom the poet describes in a note: "a celebrated female sculp-
tor of Bologna [1490–1530], possessed also of talents for poetry and
music, died in consequence of an unrequited attachment.—A painting
by [Jean François] Ducis [1733–1816], represents her showing her last
work, a basso-relievo of Ariadne, to a Roman Knight, the object of her
affection, who regards it with indifference" (45). A dramatic mono-
logue, perhaps the closest thing to Browning before Browning, the poem
clearly has autobiographical overtones, not only in the choice of its artis-
tic protagonist but in the aspect of unreturned love. (Felicia had married
Captain Hemans at eighteen. In 1818 he left for Italy for the sake of his
health. The separation was permanent.) In the first part Properzia voices
the wish that "earth retain a trace/ Of that which lit my being." Her new
stone carving, depicting Ariadne both as an effigy and as a symbol of her
life, will embody that being: "I would leave enshrined/ Something
immortal of my heart and mind." As a monument, it is an effigy of her
and a symbol of her life: "It grows—and now/ I give my own life's his-
tory to thy brow/ Forsaken Ariadne." At the end she realizes that it will
be as indifferently remembered as she will; her only fame will depend on
a male painter's image of her male lover's cold response. Like "The
Image in Lava," both Properzia's utterance and the Ariadne relief are
heart's impressions, records of her "affection." That her art alone did
little to immortalize her is evident from her neglect by later historians.[28]
Hemans's poem gives her a certain additional measure of fame.

The early poems in the *Records* attempt to revive the original image
and voice of the deceased. Prosopopoeic dramatizations or narratives,
they focus on the idea of a death in need of a monument, or simply on
the use of the poem to remonumentalize. Each of the last three, "The
Queen of Prussia's Tomb," "The Memorial Pillar," and "The Grave of
a Poetess," is a meditation on a sepulchral object that becomes the poet's
own ideographic record. Thus they feature both a distancing "thou" and
an implicit self-identification. As is often the case in *Childe Harold,* this
tends to give the monumental form not merely the "double identity"
noted by Philipp Fehl (itself as object and what it stands for): it absorbs
the identity of the gazer. "The Image in Lava" is perhaps the most obvi-
ous example of a dead person's "image" (both a likeness and the public
perception) monumentalizing itself. The loving mother's petrified
impression may also be taken as an emblem of the stony mourner. There
are other examples in Hemans's verse. In "Imelda" the woman, seeing
the body of a lover who has been killed in a duel, sucks poison from the
wound and dies: "Two fair forms laid/ Like sculptured sleepers."

Together, the figures comprise a monument both of the man's form and of the woman's own grief and fidelity. In "The Peasant Girl on the Rhone" a young warrior is laid to rest within his family's chapel. His effigy has the same kind of mixed status—corpse and artifact—as Keats's "Sculptur'd dead" in *The Eve of St. Agnes*. "The sculptor gave/ Trophies, ere long, to deck that lordly grave,/ And the pale image of a youth, arrayed/ As warriors are for fight, but calmly laid/ In slumber on his shield." Flowers begin to appear beside the tomb regularly and mysteriously. One day their presumed donor is discovered there dead: "That still face/ Had once been fair; for on the clear arch'd brow,/ And the curv'd lip, there lingered yet such grace/ As sculpture gives its dreams."

"The Queen of Prussia's Tomb" is that of Louise (1776–1810), the strong, politically capable wife of the weak Frederick William III. She helped reform the army and interceded unsuccessfully with Napoleon to save her territories. Hemans draws on a recent visitor's account of the burial place on the palace grounds at Charlottenburg, describing a "portrait-statue recumbent, said to be a perfect resemblance—not as in death, but when she lived to bless and be blessed. Nothing can be more calm and kind than the expression of her features. The hands are folded on the bosom; the limbs are sufficiently crossed to show the repose of life." (150). Hemans's poem is a paraphrase, with commentary, of this account: "And what within is richly shrined?/ A sculptured woman's form,/ Lovely, in perfect rest reclined. . . ." Like those in Tennyson's possibly derived "Sleeping Beauty"—"A perfect form in perfect rest"— Hemans's lines can allude to the poem as well as its subject. In either case its "rest" is from the transforming processes of life and death: a monumental repose. It is this "living image," as it is characterized in Hemans's source, which she treats for half of the poem. Because of its strong sense of the physical ("Thou feel'st the presence of the dead"), this piece has more of immediate, real experience than any preceding it in the volume.

In the Queen of Prussia's monument an eagle is situated at the effigy's feet. This is her regal insignia (she "Was royal in her birth and wo"), but at the poem's end it becomes an emblem for the national liberation to occur after her death: "And the crown'd eagle spread again/ His pinion to the sun." Historically there have been two kinds of sepulchral insignia, according to Erwin Panofsky: the retrospective, commemorating the person's past life and deeds (military trophies, etc.), and the prospective, looking toward the future—in the Middle Ages, for example, toward an afterlife.[29] One might say that retrospective imagery pertains to the person as having lived, prospective to the person's living spirit.[30] Romantic elegy creates a prospective image of life after death (fame, immortality) by converting or transforming a death figure (por-

trait, effigy, death mask), which stands for a dead, past self, in effect interring the figure. Thus the eagle becomes a complex *symbol* not of the Queen, but of her fame and of Prussia's eminence (the two are connected). This conversion of an image of the dead to symbol of eternal life occurs in all three of the final *Records*. It is a conversion meaningful for both the writer and her female subjects.

The next-to-last piece in the collection, "The Memorial Pillar," tells of a small post standing by the roadside near Penrith, inscribed with its own story: it was placed there in 1656 by the Dowager Countess of Pembroke to remember her last parting with her mother forty years before. Hemans had read about it in Samuel Rogers's *Pleasures of Memory*, where the inscription is recorded in a note. As with other pieces in the collection, she paraphrases a man's account of a woman's record. Here is Rogers: "That modest stone, by pious Pembroke rear'd,/ Which still records, beyond the pencil's power,/ The silent sorrows of a parting hour." And here is Hemans: "Oh! ye have shrin'd a spell of power,/ Deep in your record of that hour!" Both Rogers's lines and Hemans's are in effect reinscriptions, writing over what has been written before, memorializing what Hemans calls, as the title of another collection, "domestic affections." And again, because of biographical parallels (her own mother had recently died), the monument of the woman in the poem stands as her record as well:

> Yet, while thy place of weeping still
> Its lone memorial keeps,
> While on thy name, midst wood and hill,
> The quiet sunshine sleeps,
> And touches, in each graven line,
> Of reverential thought a sign;
>
> Can I, while yet these tokens wear
> The impress of the dead,
> Think of the love embodied there,
> As of a vision fled?
> A Perish'd thing, the joy and flower
> And glory of one earthly hour?

The next stanza calls, as does "The Queen of Prussia's Tomb," for Christian faith in an existence escaping life's bondage of present to past. As a *memento mori* the monument reminds the viewer of the brevity of life. Hemans's conclusions attempt to go beyond that, by interpreting an offered, fortuitous symbolism of impressions and tokens. When Hemans asks, "Can I . . . ?," she begins to include herself in the scene as a viewer impressed with the tokens of the dead. The "impression" on the pillar

becomes an impression made by it. The tokens on the work are read as tokens of general truths, true symbols (the universal seen through the particular) arising from the superscripted emblematic.

As with "Properzia Rossi" and "The Memorial Pillar," Hemans's final piece, "The Grave of a Poetess," identifies the writer with a dead female subject. That person is Mary Tighe, the author of *Psyche,* a source for Keats's Ode. Hemans's poem first dwells on the grave's beautiful sunlit vernal setting, mirroring Tighe's poetry, a "ray that brightens earth and sea,/ the light of song." Then, as they consider the woman's present darkness, the lines turn "mournful." Finally, with thoughts of all the "lovelier things" Tighe's spirit may now be enjoying, Hemans puts aside her "vain sadness."

Although this poem begins "I stood beside thy lowly grave," Hemans had then only read about the place in some of Tighe's family records. In "Written after Visiting a Tomb,"[31] composed some years later, there is more both of the actual memorial and of Hemans herself. This epilogue is about grieving: "And mournful grew my heart for thee. . . . Mournful, that thou wert slumbering low. . . ." But here too is a Christian resolution, with the poet identifying with one in whose "woman's mind. . . . The light of song was shrined," and who now sees the light of Heaven.

The Tighe memorial, executed by John Flaxman and exhibited at the Royal Academy in 1815, shows her asleep on a mattress, her head resting on her arm. An 1824 visitor to the grave mentioned the "beautifully composed lines" of the draperies and also the "fairy-like Psyche in a mournful attitude" sitting at the head of the sleeping form.[32] This small figure, which Hemans herself thought "interfered woefully with the single-ness of effect which the tomb would have produced,"[33] is perhaps the "marble weeper" keeping watch in her poem. Hemans's own "Psyche" is a butterfly passing by "in radiance" as she gazes at the grave: "Thou that dost bear on thy fairy wings,/ No burden of moral sufferings!" The vision, like that in Keats's "Nightingale," creates a moment of romantic envy because Tighe's new life has none of the speaker's own woes. "*Mine,* with its inborn mysterious things,/ Of love and grief its unfathom'd springs,/ And quick thoughts wandering o'er earth and sky,/ With voices to question eternity!" Like the Queen of Prussia's eagle, the Psyche-butterfly is an emblem of the liberated and risen spirit: "Oh! fitly thy path is through flowers that rise/ Round the dark chamber where genius lies!" As Nicholas Penny has noted, Romantic monuments often displayed a "feminine heaven," with female angels, ascending bodies, and/or ascending spirits. "Society permitted women, or at least Ladies, to ascend to Heaven on monuments, just as it let them pass first through sublunary doorways. . . . Thus women who are barred from most forms

of earthly privilege . . . are granted great prospects of heavenly crowns" (107). It was a fact not missed by Hemans.

A finished elegy, writes Eric Smith, is a monument, which "is essentially an object, a unity, and it is the paradox of art, and the core of personal elegy, that a sequence of communicating words, produced by self-expression and able to influence the reader by example, may become a monument, a symbol which, although it is read as a sequence, is nevertheless more than a sequence."[34] Perhaps Tennyson's *In Memoriam* best illustrates the elegy's basically sequential, temporal nature, composed as it was over many years and recording the phases of inner experience. The *situating* of the meditating figure (as Smith says, an "imagined being," not the poet [15]) within an elegy spatializes the experience, giving it that visualizable quality that I have defined as form. As form it is a conspicuous achievement and memorializes the subject's own form-making achievement. The Romantic elegist is not solely an immanent spiritual presence in the work as a whole. A diminished *version* of him or her can be located somewhere within the work, beside the viewed object, like the auxiliary figures in memorials of the time, a part of the displayed monument. This is certainly true of Hemans's lines on the Tighe monument. They begin by representing a solemn experience by the speaker, "I stood where the lip of song laid low" (as Byron's elegiac fourth canto begins, "I Stood in Venice, on the 'Bridge of Sighs'"). Then they merge that standing authorial figure with the monument's "marble weeper" who is part of the envisaged monumental space. Freud describes the "identification of the ego with the abandoned object in mourning" (quoted by Smith, 136). By "object" he means the deceased, but with the elegists I have been treating in this chapter—Wordsworth, Byron, Hemans, and even Gray—the object is also that thing which stands for the deceased. As in Wordsworth's "Peele Castle," the sequence of highly personal, mournful meditation is stabilized into something recognizably monumental and fixed. Hemans's poems investigate the nature of monumental power, the power of form to express and contain remembered experience, and finally the power of the poem to be both elegiac experience and monumental form.

A monument is—and this is Freud's point about the general inappropriateness of displays of grief before it—a public record, the self given a lasting public, above-ground identity. Monumentalization is therefore quite different from mourning, which involves the focusing of present feelings on an occurrence—a death—that can never happen again, or again command that kind of emotive attention. Unless mourning is given form as it is in an elegy, it leaves no record for the next generation.

Mourning is an expression of those "best affections," which, as Wordsworth wrote, naturally emerge at gravesites where life is conjoined with death (*Excursion* 5: 903–6). (Wordsworth's passage, considerably rephrased, was used by Hemans as the epigraph to "The Tomb of Madame Langhans," one of the *Songs of the Affections.*) The monument can become the locale for a more or less private experience, a "place of weeping," as she calls it in "The Queen of Prussia's Tomb." Although the person's achievement is alluded to in a number of the *Records,* Hemans tends to monumentalize the familial bond and its emotions and feelings, especially "affection's woes" ("Arabella Stuart"). Tighe's name is not mentioned in "The Grave of a Poetess." In neither poem about her is there a sense of her as well known (*Psyche; or the Legend of Love* was printed privately in 1805 and published in 1811, after her death from consumption). Her gravesite is a secluded place, the encounter between the two poets a private one. What Tighe or Hemans has left *within the poem* is not renown but "sorrow in [her] song."

"Mighty is anguish, with affection twined!," Hemans exclaims in a piece titled "Pauline." That could stand as an epigraph for many of her poems. Pauline rushes back into a blazing building in a fatal attempt to rescue her child. Some later-discovered jewels that had graced a locket with a picture of her daughter are the sole "recording trace/ Of all that woman's *heart* had dared and done" (emphasis added): an appropriate memorial to the "mighty" domestic affections.

Despite Byron's flippant dismissal of Felicia Hemans's talents, the two had this in common: both used the monument, the stone form meant for public viewing, as a symbol of and a locus for private mourning. The very communal nature of the monument and its situation is an important element here. The Dying Gladiator, Caecilia Metella's tomb, and the other objects of *Childe Harold* IV were seen by thousands of visitors each year; they were read about in tourist guides; they were reproduced in watercolors and engravings; they were described in published travel journals. In all these ways they were, so to speak, being inscribed *as* belonging in the public domain and still potent as artifacts. The memorials in *Records of Woman* were not so famous or well visited, but they were constructed in public places, and they were inscribed for the public. However, since both monument and poet are seen as neglected or disempowered, the stone form has not that informing principle enabling it to be reformed into something new. Personalized, personally inscribed by the poet, it merges with her consciousness of the private, unhappy situation. In this process the monument is transported from the

realm of public gazing into that of private feeling, which is then publi-cized obliquely through the verse. Byron's "dim forms," which "despond" atop the Doge's Palace in Venice become forms (in another sense), of Byron himself, even suggesting his own form, his visualized person, as reviewers noted. The Romantic ideogram, in the poetry of Byron, Hemans, and, as we shall see, Shelley and Keats, is really a spec-tral form, something between inanimate object and self-image, never quite wholly either.

FIGURE 10. "Portrait of Beatrice Cenci." Attrib. Guido Reni.
Galleria Nazionale d' Arte Antica (Pal. Barberini), Rome.
Photo: Alinari/Art Resource, NY.

"Those Speechless Shapes": Shelley's Rome

He lingered, poring on memorials
Of the world's youth, through the long burning day
Gazed on those speechless shapes. . . .

—Shelley, "Alastor"

THE MARLOW POEMS

At the very time Shelley was composing "Ozymandias," the Count de Forbin was journeying through Egypt, encountering "with a sort of terror . . . mountainous figures wrought by the hand of man, who had even engraven his image upon them."[1] The man-made "image" of man had been meant to give these monumental shapes a permanent human memory, but their massive objecthood left them with the blank monumentality of natural things. For the artist and archeologist Baron Denon (a member of Napoleon's expedition to Upper Egypt and future director of the Louvre museum), not only the size of the figures but their "want of decided expression" of face or body made them seem to belong outside, in a world of things. If the Egyptian colossi, like the Laocoon, had been distorted to "express some violent passion," they would not have been "eminently monumental, a character which should belong peculiarly to that out-door sculpture, which is intended

to harmonize with architecture, a style of sculpture which Egyptians have carried to the highest pitch of perfection."[2]

To Byron, the most expressive forms were not those found in nature but those made by man. He argued to William Lisle Bowles,

> St. Peter's, the Coliseum, the Pantheon, the Palatine, the Apollo, the Laocoon, the Venus di Medicis, the Hercules, the dying Gladiator, the Moses of Michel Agnolo, and all the higher works of Canova . . . are as *poetical* as Mont Blanc or Mount Ætna, perhaps still more so, as they are direct manifestations of mind, and *presuppose* poetry in their very conception; and have, moreover, as being such, a something of actual life, which cannot belong to any part of inanimate nature, unless we adopt the System of Spinosa, that the World is the deity. (*L&J* 5: 547–8)

These remarks probably responded not only to Bowles but also to Wordsworth, who saw much human meaning in nature's "mighty objects." Although in *Childe Harold* IV some forms like the "nameless column" and the tomb of Cecilia Metella remain opaque, the "poetical" ones, including several mentioned in his letter, are readable as "direct manifestations of mind." They have "something of actual life, which cannot belong to any part of inanimate nature." *Don Juan*'s account of Haidée's lingering death alludes for a visual comparison to the Gladiator's "ever-dying . . . air" and the Laocoon's "all eternal throes." In those "exquisitely chiselled" figures, however, it is the "marble's unchanged aspect," the appearance of the form as a whole, which though "still the same," is as vital and expressive as the emotive features themselves.

As I have noted, Shelley sought both kinds of "expression" in the sculptures he studied: the depiction of transient human feeling no less than the formal embodiment of eternal ideas of beauty and power: Byron's manifestations of mind. Both are in play in "Ozymandias," the most familiar of the poems of the Marlow period (fall and winter 1817–18).

> I met a traveller from an antique land,
> Who said—"Two vast and trunkless legs of stone
> Stand in the desert. . . . Near them, on the sand,
> Half sunk a shattered visage lies, whose frown,
> And wrinkled lip, and sneer of cold command,
> Tell that its sculptor well those passions read
> Which yet survive, stamped on these lifeless things,
> The hand that mocked them, and the heart that fed;
> And on the pedestal, these words appear:
> "My name is Ozymandias, King of Kings,

Look on my works, ye Mighty, and despair!"
Nothing beside remains. Round the decay
Of that colossal Wreck, boundless and bare
The lone and level sands stretch far away. (Dec. 1817)

Much of the poem's stunning complexity lies in the interplay between the enduring, mute presence of matter as against the receding presence of man's image, words, and intentions. Although the first speaker, the "I," begins the sonnet with an abstract narration, itself unlocated as to time or place, the traveler's theatrical presentation of stone objects creates a place and stages an event—the pedestal's utterance. The strongly positional "stands," "lies," "appears," and "near them" give the poem body as well. With the sudden use of the present tense, they offer an immediacy to the fragments of a different kind from the haughtiness depicted thereon or the flat facticity of the first speaker's voice. Both of those have a personal presence, but the objects have a material one, albeit silent and motionless: it stands *here;* as image the monument stands for something *there,* something once present but now absent, like the represented Ozymandias. "Shattered," "trunkless," and "of stone" indicate the purely physical aspect of the piece—these lifeless things, which "stand" or "lie" not as humans do, but as stone does.[3] They are reminders of that aspect of the subject not *depicted* in the object. Human stances are expressive of character, of personality, or attitude; these fragments have the non-human "attitude" of Keats's Grecian Urn, and the word "stand," like the sands' "stretch" (another word that, contextualized differently, might have a human application), here suggests a merely material endurance.

Both the stone itself and its enfigured subject signify what were least human in the age of Ozymandias: laws, commands, the exercise of authority generally. "Stamped on" the "lifeless" stone, his person and achievements have become with time absorbed into its petrific lifelessness. (During the French Revolution, Jean Starobinski relates, when religious and political statues were being pulled down, "the stone itself was destroyed as an emblem of the old oppression, of a law dictated from above by imposters and tyrants."[4]) Our consciousness that the human figure *has* been stamped, or drawn, on some material not only materializes the image but, as that image strikes us as lifeless, gives a strong lifeless presence to the material itself. The British Museum's own Ozymandias, the statue of Rameses II in the Egyptian collection, attracts the visitor's gaze to its frontal surface, the one carrying the king's image. From the back the viewer sees not a human figure at all, but two different colored masses of stone. Considering this latter aspect as the more comprehensive may make it impossible to view the figure in the same way again as a representation of living humanity.

Ozymandias's expression is "stamped," fixed grotesquely as Lessing said passionate expressions are in visual art. But as an artistic expression it exemplifies embodiment, "the imagination . . . expressed upon its forms" ("Defence" 581). As such it survives the king's body and its expressions. The human element, permanently recorded in the work as art, is a form that "survives," as Shelley says, longer than the shape of lifeless things. As with Winckelmann's description of the Belvedere Torso, the figure's hand is not in evidence but the artist's is.

One likely source for both the poem's images and its language is Baron Denon's *Travels,* the English translation of which had appeared in 1803. Denon writes of the "pompous" inscription that "now appears only a fantastic dream." The figure itself he finds no more expressive, retaining only a purely lithic aspect: "nothing of it remains but a shapeless rock of granite" (2: 93). In Denon's eyes this absence of human expressiveness would have given the colossal fragments their "eminently monumental" aspect. Shelley's additions, the "wrinkled lip, and sneer of cold command," are meant to exemplify the dead expressiveness of monuments of power while pointing up lasting conceptual expressiveness of art. As we shall see, Shelley especially valued the monumental forms he saw for those ideal aesthetic expressions—embodiments or representations—which had the power to emerge from under depicted expressions of passion.[5]

I have argued that restoring a monumental form entails grasping its "idea" in the Coleridgean sense, its constituent meaning, through a meaningful picturing of what was previously beheld or seen described. Shelley of course never saw with his own eyes what Denon had, but had probably read his account. His poem as a whole is an exercise in imaginative recreation. Every thing is envisaged. The traveler images in his mind what presumably (though the poem does not exactly say this) he once saw. In his work the sculptor represents and interprets the image *he* once beheld. And of course the sonnet's "I" communicates his own mental apprehension to the reader.

Since the Renaissance, the sonnet has been deemed an apt form not only for meditation upon monuments but for the poet's own composition of a memorial. In chapter 3 I discussed Coleridge's interest in the Shakespeare sonnets fitting this description. Spenser's *Ruines of Rome* (from Du Bellay) ponders the remains of the Eternal City ("Rome, living, was the worlds sole ornament,/ And dead, is now the worlds sole moniment"). Shakespeare's and Spenser's are formal works that rise, octave upon sestet, on a couplet base. Perhaps with a hint from Spenser, Shelley finds a monument in ruin and reconstructs it as a sonnet. The figure stands assembled in the octave, which itself stands on its "pedestal" sestet, the whole then situated upon Egypt's "lone and level

sands." Like his wife's most famous novel, the poem is an assemblage of disparate, otherwise lifeless parts, including past and present expressions—in *Frankenstein* of the various stitched-together narrative voices, in "Ozymandias" of the "I" that narrates and quotes; of the traveler who does the same; of the sculptor; of the king of kings; and of the voiceless level sands. Each of these in the poem is separated from the rest by strong breaks within or at the ends of lines, yet the unity of the sonnet, as a work, is manifest. Form protects the inscribed image from dead historicity, reduction to object status.

Unlike such inevitably defeatured and silenced objects, the "monument/ Vital with mind" (*Laon and Cythna* II, 230–1) in Shelley's poetry may have a very indistinct shape or none at all, so obviously form in the painter's or sculptor's sense—contour—isn't what he has in mind. Shelley's "forms," like Byron's, are highly indefinite. They are sculpted shapes, aesthetic ideas, things at once human and inanimate, things real and visionary. Usually they are undescribed. Some poems he wrote at Marlow before returning to the Continent tend to move away from the object and its visual definition, dissolving instead into these forms. Such are the "Sculptures like life and thought; immovable, deep-eyed," in another Marlow poem, *Laon and Cythna* (1: 585). Such also are the sculpted "forms most beautiful and strange" visited in "Marianne's Dream" (116–33), forms made from "shapes" that range through the sleep of the good and the fair:

> And as she looked, still lovelier grew
> Those marble forms;—the sculptor sure
> Was a strong spirit, and the hue
> Of his own mind did there endure
> After the touch, whose power had braided
> Such grace, was in some sad change faded.

Though the figures are "Like nothing human," they must in some way resemble human beings and, as in "Ozymandias," the *works* as forms endure with their maker's "strong spirit." The titular male character in *Laon and Cythna* wanders through "the wrecks of days departed," among "ruins gray," "broken tombs and columns riven" (2: 82ff.). Though he had heard or read nothing of those once inhabiting the place, their traces need no other text: "monuments of less ungentle creeds/ Tell their own tale to him who wisely heeds/ The language which they speak." Then to him nature itself, the moonlight on the nearby wild flowers, the reflection of stars on the sea, "Interpreted those scrolls of mortal mystery." Mere gazing elicits from these ruins their eternal truth, conveyed in the unspoiled idiom of the "monuments of ancient times,"

which, according to Schiller (see chapter 5), take us back to our "lost childhood," filling us with "sublime tenderness." They uncover our original empowered selves and their expressive potentiality. Historical distance vanishes. Shelley's next lines recall Schiller's essay (*"They are what we were;* they are *what we should once again become"*) as well as the derived passage in Coleridge's recently published *Statesman's Manual:* "from this state hast thou fallen! Such shouldst thou still become":

> Such man has been, and such may yet become!
> Ay, wiser, greater, gentler even than they
> Who on the fragments of yon shattered dome
> Have stamped the sign of power—I felt the sway
> Of the vast stream of ages bear away
> My floating thoughts. . . .

In his early poems—that is, before his final residence on the Continent—monuments in Shelley's verse tend to be traces from some remote past: Egypt, Palmyra, Phoenicia. His protagonists—Laon, the "Spirit" in "Queen Mab," the poet in "Alastor"—"seek strange truths in undiscovered lands" ("Alastor" 77). The influence of Volney and the tradition of poetic ruins is everywhere, especially in the power of these mysterious forms to disclose their truths to the gaze alone. The poet in "Alastor" surveys (106–28) "memorials/ Of the world's youth," the ruins of Egypt, Greece, and the Middle East, "stupendous columns, and wild images/ Of more than man." He revives a ruined past by reviving the images of these fragmented and cryptic monumental objects. On the "speechless shapes" he "ever gazed,/ And gazed, till meaning on his vacant mind/ Flashed like strong/ inspiration, and he saw/ The thrilling secrets of the birth of time."

These silent figures are monumental in their impact and in their meaning. "More than man" suggests a gigantic size in the objects themselves; and as images they are "memorials" of an otherwise unknown past with thrilling secrets. Belonging to a period iconically but not verbally self-expressive, those "mute men" with "mute thoughts" necessarily hung their thoughts on mute walls and demanded, but also allowed, an intuitive comprehension of what Mab calls "the secrets of the immeasurable past" ("Queen Mab" 1: 169). With all Shelley's rhetoric of origins and secrets, in these poems history and myth seem indistinguishable. Both the monumental figures and what they stand for are "more than man." Shelley is much less interested in the thing itself, in what it looked like and what it looks like now, than in the "thought" of it, and how these might inspire other thoughts.

All this changed in 1819, when he was able himself to plunge into a world of historic, not prehistoric, monuments. As had happened with

Byron, that world, personally encountered, proved disturbingly para-
doxical. It also proved much more human. The situation was epitomized
in a scene he encountered in St. Peter's Square that spring: amid the
beauty of splashing fountains and blue sky, a chain gang of brutally fet-
tered convicts hoeing weeds from between the pavement stones. The
scene roused "a conflict of sensations allied to madness. It is the emblem
of Italy: moral degradation contrasted with the glory of nature & the
arts" (*Letters* 2: 93–4). All around Rome he saw the same history, reced-
ing into a skeletal pastness, that had been imaged in the monuments to
tyranny and superstition in the Marlow poems.

But after all, he had remarked in that letter, "Rome is eternal & were
all that *is* extinguished, that which *has been,* the ruins & the sculptures
would remain. . . ." Like Byron, Shelley discovered that what most
impresses the visitor about the city is that its present contains its past,
both dead and living. "And what shall I say to you of Rome?," he mused
in his lengthiest letter to Peacock (3/23/19). "If I speak first of the inani-
mate ruins, the rude stones piled upon stones which are the sepulchres of
the fame of those who once arrayed them with the beauty which has
faded will you not believe me insensible to the vital, the almost breathing
creations of genius yet subsisting in their perfection?" (2: 84). Among
these latter works, their "forms" so obviously of "profound beauty,"
were the Belvedere Apollo, the Laocoon, and paintings by Raphael and
Guido Reni—works that had so affected Byron two years earlier. But
more fascinating than the memorials of genius were those to power, and
even more so those, like the Colosseum, that mixed both aspects of the
Roman historical landscape. Shelley dwelt at length on the Arch of Titus,
one of the "monuments . . . completely fitted to the purpose for which
they were designed of expressing that mixture of energy & error which is
called a Triumph" (86). After moving to other works, including St.
Peter's ("an astonishing monument of the daring energy of man"), he
went on to compare Roman art with that of the Greeks, "what little has
escaped the *deluge*" (89). This subject may have brought him back to the
Roman Arch, and to the way its figure of Victory with parted lips recalls
Greek statuary, "the forms expressive of the exercise of the imagination
& the affections," which were "so essential to beauty." What had sur-
vived even longer than the Arch's Roman shapes of error and energy were
such *Greek* forms discoverable to patient observation. On the surface,
the Arch was a tribute to the Roman sack of Jerusalem, and herefore, like
the "Ozymandias" fragments, to dominion and captivity. Closer viewing
revealed the free "exercise of the imagination & the affections" that Shel-
ley always associated with the Greek culture that underlay the most inter-
esting of the Roman artifacts. As usual he found the work's inner form,
its constituent aesthetic idea, conveyed by the faces *on* the work. The

beauty of one was revealed in the beauty of the other. In "Ozymandias" the countenance "tells" of the sculptor's hand.

These thoughts were incorporated that same spring into "Prometheus Unbound" (III, iv), when the Spirit of the Hour, during a long discourse filled with images of Rome, describes "those monstrous and barbaric shapes,/ The ghosts of a no more remembered fame,/ Which from their unworn obelisks look forth/ In triumph o'er the palaces and tombs/ Of those who were their conquerors, mouldering round" (168–72). The Spirit foresees the falling of the "loathsome mask" from these "barbaric *shapes*," leaving man "Sceptreless, free, uncircumscribed—but man." It also foresees "A temple, gazed upon by Phidian *forms*" (195, 112; emphasis added). Like the figures of Victory on the Arch of Titus, these forms are what the drama's preface calls images "drawn from the operations of the human mind" (133). They have "the glory of that form/ Which lives unchanged within" (II, i, 64–5) and are records of emotive experiences like love. "The impersonations clothed in [poetry's] Elysian light stand thenceforward in the minds of those who have once contemplated them, as memorials of that gentle and exalted content which extends itself over all thoughts and actions with which it coexists" ("Defence" 487). The distinction is between inner form and outer shape. Whether sculpted, painted, or described, figures for Shelley had two aspects: their shape or external objecthood, and their form, the true, aesthetic identity. The latter, as he explains in the "Defence," will "express" itself "through the most barbarous and tasteless costume" or any other merely historical "shapes" concealing it (487; see chapter 2).

Dead Roman shapes disguise living Grecian forms. Although each age inherits superstitions and practices of those before, it also holds concealed their beautiful forms. Living and dead monuments represent living and dead history. Living history, the history of the free mind's ideas, always monumentalizes (and potentializes) itself in forms that generate other forms. "Barbaric shapes," dead or living, natural or artificial, represent history as a dead pastness, as "moral degradation"—superstition, oppression, the causing of unmerited suffering: "The past Hours weak and grey/ With the spoil, which their toil/ Raked together/ From the conquest but One could foil" (IV, 31–4). The present is a part of that history; it is already in the process of degrading or defacing its figures.

Thus *as* process, time designifies some of its monumental figures. Even an unmutilated work can become deformed if its power of conveying its original purpose is lost—if it is designified. The first of Shelley's Italian "Sculpture Notes," describing a scene with several monuments, including the Arch of Titus, regards this process (*Prose* 343). The Arch, an "obscure monument of Hebrew desolation," is "now mouldering into ruins, and the imagery almost erased by the lapse of fifty

generations." A long paragraph is devoted to those images, erased as much in their authority as their visibility. One of these is the Flavian Amphitheater (Colosseum): "The power, of whose possession it was once the type, and of whose departure it is now the emblem, is become a dream and a memory. Rome is no more than Jerusalem." Detached from its subject, as it were historically here, and not there, it now can stand for the its own disempowerment and the unbridgeable distance between the emblem and its referent.

ROMAN MISERY: MEDUSA AND *THE CENCI*

The spring of 1819 began with these glorious images of Italy to pass on to friends at home, including the wondrous "wrecks of all that was most magnificent and lovely in antient art" (*Letters* 2: 68). It ended in "our Roman misery," the wholly unexpected death of his favorite child William.[6] His concern now was with the monuments of beautiful victims: Beatrice Cenci, Willie, John Keats, and various subjugated modern peoples like the Greeks ("Hellas") and Italians ("Ode to Naples"). As Byron had, he considered the role of personal memory in resignifying these very public monuments.

Time in *Prometheus Unbound* revives the image of ideal beauty by effacing the emblems of power with which its own and subsequent ages have overlaid it. After William's death, however, Shelley tended to see time not so much as an agent, an apocalyptic revealer of beauty or truth, or merely as change, but as an historical structure made up of separate but connected periods (as it is, for example, in the "Defence"). Within these, he saw figures of the past as real people, like Willie, Mary, and himself, who lived within these particular stretches of time. If some monumental image of the past is to be revived it must be done recognizing this structure, and not seeing history as *Laon and Cythna*'s "vast stream of ages."

During the summer and fall following William's death Shelley composed *The Cenci* and the unfinished "Medusa," works based on monuments he had seen—in the first a portrait, in the second a mythological painting. Contemplating these in the light of his current grief, he dramatized the conflict between beauty and horror—form and deformation—taking place during a particular time in the past, as well as in the present. As the beauty and horror registered on the faces in the two paintings are impressed on his own, they reflect the most painful aspects of the subject as well as (not instead of) the most elevating. If drama is a mirror for the spectator, as the "Defence" asserts, it can also be a mirror for the author.

To Shelley the poet was a recoverer of lives from the past, a regenerating spirit like the West Wind. "He began, and proceeded swiftly," reads Mary's note to *The Cenci,* "urged on by intense sympathy with the sufferings of the human beings, whose passions, so cold in the tomb, he revived and gifted with poetic language" (*Works* 1905, p. 335). The preface to *The Cenci* tells of his having sought out "monuments of this story," two of which he describes, the Cenci Palace and a portrait of Beatrice. As objects these are markedly opposed. The horrible "circumstances" constituting Beatrice's historical self and situation, the "mask and mantle" for the part she played "on the scene of the world," are represented by the palace, which with its "gloomy subterranean chambers" symbolizes dead history. Although "in part modernized" (242), it is "a vast and gloomy pile of feudal architecture in the same state as during the dreadful scenes which are the subject of this tragedy." It resembles therefore the "monstrous and barbarous shapes" on the Palatine Hill visible from a window and referred to by Beatrice at the beginning of the play's second scene. It is a real object, as its deteriorated state reminds us. Although Shelley maintained that he tried to limit "the actual horror of the events" (239), both he and Mary insisted on his play's historicity, its "sad reality," as he put it in the dedication to Hunt. He claimed that "the facts are a matter of history" and spoke of "the real incidents of the tragedy" (*Works* 1905, pp. 336, 337).

The "Defence" was to declare that, whereas any story is a "catalogue of detached facts," a poem is "the very image of life" existing in the poet's mind (see above, chapter 2). The Cenci portrait also is an image, a "just representation," and an admirable "work of art" painted, he says, by Guido Reni while Beatrice was in prison. But the Palace is a detached fact, as are any of the events of a case that the Preface repeatedly calls the "story" ("This story of the Cenci is indeed eminently fearful and monstrous": 239). The bare history then—a "detailed account of the horrors"—as related by the Preface or by Mary in her later note is dark and uncomely.

However, either tale or palace would be a "light" for "the most dark and secret caverns of the human heart" if the participants themselves were focused on it rather than the appalling events (239). The portraits of Beatrice, on canvas and in Shelley's play, are "pictures of integral thoughts," to quote the "Defence." The first picture Shelley gives the reader, set side by side with the summarized events of the story, is a recollection of a painting in the Colonna Palace no doubt aided by his own copy, which he also mentions. He speaks of the "fixed and pale composure upon the features," describes the white scarf enclosing "the yellow strings of her golden hair," and then moves on to the face: its "delicate" molding, the arched brows, her lips. All these details are

brought together in a "whole," an interpreted form: "In the whole mien there is a simplicity and dignity which united with her exquisite loveliness and deep sorrow are inexpressibly pathetic" (242). Thus Shelley's transmitted portrait stands against the deteriorating barbaric shape, the Cenci Palace. This reading of the portrait, like the play itself, actively seeks to restore an object to its original integrity. Through the recognition of form the poet wishes to create from the receded image a figural presence, an emergent figure.

Like Byron, Shelley was especially drawn to portraits and single- or dominant-figure paintings, which he felt he could interpret by reading facial expression. One letter to Peacock tried to convey the classical "unity & perfection," of Raphael's St. Cecilia (*Letters* 2: 51–2). First he divined the artist's intention: "St. Cecilia seems rapt in such inspiration as produced her image in the painter's mind." This integral image helped him "imagine"—narratively interpret—the figure's situation: Cecilia is solitary because "She is listening to the music of Heaven, & I imagine that she has just ceased to sing for the three figures that surround her. . . ." The *Cenci* preface implies that Shelley understood the circumstances of Beatrice's tragedy more fully by imagining the portrait than by looking at the Palace or listening to the story. Reproducing that "work," he could "represent the characters as they probably were" (240) and "present to the reader all the feelings of those who once acted" in the real drama (239).

We now know that the often-reproduced and widely admired "Guido's picture of Beatrice" is not by Guido Reni at all, nor is it a portrait of the unhappy woman dramatized in Shelley's play—probably not even a portrait. But like Shelley, other viewers were fascinated by the feelings they saw registered in the face. Stendhal described her look as very sweet, her eyes *"fort grands"*; she has "the astonished air of someone who happens to be surprised at the moment of weeping warm tears."[7] Even as late as 1847 a James Whittle in *Bentley's Miscellany* reported that no matter what time of day the painting was visited in Rome one would see a group of people gazing at it. Though as a painting the "object" was unprepossessing, the face itself, he said, riveted the spectator's gaze with its "look of wild sorrow," its "expression of hopeless misery and despair." "The remembrance of that lovely face lingers in his mind, awakening a powerful and harrowing interest."[8] Important here is the unstated but implicit wonder that a dead person's face, consigned to canvas, lives on in the mind, not because of the power of the representation (Whittle criticizes the drapery, color, and accessories), but as an image to a degree independent of the painting and its presence. The painting recalls and bears that living image, but is less than it. Of similar accounts Dickens's may be of most interest to readers of Shelley,

for like the poet he contrasts the two objects, "the guilty palace of the Cenci . . . withering away by grains" and the portrait, "a picture almost impossible to be forgotten. . . . She has turned suddenly towards you; and there is an expression in her eyes—although they are very tender and gentle—as if the wildness of a momentary terror, or distraction, had been struggled with and overcome, that instant; and nothing but a celestial hope, and a beautiful sorrow, and a desolate earthly helplessness remained."[9] Mark Twain parodied the assumption, as Dickens had put it, that "the History is written in the painting." "It shows what a label can do," he reflected. "If they did not know the picture, they would inspect it unmoved, and say, 'Young Girl with Hay Fever; Young Girl with Her Head in a Bag.'" W. J. T. Mitchell has cited these remarks in his discussion of whether pictures can, in Lessing's words, "express universal ideas."[10] Lessing said they could not. That was then far from the common view.

The beauty of Beatrice's portrait "cast the reflection of its own grace over her appalling story" (Mary's note, *Works* 1905, p. 335). To the play's Bernardo, Beatrice is "That perfect mirror of pure innocence/ Wherein [he] gazed, and grew happy, and good" (V, iv, 130–2). "Mirror" here means exemplar, but also a device for showing the viewer his own countenance and thoughts. Shelley was always interested in how figures seen may correspond to and help bring out an ideal form within our own consciousness, "a miniature as it were of our entire self, yet deprived of all that we condemn or despise, the ideal prototype of every thing excellent or lovely that we are capable of conceiving as belonging to the nature of man. . . . A mirror whose surface reflects only the forms of purity and brightness" ("On Love," Reiman 473–4). "As it were" suggests an analogy to *miniature*'s principal meaning at the time, a small portrait. Coleridge called the infant "Man's breathing miniature" ("To an Infant"), thinking of it as our essential, innocent self. Shelley's "miniature" is not the uncorrupted self, but the corrupted self minus the corruption, just as a portrait might idealize or beautify its subject like a mirror reflecting only "forms of purity and brightness."

To Shelley, reading the past meant measuring historical events and persons against the pictured ideal. Greek tragedies "are as mirrors in which the spectator beholds himself, under a thin disguise of circumstance, stript of all but that ideal perfection and energy which every one feels to be the internal type of all that he loves" ("Defence," 490). Here, the presented image is a mirror—both looking-glass and model to be emulated—for that internal portrait, the miniature self, and a symbolic form or "type." "Neither the eye nor the mind can see itself, unless reflected upon that which it resembles" (491). The mutual reflexiveness of the external representation and that ideal image results in what I have

been identifying as the living form: a figure in the mind which can be publicly reproduced, but which is not itself as vulnerable to time as paintings or drawings. In summary, the communion of the ideal self with the encountered portrait-figure is a way not only of depicting the self but of idealizing or aestheticizing the portrait, rescuing it from a merely historical or retrospective monumentalism.

Poets "can colour all that they combine with the evanescent hues of this etherial world . . . and reanimate . . . the sleeping, the cold, the buried image of the past" ("Defence" 505). Although the Preface's description of Beatrice is but another copy, the ensuing dramatization is a reproduction, mirroring the author as much as the picture he owned. "I lay aside the presumptuous attitude of an instructor, and am content to paint, with such colours as my own heart furnishes, that which has been" (Dedication 237). Shelley repaints the Cenci portrait with such thoughts. His description to Hogg of his dead son may remind readers of his Beatrice. He recalls William's "beauty, the silken fineness of his hair, the transparence of his complexion, the animation and deep blue colour of his eyes" (*Letters* 2: 104). Even as an unapproachable entity the past may gain in vividness through the merging of personal memories with reflections on it.

> There is regret, almost remorse,
> For Time long past.
> 'T is like a child's belovèd corse
> A father watches, till at last
> Beauty is like remembrance, cast
> From Time long past.
>
> ("Time Long Past" ll. 13–18)

Though the subject of the lines is the lament for a lost time, not a lost child, it is conceived in most personal terms. Mary connects the writing of the play with the death of William, which of course occurred while Shelley was working on it. Shelley may also have linked the Amelia Curran portrait of William with his own copy of the Beatrice portrait, with which it has some resemblance.[11] When he says he will paint with his own heart's colors "that which has been" (237), he certainly can be referring to his own recent life. When Mary says that he revived with poetic language those "passions, so long cold in the tomb," the passions of suffering human beings, she may also be referring to that occasion to which she alludes immediately after, "the loss of our eldest child, who was of such beauty and promise to cause him deservedly to be the *idol of our hearts*" (*Works* 1905, p. 335). As might be expected, Willie's face, his gaze, seemed important to both parents' memories of the

child.[12] Shelley described the "mingled look of love and glee/ When we returned to gaze on thee."[13] Mary also recalled that face, in words very similar to Shelley's on the Cenci portrait: "No grief upon thy brow's young purity/ Entrenched sad lines, or blotted with its might/ The sunshine of thy smile's celestial light."

All of this gives point to the play's motif of vocal silence as against facial expressiveness.[14] When the Preface calls the face in the painting "inexpressibly pathetic," it comments, as does the play, on the inadequacy of language as against pure form or image. Much is made, particularly in Act Three, of Beatrice's inability to articulate what has happened. She is speechless because she can form no image (II, ii, 108); if she speaks she will go mad (III, i, 85–6). Others refer to her as if she were already the portrait. Orsino says that despite her silence he could read her face (III, i, 49ff.). His language ("her fixed paleness, and the lofty grief/ Of her stern brow . . .") recalls Shelley's description of the portrait: "a fixed and pale composure upon her features . . . her forehead . . . large and clear."

To understand an historical period as more than a span of now-exploded ideas and barbaric practices, to "reanimate" the "sleeping, the cold, the buried image of the past," one must view its monumental images as portrait-mirrors, or portrait-ideals, as Coleridge thought of them. Beholding them as portraits alone leaves them belonging to the past. Beholding them as mirrors alone only leads to despondent solipsism, of the kind, as we shall see, that Shelley found in Byron's fourth canto. He himself wished to use the ideal "types" in his own mind to vivify real historical people, as he does in describing the Cenci portrait.

The painting is one of those "monuments . . . accessible to a stranger" like Shelley, who can read in it what Beatrice "appears to have been" (242). The woman's countenance is a language expressive in two ways. First, it mutely conveys, as faces do, her emotions at the time: "she seems sad and stricken down in spirit, yet the despair thus expressed is lightened by the patience of gentleness." Second, it embodies and records her beautiful spirit. The lips "have that permanent meaning of imagination and sensibility which suffering has not repressed and which it seems as if death could scarcely extinguish." Thus two different kinds of "meaning," one permanent, the other "fleeting," are revealed in the face. In Mary's words, "the noble heart [is] imaged in the lovely countenance of the unfortunate girl" (*Works* 1905, p. 337). The many nineteenth-century admirers of the portrait (in its various versions) tended to fix attention on the expression of emotion—the "expression of hopeless misery and despair," for example—rather than that of spirit or character. That expression had a personal significance and life for Shelley, but it needed to be counterbalanced, as were his own poetic expressions of sorrow, by

something more stable and lasting. Shelley was to lament the disappearance from the dramatic stage of the Greek actor's mask "on which the many expressions appropriated to his dramatic character might be moulded into one permanent and unchanging expression" ("Defence" 489). The mask is the embodied "character" underlying the various moods or emotional states that the *action* of the play might cause to be "appropriated" to it. It is the "moulded" and monumentalized self.

For Shelley the horrors of history included its reduction of human expressions to monumental objecthood. Only the most beautiful forms resist such disfigurements, as attested by the fragmentary "On the Medusa of Leonardo da Vinci in the Florentine Gallery." The poem begins, "It lieth, gazing on the midnight sky,/ Upon the cloudy mountain-peak sublime;/ Below, far lands are seen tremblingly;/ Its horror and its beauty are divine." Like "Ozymandias" and the preface to *The Cenci*, the Medusa poem contemplates a "trunkless head," missing that part, the torso, that Winckelmann and others found so expressive that no face was needed. The Medusa's expression is more complex than Ozymandias's; therefore, seeing what this poem itself expresses may be a more involved process than seeing what that sonnet does. What is the secret of its "tempestuous loveliness of terror"? Does its "horror" signify that it is horrible or horrified?

As with *The Cenci*, Shelley addresses an object—a painting—publicly with his gaze. (In fact, as John Hollander notes, the "gazer" is first the Medusa, then the poet contemplating the figure, and finally the reader gazing at and through the poem.[15]) And yet like Byron in *Childe Harold* IV, the gazing poet keeps a secret: the very private significance of the figure, which may be more subject than object:

> Yet it is less the horror than the grace
> Which turns the gazer's spirit into stone,
> Whereon the lineaments of that dead face
> Are graven, till the characters be grown
> Into itself, and thought no more can trace;
> 'Tis the melodious hue of beauty thrown
> Athwart the darkness and the glare of pain,
> Which humanize and harmonize the strain.

In *The Cenci*'s preface, who is the gazer—Beatrice or Shelley? And in the second stanza of the "Medusa," who is the gazer? The gazing head in the first stanza has become in the second the gazer *at* that head, one who beautifies, harmonizes the "strain" (melody *or* tension) by identifying his own spirit with that of the creature in the painting. As the features of the dead face are engraved on the gazer's spirit, subject and object are

so at one that thought *of* the object is impossible. It is, then, the viewer's spirit that throws "the melodious hue of beauty" across the scene of pain and darkness, creating an integrated living image: first "Leonardo" or whoever the painter was, then Shelley the ekphrastic maker of the poem, and finally Shelley's reader.

Historically, Medusa's tale in some ways resembled that of Beatrice, a story of violation and vengeance. In Ovid (*Metamorphoses* IV, 770ff.) Medusa is a beautiful woman raped by Neptune in the temple of Minerva, who changes her hair to serpents as punishment. (This late version started the tradition of beautiful Gorgon paintings and tended to "humanize" the legend.) "The story of particular facts is as a mirror which obscures and distorts that which should be beautiful. Poetry is a mirror which makes beautiful that which is distorted" ("Defence" 485). History, then, is "the fragment of an uncreated creature," poetry (or the painted image) an integral reflecting countenance. The images of objects too overborne by a dead and deadening history tend in Shelley to be seen as irrecoverable, leaving the object itself as relic. History as history is never wholly recoverable: to an extent the sources of information are always unclear or unreliable. A test of monumental form was whether the *image* on or in the object is living or dead. Could the figure be dehistoricized into a thing of beauty (grace, in the Medusa poem) or would it remain a particularized one of historical horror? Beatrice Cenci's portrait derived much of its beauty from its being a personal mirror, reflecting Shelley's thoughts of the dead William and, perhaps, the grieving Mary. As it monumentalized the personal situation of the gazer who saw in it its significant form, it was itself in turn remonumentalized by the words of the poet.

Perhaps, then, like *The Cenci* this poem is about the reading of figures, indicating that only the gazer's "spirit" meaningfully connects historical image and historical occurrence. *The Cenci*'s preface considers the survival of legends, myths, or superstitions in the popular imagination. Its "story" exists in two forms: the manuscript given Shelley and the legend alive in Italy as a matter of "popular belief and interest." People have contemplated her "eminently fearful and monstrous" story— both her wrongs and her revenge—"with superstitious horror." As a stranger looking at "monuments," Shelley wants to counter the superstition and alleviate the horror. He viewed the "Leonardo" Medusa or Gorgon in the Uffizi in 1819, but he had posed the key question earlier in Rome, speaking of Michelangelo's "Last Judgment": "What is terror without a contrast with & a connection with loveliness?" (*Letters* 2: 80). Obviously that contrast produces a "strain" that can only be reconciled in a true artwork. In the painting he finds a humanized version of a ghastly legend, one that lets the beauty of the Medusa humanize and harmonize the scene.

As we saw, Shelley's first impressions of Rome were of two distinctly different sorts of monuments: "inanimate ruins, the rude stones piled upon stones," deformed through time, their beauty faded; and the "almost breathing creations of genius yet subsisting in their perfection." In the Medusa painting the two aspects are disturbingly coalesced: the face or "countenance" is depicted "With everlasting beauty breathing." The head, the figure as object, is a "fragment of an uncreated creature"— perhaps discreated or discomposed, perhaps as yet not created. Like the figure in "Ozymandias" with its "shattered visage" and other "lifeless things," this one is a visage in a landscape, "a trunkless head." Still, like both of those figures it represents the fate of *things* in time, as described in the fourth act of *Prometheus Unbound* when Panthea contemplates the "sepulchred emblems/ Of dead destruction, ruin within ruin":

> see, they lie,
> Their monstrous works and uncouth skeletons,
> Their statues, homes, and fanes; prodigious shapes
> Huddled in grey annihilation, split,
> Jammed in the hard black deep. (294–302)

What survives all this decomposition is a form, a "countenance" that expresses because it mirrors, gazes because it reflects a gaze. That expression lends both the thing and its depiction a formal integrity and therefore an aesthetic presence no matter how absent from our own thoughts was the original myth.

Ultimately, the world of the poem is of stones and mirrors, like the Palace and portrait of *The Cenci*'s preface. A mirror is a quintessential reflecting image, a stone a quintessential thing: silent, unresponsive, indifferent to perceptions of it. (I am using Matthew Lipman's concept of "things"—"sets of physical conditions which have not yet been con-verted into instruments, means, or media"—though I would add that these instruments, etc., may also be seen as things if the medium is no longer functioning.)[16] Because of a "hideous light" coming from the creature itself, all the "things" ("wet rocks") become mirrors, mirroring each other ("as . . . grass out of a watery rock") and, more important, mirroring the mind, and the mind mirroring objects. For Mary, the proof of her husband's ability to "read" the secrets in the face of the depicted Beatrice Cenci were the "hues so vivid and so beautiful" (*Works* 1905, p. 337) in his own dramatized portrait of the woman. When the mind registers an image as horror, however, rather than as beauty—and this depends on its present disposition—the gazer may be turned to stone. In a passage from Goethe that Shelley translated, Faust, alone, has seen a phantom of Margaret, whom he seduced and who

killed their child. Mephistopheles calls the vision "an enchanted phantom,/ A lifeless idol; With its numbing look/ It freezes up the blood of man; and they/ Who meet its ghastly stare are turned to stone,/ Like those who saw Medusa." The lines recall the "lonelier column" of *Childe Harold* III (see chapter 8), which looks like "one to stone converted by amaze,/ Yet still with consciousness." Both figures exemplify the designified image ("lifeless idol" in Faust) become pure object, paralyzing the viewer. At the end of Shelley's poem, however, the image's beauty makes the air—the atmosphere—a mirror for the spectator to see it without turning to stone.

Before we leave the stone female head and its petrified viewer, I might mention Shelley's notes on the Uffizi Niobe, the sculptured representation of the woman who, viewing in horror her children being slaughtered, was turned to stone. The marble in which the figure is worked has barely "suspended the motion of her terror." The "countenance" that expresses this emotion is also "the consummation of feminine majesty and loveliness. . . . It seems as if despair and beauty had combined to produce nothing but the sublime loveliness of grief" (*Prose* 352).

"ADONAIS"

Poiein synthesizes history's "detached facts," and *The Cenci* and the Medusa poem "harmonize" the horror of events and the beauty of human spirits. The works thus give new monumental form to the disformed. In "Adonais" Shelley is once more contemplating monumental remnants: architectural, sculptural, and above all, with Keats, poetic. He is looking for what Hazlitt calls that informing principle which is also a transforming and reforming power.

Like Matthew Arnold later, Shelley always considered Keats a poet of brilliant bits and pieces. Perhaps he would have ranked Keats higher, he observed to Charles Ollier, if about fifty pages of "fragments" of *Endymion* had been published instead of the whole poem (*Letters* 2: 117). To Peacock he called the "fragment" of *Hyperion* "astonishing." Because he deemed *Hyperion* to be unparalleled for one so young (Preface to "Adonais") he had intended to print his elegy with a critical essay on the poem, restoring, no doubt, its torso's true monumental form. He also had intended to publish "the remnants of [Keats's] compositions" with a life and criticism. He wrote Severn, however, that the reason for letting "Adonais" suffice as monument was that his own fame was so meager that anything else would help little in remedying "the total neglect & obscurity in which the astonishing remnants of [Keats's] mind still lie" (*Letters* 2: 366).

The first half of "Adonais" concerns those remnants. Whatever Keats "moulded into thought" now lay in scattered feelings and impressions. Images in the first part are of separation and fragmentation: a broken bow and arrows (St. 11), a breaking billow, a broken heart (St. 32), and—a favorite motif of funereal monuments in Shelley's day—a lily with a broken stem (St. 6). (Ultimately Keats's stone memorial was to have its own emblematic motif, a partially strung lyre signifying songs unsung.) The orphic scattering of the body parts throughout the early stanzas of "Adonais" (heart, brain, head, eyes, limbs), with emphasis *on* those parts, both mirrors and stands for the scattering of his mind into different fading images, adorations, and so on.

As the poem begins, a personified echo recalls all the "fading melodies" with which, as if with flowers, Keats had "adorned and hid the coming bulk of death." One of the Dreams throws on the body a wreath woven of her hair. Shelley stylistically strews the early stanzas with echoed Keatsian melodies: phrase- and image-flowers. Fearing to "become" like the dead (St. 51)—disfigured, unmade, a "bulk"—the mourner resists deformation with this elaborate figuration, decking with leaves and flowers the "dead Season's bier." Presently Shelley makes an appearance as himself so decked. All of this seems a placating caress of death and deformation (St. 25). But those emblems themselves are transient, sustaining the mourner more than the mourned.

With the seventh stanza the poet moves to give form to the processes both of disfiguring and of lamenting disfigurement by personifying them in a manner reminiscent of early emblematic title pages. "Kingly Death/ Keeps his pale court in beauty and decay," not only in the world of Keats's death but in the world of the poem. In clear contrast to the earlier *un*figured (unpersonified) "bulk" of death, this quite artificial but formal figure for death presides over a falsely unified conventional scene (Sts. 7–15), false because its own abstractions are never reconciled with death's physical realities. The personifications of the "twilight chamber" in Stanza 8 build into an especially elaborate allegory, with pity and awe soothing the pale rage of Hunger, and later (St. 25) Death rising, smiling, and meeting the "vain caress" of Urania.

Shelley's richly configured sepulcher for Keats's "fading melodies" appears against the historical, urban background of the "high Capital" and its own monumental decomposition. "States fall, arts fade," writes Byron, indicating the essential difference between the two kinds of monuments and what happens to them (*CHP* 4: St. 3). Art is essentially image, and images grow pale with time. Monuments of power, on the other hand, like the institutions they represent, "fall." Essentially objects, they collapse and fragment. The treatment of Rome in Shelley's letters and in "Adonais" no doubt derives partly from the Roman stanzas of

Byron's Canto IV, especially those on the Palatine Hill, which to both men represented the degradation of Republican into Imperial Rome. (Parallels with contemporary French history are obvious.) "Behold the Imperial Mount! 'tis thus the mighty falls" (St. 107). Shelley's own description to Peacock of the Palatine's "shapeless masses of ruin" (*Letters* 2: 85) gave him a vision of Rome to use in "Adonais," where the "shattered mountains rise" (St. 49). The Palatine, like the city generally, illustrated the difficulty of reading history in her relics. "Rome has fallen," Shelley wrote in a fragment, "ye see it lying/ Heaped in undistinguished ruin" ("Rome and Nature 1819"). "Undistinguished" neatly combines suggestions of the ignoble, the formless, and the unidentifiable. "Come to Rome," he urged Peacock. "It is a scene by which expression is overpowered: which words cannot convey" (*Letters* 2: 85). Such sublime scenes can be *beheld,* seen by the mind's eye as complete images of moral ideas, as in *Queen Mab.* "Behold! where grandeur frowned;/ Behold! where pleasure smiled" (2: 111–12; see above, chapter 7). Beholding is a sort of visual grasping or cognizance, appropriate, as in Fortune's rhetoric, with dis-figured or mysterious monuments: "Behold the wrecks of what a great nation once dedicated to the abstractions of the mind. Rome is a city as it were of the dead, or rather of those who cannot die . . ." (*Letters* 2: 59).

Byron represents the process by which "All things grow phantoms" with an allegorical beholding of the landscape. In a setting without living residents and where the dead are pale ghosts, his emblematic figures ("Knowledge," "Night's daughter, Ignorance": St. 81) give an eeriness to the Italian scene much as do Death and his court in "Adonais." In Byron's Rome we plod our way "O'er steps of broken thrones and temples." Shelley's female mourner, the "childless Mother" Urania (St. 22), speeds "Through camps and cities rough with stone, and steel,/ And human hearts" (St. 24), an emblem of a grief that is "chained to Time, and cannot thence depart" (St. 26). As Ross Woodman has observed, Urania here is a figure for only the first part of the poem, the stage of futile mourning, of a yearning for the past that ends in despair before the upturn of the poem. "Those who remain with Urania, playing with lovely images, ultimately delude themselves."[17] In one way, then, like Byron's "Lone Mother of dead Empires" (St. 78), Shelley's Urania is a phantom image mourning itself as it vainly caresses Death, with her presence and voice seeking to adorn and hide its oppressive "bulk." *Like* Death she is an emblem of conventional emblematization, and may bring to mind the sort of allegorical tomb figures that, as we shall see, Shelley and Mary rejected for William. In lines on the spirit of Rome, Martin Archer Shee used a similar figure: "Hail awful shade! that o'er the mouldering urn/ Of thy departed greatness lovest to

mourn;/ Deploring deep the waste where, once unfurl'd/ Thy ensign glitter'd o'er a wondering world."[18]

With its "massy walls and towers, now mouldering and desolate" (Shelley's Preface 390) the urban setting of "Adonais" embodies both historical ruin and private grief. But if "desolation" becomes an emblem, like all emblems in the poem it is a screen for the poet himself, who appears halfway through as "a Love in desolation masked" (St. 32). Protested Hazlitt, contemplating all the floral decorations and tributes that festooned the monuments in Paris's Père la Chaise cemetery, "True sorrow is manly and decent, not effeminate and theatrical. The tomb is not a baby-house for the imagination to hang its idle ornaments and mimic finery in" (*Works* 10: 145). The world of forlorn public monuments in "Adonais," figured with elaborated personifications, conceals a more private wretchedness exposed in the course of the poem and finally interred in the Protestant Cemetery where "flowering weeds, and fragrant copses dress/ The bones of Desolation's nakedness" (49). An earlier Shelley poem, "The Past" (1818), likened forgetting one's loss to heaping flowers and leaves on a cold corpse, a process that cannot prevent certain memories from making "the heart a tomb." They with "ghastly whispers tell/ That joy, once lost, is pain." In "Adonais" monumental Rome is the sepulcher of joy, the place where the pain of personal memory of joy is covered over, decked with images that Shelley in his preface to *The Cenci* calls "mere poetry": detached similes or isolated descriptions, not true incarnations (241). Echo, Ocean, Spring are all changed by sorrow into conventionalized Melancholia ("Misery") figures that tend the memory of Keats, recalling another earlier Shelley poem titled "Death." "They die— the dead return not—Misery/ Sits near an open grave and calls them over,/ A Youth with hoary hair and haggard eye. . . ." Here what is obviously an image of Shelley himself is reduced to a role played *by* him. The *figure* Misery disguises what his letter called "*our* Roman misery." (In Shelley's time, following the influence of Flaxman and others, sepulchral allegorization of the deathbed scene was being supplanted by naturalistic depictions,[19] as with the monument to the Chantrey children.)

When the poet exclaims, "woe is me!" (Sts. 18, 21) he pursues the point by asking, "Whence are we, and why are we? of what scene/ The actors or spectators?" It is then that a figure called "Misery" urges Urania to "slake, in thy heart's core,/ A wound more fierce than his [Adonais's] with tears and sighs." She rises like a thought stung by the snake Memory (St. 22). At length the poet appears in the costume of misery, garlanded with floral emblems of memory. That "frail Form" (St. 31), however, usually identified as Shelley, is a kind of Shelley-Keats figure, with some attributes (weakness, beauty, the floral adornment) adapted from earlier passages describing the dead poet.

Such formal emblematic masks prove inadequate to express shapeless and imageless mysteries. In reality Shelley is not "woe," and "Death" is not a "king" or any other powerful agent, but a process of ending, or else all things dead—in either case a "coming bulk." By imaging it as the "court" of Death the poet seeks to give intelligible form to Rome with its landscape of degenerating monuments. He proceeds to the conviction that "Death is dead" (St. 41): death, that is, as a metaphysical construct (like *Prometheus*'s "Jupiter") rather than a physical fact. At that point he returns both Keats and "death" to the world of the real, where they belong.

The poem's movement away from disguise and role-playing, away from Byronic self-inscription to accurate description, reflects the growing desire to represent places and things as they were. The letter telling Peacock both of the Protestant Cemetery and of the Forum ("a kind of desart full of heaps of stone & pits . . . the most desolate place you can conceive") began by accusing Byron of having written his fourth canto of *Childe Harold* in a spirit of "insanity," of viewing "the nature & the destiny of man" "in the distorted mirror of his own thoughts" (2: 57–8; 12/17 or 18/1818). That second point was essentially admitted by Byron in his own letter on Rome (see chapter 8), since letting his "memory" bring all the objects into an "order" means using it as an undiscriminating mirror reflecting all of his memories at once. For his own part, Shelley, with much the same daunting task, preferred to "speak of these things not in the order in which I visited them, but in that of the impressions which they made on me, or perhaps as chance directs" (*Letters* 2: 85). This method turns out to be, as he says, unchronological but precisely descriptive: several hundred words, for example, on the Caracalla Baths (84–5). The letters and the sculpture notes feature minute, objective scrutiny. The historical stance deliberately adopted in *The Cenci*, to present "that which has been," involved the poet's decision to record both public and private historical memory accurately, giving up, as the resolution of "Adonais" does, "mere poetry"—myth, emblems and decorative imagery—and urging himself and all such mourners to "come forth/. . . . And know thyself and him *aright*" (St. 47; emphasis added). The poem becomes a more straightforward meditation when Shelley begins to address *himself* as mourner and to look critically at his own "heart." The question "Who mourns for Adonais?" earlier asked by Urania among the mourners, is posed here for the first time by the poet in his own voice.

The living are condemned to remember and mourn continually without being mourned themselves (40). As we saw with both Byron and Hemans, Romantic elegiac poetry attempts to make the poet's private feelings a legible public record by affixing them to monuments

already *in* the public world, giving those monuments a new, legible form in "Fame's serene abode," and converting transient but devouring emotions and their manifold expressions into a unified embodiment of idea. In "Adonais" he comes to do this not by adorning history's rubble but by uncovering from it a sublime monumental shape, the pyramid. Byron's Palatine Hill features monuments and the ages they recall crammed together upon on a hill resembling one of those famed Egyptian edifices which, Byron's Sardanapalus says, "have forgotten their very record." "Ages and realms are crowded in this span,/ This mountain, whose obliterated plan/ The pyramid of Empires pinnacled. . . ." In their sheer planlessness the Caracalla Baths struck Shelley the same way, the confused mingling of nature and human history. A "lofty & irregular pyramid, overgrown like itself by the all-pervading vegetation," is surrounded by "other crags & other peaks all arrayed & the deformity of their vast desolation softened down by the undecaying investiture of nature" (2: 85). Till the conclusion of "Adonais" no single definable monument emerges, no pyramidal form like Mont Blanc, above nature but involved in living process.

In Shelley's day the pyramid was emblematic of lost history and the irrecoverability of human intention. It also had quite personal associations for him. Although ultimately William's parents settled on "a plain stone to be erected to mark the spot with merely his name & dates," for a time they seriously considered a pyramid "as the most durable of simple monumental forms." They requested Amelia Curran to draw a sketch and investigate the cost of one of these made of "solid materials" and covered with white marble.[20] But they wanted no "attempt at *Sculpture*." As Shelley put it, "I strongly incline to prefer an unornamented pyramid of white marble as of the most durable form & the simplest appearance" (Letter 8/15/19; 2: 107). The poem "Adonais," however, Shelley was to term a "highly wrought *piece of art*" (*Letters* 2: 294). Its first half is wrought in the sense of decorated, worked *over*. It finally becomes, like the pyramid, a wrought *form*—shaped or fashioned, like a pyramid, or like Keats's poetry, "moulded into thought" (14). In this process Shelley counters the "undistinguished" voicelessness of the past first with a highly adorned lament, then with a mute aesthetic form, "one keen pyramid with wedge sublime," an apt symbol, for Keats, not only of private memory but of fame and influence. "The dead live there" as in the realm of "lofty thought" (St. 44).

Objecting to the stylistic character of "Adonais," Richard Holmes calls it "curiously reminiscent of the Baroque": "The attempt to combine overwhelming personal feelings with the high, marmoreal style of a public monument did not succeed."[21] The poem may at times seem marmoreal: cold and massive, meant to impress rather than touch the

reader, and in its pictorial quality calling more for a viewer than for a hearer. It seems "curiously" baroque perhaps because like the pyramid it has a highly stylized, contorted energy as well as a classic stateliness: it "doth stand/ Like flame transformed to marble" (St. 50). Shelley himself recognized this stylistic tension: "I have dipped my pen in consuming fire to chastise his destroyers; otherwise the tone of the poem is solemn & exalted" (*Letters* 2: 302).

Within Rome's Protestant Cemetery, as Samuel Rogers once described it, is "a quiet and sheltered nook, covered in winter with violets." Imparting to that scene "a classic and singularly solemn air" is the pyramid of Cestius, "a stranger among strangers."[22] Intended as a "refuge for his memory" (St. 50), the sepulcher marks a kind of memory garden, a living place within the mouldering walls of time, but secure from desolation. (See Shelley's poem of this period, "The Tomb of Memory.") Memory of course is what Byron attempts to exclude from *Childe Harold*. In "Adonais" personal recollection is suppressed until the very end, where Shelley's memory of his own family experiences provides the real basis for the monument. Before that, memory comes disguised in the figure of Urania, with its traces of the mourning Mary and especially perhaps of her elegiac lines on William: "Grim death approached—the boy met his caress,/ And while his glowing limbs with life's warmth shone,/ Around those limbs his icy arms were thrown." Certainly Shelley's image of Keats's ascension to the sphere of Venus-Hesperus (St. 46) draws from his recollection of lines at the end of that poem: "The image shattered, the bright spirit fled,/ Thou shin'st the morning star among the dead."[23]

"Adonais," like "Mont Blanc," is an exercise in monumentalizing: taking disturbing processes of experience, the destroying aspects of life (for example, grieving), and fixing them with an enigmatic, opaque, large symbolic object. As human experience is (within the poem, too) linear, a matter of change or development, it eats what it has been. Like Echo (St. 15), the poet of "Adonais" feeds on grief "with his remembered lay," an act of consuming and being consumed with apparently endless mourning. Throughout, his thought has been a consuming flame.

The great image of horror in the elegy's first half is that of the "eternal Hunger," Corruption, waiting to "deface" his prey John Keats. Unlike Shelley's other monumental figures—Ozymandias, Victory, St. Cecilia, Beatrice, Medusa—Keats is allowed total defeaturement: we hear no more about his face or his figure as he rises to the realm of the unapparent. Nor do we hear more of the Keatsian figures by which he is known—either the tropes as tropes or the forms they present. In a sense he has become an unknown person—as Shelley describes himself in the letter to Severn, someone "obscure," whose own influence is felt,

but not seen, through that form symbolized by the pyramid. Form in Shelley is not, of course, any visible shape but that eternal "thought" or idea that precedes, causes, and is contained by its manifested forms. Discussing Shelley's metaphoric reproductions in the "Defence," I earlier quoted J. V. Cunningham: form is known only in its alternative realizations. One alternative realization for the forms of Keats's thought in his poetry is "Adonais" (critics have often pointed to the Keatsian spirit of the poem), a monumental effort to transform flame into marble.

The pyramid of flame marks the monumental triumph of the spiritual, mental, or human over the devouring forces of history, of Keats's thought over his age and its predators. Mausoleums, writes James Stevens Curl, are "objects in space, set immutably in the landscape, silent, and grand" (168).[24] Although the pyramid in Rome holds the remains of neither William nor Keats, it originally had served as a mausoleum, "Pavilioning the dust" of the otherwise unknown Roman tribune. Its purpose, then, was to hold what was left of that man as a person. As we have seen, in writing "Adonais" Shelley wished to save from "total neglect & obscurity" the "remnants" of Keats's mind. Azuredomed Rome is no true sepulcher for Keats (St. 48), no "refuge for his memory" (St. 50), as the pyramid was for Cestius. The cemetery is, however, and so also is Shelley's poem, which it may be seen as symbolizing. However, feeding "like slow fire on a hoary brand" (St. 50), Time is the "flame transformed to marble" in the pyramid, that is, changed to what cannot be consumed. The pyramid gives a closure for the poem as well as a symbol for it, a significant form that embraces and encompasses change while standing apart from it. As public memorials, both structures offer termination points for private grief.

Through the cemetery scene the poem's second half more directly engages the personal aspects of the Roman misery. The focus in this part, however, is more on the public self and on fame or public memory. It concentrates on the *power* of the poet's "thought," not any image of him or work by him. One's thought is the real monument, the guarantor of fame. What Bacon calls monuments of power or of the hands are shaped objects—they *lie* in ruin and bury their makers. The monuments of the "kings of thought" like Keats (48) are not portraits of the person but iconic images of his mind. Therefore both the kings and their thought are in the "unapparent." Keats is one of the "Armies of the Eternal" invoked in "Hellas," "Whose fame though earth betray the dust it clasped,/ Lies sepulchred in monumental thought;—/ Progenitors of all that yet is great" (419–21).

FIGURE 11. Niobe and Child. Uffizi, Florence. Illustr. from Joseph Spence's *Polymetis,* Yale University Library. Photo: Marriott Library, University of Utah, Special Collections.

CHAPTER TEN

Keats's Temples and Shrines

Fame is the recompense not of the living, but of the dead. The temple of fame stands upon the grave: the flame that burns upon its altars is kindled from the ashes of great men.

—Hazlitt, "On the Living Poets"

TEMPLES WITH FAIR LIVING FORMS:
POEMS, 1817, AND ENDYMION

In the autumn of 1817 Keats confided to Benjamin Bailey the hope that *Endymion* would take him "a dozen paces towards the Temple of Fame" (*Letters* 1: 170). The "long Poem" was to be a test of his powers both of imagination and completion. Its success would be his own monument as well as a temple of homage to the kinds of works his letter cited as his models: long poems by "our great Poets . . . in the shape of Tales." Possessing what Hazlitt called the "informing principle," tales were never shapeless to Keats: they provided a defined "Region to wander in." In *Endymion* region and narrative are interchangeable forms: periodically the story line is stilled and framed as a pictorial landscape standing for the whole tale. Accessible by many paths, situated in "the middle of this pleasantness" (1: 89),[1] as in a Poussin or Claude landscape, stands *Endymion*'s marble shrine of Pan, symbolizing Keats's reverence for the old tale, one of those "things" or "essences" of beauty that haunt us as trees "whisper round a temple" (1: 27). In the poem the rural shrine or

219

temple and the figures enshrined there constitute an interpretive monumental form, a spatial realization of the narrative's linear form.

With all its constituent legends and temples, *Endymion* would be a monument both to Keats and to narrative verse as a living form. However, before settling with it on the Isle of Wight he spent a couple of months reading volumes of "eternal poetry" (*Letters* 1: 133), rather than doing the sort of ambitious story telling that might immortalize him.

All human achievements are caught in the "feud/ 'Twixt Nothing and Creation" (*Endymion* 3: 40–1), including "Lovely tales that we have heard or read" (1: 33, 22). The Endymion story itself could be "engulphed in the eddying wind" (2: 846) unless continually reshaped and reproduced. Like *Endymion,* a number of the pieces in the 1817 collection are efforts at reimagining the tales and the figures in them, thereby keeping them all "with us." Its dedicatory sonnet to Hunt ("Glory and loveliness have passed away") does this while announcing the theme of the book as a whole, as Jack Stillinger and Martin Aske have pointed out.[2] Keats regrets that these days country folk no longer meet "soft voic'd" nymphs bearing baskets of flowers and corn to deck the "shrine of Flora in her early May." He "feel[s]" a "leafy luxury," however, which his second quatrain translates into exactly that lost scene, centering on and memorializing Flora's shrine.

Three years earlier Wordsworth's *Excursion* had described how easily ancient Greeks converted impressions of natural forms into human figures, and those figures into immortal tales. "Sunbeams, upon distant hills/ Gliding apace, with shadows in their train,/ Might, with small help from fancy, be transformed/ Into fleet Oreads sporting visibly." (4: 873–6). "I stood tip-toe," which follows Keats's Dedication and introduces the first group of poems, also associates this kind of composition with fancy, that effortless linking and transmutation of images that Coleridge would notably relegate to a lower order than the imagination. Keats first enumerates many of the natural "glories" that "smile on us to tell delightful stories" (123–4). He then proceeds to retell several of these—of Psyche, Narcissus, and Endymion—with accounts of how they may have been first imagined. For example, coming on a "little space, with boughs all woven round," and within it a "meek and forlorn flower" (163ff.), the bardic poet felt inspired to give that "sweet spot" a narrative form: "Nor was it long ere he had told the tale/ Of young Narcissus, and Echo's bale." Envisaged figures of Narcissus, Endymion, and Cynthia were dream-icons able to generate enveloping and enshrining legends for themselves. Listening atop Mount Latmos to a "hymn from Dian's temple," the earliest Endymion poet beheld the face of Cynthia. Then, spontaneously, "in fine wrath some golden sounds he won,/ And gave meek Cynthia her Endymion" (203–4). Keats imagines a pro-

cess beginning with a strong consciousness of a landscape and figure, around which a tale developed. But of course Keats's own modern poem *begins* with a sense of the old legend, envisions an appropriate "spot" for it, and so on.

In 1816 and 1817 Keats was pondering the equivalence of scene and story, the spatial and the linear. In his sonnet on Hunt's "Rimini" (written at this time but published posthumously), the "sweet tale" is for Hunt's reader, or for Keats's, "a region of his own,/ A bower for his spirit." In turning tale into place or picture, the poem reflects what Schiller would call a "sentimental" nostalgia for easily expressing a feeling (like that of "leafy luxury" in his Dedication) as narrative setting, character, and incident. To metamorphose place into sustained story or vice versa, any modern poet required conscious effort unneeded in earlier days when feeling a little space—taking in its essence—was enough. Such ekphrasis can occur naturally, semi-consciously, in the "realm . . . of Flora, and old Pan" ("Sleep and Poetry"). There, myth and nature are so mutually referential that no meaning beyond the "realm" is looked for. This provides the experience of beauty, of fine similitude, without an irritable reaching after (historical or archeological) truth, as, for example, what the legend originally meant. "O for three words of honey," the poet declares to Cynthia after telling the origin of the Endymion story, "that I might/ Tell but one wonder of thy bridal night!" (209–10). The lines anticipate not only Endymion's own tale of desire and consummation but Keats's "great task" of reiterating that design in 4,000 subsequent lines (letter to Bailey). In "I stood tip-toe" he attempts to reverse the process by creating a particular, imagined space from the feeling of the tale. "And when a tale is beautifully staid,/ We feel the safety of a hawthorn glade" (ll. 128ff.).

Despite this emphasis on easy writing in "I stood tip-toe," the other eight pieces in this first section—poems dealing with women, chivalry, and old romance—often reflect a narrative impulse stalled and frustrated, most markedly in the three Spenserian poems. The "Specimen of an Induction to a Poem" tells of wanting to write but being unable to. Twice Keats says he "must tell a tale of chivalry," but awed by his "own strange pretence," he never does. His next effort, "Calidore," is a "fragment" of a tale. The "Imitation of Spenser," written a year earlier and included as the next to last of the group, mainly consists of some florid description and speculations about the possibility of telling "the wonders of an isle." Keats here seems blocked, hampered by a sense of his own belatedness and of the remoteness of medieval heroism and gentilesse.

Most of these had been written in 1814 and 1815. In October 1816 Keats began visiting Hunt at Hampstead. At this time he felt strongly the connections of his family and of a growing but very close circle of friends.

These changes, both the new ties and the sense of liberation, are suggested by the three epistles constituting the middle section of the book—addressed to George Felton Mathew, Keats's brother George, and Charles Cowden Clarke. They are meant to show the close connection between friendship and narrative recreation. (They also defer serious thoughts of temples, shrines, and personal posterity.) "Easy writing's curst hard reading," the playwright Sheridan remarked, but not, Keats thought, with the verse letter, which like the prose letter gained its fluency from knowing the audience (as the whole volume is, significantly, presented to a friend, Hunt). The friendly environment is to the modern writer what nature was to earlier ones: the "feel" of it facilitates composition and assimilation.

"To My Brother George" opens with hard writing, Keats unsuccessfully striving "to think divinely." The lines are stiff and poetical. As he moves into the poem (67 ff.) with thoughts of "scribbling lines for you" the syntax and language become much more relaxed, even careless. The difference has to do with the writing's aim. An ambitious spirit wants to hold "lofty converse" with "after times." When he thinks of fame or posterity, addressing a general public ("my mad ambition"), his verses come reluctantly. But when "tasting" domestic "joys" the pen moves smoothly. "As to my sonnets, though none else should heed them,/ I feel delighted, that you should read them." The "lays" of "dear delight" that he leaves to posterity will be sung at some later day by villagers who have "form'd a snowy circle on the grass." Keats sees himself at last sacrificing social "joys like these" for his mad ambition, but meanwhile he lies on the grass and scribbles his lines to George (67–121). Feelings of "delight" inspire visions in the sky of those huge cloudy symbols of a high romance: ladies fair, gay knights on white coursers, and banquets. These are the sorts of happy figures—Phoebus and Aurora in the sunrise, a Naiad in a "rippling stream," a "rapt seraph" in a moonbeam—that in the epistle to Mathew he recalls seeing when "with" his friend.

Following these epistles and making up the third section in the volume are seventeen sonnets, six of which honor iconic or narrative versions of various legends. Three of those concern mythic figures monumentally carved in stone: a pair on the Elgin Marbles (assumed to represent mythic characters such as Theseus) and one on a gem engraved with the figure of Leander. Two others are about figures in poetic legend: the Dedication and "This pleasant tale is like a little copse," on the medieval *Flowre and the Lefe*. Other sonnets in this section connect friendship and writing. Two tell of walking home to Cheapside after pleasant evenings at Hunt's cottage. "Keen, fitful gusts . . ." has him still "brimfull of the friendliness" he had experienced at Hampstead, an environment conducive to his envisioning the friendship between Milton and "gentle Lycid" and Petrarch and his Laura. In "On Leaving Some

Friends at an Early Hour" he asks for a "golden pen" to "write down a line of glorious tone," for his spirit is "not content so soon to be alone." The 1817 volume ends with "Sleep and Poetry," Keats's Song of Experience, as "I stood tip-toe" is his Song of Innocence. Like the book's Dedication to Hunt, it tells how poetry fell from nature, and why therefore the poet must *self-consciously* attempt to recover the earlier vision through reverie or half-sleep.

Toward the end of the first poem Keats describes the "wonder" of Endymion and Cynthia's bridal night. All the attendants are graced with classic health and beauty, the men resembling the Apollo Belvedere "on the pedestal," the women, like the Venus di Medici, "looking sideways in alarm." All ultimately fall asleep, but wake refreshed to meet "the wond'ring sight/ Of their dear friends, near foolish with delight." The figures seem posed, like a large statuary group:

> Young men, and maidens at each other gaz'd
> With hands held back, and motionless, amaz'd
> To see the brightness in each other's eyes;
> And so they stood, fill'd with a sweet surprise,
> Until their tongues were loos'd in poesy.

"Was there a Poet born" that night? Keats finally asks. It is a question that the volume as a whole may be intended to answer.

The conclusion of "Sleep and Poetry" describes a modern site of friendship, Hunt's house. In place of the companionable silent gestures and other expressions of the ancient Greek wedding guests are the "friendly voices" of the Hunt circle. Perhaps recalling the earlier episode, Hunt's art collection is ranged about "pleasure's temple," the guest bedroom where Keats slept: "cold and sacred busts" smiling at each other, and, from hung pictures, Sappho "half smiling," Alfred "with anxious, pitying eyes," Kosciusco's countenance "worn/ By horrid suffrance." These portrait figures are meant to merge with the live inhabitants of the house—representations with living bodies—as occurred metaphorically at the end of "I stood tip-toe." After "sleep," the poet awakens refreshed and begins to write, clearly a "Poet born." This ending of "Sleep and Poetry," and of the volume, parallels that of "I stood tip-toe," where the Grecian men and women wake "clear eyed," "their tongues . . . loos'd in poetry." The difference is between singing and writing, and between transitory expression and self-embodiment. In "I stood tip-toe" a poet is born. In "Sleep and Poetry" a poem is; Keats leaves his verses "as a father does his son."

To summarize, the two poems framing the 1817 collection tell their own tale: how it is possible for a modern poet like Keats, in a friendly communal environment, to recapture some of the natural creativity of the earliest oral story tellers while leaving an image of himself in the Temple of Fame. In this way the whole volume functions as a sort of prelude to his next work, *Endymion: A Poetic Romance.*

Just after *Endymion*'s Hymn to Pan, Keats shows how transformed figures are culturally perpetuated. He is describing the dancing celebrants:

> Aye, those fair living forms swam heavenly
> To tunes forgotten—out of memory:
> Fair creatures! whose young children's children bred
> Thermopylæ its heroes—not yet dead,
> But in old marbles ever beautiful.
> High genitors, unconscious did they cull
> Time's sweet first-fruits. . . . (1: 315–21)

Keats's source may well have been the address to Homer in James Thomson's ode on "Liberty" (2: 272 ff.) in which "Forms" or figure-"ideas" are translatable from Homer's lines to standing stone forms and then to Thomson's poetic lines:[3] "Thy fair Ideas, thy delightful Forms,/ By Love imagined and the Graces touch'd,/ The Boast of well-pleas'd Nature! Sculpture seiz'd,/ And bade Them smile in *Parian* stone."[4] I would take both Thomson's and Keats's "forms" then to be not merely either the live bodies or the stone figures ("living" in different senses). They are also visual "fair ideas" capable of reproducing themselves in these or other modes, ideas that incorporate and merge impressions of at least two of the possibilities into a single complex, fluid impression, as it does in the passage. Keats's ideal forms forever swim to a lost music, unheard melodies. Indeed, the passage implies that even in "old marbles ever beautiful" they are not fixed but convertible into yet another medium, the poetic image, as in the *Excursion,* where early Greek "fancy" effortlessly "transformed" sunbeams and shadows into fleet Oreads. As mere shapes or objects—phenomena in the historical world—forms change in one direction, toward death, historical silence, and monumental objecthood. As living images they are high genitors, infinitely recast. *Endymion* was the latest recasting, the present monu-mentalizing of the essential, living idea. Just after the *Endymion* passage, Keats describes other goings-on at the feast of Pan. Having tired them-selves with dancing, the attendants are lying on the grass, some listening

to strange tales "potent to send/ A young mind from its bodily tenement." Others, idly watching an archery contest, are put in mind of the mournful legend of Niobe, whose children were massacred by arrows and whom Zeus, out of pity, transformed into a rock (or statue). The celebrants recall how "very deadliness did nip/ Her motherly cheeks."

The group of Niobe and her children in the Uffizi gallery had come to typify that kind of art able to fix and monumentalize human feeling. Hazlitt, who like Lessing believed that the only successful antique statues were "those which affect the least action, or violence of passion," made an exception for the Niobe, where "the passion is fixed, intense, habitual" (*Works* 18: 113). Shelley's sculpture notes made similar remarks on the work (*Prose* 252–3). The whole Niobe section of *Endymion* reflects Keats's concept of the history of expression from display or utterance of feeling to its unfading embodiment in the work of art. Like Thomson's "delightful forms," Keats's "fair living forms" seem initially to be the expressive bodies of the live celebrants. But what are "not yet dead" must be their images—forms in quite another sense— either in memory or in later representations of those people (as "old marbles" or the poem *Endymion*).

Among those works from which Keats gained his familiarity with figures in Greek mythology—Lemprière's classical dictionary, Tooke's *Pantheon,* and Spence's *Polymetis*—I want to stress the probable importance of Joseph Spence's book, whose title page reads, "*Polymetis: or, An Enquiry Concerning the Agreement Between the Works of the Roman Poets, and the Remains of the Ancient Artists. Being an attempt to illustrate them mutually from one another.*"[5] Polymetis in that book is a modern connoisseur and collector of *objets d'art.* The first dialogue has him showing his friends around his garden, where he has constructed a number of temples housing statues of various deities. The statues' pedestals contain drawers for gems, medals, prints, and drawings depicting these "imaginary beings." A traveler, Polymetis recognizes that few enjoy his advantage of consulting "the finer remains of antiquity" and must rely on various reproductions.

Spence, Oxford Professor of Poetry, had himself spent five years abroad, as he tells us in his preface. He became convinced that the mind of the past could only be effectively recovered by juxtaposing in *our* minds images in books with those on paper or in stone. (Spence's debt to Addison's "Dialogues upon the Usefulness of Ancient Medals" is acknowledged in the preface). Thus *Polymetis*'s own dialogues feature remembered visual experiences in the Vatican Belvedere, the Uffizi, and so forth, with many references to particular engravings that readers of the time may have seen, and of course frequent references to Ovid, Virgil, and others. Also, and equally important, the book contained dozens

of illustrations, many of real sculptures like the Farnese Hercules, the Venus di Medici, and the Niobe.

Unlike Spence, and also unlike Shelley and Byron, Keats would have recognized himself as belonging to the class of those needing reproductions to take the place of European museum visits. Along with information about, and speculations on, Apollo, Saturn, and the rest, Spence provided him with alternative versions of "fair living forms" and a graphic example of how such forms become high genitors of corresponding ones in other media. *Polymetis* as a whole might be described as a groundbreaking study in the transformative imagination, in a direct line between Addison and the German art theorists.

In Spence's sculpture garden wildness is allowed to prevail. Similarly, for Keats the past is made up of figures in natural landscapes. In "Ode to Psyche" he discovers the forms he enshrines while wandering "in a forest thoughtlessly" (as the "delicious ramble" in "I stood tiptoe" turns up a flower beside a clear pool that inspires the poet to "sing" the Narcissus tale). The verdant scene is a symbol of the poet's situating these figures in natural, human-seeming narratives. To create or recreate such a legend is to "leaf-fringe" both its figures and it, "wreathing/ A flowery band to bind us [and them] to the earth" (*Endymion* 1: 6–7). Set in an age of "prosperous woods," *Lamia* begins with Hermes searching for a nymph in "a forest on the shores of Crete." "A forester deep" in the "midmost trees" ("Spenser, a jealous honorer of thine") or a traveler in "the old oak forest" (sonnet on *Lear*), Keats takes as his task either to embower his woodland figures or to pull "the boughs aside,/ That we might look into a forest wide,/ To catch a glimpse of Fauns, and Dryads" ("I stood tip-toe" 151–3).

The poet is a forester disclosing and enclosing these fair forms: disclosing those found within groves or arbors of ancient growth and re-enclosing them in the growth of his own modern, romanticizing consciousness. Such reforestation, supplementing or replacing old growth with new, is demanded because of "the down-trodden pall/ Of the leaves of many years" ("Robin Hood"), the detritus of dead ideas. The woods of Latmos with their "gloomy shades," made by the ancient Greek myth-crafters, are remade by Keats's recontextualizing the figures in the screen of his own consciousness.

All of this makes *Endymion*'s Hymn to Pan indispensable in understanding Keats's poetic history. In the 1817 volume's Dedication to Hunt, Keats laments that "under the pleasant trees/ Pan is no longer sought." The figure of the figure-embowering god can no more be seen in the woods he himself has made. As Apollo is associated with the sky, Pan is a "forester divine," therefore the god of disclosure and enclosure, the model of natural poetic creativity. Once his "mighty palace roof

[did] hang/ From jagged trunks, and overshadowe[d]/ Eternal whispers, glooms, the birth, life, death/ Of unseen flowers in heavy peacefulness." So the figure of Pan is itself the type of enforested figure, surrounded by "strange overgrowth" (241). He both is and symbolizes the "symbol of immensity," a living image as long as encompassed by natural, mythic thought, and as such the keeper of conceptions that otherwise would disappear into nothingness.[6]

Standing for mythopoeic or symbol-making power, Pan is an anchor for thought, sustaining the integrity of the mental self: "the unimaginable lodge/ For solitary thinkings; such as dodge/ Conception to the very bourne of heaven,/ Then leave the naked brain" (1: 293–6). *The Pantheon,* a young person's guide to ancient mythology by Godwin (as "Edward Baldwin"), which has some echoes in *Endymion,*[7] contains one chapter particularly germane to this discussion. Titled "The Gods Representative of the Faculties and Conceptions of the Mind," it concerns the muses, graces, and various personifications such as Fortune and Fame. Besides animating nature, the imagination "substantiated mere abstractions, the unreal and fleeting ideas of the soul ['it gave to airy nothing/ A local habitation and a name']." By this habit of metamorphosis the poet "contracted a deep feeling of the reality of these things."[8] Godwin's (and Shakespeare's) "local habitation" for fleeting ideas may in Keats's Hymn be the figure of Pan, a "lodge" for solitary thoughts. Wherever he obtained it, thought-enclosure—the lodging (and enshrining) of conceptions—was to be a powerful conception in Keats's poetry. Beings of the mind were to Keats the only permanent ideas we can have.

The leaf-fringed legend, of which "Psyche" is a beginning and *Endymion* a developed example, constitutes a fresh conceptualization of human activity, one signifying natural or primary consciousness. Early poetry was kept fresh by daily contact with its legend-material and with nature: "if Poetry comes not as naturally as the Leaves to a tree it had better not come at all" (*Letters* 1: 238–9). Therefore legend and its vernal decoration—content and style—are interwoven, a true example of organic form. Because modern, self-conscious poetry must inevitably be about consciousness (as Schiller, Coleridge, and Hegel, among others, held), its texture and imagery must be seen to be those of the individual poet's mind, the "working brain." I want to spend a little time now examining Keats's sense of the relation between the poetic reading consciousness and its encountered narrative figures, which, like the "lovely tales" themselves, we must always "have with us, or we die" (*Endymion* 1: 33, 22).

Keats posits two fields of existence. One, "the" or "this" world, is an undefined space constituted of "thought" and its objects; the other comprises different imaginative "realms" or "worlds" of being. One of

his letters (1: 403–4) will illustrate the relation between "this" world and the realms. He is explaining to his brother and sister-in-law why he is content to be single.

> I feel more and more every day, as my imagination strengthens, that I do not live in this world alone but in a thousand worlds—No sooner am I alone than shapes of epic greatness are stationed around me, and serve my Spirit the office of which is equivalent to a King's body guard—then 'Tragedy with scepter'd pall, comes sweeping by'. According to my state of mind I am with Achilles shouting in the Trenches, or with Theocritus in the Vales of Sicily. Or I through my whole being into Triolus, and repeating those lines, 'I wander, like a lost Soul upon the stygian Banks staying for waftage,' I melt into the air with a voluptuousness so delicate that I am content to be alone.

Keats may have intended the passage itself to show his power of projecting, of throwing his "whole being" into those figures he encountered when reading or looking at prints. He would "feel" so much like them that he felt with them. But it reflects more the interiorization of these figures into *his* "thousand worlds" of "imagination": his trenches, vales of Sicily, and Stygian banks. He is the "king" of those worlds, and the shapes of epic greatness are his guard. The strengthened, regal imagination is one that can enshrine itself with such discovered figures.

Both the fictional (Achilles, Troilus) and the historically remote (Theocritus) are incorporated into the worlds of his imagination. Homer's "realms of gold," ("Chapman's Homer"), like Apollo's "western halls of gold" ("Ode to Apollo"), are among them, distinct from "the world" he will leave "unseen" in the Nightingale Ode, the one in which "we jostle" ("Dear Reynolds"). While the poet or reader may have the "greatest mastery/ And kingdom over all the realms of verse" ("Give Me Your Patience, Sister") and shows it by enshrining its icons, *the* world is a place that masters one; it seems also to be one's term of life ("On Some Skulls" 63) but always the real world (*Lamia* 2: 33; *Fall of Hyperion* 1: 201). The pure imagination creates intact, enclosed realms and lets mental voyagers like Endymion go from one to another. Life and death are not considerations in the aesthetic world of *being,* because in it there is no non-being, nothing beyond the mind. They are the most important considerations in the world of *beings,* where what is not self is apart from the self. In writing his poem, in "tracing" the legend, Keats seeks to protect the idea or essence from the world, keeping it "alive" and intact in its own realm, that of imaginative history.

Yet despite the impression of his wanting to give himself over to one imagined identity, at every stage his Troilus letter reflects the consciousness of his imagination's accommodating several optional realms for several possible selves; it also reflects the partially suppressed con-

sciousness of a unitary sole self, the one alone. That is, the "I" who begins the passage and who is content to "be alone" at the end, is the self-conscious John Keats. It is obviously not the same one, therefore, as the one with Achilles in the trenches, or with Theocritus, the one that melts into the air; it therefore cannot be his "whole being." In fact, as I hope to show, that whole being, the "sole self," is precisely what the consciousness temporarily seeks to repress in placing him with Achilles, Theocritus, or Troilus.

Such "fellowship" with a figure or character's "essence" leaves us "Full alchemiz'd, and free of space" (*Endymion* 1: 779–80), but it is only "a sort" of oneness (796). In 1817 Keats was thinking of aesthetic fellowship as crucial to his very poetic identity, and therefore to his fame, his permanent identity. In May, in the midst of writing *Endymion,* he quoted to Haydon some lines from *Love's Labour's Lost* voicing the hope that our "brazen Tombs" (tomb in its early sense: monument) may represent honor gained in our present lives and thus make us "heirs of all eternity." Keats declared: "To think that I have no right to couple myself with you in this speech would be death to me so I have e'en written it—and I pray God that our brazen Tombs be nigh neighbors." At this time, while the sole self was Keats's sense of a separate, constant identity (his "identical" self: letter, 1: 387; see below), he gained his strongest and most satisfying "identity" by imagining himself being "with" a focused-on figure, either a real one like Haydon or Hunt, or an imagined one like the nightingale ("already with thee"). He borrowed "life"—from an objectified figure while preserving his separate, "real" identity. "But even now I am perhaps not speaking from myself," he allowed in the "camelion poet" letter, "but from some character in whose soul I now live" (1: 388). The "myself" and the "character" are coexistent, but while he lives in the character the other self remains a sort of watchful specter. (In "Sleep and Poetry" the charioteer is both Apollo and John Keats observing him. In *The Fall of Hyperion* he is with Moneta, seeing through her eyes, but conscious of him watching her.)

In an experience probably alluded to in his sonnet, Keats heard Chapman speak out in the voice of Cowden Clarke, who was reading the lines aloud from the *Odyssey*. The passage described, and expressed, Odysseus's feelings on being nearly drowned. For Keats to feel like Chapman feeling like Homer, as well as to feel like Odysseus, released him from his sole self (the solitary, enclosed, distanced "I" at the beginning, like the "I" at the beginning and end of the Troilus passage). Then he felt like an astronomer, then like Cortez. Feeling, or feeling "like," in Keats means associating oneself with and feeling the same as: "Yet, in our very souls, we feel amain/ The close of Troilus and Cressid sweet" (*Endymion.* 2: 12–13). It therefore means losing the feeling of one's

whole self, as one's *consciousness* becomes identified with its object. "Feel we these things?—that moment have we stept/ Into a sort of oneness, and our state/ Is like a floating spirit's" (*Endymion*. 1: 795–7). That is his idea of aesthetic response; reality response is feeling aware of self and the "feel of not to feel it" ("In drear nighted December").

Negative capability is the power of feeling something without trying to know it, that is, declining to *interpret* a sole thing in relation to one's sole self. "Chapman's Homer" exemplifies that capability, the essentially natural power, possessed especially by the early authors and readers, of traveling wholly within imaginative realms: of being someone or something seen or read about ("being in") without scrutinizing ("reaching after") that discovered image, and of moving easily from that figure, and its realm, to another, and its realm. It is negative in the sense not only of repudiating personal action, but of repudiating or concealing one's own being as a single identity.

A poet has no personal character because he is "in for and filling" some other one (*Letters* 1: 387). Woodhouse read this as meaning that by the intensity of his imagination the poet can "throw his own soul into <the> any object he sees or imagines, so as to see feel <&> be sensible of, & express, all that the object itself wo[ul]d see feel <&> be sensible of or express—& he will speak out of that object so that his own self will with the Exception of the Mechanical part be 'annihilated.'"[9] This is what happens in "Chapman's Homer," at least until the end, when there is a separation, a distancing, and a self-presentation of the watcher himself. In "Sleep and Poetry" the speaker, watching the Apollonian poet gaze at and intently listen to "Shapes of delight, and mystery, and fear," wishes actively to "know/ All he writes." This intellectual curiosity has the effect, apparently, of making all the visions flee; "real things," like his own person, sweep away his imagination or "soul," that purified aspect of the self that can lodge figures without examining them. Negative capability can thus be recognized as employed in sustaining and enshrining works of art or poetry without seeking to comprehend them. "Adonais" asks whether thoughts die when the mind does. A corollary question is whether the image of the mind itself, that is, other people's sense of it, dies when the images it creates die. For Keats, the main test for these issues was the survival of early narrative. By ekphrasis he sought to preserve in different form its distinctive quality or essence: that of the "pleasant."

Among the "pleasant sonnets" that "Sleep and Poetry" speaks of as being sent into the brain instantaneously and unconsciously is the one he inscribed in his copy of Chaucer, "This pleasant tale is like a little copse" (written in 1817, but not included in that year's collection). In its shape *The Flowre and the Lefe* is nothing like a copse, but as I have said,

the informing principle is the power a work has, when seen as a work, to express its own unified character in alternative versions. Reading the old allegory felt to Keats like being in a small wood, and that feeling, not really the "lines" themselves, constituted the new growth that can "freshly interlace,/ To keep the reader in so sweet a place. . . ." They create the lines of the sonnet that enclose his reader's and Keats's own consciousness. Meanwhile, the guilty, anxious, writing "I," who both longs for fame and dreads its own mortality, is confined and concealed in the elaborated mind of the reading "I" (a temporary, contingent self). The feeling of the writing self, who will always "feel athirst for glory," is a self-awareness, at odds with the sense-awareness of the reading self who "feels the dewy drops/ Come cool and suddenly against his face." The attention to pure form and the aesthetic feeling it elicits—sensations that come *to* the body—supplant the desire to express emotion, though the latter emerges in the sonnet's last two lines, when he says that he will lie on the grass "as those whose sobbings/ Were heard of none beside the mournful robbins."

In short, Keats's exercises in interpretive reading embower and hush figures from the cultural past while concealing and silencing the present unhappy self. By conceiving of his encounters with tales and their characters as aesthetic experiences and providing new forms to express these experiences, he resists interpreting them as ideograms or personal symbols expressing some important emotional situation.

Thus, like Shelley in the beginning of "Adonais," Keats tries to enshrine narrative figures as living forms. Endymion in his travels comes upon Adonis in a "chamber, myrtle wall'd, embowered high,/ Full of light, incense, tender minstrelsy,/ And more of beautiful and strange beside" (2: 389–91). "Safe in the privacy/ Of this still region all his winter-sleep" (479–80), the sleeping youth is watched by some cupids, one of whom, "kneeling to a lyre, touch[es] the strings,/ Muffling to death the pathos with his wings" (420–1). As with *The Eve of St. Agnes's* Madeline, Keats creates a tableau both *vivant* and *mort,* a sort of funeral piece or memorial group with "waned corse" and allegorical figures. On the other hand, he keeps the image of "Adonis" alive, embowering and sustaining it, as do the cupids, until it wakens. Adonis might embody Keats's fears about his ailing brother Tom or even speculations about his own future. But whatever personal feelings the figure incorporates are screened within the "chamber, myrtle wall'd," and under his coverlet.

As sleeper, the figure is encircled by all kinds of live plants, a "coronal" of lily stalks above its head. As corpse or effigy it is draped with a coverlet like a mortcloth, which falls "sleek about him in a thousand folds—/ Not hiding up an Apollonian curve/ Of neck and shoulder, nor the tenting swerve/ Of knee from knee, nor ankles pointing light"

(398–401).[10] The scene is much more sculptural and highly realized than in Bion or Ovid. It is only after one of the tending cupids revives for Endymion the whole tale of Venus and Adonis that *Endymion*'s Adonis figure itself revives and briefly participates in the story of the Latmos shepherd. Then he, Venus, and the rest "minish into nought," leaving Endymion "once again in twilight lone . . . those visions . . . o'ergone." Especially with the chariot carrying off the figures, the episode has obvious parallels with the one in "Sleep and Poetry," where the mythic car vanishes from sight, leaving the poet's soul in danger of being borne to nothingness. The discovery of Adonis, like that of the charioteer and of Psyche, represents the encounter not with a particular mythic figure but with gray legend itself, one of those "things" that "alway must be with us, or we die." In the course of the poem many of these tales and their figures are revived. When Adonis is addressed by Venus his features suddenly show expressive mobility: "from forth his eyes/ There darts strange light of varied hues and dyes:/ A scowl is sometimes on his brow, but who/ Look full upon it feel anon the blue/ Of his fair eyes run liquid through their souls" (540–4). To revive the image of the legendary is to give it both a human voice and an expressive countenance, natural elements of any narrative development. Without these the sculpturesque figure is embodied and enshrined, but not alive. *Endymion*'s Adonis is represented as dead body, monument, and finally living person, thus conveying Keats's notion of the ambiguous status of such figures.

Elegies like "Adonais" work to mask death or historical silencing by framing it in an aesthetic silence, one of sleep rather than death. In so doing they attempt to suppress their own aspect of lamentation, their truly elegiac quality. (As I have suggested, contemporary sleeping-figure memorials by the sculptor Chantrey and others were accomplishing the same feat.) Keats's Adonis, though apparently both corpse and effigy, is kept "safe in the privacy/ Of this still region" of aesthetic stillness. The whole emphasis is on the beauty of the tale as tale. In the historical world stillness is the absence or loss of something, a negative, non-affective relation between persons or between a person and an object. In aesthetic "realms" it is a kind of sensation within a realm, in which the mind creates what the senses do not hear.

Thus, like the Psyche ode, the equally monumental Adonis passage is a collapsed elegy, concealing the element of "desolation." Not only does it try to create a more lasting version of its subject, but in doing so it 1) implies the need for doing so, the potential death of images in historical silence; and 2) calls attention to its own possible failure. Both ideas are overtly dealt with in the traditional elegy. The figures are concealed as the mind-architecture is revealed.

SHRINES WITH FIXED SHAPES: *POEMS,* 1820

In 1818 Keats declared on seeing a lock of Milton's hair, "O, what a mad endeavour/ Worketh he, Who, to thy sacred and ennobled hearse,/ Would offer a burnt sacrifice of verse/ And melody." Here "hearse" means the temple-shaped edifice *(OED)* once featured at funerals of nobility, "decorated with banners, heraldic devices, and lighted candles" (Keats's "ennobled"). Mourners commonly presented offerings at it; sometimes they pinned poems to it.[11] Therefore with "hearse" Keats conflates three ideas: the mourner's offering, the attached poem, and the sacrifice of the reading self. The temple or shrine is an earlier work seen as a living monument to its own mastery of a form or type. It is also, in Keats's interpretive lines, a commemoration of his own experience in perceiving that work. Now I shall trace the process by which the pastoral temple or green altar becomes a sacrificial shrine signifying the original shape's resistance to interpretive reformation. The quiet, pictorially presented "temple" of delight and honor holds the "sovran shrine" of melancholy, silence, and death, where solid, weighty figures stand or lie as "effigies of pain" *(Hyperion),* enfiguring the dead or the suffering. Keats's imagined urn will be the focus of this discussion. Its legends haunt about its shape (and depicted shapes) because the transformation of scene into story is never fully realized: both the leaves and the people remain marmoreal. The fixed shape, one for whom no essence can be perceived (which cannot, as Coleridge might say, be intuited), stands outside the mind, demanding, yet baffling, interpretation or commentary. If life is "the reading of an ever-changing tale" ("Sleep and Poetry" 91), death is the reading of an unchangeable tale or an unchangeable form within a tale. First, to see how a figure-bearing object might be investigated in those days, some historical remarks on the most famous real urn in England.

Sir William Hamilton in 1786 declared the Portland Vase one of the great "monuments of antiquity," standing only below the Apollo Belvedere, the Niobe group, and a few other "first-class marbles."[12] The Prince of Wales, the Duke of Marlborough, and Erasmus Darwin all owned copies.[13] It now rests reassembled in the British Museum after being shattered years ago by an unbalanced ex-university student. Still regarded as monumental in its beauty, it has a further interest: as the Museum's official guide to it notes, "The subject of its frieze is an enigma which has challenged and defied three centuries of classical scholarship."[14] Made of dark blue glass with opaque white relief, the Vase was only the most familiar of many being brought to general public view and subjected to intense scrutiny, scholarship, and speculation as to who or what the figures pictured on them were supposed to represent. These

ghostly shapes seemed to be signs with lost referents, a hieroglyphic language that might or might not be dead, and which was meant to embody then-dead myths or depict then-dead real people. Partly because of an erroneous story that the Portland Vase had been discovered in a tomb, it was for centuries assumed to be a cinerary urn with the subjects of its depictions referring in one way or another to the life, death, and perhaps future life of the person whose ashes were inside it.

On "Portland's mystic urn," as Erasmus Darwin referred to it, is a frieze with seven figures comprising one or perhaps two scenes. One side has three figures on a stone platform: a reclining woman holding an inverted torch is observed by a young man to her right, and both of them by another woman to her left. On the other side of the vase a seated woman embracing a serpentine creature grasps the arm of a young man walking from a temple. They are watched by a bearded man and by a winged Eros overhead.

Reviewing the various then-current readings of these scenes discloses two principal strains, the personal or biographical and the allegorical or mythical. Proposing that it had once held the ashes of the Roman Emperor Alexander Severus, its owner's librarian in seventeenth-century Rome published a biographical interpretation, claiming that one side of the vase pertained to the Emperor's birth, the other to his death. However, Montfaucon in 1722 believed he could identify the figures of Leda, the swan, and Jupiter. In a brief reference Winckelmann dismissed the notion that, for example, two of the figures could have been Alexander Severus and his mother. An account published in *Archaeologica* in 1787 by J. G. King, however, stated that the figures were those of Alexander (represented twice), along with those of his mother, Jupiter, and "Constancy."

By the beginning of the nineteenth century the common view held that the vase pictured the Eleusinian Mysteries, the figures showing an allegorical scene of death and human immortality, featuring a picture of the man whose remains were contained therein.[15] This reading had been endorsed by the potter Josiah Wedgwood, whose "Etruscan" pattern, inspired by the vase, is still associated with his name.[16] It was also Erasmus Darwin's reading in *The Botanic Garden* (1791; Part I, Canto II, 321ff.). In those lines the young man leaving the temple (the pale Ghost) is the spirit of the dead person commemorated by the Vase. As a "hieroglyphic" tableau, however, this portrait becomes translated into a personification of man's soul. Darwin represents his own allegorizing self as "Humankind" meditating among ruins, making his act of interpretive personification part of the scene itself (a familiar situation, as I showed in an earlier chapter). As the images in the scene change from records of a personal life and death to emblematic universals (the "pale ghost"

becomes a "lingering form"), they break the silence of the dead past, identifying themselves and speaking (anachronistic) Christian truths about "love divine" and "immortal life." Darwin's interpretation, combining person- and idea-representations, with himself as both person and idea, underscores the dual nature of those figural monuments, which are meant to stand for and commemorate real people while conveying truths about life and death. In this case, seen in different ways, the Vase is both a retrospective and a prospective monument. Both the object (the Vase) and the person supposedly connected with it are given an ideal existence by being transferred from the world of historical particularity into that of conceptual universality. *Both* become figures of thought. But because the historical, artifactual identity of both remains, the depicted scenes seem apparitional, inhabited or haunted entirely by ghost-images of once-living ideas.

This is also true of a striking piece by Felicia Hemans titled "The Antique Sepulchre" (*Works* 485), which offers interesting parallels with Keats's Ode. Unlike Keats's opening apostrophe to the object, Hemans's is to the figures depicted on it. "O ever joyous band/ Of revellers amidst the southern vines!/ On the pale marble, by some gifted hand,/ Fixed in undying lines!" Then, having vividly conveyed the scene, with its piper and dancers linked by trains of flowers, she poses the question, "What do you there, bright things!/ Mantling the place of death?" Is it "to show how slight/ The bound that severs festivals and tombs,/ Music and silence, roses and the blight,/ Crowns and sepulchral glooms?" Hemans, perhaps like Keats, is fascinated by the paradox of a lively display "mantling" a person's remains. She seems disturbed by the apparent inability of the figures to speak, to voice the truth about themselves (though she herself is silent both about herself as a person and about the sepulcher's contents). "Ye have no voice, no sound,/ Ye flutes and lyres, to tell me what I seek;/ Silent ye are, light forms with vine-leaves crown'd,/ Yet to my soul ye speak."

These forms sculpted "by some gifted hand" on the "pale marble" are ghostly because they cannot explain themselves or "tell" her the answer to what she seeks: why, as Madame de Staël wonders in Hemans's note to the poem, do antique sarcophagi depict dancing or joyous figures? Why *are* the "bright things" bright? The poem's reading de-historicizes (in fact anachronizes) the whole piece, making classic immortal beauty an emblem to the "soul" for Christian immortality. The archeological question asked by Keats of *his* sylvan historian is passed over by Hemans in favor of a religious one: what eternal truths have these unidentified figures for us? The joy expressed, on and therefore by, this pagan object and the scene's "undying lines" is a Christian intuition of an eternity without death. As I remarked, also passed over

is the identity of the person the sarcophagus was supposed to contain and commemorate. With Hemans the sarcophagus is less meaningful as functional object than as a surface for pictures. As with Darwin and Wedgwood's readings of the Portland Vase, the message of the image and the eternal overrides that of the thing itself and of the particular past.

Still the object remains, a conspicuous shape. With Etruscan vases, James Christie argued, "the mystic doctrine of the immortality of the soul being allegorically expressed by an elegant groupe on one side of the vase, *the painting itself was put for the religious opinion of the person, and the person was consequently represented by the vase*" (quoted in Dallaway, 24; emphasis added). Whether consciously or not, Christie makes an important distinction between two kinds of monumental representation: while the pictured forms *articulate* something timeless, in another way the shaped object itself stands for, embodies, someone no longer here. A figure in a different sense from the figures on it, the urn is an ideogram for the person. Hazlitt said that though the sculpted form could not, like a picture, "express" life, it could be employed in "embodying a lifeless shadow" (see chapter 8). The convention of divining whose life was "allegorically expressed" by figures on antique urns and sepulchers provides a context for now considering what Keats's "foster child of silence and slow time" "can express" in its pictures and what in Christie's sense the object might itself represent.

J. Middleton Murry[17] first noted the connection between the Ode and a phrase at the beginning of *Endymion*'s Book Three, where, above the empty noise of the self-important ruling class, a "thousand Powers," such as the moon, distantly keep their court, "silent as a consecrated urn" (30–2). What sort of silence has that urn? What does it not proclaim? Does it not express at all, or does it express silently; not represent, or represent silently? One variant of the line reads, "And silent, as a corpse upon a pyre." As usual, Keats himself is silent about "silence," in both versions letting the trope speak for itself about the word's meaning. Figurative language as well as figures themselves—representations of persons painted or sculpted on urns, say—are mutely expressive: they have no need to lecture. Or, perhaps, like a body or ashes on a pyre (or *in* a consecrated urn) such representations can't "express" a "doctrine" the way Christie found Etruscan vase "allegory" to do, and the urn itself as a thing and a shape is left to represent the dead. The published *Endymion* version of the line seems to have opted for the first possibility. The "Grecian Urn" leaves the matter of aesthetic and historical silence fascinatingly ambiguous.

Despite the allusions to death and loss in the Ode's fourth stanza, the object is not identified as a funerary article. But no shape in the Romantic period was more associated with death than the urn or vase.

At the end of the eighteenth century the cinerary urn was the favorite tomb *ornament* in England, and even in Keats's time its popularity withstood attacks by churchmen on such a pagan insigne.[18] With Keats this function (and therefore the urn's objecthood) is for the most part phenomenologically and aesthetically bracketed in favor of the notional realm depicted on it. That bracketing begins with the poet's *supposing* the piece itself to be a living image-form: bride, child, historian. Such a form can express a pleasant, "sweet" tale, but not, apparently, an idea.

Any concept it might express, such as those read on the Portland Vase or the "Antique Sepulchre," would also help explain its own history and purpose: there is no way of talking about what monumental imagery means without taking into account what the monument is for—and vice versa. Christie, Hemans, and Darwin speak of the two aspects in relation to each other. But to be silent about one is to be silent about the other. The imagery on Keats's Urn is inspected in terms of imagined expressive aspects (happiness and warmth, for example: those feelings and sensuous qualities it conveys wordlessly) rather than its signification. Of those expressive aspects the most prominent, naturally, is stillness.

An ancient urn's soundlessness is of two kinds—"quietness" and "silence"—each corresponding to its own kind of "eternity." Silent means silenced: stilled, dead, inexpressive, the silence of ashes on a pyre. Human silence is absence, vacancy, loss of something that once existed, or inability to speak about something. Since the aesthetic world has nothing to do with speaking or living, aesthetic stillness is not really absence but the presence of quietness: the sublime silence of "consecrated" things (like a temple or shrine). A thing of beauty will "keep a bower quiet for us," a place for "quiet breathing" *(Endymion).* There forms are piped to the spirit *because* they have no tone—no meaning or intellectual tendency: "[I]n the bosom of a leafy world/ We rest in silence . . ." ("Sleep and Poetry" 119–20). The poet's music is unheard but will "remain," unlike the poet and his voice. In human terms "for ever" and "ever more" mean that life and time are over, gone, and silent, but in art-world terms they mean outliving any wasted generation. The urn is present, has a presence, and represents the dead, as Christie said. The people on it, even the town, are ghostly presences.

The urn's own presence is that of a deserted child—a foundling ("foster child," *OED*)—adopted by slow time, or history. Like the consecrated urn *or* the corpse upon a pyre, however, it keeps mute about both its origin and its meaning. As itself, a container and a solid thing standing for a silenced person, it stands for historical silence. However, Cleanth Brooks reminds us, as a sylvan historian or storyteller it does not speak of itself but of activities of imaginary figures.[19] Thus Stanza Four is not only about death but about not telling. Ultimately, the poem

is quiet about silence, alluding to it only figurally and figuratively, that is, symbolically. Its pictures, which can tease us out of thinking about the object and about historical silencing, are of "eternity": of no time as opposed to slow time, or gradual, generational change, identified in the last stanza with "woe," as it always is when it is considered in terms of human life ("Thy streets for ever-more/ Will silent be").

Actually, in the Ode Keats recalls not only painted vases but those stone receptacles with scenes sculpted in relief ("with brede/ Of marble men and maidens overwrought"). Like the British Museum's Townley Urn, his is both picture and sculpture, partaking of the aesthetic aspects of form commonly associated with each. The poem's initial response to the urn, a bracketing of its suggestions of death or unhappiness, invites us, as Eugene F. Kaelin says of art's phenomenology, to "linger over the taste" of the work's "sensuous qualities."[20] As usual with Keats, those aesthetic qualities are of a mentally pictured world held and presented by the work as a living picture. Typically, and most evidently in the "Ode to Psyche," warmth, coolness, softness, and quietness are among those qualities for Keats (as opposed, in this poem, to "Cold Pastoral," "burning forehead," and "silence," aspects of the urn or its reader as existing in the bracketed world). The phenomenological choice is whether to live *in* the picture, with its figures, or *with* the object. "To me the finest sculpture compared with a picture seems like a cold abstraction," Southey told Sir George Beaumont in 1822. "But on the other hand there is a durability in marble which affects my mind strongly: no term can be assigned to its duration, no common accident is likely to reach it."[21] As image the sculpture is cold in being so severely reductive as to exclude "expression" in several senses. As object it is materially cold but with a presence that overcomes its iconic distance. Like the corpse, which Southey seems to have in mind as a comparison (as do Hazlitt, Coleridge, and Alison: see chapters 5 and 9), the body of the piece cannot be "reached" by life's vicissitudes.

A sculpted figure is a cold "abstraction" because it omits much that is present in any human visual experience. For Keats and these others a warm abstraction of life was a narrative picture with figures. When some personification seemed familiar, Keats concretized it with a new, embowering situational context. Because he "knew" the two figures in the "Ode to Psyche," they became not mere representations but beings. (After the three in "Indolence" pass by him the third time, he knows them too, but then chooses to unrecognize them, and they return to being "masque-like figures on the dreamy urn.") As "warm" beings, Love and Psyche appear neither to have a different ontological status from his own nor to exist in a different (past) time. Therefore "Psyche" is a "thoughtless" poem, making its enshrining form-equivalents, origi-

nal, organic images, unconsciously and naturally: "branched thoughts, new grown with pleasant pain." "Thought"—for example, being conscious of representation itself—distances a figure. Unlike "Psyche," the "Grecian Urn" is a thought provoked, perhaps irritable, reaching after the truth of figures whose most important aspect is an origin much before the poet's inquiry, which begins by asking about identities and ends with a presumably uncovered truth.

"What men or gods *are* these?" The question positions the inquiry in the present, underscoring both the pastness of the original inscripting and the presentness of the current reading, and therefore the inescapable distance between human expression and human interpretation. (By contrast, Hemans's "Silent ye are" is immediately followed by "Yet to my soul ye speak," reflecting her view that there is a transhistorical present tense for allegorical speaking different from the short-lived expression uncovered by archeological scrutiny.) Failure to interpret such figural picture-language accentuates the urn's presence as an object. Like the "Nightingale" Ode's ambiguous "Forlorn," here the fourth stanza's "desolate" (joyless and abandoned, or merely devoid of figures) insists on a choice. The world on the urn cannot be both human and aesthetic, the urn itself both historian and object (in Foucaultian terms, both "document" and "monument"). The problem is less that no figure on the piece can tell "why" the town is silent than that none can tell *how* it is: like a consecrated urn. The Ode's ending supplants the effect of a warm abstraction by that of a cold one while not erasing the memory of the first. The urn is resolved into its constituent elements: fading image and imposing monumental shape, both resituated within the physical and historical world.

It is as historian that the urn is first probed. "What leaf-fring'd legend haunts about thy shape . . . ?" attempts to identify a story, fiction or history, to tell about itself, thus interpreting its own form. Keats seems to have found disturbing those mythic or allegorical personifications, like those found in Godwin's *Pantheon* or Lemprière's *Dictionary,* dissociated through time from their original narrative contexts. They seemed dreamlike: not exactly dreams but not exactly realities. "Surely I dreamt to-day, or did I see/ The winged Psyche with awaken'd eyes?" He tells about that experience, but doesn't tell or interpret the figures' meaning. The urn figures, too, remain a vignette without past or present, orphaned of their tale as the urn is of its own history. "We know no more of the men than of the gods of the Iliad," Peacock remarked in his "Four Ages."

More manifestly, the unasked question of the "Ode on a Grecian Urn," its untold dream, is what the figures mean to the speaker personally, to his sole self. The urn resists the attempt to make it "tell" not only

an originally implied story, but one read from it ideographically by John Keats. There is not a soul in it, nor any looking at it, to tell why it speaks to the viewer of both desolation and ecstasy. There is nothing within the scenes themselves or outside them to offer a signifying narrative continuity, nothing to turn the figures into a *formed* "legend": tale or explanatory inscription—such as Darwin, Christie, and Hemans were able to read on funerary objects. In the "Psyche" ode, although bower and legend are peered into, the *author's* own psyche is not. Nor is it in the "Grecian Urn," where the urn, an ideogram for the psyche, is ambiguously represented as an opaque Attic shape—either a quietly ecstatic one formed to accommodate remote images on it, or a silent, sepulchral one accommodating human remains. Thus the urn/psyche makes no choice between intense experience and profound truth, but equates the two by equating the urn's form and the psyche's. The form—the impression conveyed by urn/psyche of its own character and wholeness—is also the Ode's, achieved by a tracing around the pictorial surface that discloses the urn's Attic shape. We see not the linear, progressive form of a tale—but fixed figures covering a round fixed surface.

Finally, the readable monumental form, the one that "tells" (though it must be told what to say) is that surface's shape, the fair "attitude." That word locates the expressiveness of the urn, like that of the figures on it, as not in face or voice but in configuration and bearing. "Attitude" is "the position of an animated figure," to quote Michael Bryan's *Dictionary of Painters* (1816), "to which painting gives fixed and permanent form, and by which it can exhibit all the various movements which the passions can excite in the human frame."[22]

Both the urn's shape and the formal disposition of figures on it stand at least for a period style: the "Attic." Encounters with such styles are commonly recorded in Keats's poems as discoveries of positioned figures. The three with "bowed necks, and joined hands, side-faced" in "Indolence"; the "couched" lovers in "Psyche"; those permanently arranged beneath the boughs in the "Grecian Urn"; the "hovering" Diana seen by Endymion (1: 624); the kneeling and then recumbent Madeline seen by Porphyro, the sculpturesque figures in *Hyperion:* in the "attitudes" they have assumed each personifies some "realm"—of art or of the imagined past. (As I have been saying, it was a common method used by art and literary historians to imagine historical periods and their cultures.)

But an author may dreamily breathe the pure serene of such a past realm without having any role in it. In "Chapman's Homer," just when

the issue of the poet's own situation might be raised, the protean speaking "I" transforms itself into one figure and then another, both of them "watchers" or readers, and therefore "silent" (Cortez and his men specifically so). As our own gaze is shifted to the transformed selves, then to Cortez's soldiers, the whole issue of the discoverer's capability is finessed. Keats transforms a work he reads into a scene accommodating a figure for his reading self—as both Psyche's priest and Eros, for example, or Endymion, or Porphyro, or Cortez. In this procedure no record is made of the continuously existent self, John Keats, the *un*transformed person and author. That self emerges from time to time in *Endymion,* most conspicuously at the beginning ("many and many a verse I hope to write," etc.: 49), and, the work finished, as an immature, chastened figure of failure in the Preface, hoping he has not "dulled" the "brightness" of the mythic world. At the end of *Lamia,* however, in *The Fall of Hyperion,* and especially in "Melancholy," that self is theatrically displayed and stationary.

In phrases that seem echoed in "Melancholy"[23] Hazlitt wrote that "the poetical impression of any object" is an "uneasy, exquisite sense of beauty or power that . . . strives to link itself to some other image of kindred beauty or grandeur; to enshrine itself, as it were, in the highest forms of fancy" (*Works* 5: 3). As he often does, Hazlitt is discriminating those forms of fancy or the imagination from the more visibly monumental, "fixed" forms of painting and sculpture, like those figured on Hemans's ancient sepulchre, "Fixed in undying lines." A poetic cascade of forms occurs throughout "Melancholy," but especially in the middle stanza, in the movement from the droop-headed flowers to the green hill, the morning rose, salt sand-wave, globed peonies, and finally the mistress and her eyes. These are not merely all beautiful forms but forms of "kindred beauty," the same quality in different instances.

As these successive forms of beauty die away in the final stanza, Melancholy's figure is "enshrined" as a personified, stationary, sublime form of "grandeur" or "power." In "Psyche" the poetical impression of the object is preserved in a living shrine, a memorial keeping in view the image of the remembered being, as grove, oracle, and dreaming prophetic passion. In "Melancholy" the poet and his poem are maintained in a different sort of monument. Like "altar," "shrine" in Keats suggests rituals of both worship and death. While Melancholy's own sovereign shrine is the temple where she is worshipped, that of poet and poem is "a case or casket for a dead body" or "a tomb or cenotaph of an elaborate kind" ("shrine": *OED*). The self is exposed as inactive and incapable, a "cloudy trophy." As well as obscure or indistinct, "Cloudy" can mean gloomy or unfortunate *(OED)*, and a person hung as a cloudy trophy may be making display of his inarticulate, melancholy self, the verbal ineffectiveness

made more conspicuous by the physicality of the sole self. A poetic shrine serving as temple for a discovered figure may ultimately entomb both it and the devotee. Whereas Shelley sought to unveil the living aesthetic form within dead historical shapes, Keats's vision saw the coming bulk of death in all figures.

In her own ode, Psyche is the "happy, happy dove" who shared her peaceful bed with Eros. "Mournful Psyche" in the "Ode on Melancholy" recalls the rest of the myth, where she is pursued by a jealous Aphrodite and abandoned on a solitary rock. (Both phases are alluded to in "I stood tip-toe" (147–8): "The silver lamp,—the ravishment,—the wonder—/ The darkness,—loneliness,—the fearful thunder.") In "Psyche" the poet is the priest and happy Psyche is enshrined; all pain is pleasure. In "Melancholy" she becomes the veiled priestess and he her trophy; all pleasure is pain. Whereas "Melancholy" "tells" the rest of the tale (what happens after sorrow is glutted), not in narrative, but in an alternative shrine image, "Psyche" enshrines the dreamier or more romantic aspects of the legend.

The "Grecian Urn" attempts to tease out such a dream narrative, one like *Endymion*'s of panting youth yearning toward some fulfilling event. All of the odes of spring 1819 are curtailed stories about emergent beings who become featured in sequences of two or three envisaged events in a pastoral setting. As the figures move off, or as they are enshrined and stilled, any expected continuation of the action is stalled. Like "Psyche," the "Grecian Urn" is a stillborn romance, sacrificed with its eligible characters to pictorial beauty. Its fourth stanza enshrines the unsatisfied desire, the uncompleted romance, and tells a situation of desolation. The shrine provides a destination not offered in the first three stanzas, a closure. But of what sort?

In the early poems Keats often enshrined the tale as a sonnet or as a brief passage in a longer poem, such as an epistle, a "little space, with boughs all woven round" ("I stood tip-toe"). With *Endymion* he began to preserve as well the story's linear aspect, though elaborating on its form, and situating little spaces as shrines within the narrative. "And when a tale is beautifully staid,/ We feel the safety of a hawthorn glade: When it is moving on luxurious wings,/ The soul is lost in pleasant smotherings" ("I stood tip-toe," 129–32). *Endymion* moves along on luxurious wings, but is sometimes staid or stayed: fixed as a small shrine of "safety." It is a sanctuary or monumental form for the tale as well. The nature of the narrative is defined by the enshrined figures it encloses, whether a dream icon for what might be or a memorial icon for what has been and can be no longer. As with the movement from "Psyche" to "Melancholy," the stories of *Isabella, The Eve of St. Agnes,* and *Lamia* begin by framing dream icons and conclude by enshrining them as relics.

The lovers in the opening of *Isabella* "to each other dream," the image of each filling the prospective consciousness of the other. He: "To-morrow will I bow to my delight,/ To-morrow will I ask my lady's boon." She: "O may I never see another night,/ Lorenzo, If thy lips breathe not love's tune" (St. 4). As these icons sustain desire, feeding the story's future movement, the present is absorbed in the future. "Lady! thou leadest me to summer clime/ And I must taste the blossoms that unfold/ In its ripe warmth this gracious morning time" (St. 9). The narrative's early, happy events take living form, "like a lusty flower in June's caress" (St. 9). After the murder, Isabella's dream of a dead, weeping Lorenzo leads her to discover the body. This pathetic turn proceeds from a *fait accompli,* an outcome already achieved, and culminates with an enshrined icon of the past, Lorenzo's head: "love; cold,— dead indeed, but not dethroned" (St. 50), an example of the monument as memorial icon (like the Ode's trophied melancholiac).

What may be called the small-shrine poems—"Psyche," some sonnets in the 1817 volume, and the Milton piece—are shrines in two senses: 1) They are places to house relics or remnants of a figure or tale to be honored; 2) They are temples—places for honoring or worshiping and for praying, giving verbal form to ardent desires. The third meaning of "shrine," however, is appropriate here: a receptacle for publicly displaying the dead. The pot of basil is one of these.

The chapel where *The Eve of St. Agnes* begins is most notably the second kind, a temple housing the Virgin's picture. But it is also the third, lodging the "sculptur'd dead." (As in several of his poems of this period, corpse is merged with effigy.) Madeline's moonlit room houses imagined figures in its stained-glass windows. From the chapel at the beginning the poem proceeds to several of these icons—St. Agnes herself, the Virgin, Porphyro's image in Madeline's dream—and then to the dream shrine in the poem's center. So it moves forward as a quest-narrative to some *personally* determined, or willed, future of new wonders whose outcome is uncertain and, when achieved, ambiguous. Maidens in Madeline's position "require/ Of Heaven with upward eyes for all that they desire" (St. 6). But from the shrine for the sculptured dead and the beadsman's figure, the tale moves toward an externally, not personally, determined future. It is a narrative which, though past-situated, is full of presentiments: "already had his deathbell rung" (of the beadsman). The shrine reached is the same chamber, but here Porphyro, "pale as smooth-sculptured stone" (St. 33), recalls those "sculptured dead" in the chapel.

Just as the presiding spirit of one ode is the "winged" Psyche of desire and hope, and of the other the "mournful" Psyche of death and memory, Keats's *Eve of St. Agnes* has two patron saints, the "wing'd St. Agnes" (St. 5) with her "saintly care," and the confined, violated, and martyred Agnes of the original saint's legend. The winged figure is the spirit of new romance or romantic legend, of Madeline and Porphyro. That unmentioned or unmentionable figure is the spirit of the anti-romance, the narrative that, having already determined its events dolefully, admits no changes, no new wonder, and, like written history, looks backward. Because the beginning three stanzas of *The Eve of St. Agnes* anticipate the cold ending, nothing between can change what happens to the initial protagonist, the beadsman. *The Eve of St. Agnes* begins with Madeline's dream of and anticipation of the future, the perspective that we readers adopt, focusing "sole-thoughted" (St. 5) on the lovers. At the end, the two main figures are ambiguously "gone." So also, in a different sense, is the real martyred St. Agnes, who might have been the protagonist of her own tale, which like those of Angela and the beadsman can have no other outcome but the death of its protagonist, no matter how often told. The beadsman's chapel of prayer is a temple of hope, personified by the pictured Virgin. With its "sculptured dead," it is also a shrine for those who have passed on. As *a* history or story, history points to hope, expectation, growth. Viewed retrospectively, as history, it is an emblem for the past itself, "deathwards progressing/ To no death" (*Fall of Hyperion* 1: 260–1). Even in Madeline's moonlit bedroom—a silver "shrine" for the personification of Porphyro's most ambitious dreams—windows depict not only "twilight saints" but "the blood of queens and kings." The chamber itself has something of the tomb about it, the kneeling, effigy-like Porphyro "pale as smooth-sculptured stone."

The story of course has a number of such ambiguous representations of divinities and other spiritual beings. These icons—carved angels, a picture of the Virgin Mary, stained-glass saints—can be seen as housing either living or dead ideas, as being either living or dead symbolic forms. In *Lamia* this is also true of the banquet tables, "Each shrining in the midst the image of a God" (2: 190): monuments, depending on perspective, either to dead ideas or to still-vital ones. The beginning of *Lamia* talks of the displacement and supplanting of such ideas and their personifications. By situating the legend itself, as legend, in the distant past Keats reminds us of the tenuous nature of iconic figures: "the Gods, whose dreadful images/ Here represent their shadowy presences" (2: 279–80). "Here" can mean on earth or in the banquet room; it can also mean within the poem. The divine images are memorials to the death of the icon in an age of penetrating analysis. Donald Reiman has found a

"humanistic paradox" in the appearances, displacements, and ambiguous positioning of divine figures in the poem. These comings and goings teach the lesson of history, that man's gods are "merely the creatures of his own imagination, which is in itself changeable."[24]

And yet as *Lamia* proceeds like *Isabella* from this reality of a displaced past with its representations, it also moves its principal characters forward romantically from Lamia's dreamed image of Lycius, then in the second part unromantically towards the displaying of his "heavy body" on a "high couch," another of melancholy's cloudy trophies. The initial iconic vision of the figure realizes itself in narrative action: what the imagination seizes as beauty must be truth. Although "Real are the dreams of gods" (1: 127), the dreams of mortals are realizable in narrative and must enact real change, not the reversible metamorphoses of the gods. Lycius's dream, unlike Lamia's dream of Hermes, is of the sort that generates permanent changes. Significantly, Keats's note, positioning the legend more specifically in the historical past, is appended to the last line: "[M]any thousands took note of this fact, for it was done in the midst of Greece."

To summarize, shrines in Keats are ambiguously monumental, incorporating aspects of memory and death as well as of hope and desire. They are *intended* as sanctuaries for ideas preserved and given shape by personification, an always-decipherable language. The worshippers at the shrine of Pan in *Endymion* exhort him to "Be *still* the unimaginable lodge/ For solitary thinkings," and "*still* a symbol of immensity" (1: 293–4, 299; emphasis added). The rites are meant to maintain the symbolic power of the figure within its own monumental "lodge." In most cases, however, the signifying figures are like idea-effigies—emblems, such as Roman personifications, of now more or less remote concepts. Endymion's own lodge for solitary thinkings is the figure of Diana he pursues throughout the poem. Just before reaching the bower of Adonis he descends into a chilly cavern of "sadness" (2: 219ff.), where he discovers one of her shrines with a stone representation of her, "quiver'd" and on tip-toe. After touching his forehead on that "marble cold," he finds himself peering into many dark corridors and ancient niches. The shrine turns out to be no resting place or lodge for his imagination, but nearly the site of its death: a "journey homeward to habitual self" occurs, and with it the "deadly feel of solitude." The Cave of Melancholy episode, tracing a movement toward a stone enclosure resistant to both life and the imagination, is a melancholic counterpart to the poem's Adonis scene as well as to the Psyche ode.

In its chill, its darkness, its absence of enfolding live vegetation, it parallels too the opening of *Hyperion*, where "Deep in the shady sadness of a vale" Saturn lies "quiet as a stone,/ Still as the silence round about his lair" (1: 1, 4–5). Hyperion is horrified by monumental "forms," those of Saturn and his fellow Titans, representing once-living concepts of the eternal, now historically situated and therefore subject to history. They seem disturbingly emblematic of his own situation:

> O dreams of day and night!
> O monstrous forms! O effigies of pain!
> O spectres busy in a cold, cold gloom!
> O lank-eared Phantoms of black-weeded pools!
> Why do I know ye? why have I seen ye? (1: 227–31)

To use Southey's description of sculpture, the tableau seems to be a "cold abstraction," a remote image of an idea. The first line may recall those allegorical figures in the Medici tomb, "gigantic shapes of Night and Day,/ Turned into stone," as Rogers described them. The ultimate, historical silence is that of the *thing*, and while the stillness of the aesthetic image is coolly fascinating, the artifactual stillness of the pure object is ponderously cold.

In *The Fall of Hyperion* these mysterious figures appear even more conspicuously as effigies, "sculpture built up" on the "grave" of their own potency (1: 383), immobile, "fixed shapes," which the poet watches motionless for a long month, all the time growing more "gaunt and ghostly" (1: 391, 396). As with Endymion in Diana's underground shrine, the poet's contemplation of "unchanging" figures engenders an oppressive sense of his own person as isolated and unchanging, the image of the dead body.

I discussed above the Romantics' fascination with the myth and statue of Niobe as a trope for the "fair living" form, one able to evolve into different kinds of forms. Now I want to turn to a quite different aspect of *Endymion*'s Niobe, the theme of petrifying sorrow:

> Poor, lonely Niobe! when her lovely young
> Were dead and gone, and her caressing tongue
> Lay a lost thing upon her paly lip,
> And very, very deadliness did nip
> Her motherly cheeks. (1: 339–43)

The lines, following closely on the "fair living forms" section, recall Ovid: "her eyes were fixed and staring,/ The picture of utter grief, and in the picture/ No sign of life at all: the tongue was frozen/ To the roof

of the mouth. . . ." Ovid's Niobe is turned to stone, carried to a mountain top, and "even to this day/ The marble trickles with tears."[25] As a statue, Niobe remains a monument to her own grief and helplessness.

There is a further tradition in which the witnesses to Niobe's misery themselves are turned to stone, preventing them from burying her (*Iliad* Bk. 24). Hazlitt's remarks on Niobe, quoted above, continue: "the grief it expresses is such as might almost turn the human countenance itself *into marble!*" (*Works* 18: 113). Niobe then can be regarded as another version of the Medusa motif, in which the sight of something unutterable "turns the gazer's spirit into stone," to quote Shelley's line. Obviously, these writers are concerned with some kind of grieving gaze, but the grieving of what loss? In notable cases it is Time's alteration of the figure from fair living form into fixed shape—that is, from the fluid, expressive, and transformable to the static, mute, and permanent.

By the Renaissance, writes Jean Hagstrum, "It had become conventional to say that a person in great grief, admiration, or any other overwhelming emotion had been so drained of vital power that he was like a statue, a monument, or some other graphic representation of reality."[26] Hagstrum briefly mentions two passages from Thomson's *The Seasons* ("Summer"). In what became the most famous allusion to the Venus di Medici and one of the most famous poetic references to any statue, Thomson's Musidora sees her lover Damon watching her bathe: "With wild surprise,/ As if to marble struck, devoid of sense,/ A stupid moment motionless she stood:/ So stands the statue that enchants the world . . ." (1344 ff.). In the other passage Thomson compares a grieving Celadon, "fixed in all the death of woe," to a mourner standing on a marble tomb, "For ever silent and for ever sad" (1217–22).

Both passages effect analogical transformations of the human body into sculptural form and then into poetic image (the whole process being a figure, trope, or change), thus illustrating the *Endymion* passage about fair living forms. Paradoxically, however, both also bespeak monumental silence and stasis. From this standpoint the second is especially interesting, alluding as it does to the convention of the double-figure effigy, mourner and mourned, with the grief of the mourner almost like death.

Shortly after the Niobe passage (l: 397ff.), Endymion falls into a melancholy "fixed trance," heedless to the sympathetic expressions of onlookers: "Like one who on the earth had never stept—/ Aye, even as dead-still as a marble-man,/ Frozen in that old tale Arabian" (403–6). It is of course the familiar motif of being petrified by grief or astonishment. But the last lines are curiously ambiguous. They refer to the wicked town in the Arabian Nights (17th night) whose people were all turned to stone. Like the figures on the urn, however, these are also frozen in their own tale: a tale frozen in the history of those narratives that, like all "old"

romance, are themselves fixed in time. "One who on earth had never stept" could refer to figures in narrative or pictorial art. Like Porphyro, Keats the poet in *The Fall of Hyperion* gazes at these still figures, and like him he turns into a marble man: the petrified watcher. The question is, What accounts for the "fall" of the Hyperion forms into fixed shapes? Why do they, like the poems that feature them, remain immobile?

Perhaps that fall has to do with their not participating in, or generating, any new narrative situations as the Psyche and her Cupid do, or at least promise to. Again to quote Hazlitt, unlike sculpture, poetry "represents forms chiefly as they suggest other forms. . . . It describes the flowing, not the fixed." In fact, for a time Diana's sculpted form in *Endymion* and Saturn's and Thea's in the Hyperion poems halt the narrative movement by their presence. The "deadly feel of solitude" experienced by their viewers results less from what they are than from what they have ceased to be. Keats wrote in the Troilus letter that he was content to be alone because he could be with those figures he met in books. The state of melancholy, the state of being one's sole self and not a reader-poet, involves being fixed or "hung" beside a figure recognized as fixed and monumental, like Diana, Saturn, or the Ode's "Melancholy."

Like a number of the stone forms in *Childe Harold*, those in the Hyperion poems present themselves as ideograms. Unlodged in any tale that might be read or listened to, they are no longer, like *Endymion*'s Pan, lodges for solitary thoughts, that is thoughts *by* the solitary self. They now house thoughts *of* the self as solitary and individual. Their original referential power lost, they attach themselves, with their connotations of loss and death, to the person of the poet conscious of his present situation.

When the self is no more than a pictorializing (not a scrutinizing) consciousness, there can be no true self-consciousness, because the sole self, the person, is excluded from the picture. However, although that aesthetic experience itself is secret or private, its written expression is public. Private reading or viewing is very much a matter of wandering alone and secure in a "little Region." While in *Endymion* Adonis's "winter-sleep" is "safe in the privacy/ Of this still region" (2: 479–80), Keats's is too, protected as much by his own "branched thoughts" in "Psyche" as are the two forms enshrined there. The two "Elgin Marbles" sonnets, on the other hand, like *The Fall of Hyperion*'s "effigies of pain" passage, reflect an ambiguous personal situation in viewing such forms. The speaker is wonderfully awe-struck by the colossal fragments, but also "sick," "weak," weighed upon by his own mortality, finally more conspicuous as a presence in the poem than are the statues themselves. Generally, Keats presents the melancholiac as alone and exposed, not assimilated by or assimilating other figures in some "pleasant," pictorialized

narrative realm. In Melancholy's realm mortal identities and immortal abstractions have little involvement with each other. In her Ode, Melancholy, as reigning *abstraction,* has nothing to do with the highly embodied worshiper, who is near but not "with" her, as in the "Psyche" ode.

Apparently it was when working on the first *Hyperion* that Keats began thinking of "identities" and "abstractions" as necessarily opposed to each other. The "identity" or the "identical nature" is someone's personal presence. Perhaps because he believed the poetical "Character" lacked this (*Letters* 1: 386–8), he often felt the identities of others pressing upon him. In both his letters and verse Keats came to associate woe with the pressure of physical presence, a pressure that increased the sense of the world's physicality. Especially in the summer and fall of 1819, his invalid friend James Rice was both a personal and conceptual burden to him: "He was unwell and I was not in very good health: and I am affraid we made each other worse by acting upon each others spirits. We would grow as melancholy as need be. I confess I cannot bear a sick person in a House especially alone—it weighs upon me day and night—and more so when perhaps the case is irretrievable—Indeed I think Rice is in a dangerous state" (*Letters* 2: 134). Rice has been "unfortunately labouring under a complaint which has for some years been a burthen to him—This is a pain to me" (*Letters* 2: 126). A female boat passenger with consumption affected him the same way and made him think of his friend: "I shall feel a load off me when the Lady vanishes out of my sight" (2: 349–50). And in November he wrote of "the load of WRETCHEDNESS which presses upon me" (2: 351). Supported only by his "own weak mortality," the "watching poet" in *The Fall of Hyperion* bears the "load of this eternal quietude,/ The unchanging gloom and the three fixed shapes/ Ponderous upon [his] senses" (1: 389–92). Once again the "eternal," suggesting here both the timeless and the abhorrent *(OED),* is linked with silence. Paradoxically, these figures are seen in the context of Moneta's temple, the "eternal domed monument" (1: 71) with its own suggestions of the deathlessness of human material and intellectual construction: of the work itself.

When in 1818 Keats had felt pressured by the physical presence of his ailing brother, he clearly tried to escape it by identifying with envisioned figures: "His identity presses upon me so all day that I am obliged to go out—and . . . to write, and plunge into abstract images to ease myself of his countenance his voice and feebleness . . ." (1: 369). Having "relapsed into those abstractions" which were his "only life," he could elude "a new strange and threatening sorrow" (1: 370). Also at this time he began to consider his "love of beauty in the abstract" (1: 373) and his "mighty abstract Idea" of beauty (1: 403). No doubt it was *Hyperion* that he referred to as "a very abstr[a]ct Poem" (2: 132).

Greek divinities and other figures are in part embodiments of "abstract ideas," Godwin wrote, such as grief, fear, war, peace, life, and death. Keats's letters and poems often reflect the intense reality for him of such embodied abstractions, as well as the tragedy or melancholy of their loss of power: Beauty losing her lustrous eyes, Love no longer able to pine. Such abstractions as beauty and love become hollow or one-dimensional figures like those in "Indolence." *Hyperion*'s fallen Titans are "Scarce images of life" (2: 33), that is, not only representations of barely living beings but barely living images of beings. This iconic aspect is emphasized in *The Fall of Hyperion*, where the figure of the fallen Saturn, an "image huge," resembles the sculptured "image" the poet sees on entering Moneta's temple (1: 88, 213, 224, 298–9). The *OED* quotes Hazlitt on Milton's "mighty abstractions" of Night and Death (*Works* 6: 57) to illustrate the meaning of "abstraction" as something without independent existence. To be real, Keats ultimately concluded, all figural abstractions must embody not mere dreams but the world we "jostle" in, the world of bodies. In other words, they must become identities. His "Melancholy" ode turns from conventionalized literary abstraction to the personal experience of melancholy: proved on the pulses. Melancholy then becomes an identity ("thy mistress").

In melancholy situations abstractions are fully and meaningfully incarnated to the gaze of the viewer, whose soleness (particularity and solitude) is emphasized by an obscure, remote setting. Such is the "hollow vast" of Endymion's sea-journey in Book III (119ff.), where, among "things/ More dead than Morpheus's imaginings"—rusted anchors, rudders, helmets, breastplates—the young man encounters "sculptures rude/ In ponderous stone, developing the mood/ Of ancient Nox; then skeletons of man,/ Of beast, behemoth, and leviathan. . . ." Unreadable as images, these are "things." Foster children of time, decontextualized and never relodged, they have passed into the "illimitable gulph/ Of times past, unremembered" (*Otho* III, i, 5–6). These are Shelley's "monstrous and barbaric shapes," or Herder's Sphinx demanding an explanation. And they are proof that A. W. Schlegel's claim—the human form needs no interpretation—holds true only if the form has not been abandoned to Time as historical debris. Like the human remains, the statues are "skeletons," inviting but resisting interpretation, thus imparting a dangerous "heaviness" like theirs: "A cold leaden awe/ These secrets struck into him; and unless/ Dian had chaced away that heaviness,/ He might have died." As a whole *Endymion* sustains and lightens its figures in a new, complete version of their legend, but this does not happen in either of the Hyperion poems.

Two effects of vastness in the *Fall of Hyperion*, according to Walter Jackson Bate, are a "remote and abstract" background and "a new,

sharply analytic consciousness of the body as an anatomical event both brief and complex."[27] I believe the reason for this contrast between the figure and its environment is that Keats's figures *are* figures of thought placed in a signifying context that is necessarily obscure. They then are abstract as personifications of or figures for something, but ponderous as presences in themselves. As objects (that is, as impenetrable, unadmitting things) they are extremely powerful, even intimidating. As images they seem vague, lost, spectral, like the "lost" language of hieroglyphics whose only vestiges are found "on remnants huge/ Of stone, or marble swart; their import gone,/ Their wisdom long since fled" (*Hyperion* 1: 281–3). Yet their continuing monumental existence, like Saturn's, is a heavy, "awful presence" (*Fall* 1: 448). This leaves them a mysterious source not of meaning but of effect (of "mere astonishment," as Shelley says in *Prometheus Unbound*).

Sculpture "of its nature, *is* object, in the world," writes William Tucker, "in a way in which painting, music, poetry are not."[28] As I have said, Keats's model for the realm of imaginative association and transformation is the picture, a world of ordered spaces, the most important aspect of which is the viewer's distance from the scene, an "ambiguous threshold" of desire or longing, according to Geoffrey Hartman.[29] His pictorialized figures such as Psyche and Eros and *Endymion*'s Adonis tend to be distanced by romance framing, removed into a kind of limbo not only from the observing subject but from history itself. By contrast he emphasizes the physicality of his melancholy figures by having them "postured motionless" (*Fall* 1: 382) in a Miltonic "*Stationing or Statuary.*"[30] Being thus stationed, situated on or in a place, but not framed or enclosed, emphasizes their ability to bear their own weight or their tendency to sink or fall. "Melancholy realms," like those of *Hyperion* and the *Fall of Hyperion* seem under water: "Deep in the shady sadness of a vale/ Far sunken from the healthy breath of morn." All things seem stone or metal and sink in this sunken world. The "ponderous iron mace" of the Titan Creüs "Lay by him, and a shatter'd rib of rock/ Told of his rage, ere he thus sank and pined" (*Hyperion* 2: 42–3).

Keats's sculpturesque figures tend to be megalithic: gigantic, extremely ancient, of mysterious shape, and somewhat featureless. Hyperion resembles "the bulk/ Of Memnon's image at the set of sun/ To one who travels from the dusking East" (*Hyperion* 2: 372–6). The Titans at the beginning of Book Two are likened to an ancient stone circle: "one here, one there,/ Lay vast and edgeways; like a dismal cirque/ Of Druid stones, upon a forlorn moor" (2: 33–5). That passage recalls Keats's own walking-tour discovery of "aged stones" constituting a "Druid temple" (*Letters* 1: 306). Orphaned by their own, dead culture, megaliths are adopted by the whole of history, objects in time pointing to Time itself.

Monumental orphans like the figures in the Saturn myth are themselves historically isolated and very publicly exposed. The Elgin Marbles, in the situation in which Keats and others viewed them, had been de-shrined, displaced, exposed to history, vulnerable to the "wasting" of time, not in their deterioration as objects but as symbols.[31] They constituted a "shadow" of a magnitude: both symbol or type *(OED)* and mere vestige. Monuments to the "grandeur" of Greek symbol-making power, they now seem fallen and heavy—"mighty things"—and the poet feels a vulnerable physicality. As the "Hymn to Pan" affirms, early mythic figures were symbols of "immensities." The Hyperion figures are fallen symbols, unreadable even by a perplexed Coelus, who calls them "Sad *sign* of ruin, sudden dismay, and fall" (1: 336; emphasis added), and wonders "what shapes they be,/ Distinct, and visible; symbols divine,/ Manifestations of that beauteous life/ Diffus'd unseen through eternal space" (1: 314ff.). Born as a figural language for the ineffable, they now, "most unlike Gods," are given to human woe. They resemble real people, or characters in modern stories. "Now I behold you in fear, hope, and wrath;/ Actions of rage and passion; even as/ I see them, on the mortal world beneath,/ In men who die." Thea's plaint in the *Fall of Hyperion* also suggests that the figures have fallen as symbols of immensities. "For heaven is parted from thee, and the earth/ Knows thee not, so afflicted, for a God;/ And Ocean too, with all its solemn noise,/ Has from thy sceptre pass'd, and all the air/ Is emptied of thine hoary majesty" (1: 357–61). To the "dreamer," envisaged figures like those in the "Grecian Urn" and "Indolence" remain distanced, uninterpreted pictorial abstractions. The *Fall of Hyperion,* however, is an attempt to "tell" or decipher *Hyperion* and its figures in terms of Keats's own life. As we saw with Byron, the figure bereft of its original meaning may turn into another kind of figure, an ideogram for the living, writing person. In Fortune's rhetoric and the poetry of ruins, poets entered the melancholy realms of solitary relics to preside judgmentally, transforming the dead monuments into ghostly but powerful allegorical figures. Poets like Byron, Hemans, Keats, and Shelley found in the forever-silent form a kinship and a vehicle for self-expression. Mirrors as well as stones, the fixed forms became ideograms for the poets themselves.

Conclusion

According to Foucault, the early nineteenth-century's fear of being "dehistoricized" led to a fascination with "traces left behind by time," especially those "still capable of reflecting [man's] image." As records, however, such monuments had "fallen silent and folded back upon themselves,"[1] an apt description, perhaps, of those forms seen by travelers in antique lands, as well as the melancholy figures in the Hyperion poems and the "dim forms" in *Childe Harold*'s last canto.

In rehistoricizing the past by the recovery and display of human forms, the art museum in the eighteenth and early nineteenth centuries was a project of humanist reformation. If, as Panofsky wrote, the humanities gaze at "frozen stationary records" and endow them with "dynamic life,"[2] the museum is the quintessential humanistic project. What made the art work always knowable and readable was not merely its shape but its form, "the shape imparted to an artifact by human intention and action."[3] Thus a repository of art forms offers a history of human purpose. The preoccupation of poetics and aesthetics with "humanistic form" can be traced to Aristotle's contention that art's main attribute is "a unified and purposeful structure."[4] Since Aristotle, we have assumed an inseparable connection between unity and clear intention, two elements forever embodied "in" the work of art, each bespeaking the other. "Form" distinguishes the work from mere acts of expressing. Purpose or intention distinguishes man-made forms from natural ones. Thus the "work" itself is important to humanism as the perceivable and lasting *product* of expression and purpose.

The emphasis on form among eighteenth-century artists and connoisseurs was stimulated by that age's interest in three-dimensional figural works, especially early Greek ones. Forever decipherable because always recognizable, the enduring image of man represents the victory of the monumental, of the intrinsically and permanently significant.

Schlegel insisted that models of the human form require no interpretation because form is perpetually self-expressing. The word "form" has thus never been without its associations of the monumental: the solid and immutable. This was especially true in the world of later eighteenth-century artists and connoisseurs. Then form tended to mean outline or shape, as distinct from color or expression. Shape was the basis of the arts of form, the visual arts. The new museums collected objects comprising or containing distinctive shapes.

Largely owing to the influence of certain German writers, form in the early nineteenth century came to be thought of as Gestalt, the perception or experience of shape. Coleridge's Kantian concept of form was "that factor of knowledge which gives reality and objectivity to the thing known . . . the formative principle which holds together the several elements of a thing" (OED). Coleridge's "picturesque form" is such a Gestalt and may be contrasted, as he wanted his readers and listeners to do, with pictorial or visible form. Thus in Romantic aesthetics and poetics form came to be thought of as a configuration of the mind.

As such, form expressed itself in particular visible existences, forms of or for that idea. Poetic Gestalt, or living form, is shape experienced or felt as transformable. Shapes in stone or on canvas—mythic or portrait figures, for example—have what Hazlitt called the "informing principle" if they invite the perceiver to reproduce them. What made the word "form" fascinating in the early decades of the nineteenth century was the way it bore associations of all these various meanings: visible shape, especially human shape; envisioned shape; an informing "principle"; and a particular mode of existence for an idea.

As Morris Weitz has observed, since the Greeks, "form" has always had an "irreducible ambiguity." In the arts alone it has meant "shape, appearance, ideal, arrangement, organization, successful (e.g., harmonious) arrangement, mode of expression, kind or species, abstract pattern. . . ."[5] To illustrate Weitz's point, the Duke of Wellington's own person was a form; so was the Goya portrait's depiction of it. Goya's aesthetic scheme for the portrait, the elements of outline in that scheme, even the portrait genre, are forms in different senses. If a poem were to be composed about that portrait, all of those aspects of design, structure, genre, and figuration would fall under the category of form. In the pages of the Romantic poets and essayists we have encountered all of these meanings and others as well, for the Romantics recognized and capitalized on the word's ambiguity. In their writings it is often impossible to know just which meaning is being employed. When Coleridge speaks of remembering "the form I love" ("Lewti") the phrase hangs mysteriously between an actual woman and a mental image of her. When Felicia Hemans speaks of those "Forms of sublimity" stolen and

transported by Napoleon's armies, she means individual sublime works or types of the sublime (portraits or religious pictures, or Greek mythic sculptures), depending on how "of" is read. When Mary Shelley recalls that in Italy her husband's soul "imbibed forms of loveliness which became a portion of itself," she could be using "forms" in any of several ways: kinds or examples (sculpture, painting, natural landscape); particular material shapes (statues, paintings); aesthetic ideas (what Shelley sometimes referred to as inner forms); individual things in nature, such as Italian people or details of the landscape, which he described feelingly in his letters. She probably meant all these. However, that most of these forms, though visible and material, could *become* a "portion" of his soul suggests not just the ambiguous character of the word, but the fluid nature of forms themselves, as the Shelleys conceived them. Forms are always becoming other *kinds* of forms.

When we contemplate great statuary and painting, Shelley wrote to Peacock, we apprehend "the degree in which, & the rules according to which, that ideal beauty of which we have so intense yet so obscure an apprehension is realized in external forms." The rules, as the "Defence" makes clear, are the aesthetic laws of harmony that govern the *inner* forms of these works. They are "expressed" in, or, as he would say, "stamped on" the outer forms. On the other hand, when Wordsworth wrote that great natural objects "impress their forms/ To elevate our intellectual being" the reverse process is taking place: physical shapes are transformed into mental ones—forms still, but different kinds of forms.

So "form" is not just a polysemous but a highly protean word, one whose meanings keep merging with or flowing into one another, as images and their metaphoric forms do in, say, the "Ode to the West Wind." The very fluidity of "form" in Romantic writing reflects that a form was conceived of not as a stable thing but as one possible stage in a continuing process of thought and execution. Taking "Ozymandias" as an example, the reader sees how the sculptor internalized a natural form (the king's body and countenance), into a mental form (an idea, as he "read" the king's expression), then into both stone shape and aesthetic form (the statue). The "traveller" registered, remembered, and conveyed the image of the statue's form, so that the poet might reimagine it as a verbal form (the sonnet.) Thus, in the paradigm of the human figure *as* form, we think of all persons and objects as potential ideas, all ideas as potential objects (art works). In *Childe Harold,* the "dim forms" that "despond" on the façade of the Doge's palace are the ghosts of the men of the city's great past, or the statues themselves, or the poet's idea of both. They are in fact shadowy or dim forms in Byron's poem, undefined as figures. Most of the "forms" in Byron's poem, as well as in, say, *Prometheus Unbound,* have this significant instability. This is

why if we are looking for a core concept of form among poets and essay-ists of the Romantic period it would be one largely overlooked by those writing on the subject: "One of the different modes in which a thing exists or manifests itself" *(OED)*. In other words, we must see Roman-tic "forms" as possibilities and, above all, as things capable of *transfor-mation:* if not recreated as different forms, at least perceived as such.

This is why I have been drawing on certain neo-Kantian philoso-phers like Ernst Cassirer and Susanne Langer to help bring out the Romantic concept of "living form." That term, as we have seen, is cen-tral to Cassirer's thinking about art; Langer declares that living form expresses "a meaning that seems inherent in the work itself: our own sentient being, Reality."[6] Most important here, I believe, is the idea that meaning exists *in* the work—it's *always* there, and need not be looked for somewhere else. The "work" is, in Gombrich's terms, an "ade-quate" text.

As I said at the outset of this study, the issue of expressive adequacy became an intriguing one in the museum age, when representations of the human form, some very ancient, were presented to the public view in numbers never seen before. However, what *were* the conditions of long-term adequacy for various modes of human expression? In what circumstances is a human shape a living form? The answer is found in what I've called the core definition of form: one of the possible visual modes of existence for a thing or idea. Living forms, in this case human forms, can be metamorphosed into different kinds of forms: material into ideal, sculptural into poetic, and so forth. Again I allude to J. V. Cunningham's remarks: "Form is discoverable by the act of substitu-tion. It is what has alternative realizations." As Keats shows us in the Hyperion poems and Byron shows in *Childe Harold,* forms may become pale and lifeless, as human bodies may. For any "form," how-ever, transformation is life. Forms in nature are alive if they grow. Those in art are living if they metamorphose, and they reveal their essential idea in their metamorphoses.

Thus a form is not just a shape representing one possible "realiza-tion" of an idea, but one that borrows some of its visual or imaginative identity from other forms of the idea. This happens with what Wordsworth calls the intermediate image, one that partakes, as Wordsworth's forms often do, of both the inanimate (perhaps stone) object and the animate (usually human) figure. A form might also be a representation conveying an exceptional sense of the original, or the original conveying a strong feeling of the representation it might become. It is a realization borrowing its reality from a cognizance of "alternative" ones. When Hyperion refers to the fallen Titans as both "effigies of pain" *and* "monstrous forms," the passage reflects how

mutually referable in Keats's own mind were the ideas of symbol, sculpture, and myth, engravings of mythic sculptures, such as those in *Polymetis,* and his own characters. All were forms, and the reader cannot safely interpret the lines as signifying any of them singly. The Niobe passage in *Endymion* may draw from such forms as the Uffizi group, the illustration in Spence, the narrative in Ovid, but, most importantly, it draws from the image in Keats's mind that represented a merging of all these.

Langer's concept of transformation in art is helpful here. This transformation consists of "the rendering of a desired appearance without any actual representation of it, by the production of an *equivalent* sense-impression rather than a literally similar one. . . ."[7] The ability of rendering, not representations, as in imitation, but equivalencies, as in transformation, Langer sees as the power of abstraction. One of her examples is the phrase "pouring forth thy soul abroad" in the Nightingale ode. The long vowel sounds are equivalents of the bird's song, not an onomatopoeic imitation. The essence of the song is abstracted and converted into an equivalent form, in another medium.

Langer does not, however, consider those further transformations, or reproductions, which, I have been arguing, are central to the Romantic writer's ideas of form, especially as he or she contemplated a monumental figure as an existence within history, as Keats does in reproducing the Grecian urn. For the Romantics, it was not just the inherent and abstractable idea that enabled further forms to be created, but the informing *principle,* an essential idea that is also a power of form-making. Principles are constitutive in both senses of the word. For Shelley *poiein* was that principle which synthesized forms to create new ones. For Hazlitt the poetic principle was that of metaphor, that figurative language which translates the object "into some other form."

Monumental figures or other shapes that represented or resembled persons tended to be seen as forms by Romantic poets and essayists. But here I believe we are truly left with what Weitz calls an irreducible ambiguity. Even if we settle on form as that which can be transformed, we can be thinking about an invisible principle or active essence, or else one of the modes in which that essence finds "alternative realization."

Using the word "form" allowed poets and essayists to discourse on nature, belief, thought, and art while leaving undefined the relations between inner form and external shape, idea and thing, perception and external reality, creative force or design and created object. These very ambiguities are the ones that make up the intellectual or psychological drama of such works as *Prometheus Unbound,* "Mont Blanc," the "Ode on a Grecian Urn," *Childe Harold,* and *Don Juan.* I agree then that the ambiguity of "form" is "profound" (Miller 298) and "irreducible"

(Weitz). But it is the very irreducible nature *of* the ambiguity that does make it profound and gives it such an unmistakable and potent presence in Romantic discourse. The word "form" keeps an idea in what Coleridge called the intermundium between thoughts and things, a realm of cognizance, but not knowledge. In this realm the form was always in the process of being transformed or transmuted into the thought, or into the thing. Or from one *kind* of thought into another, or from one kind of thing into another.

Notes

INTRODUCTION

1. Erwin Panofsky, "The History of Art as a Humanistic Discipline," in *Meaning in the Visual Arts: Papers in and on Art History* (Garden City, N.Y.: Doubleday Anchor, 1955), 10.

2. David Irwin, *John Flaxman 1755–1826: Sculptor Illustrator Designer* (New York: Rizzoli, 1979), 160.

3. Pictured in Brian Kemp, *English Church Monuments* (London: Batsford, 1980), 191, 192.

4. Joseph Addison, "Dialogues on Medals," in *The Works of Joseph Addison*. 6 vols., ed. George Washington Greene (Philadelphia: Lippincott, 1870), 2: 1–130.

5. "On the Connection and the Mutual Assistance of the Arts and Sciences, and the Relation of Poetry to Them All," in *The Reflector, A Collection of Essays on Miscellaneous Subjects of Literature and Politics*. 2 vols. (London [1812]), 1: 351–2.

6. *Polymetis: or, An Enquiry Concerning the Agreement Between the Works of the Roman Poets, and the Remains of Ancient Artists* (1747), repr. (New York: Garland, 1971), 3.

7. Addison, 11.

8. *Gibbon's Journey from Geneva to Rome*, ed. Georges A. Bonnard (London: Thomas Nelson, [1961]), 112.

9. *The Final Sculpture: Public Monuments and Modern Poets* (Ithaca: Cornell University Press, 1985), 28.

10. *Lectures 1808–1819 on Literature*, ed. R. A. Foakes. *The Collected Works of Samuel Taylor Coleridge* 5, 2 vols. (Princeton: Princeton University Press, 1995), 2: 472. Hereafter abbreviated in text as *LOL*.

11. *On the Historical Novel [Del romanzo storico]*, trans. and ed. by Sandra Bermann (Lincoln: University of Nebraska Press, 1984), 81.

12. Antonio Canova, *A Letter from the Chevalier Antonio Canova . . . on the Sculptures in the Collection of the Earl of Elgin* (London: John Murray, 1816), Letter xxii.

13. Recorded in Joseph Farington's *Diary,* June 10, 1807. Quoted in David Irwin, "Sentiment and Antiquity: European Tombs 1750–1830," in *Mirrors of Mortality: Studies in the Social History of Death,* ed. Joachim Whaley (London: Europa, 1981), 134.

14. J. Hillis Miller, "The Still Heart: Poetic Form in Wordsworth," *NLH* 2 (1971): 298.

15. *Poetic Form and British Romanticism* (New York: Oxford University Press, 1986).

16. Immanuel Kant, *Kant's Critique of Judgement,* trans. and ed. J. H. Bernard, 2nd ed., rev. (London: Macmillan, 1931), 185.

17. Friedrich Schiller, *On the Aesthetic Education of Man,* trans. and ed. Elizabeth M. Wilkinson and L. A. Willoughby (Oxford: Clarendon Press, 1967), 101.

18. Friedrich Wilhelm Joseph von Schelling, "Concerning the Relation of the Plastic Arts to Nature" (1807), trans. Michael Bullock, in Herbert Read, *The True Voice of Feeling: Studies in English Romantic Poetry* (New York: Pantheon, 1953), 329.

19. August Wilhelm von Schlegel, *Lectures on Dramatic Art and Literature,* trans. John Black, 2nd ed. (London, George Bell, 1894), 419. Hereafter cited as *Lectures.*

20. *The Statesman's Manual. Lay Sermons,* ed. R. J. White. Collected Works 6. (Princeton: Princeton University Press, 1972), 113. Hereafter cited as *SM.*

21. *Biographia Literaria,* eds. James Engell and W. Jackson Bate. *The Collected Works* 7, 2 vols. (Princeton: Princeton University Press, 1983), I: 251. Hereafter cited in text as *BL.*

22. The monument in stone is more interesting to the historian in the story of its reception and conversions than in itself. This is the premise of Haskell and Penny's study of the most influential classical sculptures through four centuries of their appreciation, works that "now live most in the reflections, copies and variants which they inspired." Francis Haskell and Nicholas Penny, *Taste and the Antique: The Lure of Classical Sculpture 1500–1900* (New Haven: Yale University Press, 1981), xiv.

23. Society of Dilettanti, *Specimens of Antient Sculpture, Aegyptian, Etruscan, Greek, and Roman.* 2 vols. (London: Payne and White, 1809; 1835), xxxix, xiii.

24. *Letters,* ed. Frederick L. Jones. 2 vols. (Oxford: Clarendon Press, 1964), 2: 53. Hereafter cited as *Letters.*

1. IMAGINARY MUSEUM

1. *Museum without Walls (Le musée imaginaire)*, trans. Stuart Gilbert and Francis Price (New York: Doubleday, 1967), 9.

2. In this study I have adopted the indispensable term "objecthood" used by Michael Fried in his essay "Art and Objecthood," in *Minimal Art: A Critical Anthology*, ed. Gregory Battcock (New York: Dutton, 1968), 116–47.

3. *An Essay on Man: An Introduction to a Philosophy of Human Culture* (New York: Doubleday, 1944), 208. Hereafter cited as *Essay*.

4. Germain Bazin, *The Museum Age*, trans. Jane van Nuis Cahill (New York: Universe Books), 1967, Ch. 10.

5. Quoted in Jack Kaminsky, *Hegel on Art: An Interpretation of Hegel's Aesthetics* (New York: State University of New York Press, 1962), 72.

6. William Hazlitt, *The Complete Works*, ed. P. P. Howe. 21 vols. (London: J. M. Dent and Sons, 1930–34), 18: 160. Cited hereafter in text as *Works*.

7. Anon, "Arrangement of the Elgin Marbles in the British Museum," *Examiner* 9 (1816): 399.

8. Benjamin Haydon and William Hazlitt, *Painting, and the Fine Arts: Being the articles under those heads contributed to the seventh edition of the Encyclopaedia Britannica* (Edinburgh: A. & C. Black, 1838), 65.

9. "Winckelmann" (1805), in *German Aesthetic and Literary Criticism: Winckelmann, Lessing, Hamann, Herder, Schiller, Goethe*, ed. H. B. Nisbet (Cambridge: Cambridge University Press, 1985), 241.

10. "Upon the Laocoon" (1798), *Goethe's Literary Essays*, ed. J. E. Spingarn (1921), repr. (Freeport, N.Y.: Books for Libraries Press, 1967), 25.

11. *The Destination of Works of Art and the Use to which They Are Applied*, trans. Henry Thomson (London: John Murray), 1821, 54.

12. *History of Ancient Art.* 4 vols. in 2 (New York: Frederick Unger, 1968).

13. Haskell and Penny, 102.

14. *Aesthetic Education*, 185.

15. *Outlines of a Philosophy of the History of Man*, trans. T. Churchill (New York: Bergman, 1966), 353–4.

16. Goethe declared that when the *History* was published men were "amazed at the sudden advancement" it gave them ("Winckelmann," 256).

17. R. G. Collingwood, *The Idea of History* (Oxford: Clarendon Press, 1946), 88.

18. Madame de Staël (Ann Louise Germaine), *Corinne, or Italy*, trans. Avriel H. Goldberger (New Brunswick: Rutgers University Press, 1987), 142.

19. "Thoughts on the Imitation of the Painting and Sculpture of the Greeks," trans. H. B. Nisbet, in Nisbet, 31–54; 43, 42.

20. E. H. Gombrich, *Meditations on a Hobby Horse and Other Essays on the Theory of Art* (London: Phaidon, 1963), 51.

21. Foucault, *The Archaeology of Knowledge and the Discourse on Language*, trans. A. M. Sheridan Smith (New York: Pantheon, 1972),125, 9.

22. *The Logic of the Humanities*, trans. Clarence Smith Howe (New Haven: Yale University Press, 1961), 163. Murray Krieger, Ch. 5 ("The Humanist Aesthetic") traces the humanist attempt to impose form on formless nature. *Theory of Criticism: A Tradition and Its System* (Baltimore: Johns Hopkins University Press, 1976).

23. Cassirer, *The Individual and the Cosmos in Renaissance Philosophy*, trans. Mario Domandi (New York: Barnes and Noble, 1963), 66–7.

24. Thomas Jefferson Hogg, *Two Hundred and Nine Days; or, The Journal of a Traveller on the Continent.* 2 vols. (London: Hunt and Clark, 1827), 1: 310.

25. "Gestalt Psychology and Artistic Form," in *Aspects of Form: A Symposium on Form in Nature and Art,* ed. Lancelot Lawe Whyte (New York: Pellegrini and Cudahy, 1951), 197.

26. Wolfgang Leppmann, *Winckelmann* (New York: Knopf, 1970), 163.

27. *Fragments: Incompletion and Discontinuity*, ed. Lawrence D. Kritzman (New York: New York Literary Forum, 1981), vii.

28. *An Essay on Sculpture* (London: T. Cadell, 1800), 3: 444–7.

29. James A. W. Heffernan, *Museum of Words: The Poetics of Ekphrasis from Homer to Ashbery* (Chicago: University of Chicago Press, 1993), 8. (Heffernan defines ekphrasis as "the verbal representation of visual representation.")

30. *The Art of Sculpture,* 2nd ed. (Princeton: Princeton University Press, 1961), 40, 41.

31. "Winckelmann," 241.

32. *A Visit to Paris in 1814,* 4th ed. (London: Longman, 1816), 243–4.

33. *The Life of Forms in Art*, trans. Charles Beecher Hogan et al., 2nd English ed. (New York: Wittenborn, Schiltz, 1948), 54–5.

34. Anon., *A Descriptive Catalogue of the Ancient Statues, Paintings, and Other Productions, etc.* (Edinburgh: Francis Pillans, 1816), 1.

35. *Paris in 1815 with Other Poems* (London: John Warren, 1821), 77.

36. James Forbes, *Letters from France Written in the Years 1803 & 1804.* 2 vols. (London: J. White, 1806), 24.

37. Cecil Gould, *Trophy of Conquest: The Musée Napoléon and the Creation of the Louvre* (London: Faber and Faber, 1965), 59.

38. James Simpson, *Paris after Waterloo* (Edinburgh: Blackwood, 1853), 118.

39. *Letters on the Fine Arts, Written from Paris in the Year 1815* (London: Longman, Hurst, 1816), 23.

40. *Observations on Italy,* 2nd ed. 2 vols. (Naples: Fibreno, 1834), 2: 48, 18.

41. *Letters during a Tour of Some Parts of France . . . in the Summer of 1817,* 3rd. ed. (Liverpool: Thomas Taylor, 1820), 28.

42. *A Review of the Polite Arts in France* (London: Cadell, 1782), 27.

43. B. F. Cook, *The Townley Marbles* (London: British Museum Publications, 1985), 26. (He is quoting the archeologist Baron d'Hancarville.)

44. James A. Galiffe, *Italy and Its Inhabitants.* 2 vols. (London: John Murray, 1820), 1: 249; 2: 391.

45. "Winckelmann," 244.

46. As Kenneth Hudson has argued, the word "temple" suggests not a Christian but a secular attitude toward the past, an attitude more humanistic or nationalistic than religious. *Museums of Influence* (Cambridge: Cambridge University Press, 1987), 43.

47. Donald Horne, *The Great Museum: The Re-presentation of History* (Leichhardt, Australia: Pluto Press, 1984), 14.

48. *History* 3–4: 190.

49. Winckelmann, *History* 1–2: xiii.

50. Joseph Alsop, *The Rare Art Traditions: The History of Art Collecting* (New York: Harper & Row, 1982).

51. Lady [S.] Morgan. *Italy.* 3 vols. (Paris: Galignani, 1821), 2: 143.

52. Archibald Alison and P. F. Tyler, *Travels in France, during the Years 1814–15,* 2nd ed. 2 vols. (Edinburgh: Macredie, Skelly, and Muckersy, 1816), 107.

53. *A Letter from Paris to George Petre, Esq.* (London: Mawman, 1814), 43.

54. Alastair Fowler, "Periodization and Interart Analogies," *NLH,* 3: 3 (1972), 487–509.

55. See also Nancy Moore Goslee, *Uriel's Eye: Miltonic Stationing and Statuary in Blake, Keats, and Shelley* (University, Ala.: University of Alabama Press, 1985), *passim.*

56. Quoted in Robert E. Norton, *Herder's Aesthetics and the European Enlightenment* (Ithaca: Cornell University Press, 1991), 230.

57. *Lectures on the History of Literature* (London: George Bell, 1909), 189.

2. HISTORY'S SEEN AND UNSEEN FORMS

1. *Shelley's Prose; or, The Trumpet of a Prophecy,* ed. David Lee Clark (New York: New Amsterdam Books, 1988), 352. Cited in text hereafter as *Prose.*

2. *The Complete Poetical Works,* ed. Thomas Hutchinson (London: Oxford University Press, 1905), 274. Cited in text hereafter as *Works* 1905.

3. *Italian Journey* (1786–1788), trans. W. H. Auden and Elizabeth Mayer (San Francisco: North Point Press, 1982), 489.

4. *The Journals of Mary Shelley,* eds. Paula R. Feldman and Diana Scott-Kilvert (Oxford: Clarendon Press, 1987), 1: 198–9; 246.

5. *Sexuality and Feminism in Shelley* (Cambridge: Harvard University Press, 1979), 19–23. Brown believes Shelley was acquainted with the *History* before leaving England.

6. Citations of the "Defence" in this chapter are to *Shelley's Poetry and Prose,* eds. Donald H. Reiman and Sharon B. Powers (New York: Norton, 1977).

7. Citations in this chapter are to "The Four Ages of Poetry," in *The Works of Thomas Love Peacock,* ed. Herbert F. B. Brett-Smith and C. E. Jones. 10 vols. (London: Constable, 1924–34), 8: 1–25.

8. Edward Gibbon, *The History of the Decline and Fall of the Roman Empire,* ed. David Womersley. 6 vols. in 3 (London: Allen Lane, 1994), 3:23.

9. *The Complete Works of Percy Bysshe Shelley* (1926–1930), eds. Roger Ingpen and Walter E. Peck. 10 vols. (New York: Gordian Press, 1965), 7: 200.

10. "The true difference is that one relates what has happened, the other what may happen." *The Poetics,* trans. S. H. Butcher, 4th ed. (London: Macmillan, 1911), 9.2.

11. E.g., Francis Hutcheson, *An Inquiry into the Origin of Our Ideas of Beauty and Virtue,* 4th ed. (1738), repr. (Westmead: Gregg International, 1969), 11, 80.

12. I agree with Marilyn Butler that Shelley "outflanks Peacock, and proves more of a utilitarian than the utilitarian, when he argues that modern poetry is great precisely because it is, and must be, the product of a whole society." *Peacock Displayed: A Satirist in His Context* (London: Routledge and Kegan Paul, 1979), 292. That "whole society," however, must be seen itself as a "product" of *poiein.*

13. "Of the Rise and Progress of the Arts and Sciences," in *Essays: Moral, Political, and Literary,* ed. Eugene F. Miller (Indianapolis: Liberty Classics, 1985), 112–14.

14. See Gibbon, *Decline and Fall,* "Author's Preface," as well as William Robertson, *The History of the Reign of the Emperor Charles V,* 7th ed. 4 vols. (London: Strahan, Cadell, and Balfour, 1792), 1: 25–6.

15. "Author's Preface," *Gondibert,* ed. David F. Gladish (Oxford: Clarendon Press, 1971), 10–11.

16. Hegel defined critical history as "a History of History; a criticism of historical narratives and an investigation of their truth and credibility." *The Philosophy of History,* trans. J. Sibree (New York: Dover, 1956), 7.

17. Frederick Burwick, "The Language of Causality in *Prometheus Unbound.*" *K-SJ* 31 (1982), 150.

18. "The Aesthetics of Literary Influence," in *Literature as System* (Princeton: Princeton University Press, 1971), 49.

19. *The Collected Essays of J. V. Cunningham* (Chicago: Swallow Press, 1976), 248–9.

20. H[ippolyte] A[dolphe] Taine, *History of English Literature,* trans. H. Van Laun, new ed. 2 vols. (New York: Holt, 1889), 1: 8.

21. *The Use and Abuse of History,* trans. Adrian Collins (Indianapolis: Bobbs-Merrill, 1957), 17, 21.

22. "Literary History as a Challenge to Literary Theory," in *New Directions in Literary History,* ed. Ralph Cohen (Baltimore: Johns Hopkins University Press, 1974), 12.

3. COLERIDGE'S SHAKESPEARE GALLERY

1. M. Shelley, *Journal* 74, 88. It had just appeared in 1817 when both he and Mary read it.

2. *On the Constitution of Church and State,* ed. John Colmer. *Collected Works of Samuel Taylor Coleridge* 10 (Princeton: Princeton University Press, 1976), 183. Hereafter cited in text as *CS.*

3. "The usual trash of the Johnsons, Gibbons, Robertsons, &c." *Letters,* ed. Earl Leslie Griggs. 6 vols. (Oxford: Clarendon Press, 1956–71), 1: 619. Hereafter cited as *Letters.*

4. In James Fox's *History of the Early Part of the Reign of James II* Coleridge found "not a trace of the philosopher, the high-minded & comprehensive Historian" (*Letters* 3: 272).

5. Robertson, *History,* 1: 25.

6. *Aids to Reflection,* ed. John Beer. *Collected Works* 9 (Princeton: Princeton University Press, 1993), 179n. Hereafter cited as *Aids.*

7. "Formation of a More Comprehensive Theory of Life," in *The Selected Poetry and Prose of Samuel Taylor Coleridge,* ed. Donald A Stauffer (New York: Random House, 1951), 568–9.

8. *Table Talk,* ed. Carl Woodring. *Collected Works* 14. 2 vols. (Princeton: Princeton University Press, 1990), 2: 432.

9. *The Friend,* ed. Barbara E. Rooke. *Collected Works* 4. 2 vols. (Princeton: Princeton University Press, 1969), 1:57.

10. *Logic,* ed. J. R. de J. Jackson. *Collected Works* 13 (Princeton: Princeton University Press, 1981), 29.

11. The work's editor, R. J. White, comments that he would have been thinking of Hume and Gibbon.

12. R. J. White (*SM* 31n.) points out that Coleridge says essentially the same thing about the dramas of Shakespeare. White refers to this passage in *The Friend* (1: 457): "In all his various characters, we still feel ourselves communing with the same human nature, which is every where present as the vegetable sap in the branches, sprays. . . ."

13. "Confessions of an Inquiring Spirit," in *Shorter Works and Fragments,* eds. H. J. Jackson and J. R. de J. Jackson. *Collected Works* 11. 2 vols. (Princeton: Princeton University Press, 1995), 2: 1119.

14. *Shakespearean Criticism,* ed. Thomas Middleton Raysor. 2 vols. (London: Dent, 1960), 1:129; marginal note. Hereafter cited as *SC.*

15. Shakespeare "calls forth nothing from the mausoleum of history or the catacombs of tradition without giving or eliciting some permanent or general interest" (*SC* 1: 98–9).

16. Similarly, Hazlitt wrote of the "*circle* of dramatic character and natural passion" in a drama; in Shakespeare it was the first law of dramatic "design." See John Kinnaird, *William Hazlitt: Critic of Power* (New York: Columbia University Press, 1978), 177.

17. Krieger, *Theory,* 99, 100.

18. I am accepting the conclusions of R. A. Foakes (see *LOL* 1: 72) that certain of the notebook entries and an additional ms. sheet provide a sketch of this lecture.

19. On the Shakespeare monument sonnets see *BL* 1: 34–5.

20. Roy Strong, *The English Icon: Elizabethan and Jacobean Portraiture* (London: Routledge and Kegan Paul, 1969), 29.

21. Also Hazlitt: Shakespeare's genius "consisted in the faculty of transforming himself at will into whatever he chose. . . . He was the Proteus of human intellect" (*Works* 8: 42).

22. *The Notebooks of Samuel Taylor Coleridge,* eds. Kathleen Coburn et al. 5 vols. (New York: Pantheon, 1957–), 2: 2274). Hereafter cited as *CN.* Perhaps without recognizing this problem, in their various notes to *Biographia Literaria* Bate and Engell see this as conveying the familiar Romantic idea of the sympathetic imagination (Keats's chameleon poet), but this passage from the *Notebooks* might call such a construction into question.

23. He cites Plotinus on the process by which "the representative forms of things rise up into existence" (*BL* 1: 252; C's words).

24. *Remarks on Some of the Characters of Shakespeare* (1839), ed. Richard Whately (London: Frank Cass, 1970), 119–20.

25. William Richardson, *A Philosophical Analysis and Illustration of Some of Shakespeare's Remarkable Characters* (1780), repr. (New York: AMS Press, 1966), 29–30; emphasis added). R. A. Foakes points out that the idea that Shakespeare is "still felt to be there" is Coleridge's *own* "subtlety" (*LOL* 1: 69, n.) and that his contribution was to tie it to the distinction between imitation and copy (1: 225).

26. *Shakespearean Criticism,* 167–8.

27. There is some dispute as to when exactly it was; for one version see R. A. Foakes' note, *LOL* 1: 345. For the best account of Coleridge's reading of Schlegel see *LOL* 1: 344–5.

28. It is helpful here to consider the embodiment of the "work" in the art object as paralleling that of the person in the physical body. For a recent statement of this connection in a theory of aesthetic embodiment see Joseph Margolis, *Art and Philosophy* (Atlantic Highlands, N.J.: Humanities Press, 1980), 21.

29. It is in the seventh lecture that he makes his distinction between classical statuesque and modern picturesque, the latter being the "indefinite as the vehicle for the Infinite" (*LOL* 1: 492). (A character would be an indefinite form, partly because of its growth in the work itself.)

30. Gotthold Ephraim Lessing, "Laocoon or On the Limits of Painting and Poetry," trans. W. A. Steel, in Nisbet, 90.

31. See Malcolm C. Salaman, *Shakespeare in Pictorial Art* (New York: Benjamin Blom, 1971) and Winifred H. Friedman, *Boydell's Shakespeare Gallery* (New York: Garland, 1976).

32. Number 10 was on *A Midsummer Night's Dream,* presumably a continuation of the discussion of "ideal" plays. Number 11 began with the history plays, and then focused on *Richard III.*

33. *Shakespearean Tragedy* (1904) (New York: Meridian Books, 1955), 92.

34. *The Prose Works of William Wordsworth,* eds. W. J. B. Owen and Jane Worthington Smyser. 3 vols. (Oxford: Clarendon Press, 1974), 3: 69. Hereafter cited in text as *Prose.*

35. In the first of the 1808 lectures (*LOL* 1: 27) he announced that while "the Architect leaves his foundation hidden beneath the Edifice . . . I must build my foundation before your eyes & leave it there. . . ." Editor's note says that this kind of "apologetic form of preface" was favored by him and that he had used the architectural metaphor in 1795. Also see *LOL* 1: 437–8, 514, etc.

36. See also his letter to Robinson on the day of the first of the 1811–12 series (*Letters* 3: 348). In his lectures the reasoning and arrangement gave evidence of "long premeditation," but "the language, illustrations, &c. were as evidently the children of the Moment." Also, his letter to John Britton of the Russell Institution in 1819. He confides that he prepares for his lectures more by "varied reading and meditation" than by "set composition." That is his nature (4: 924).

4. HAZLITT'S PORTRAITS

1. W. Buchanan, *Memoirs of Painting.* 2 vols. (London: Ackermann, 1824), 22.

2. In this chapter volume and page number references to Hazlitt's essays are to the P. P. Howe edition of his *Works* cited earlier.

3. Friedman, *Boydell's Shakespeare Gallery,* 104.

4. *Annals of the Fine Arts.* 5 vols. (London: Sherwood, Neely, and Jones, 1817–20), 1 (1817): 52.

5. 1: 45, 183–4; 2: 299.

6. *The Letters of John Keats,* ed. Hyder Edward Rollins. 2 vols. (Cambridge: Harvard University Press, 1958), 2: 299. Cited hereafter as *Letters.*

7. Michael Levy, *Sir Thomas Lawrence 1769–1830* (London: National Portrait Gallery, 1979), 37–8.

8. *The Commemoration of Reynolds . . . and Other Poems* (London: Murray, 1814), 33.

9. David Piper, *The Image of the Poet: British Poets and Their Portraits* (Oxford: Clarendon Press, 1982), 97.

10. Roy Strong, *Recreating the Past: British History and the Victorian Painter* (New York: Thames and Hudson, 1978).

11. "Definitions and Reflections," *Magazine of the Fine Arts* 1 (1821): 9–10.

12. Friedman, 9.

13. *Commemoration,* 1: 177–81.

14. Anthony Cooper, Earl of Shaftesbury, *Second Characters or the Language of Forms,* ed. Benjamin Rand (1914), repr. (New York: Greenwood Press, 1969), 135–6.

15. Desmond Shawe-Taylor, *The Georgians: Eighteenth-Century Portraiture and Society* (London: Barrie & Jenkins, 1990), Ch. 2.

16. Quoted in Shawe-Taylor, 29.

17. *Lectures on Painting, by the Royal Academicians: Barrie, Opie, and Fuseli,* ed. Ralph N. Wornum (London: Bohn, 1848), 427.

18. James Elmes, *A General and Biographical Dictionary of the Fine Arts* (London: Thomas Tegg, 1826), "Portrait Painting."

19. [British Institution], *An Historical Catalogue of Portraits* (London: W. Bulmer, 1820), 3.

20. Arthur K. Wheelock, et al., *Anthony Van Dyck* (New York: Abrams, 1990), 210.

21. *Annals of the Fine Arts* 4 (1820): 180.

22. *Epochs of the Arts* (London: Murray, 1813), xviii.

23. [P. G. Patmore], *British Galleries of Art* (London: Whittaker, 1824), 86.

24. Cassirer, *Essay,* 180–1. He quotes from Goethe's influential "On German Architecture," which speaks of a work's "characteristic whole" and argues that "characteristic art is the only true art."

25. *Art as Experience* (New York: Putnam's, 1958), 62.

26. Vincent Tomas, "The Concept of Expression in Art," in *Philosophy Looks at the Arts*, ed. Joseph Margolis (New York: Scribner's, 1962), 31.

27. Alan Tormey, *The Concept of Expression: A Study in Philosophical Psychology and Aesthetics* (Princeton: Princeton University Press, 1971), 98.

28. Dewey, 61, 62.

29. Lessing, "Laocoon," Nisbet, 59–133.

30. Nisbet, 31–54.

31. Kaminsky, 74.

32. *The Life of M. A. Buonarroti*, 2nd ed. (London: Murray, 1807), 195.

33. Archibald Alison and P. F. Tyler, *Travels in France, during the Years 1814–15*, 2nd ed. 2 vols. (Edinburgh: Macredie, Skelly, and Muckersy, 1816), 110, 134.

34. *Complete Poetry and Prose*, ed. David V. Erdman (Berkeley: University of California Press, 1982), 529–30, 653.

35. E. Beresford Chancellor, *The Lives of the British Sculptors* (London: Chapman and Hall, 1911), 278.

36. *Lectures on Sculpture* (London: John Murray, 1829), 146.

37. *The Mind of Henry Fuseli*, ed. Eudo C. Mason ([London]: Routledge & Paul [1951]), 302.

38. *Mind & Art: An Essay on the Varieties of Expression* (Princeton: Princeton University Press, 1972), 305.

39. *Poetical Works* (London: George Bell, 1903).

40. William Cowper, *Poetical Works*, ed. H. S. Milford, 4th ed., rev. by Norma Russell (London: Oxford University Press, 1967).

41. *Songs of the Affections* (1830) repr., ed. Donald H. Reiman (New York: Garland, 1978), 99–101.

42. *Conversations of James Northcote, R. A.*, ed. Edmund Gosse (London: Richard Bentley, 1894), xiv–xv.

43. Kinnaird, *William Hazlitt*, 83.

5. SYMBOLIC FORMS

1. *The Sister Arts: The Tradition of Literary Pictorialism and English Poetry from Dryden to Gray* (1958), (Chicago: University of Chicago Press, 1987), 50.

2. "On Poesy or Art," in *Biographia Literaria . . . with His Aesthetical Essays*, ed. J. Shawcross (London: Oxford University Press, 1958), 253–63.

3. *Church Monuments in Romantic England* (New Haven: Yale University Press, 1977), 142.

4. *The Industrial Reformation of English Fiction: Social Discourse and Narrative Form 1832–1867* (Chicago: University of Chicago Press, 1985), 192.

5. Anon., "Francis Chantrey, Sculptor," *Blackwood's* 7 (1820): 3.

6. Penny, *Church Monuments,* 119.

7. *Poetical Works* (Philadelphia: Porter & Coates, [1907]), 464. Hereafter cited as *Works.*

8. "Concerning the Relation of the Plastic Arts to Nature," 324.

9. Samuel Taylor Coleridge, "Essays on the Principles of Genial Criticism," in *Shorter Works and Fragments.* Vol. 11 in *Collected Works,* 1: 377.

10. *Coleridge's Miscellaneous Criticism,* ed. Thomas Middleton Raysor (Folcroft, Pa.: Folcroft Press, 1969), 164.

11. Quoted in Read, *The Art of Sculpture,* 4.

12. Kaminsky, 66.

13. E. H. Gombrich, *Symbolic Images: Studies in the Art of the Renaissance* (Chicago: University of Chicago Press, 1985), 188.

14. Walter Benjamin, *The Origin of Greek Tragic Drama,* trans. John Osborne (London: NLB, 1977), 164, 165.

15. Schelling, 326–7. Winckelmann's followers were "the first fully to historicize the antique ideal, defining modern culture as the antithesis of the integrated wholeness of ancient Greek culture, of its naive simplicity and centeredness, and of its unmediated relation to itself and nature."

16. "Shakespeare," in Nisbet, 163.

17. Hegel, *Aesthetics: Lectures on Fine Art,* ed. T. M. Knox. 2 vols. (Oxford: Clarendon Press, 1975), 1: 520

18. Trans. Julius A. Elias, in Nisbet, 180–232.

19. W. J. T. Mitchell, *Iconology: Image, Text, Ideology* (Chicago: University of Chicago Press, 1986), Ch. 3.

20. *The Spectator,* ed. Donald F. Bond. 5 vols. (Oxford: Clarendon Press, 1965), No. 416.

21. *An Essay Concerning Human Understanding,* ed. Peter H. Nidditch (Oxford: Clarendon Press, 1975), Bk. III, Ch. 9, Sect. 4.

22. David E. Wellbery, *Lessing's Laocoon: Semiotics and Aesthetics in the Age of Reason* (Cambridge: Cambridge University Press, 1984), 202.

23. Hegel, *Aesthetics,* 305.

24. *Final Sculpture,* 28.

25. Wellbery, 36.

26. "Thoughts," 43.

27. *The Renaissance: Studies in Art and Poetry* (London: Macmillan, 1910), 204.

28. *A Comparative Estimate of Sculpture and Painting* (Privately printed, 1816), 16.

29. *Life of Benjamin Robert Haydon, Historical Painter,* ed. Tom Taylor, 2nd ed. 3 vols. (London: Longman, Brown, Green, 1853), 2: 188.

30. Anon., "Greek and English Tragedy," *The Reflector* 2 (1812): 139.

31. "On Virgil," *Complete Poetry and Prose,* 270.

6. WORDSWORTH'S *PRELUDE*

1. *The Prelude: 1799, 1805, 1850,* ed. Jonathan Wordsworth, M. H. Abrams, Stephen Gill (New York: Norton, 1979). Passages quoted are from the 1850 version unless otherwise indicated.

2. See for example Wordsworth's "The Pillar of Trajan," "Memorial Near the Outlet of the Lake of Thun," "Cenotaph," "Elegiac Musings," "Written after the Death of Charles Lamb," "Inscription for a Monument in Crosthwaite Church."

3. *Poems, in Two Volumes,* ed. Jared Curtis. *The Cornell Wordsworth* (Ithaca: Cornell University Press, 1983).

4. *Lyrical Ballads, and Other Poems, 1797–1800,* eds. James Butler and Karen Green. *The Cornell Wordsworth* (Ithaca: Cornell University Press, 1992).

5. *The Fenwick Notes,* ed. Jared Curtis (London and Bristol: Classical Press, 1993), 14.

6. *The Poetical Works,* eds. E. de Sélincourt and Helen Darbishire. 5 vols. (Oxford: Clarendon Press, 1940–9).

7. In *The Prelude* (8: 168 ff.) the "rocks immutable," and the ever-flowing streams are "speaking monuments" of ancient tragedies and other human experiences.

8. *Descriptive Sketches,* ed. Eric Birdsall. *The Cornell Wordsworth* (Ithaca: Cornell University Press, 1984).

9. "'A Waking Dream': The Symbolic Alternative to Allegory," in *Allegory, Myth, and Symbol,* ed. Morton W. Bloomfield (Cambridge: Harvard University Press, 1981), 4.

10. Quoted by Benjamin, 164–5.

11. *Guide to the Lakes: The Fifth Edition* (1835), ed. Ernest de Sélincourt (1906). repr. (Oxford: Oxford University Press, 1977). See 53 and notes, 184ff. on this and other circles.

12. *Table Talk,* ed. Carl Woodring: 2 vols. *Collected Works* 14 and 15 (Princeton: Princeton University Press, 1990). 1: 412–13. Dr. Johnson had said that anyone's patriotism would grow at the plains of Marathon, and piety on the ruins of Iona.

13. *The Salisbury Plain Poems,* ed. Stephen Gill. *The Cornell Wordsworth* (Ithaca: Cornell University Press, 1975).

14. Frederick Burwick connects the De Quincey, Lessing, and Wordsworth essays to the "skeptical repudiation of the mimetic and ekphrastic endeavor." See "Ekphrasis and the Mimetic Crisis of Romanticism," *Icons—Texts—Iconotexts: Essays on Ekphrasis and Intermediality,* ed. Peter Wagner (Berlin: De Gruyter, 1996), 78–104.

15. *Works.* 12 vols. (Boston: Houghton, Mifflin, 1876–7), 9: 594.

16. Anon., "Definitions and Reflections," *Magazine of the Fine Arts* 1 (1821): 9.

7. FORTUNE'S RHETORIC

1. *Theories of the Symbol,* trans. Catherine Porter (Ithaca: Cornell University Press, 1982), 205–6.

2. *Origin,* 166.

3. "The Political Turn in Criticism," *Salmagundi* 81 (Winter 1989): 111.

4. *The Classical Monument; Reflections on the Connection between Morality and Art in Greek and Roman Sculpture* (New York: New York University Press, 1972), 2.

5. Kemp, *English Church Monuments,* 133, 135.

6. Betty Willsher and Doreen Hunter, *Stones: A Guide to Some Remarkable Eighteenth Century Gravestones* (New York: Taplinger, 1979), 26–31.

7. *Essay on Sepulchres: or, A proposal for erecting some memorials of the illustrious dead in all ages on the spot where their remains have been interred* (London: Miller, 1809), 67. See Shelley's encomium on this work in his essay on Godwin's *Mandeville* (*Prose,* 309).

8. Philippe Ariès, *Images of Man and Death,* trans. Janet Lloyd (Cambridge, Mass.: Harvard University Press, 1985), 236.

9. "To the Earl of Warwick on the Death of Addison," ll. 33–6.

10. *Ad C. Herrenium de Ratione Dicendi,* ed. Harry Caplan (Cambridge: Harvard University Press, 1931), 399.

11. *Italy: A Poem* (London: T. Cadell, 1830), 104.

12. Howard Hibbard, *Michelangelo* (New York: Harper & Row, 1974), 192.

13. Jay Macpherson, *The Spirit of Solitude: Conventions and Continuities* (New Haven: Yale University Press, 1982), 15.

14. Anon., "Belzoni's Exhibition of Egyptian Antiquities," *The Magazine of the Fine Arts* I (1821): 140.

15. Edward Daniel Clarke, *Travels in Various Countries of Europe, Asia and Africa.* 8 vols. (London: T. Cadell & Davies, 1810–23), 2: 259.

16. Edward Daniel Clarke, *The Tomb of Alexander: A Dissertation on the Sarcophagus Brought from Alexandria and Now in the British Museum* (Cambridge: J. Mawman, 1805), 10.

17. Constantin-François Volney, *Travels Through Syria and Egypt in the Years 1783, 1784, and 1785.* 2 vols. (London: Robinson, 1788), 1: 276–7.

18. G. Belzoni, *Narrative of the Operations and Recent Discoveries within the Pyramids, Temples, Tombs, and Excavations in Egypt and Nubia,* 3rd ed. (London: John Murray, 1822), 61.

19. Henry Blundell, *An Account of the Statues, Busts, Bass-relieves, Cinerary Urns, and Other Ancient Marbles, and Paintings, at Ince* (Liverpool: John McCreery, 1803), 83.

20. *Outlines,* 353–4, 342.

21. See Francis Haskell, *History and Its Images* (New Haven: Yale University Press, 1993), 224–6.

22. *Journals of Dorothy Wordsworth,* ed. E. de Sélincourt. 2 vols. (New York: Macmillan, 1941), 2: 256–7.

23. *Archaeology of Knowledge,* 6.

24. Robert Blair, *The Grave: A Poem* (Los Angeles: Augustan Reprint Society, 1973).

25. Thomas Warton the Younger, "The Pleasures of Melancholy," *The Three Wartons: A Choice of Their Verse,* ed. Eric Partridge (London: the Scholartis Press, 1927), 101–12.

26. "Prosopopoeia," *Yale French Studies* 69 (1985): 107–23.

27. *Rhetoric of Romanticism* (New York: Columbia University Press, 1984), 77–8.

28. *Blindness and Insight,* 2nd ed. (Minneapolis: University of Minnesota Press, 1983), 207.

29. Murray Krieger, "'A Waking Dream,'" 4.

30. Earl R. Wasserman, "The Inherent Values of Eighteenth-Century Personification," *PMLA* 65 (1950): 440–1.

31. Wasserman, 444, 445, 457.

32. Coleridge spoke of allegory's "obvious and intentional disjunction of the sense from the symbol, and the known unreality of the latter" (*LOL* 2: 102).

33. George Campbell, *The Philosophy of Rhetoric* (1776), ed. Lloyd Bitzer (Carbondale: Southern Illinois University Press, 1963), 269. The "wit" is Samuel Butler (*Hudibras,* Bk. I, Cto. 1).

34. C. S. Lewis, *The Allegory of Love* (London: Oxford University Press, 1938), 48.

35. Constantin François Volney, *The Ruins, or Meditations [on] the Revolutions of Empires* (New York: ECA Associates, 1990), 4.

36. "Palmyra," *Works*, 6: 7–31.

37. Kenneth Neill Cameron, *Shelley: The Golden Years* (Cambridge: Harvard University Press, 1974), 315 ff.

8. THE MOURNER TURNED TO STONE

1. *Five Lectures on Psycho-Analysis,* trans. and ed. James Strachey (New York: Norton, 1977), 16–17.

2. Reviews of the Oriental tales quoted are from *Gentleman's Magazine* 83, No. 2 (1813): 246; *Eclectic Review* 10 (1813): 524; *Quarterly Review* 11 (1814): 455; *Critical Review,* 4th ser., 4 (1813): 58. These and others I have quoted in this chapter are reprinted in *The Romantics Reviewed: Contemporary Reviews of British Romantic Writers,* ed. Donald H. Reiman. 3 pts. in 9 vols. (New York: Garland, 1972).

3. *Eclectic Review,* 2nd ser., 10 (1818): 51.

4. His note to "Constancy to an Ideal Object." From *Aids,* 228. But in *CHP* IV Byron may have both recognized himself and recoiled "as from a spectre."

5. *British Review* 12 (1818): 22–3.

6. *Literary Gazette* (May 2, 1818): 274.

7. See *Works* 5: 155, for example, on the superiority of Scott's "picturesque power" to that of Moore and Byron.

8. Henry Joy quoted in Stephen A. Larrabee, *English Bards and Grecian Marbles* (New York: Columbia University Press, 1943), 162. See also Byron's "On the Bust of Helen by Canova."

9. *Byron's Letters and Journals,* ed. Leslie A. Marchand. 12 vols. (Cambridge: Belknap Press of Harvard University Press, 1973–82), 5: 114, 213, 116–17. Cited hereafter as *L&J.*

10. *L&J* 5: 213, 116, 218, 216; J. J. Coulmann, *Reminiscences* (Paris: Michel Levy, 1862), 2: 162–3.

11. "Picturesque" scenes are found principally in the first two cantos. The difference between these cantos and the second two in this respect is discussed by Robert Escarpit, *Lord Byron: un tempérament litteraire* (Paris: Le Cercle du Livre, 1955–57), 2: 65–74.

12. [Wilson, John], "Childe Harold's Pilgrimage. Canto the Fourth," *Edinburgh Review* 30 (1818): 87–120.

13. *L&J,* 5: 227. So did Hazlitt, who developed a distaste for the place directly upon his arrival there, calling the city "an immense mass of solid stonebuildings, streets, palaces, and churches" (*Works* 10: 233).

14. For striking comparisons between this poem and *The Waste Land* see Alice Levine, "T. S. Eliot and Byron," *ELH* 45 (1978): 522–41.

15. *Byron,* Pt. I: *Lyric and Romance, Writers and Their Work,* no. 215 (Harlow, Essex: Longman, 1970), 17–18.

16. The most troublesome and controversial issue has been identifying the "things" of "strong reality" (St. 6) and fixing their relation to the "beings of the mind" (St. 5). I believe they are objects actually seen—the "other sights" of stanza 7—as opposed to things imagined. I also believe that the "such" in line 55 refers to the beings of the mind and that these beings are mind's-eye experiences, however generated. Quotations from *Childe Harold* are taken from Volume 2 of *The Complete Poetical Works,* ed. Jerome J. McGann (Oxford: Clarendon Press, 1980).

17. There is a similar effect in some of Keats's poems. See Geoffrey H. Hartman, "Spectral Symbolism and the Authorial Self: An Approach to Keats's *Hyperion,*" *Essays in Criticism* 24 (1974): 1–2.

18. *The Sense of Form in Art: A Comparative Psychological Study,* trans. Alice Muehsam and Norma A. Shatan (New York: Chelsea, 1958), 21.

19. *The Marble Wilderness: Ruins and Representation in Italian Romanticism 1775–1850* (Cambridge: Cambridge University Press, 1987), 2, 6, 8.

20. In Byron's day, according to Larrabee, it was a poetic convention when writing about statues to express wonder at their appearance of being alive (*English Bards and Grecian Marbles,* 278).

21. The concept of theatricality in sculpture and painting is developed forcefully by Michael Fried in *Absorption and Theatricality: Painting and Beholder in the Age of Diderot* (Berkeley: University of California Press, 1980).

22. Haskell and Penny, *Taste and the Antique,* xiii–xiv.

23. *The Idler in Italy* (Philadelphia: Carey & Hart, 1839), 2: 105.

24. "Mourning and Melancholia," in *The Complete Psychological Works of Sigmund Freud,* Std. Edition, eds. James Strachey et al. (London: Hogarth, 1957), 14: 243–58.

25. *The Domestic Affections; The Restoration of the Works of Art to Italy; Wallace's Invocation to Bruce; The Sceptic* (1812–20), repr., ed. Donald Reiman (New York: Garland, 1978), 8.

26. *Records of Woman: With Other Poems* (1828), repr., ed. Donald Reiman (New York: Garland, 1978).

27. *Poems; England and Spain; Modern Greece,* ed. Donald H. Reiman (New York: Garland, 1978).

28. An exception was Vasari. More recently, see Ann Sutherland Harris and Linda Nochlin, *Women Artists: 1550–1950* (New York: Knopf, 1976).

29. Erwin Panofsky, *Tomb Sculpture: Its Changing Aspects from Ancient Egypt to Bernini* (London: Thames & Hudson, 1964), 16.

30. From ancient Greece, when the monument became a mnesic image, the preference alternates between these two, between memory and anticipation or

hope. Romans preferred likenesses of the living person along with carved trophies or depictions of important achievements. During the Renaissance retrospective monuments, such as the standing or riding heroic figure, came to replace the prospective. Henriette s'Jacob, *Idealism and Realism: A Study of Sepulchral Symbolism* (Leiden: E. J. Brill, 1954), 177ff.

31. *The Poetical Works of Felicia Dorothea Hemans* (Philadelphia: Porter & Coates, [1907]), 421.

32. David Irwin, *John Flaxman,* 152.

33. Mary Webster, "Flaxman as Sculptor," in *John Flaxman,* ed. David Bindman (London: Thames and Hudson, 1979), 110.

34. *By Mourning Tongues: Studies in English Elegy* (Ipswich: Boydell Press, 1977), 21.

9. "THOSE SPEECHLESS SHAPES"

1. *Travels in Egypt in 1817–18* (London: Phillips, no date), 43.

2. Vivant Denon, *Travels in Upper and Lower Egypt,* trans. Arthur Aikin. 3 vols. (London: Longman and Rees, 1803), 3: 78–80.

3. The *OED* distinguishes between those meanings of "stand" that apply to people and animals (for example, *intrans.:* "to assume or maintain an erect attitude on one's feet, etc.") and those that apply to things. Of the latter, one meaning, chiefly of towns, etc., is to be situated (in or at). Another: "To be set upright, to be in a definite position, etc." Also: "Of an edifice, or the like: To remain erect and entire; to resist destruction or decay." "Lie" has the same kinds of meanings, including the purely situational.

4. *1789: The Emblems of Reason,* trans. Barbara Bray (Charlottesville: University of Virginia Press, 1982), 98.

5. Eugene M. Waite has recently suggested another passage in Denon as a source for "Ozymandias." See "Ozymandias: Shelley, Horace Smith, and Denon," *K-SJ* 44 (1995): 22–8.

6. In 1822 Shelley reflected that every spring since 1815 had brought bad luck (*Letters* 2: 398).

7. Stendhal [Henri Beyle], *Chroniques italiennes* (Paris: Librarie Gallimard, [1936]), 148.

8. "Beatrice Cenci, the Parricide," *Bentley's Miscellany* 22 (1847): 105.

9. *American Notes and Pictures from Italy* (London: Oxford University Press, 1957), 395.

10. *Iconology: Image, Text, Ideology* (Chicago: University of Chicago Press, 1986), 40–2.

11. See Mary's *Journal* for chronology. They saw the picture of Beatrice on April 22 and visited the Cenci Palace on May 11. On the 14th William sat for his portrait, which Curran painted in mid-May. He died a few weeks later.

12. The Dedication to Hunt may have been inspired by Hunt's consolatory letter. See *Shelley and His Circle 1773–1822,* eds. Kenneth Neill Cameron and Donald H. Reiman. 8 vols. (Cambridge: Harvard University Press, 1961–86), 6: 839–41.

13. Edmund Blunden, *Shelley: A Life Story* (1946) (London: Oxford University Press, 1965), 188–9.

14. See Michael Worton, "Speech and Silence in *The Cenci,*" in *Essays on Shelley,* ed. Miriam Allott (Liverpool: Liverpool University Press, 1982), 105–21.

15. John Hollander, "The Gazer's Spirit: Romantic and Later Poetry on Painting and Sculpture," in *The Romantics and Us: Essays on Literature and Culture,* ed. Gene W. Ruoff (New Brunswick: Rutgers University Press, 1990), 132.

16. *What Happens in Art* (New York: Appleton-Century-Crofts, 1967), 53. Lipman credits G. H. Mead for the concept.

17. *The Apocalyptic Vision in the Poetry of Shelley* (Toronto: University of Toronto Press, 1964), 170.

18. *Elements of Art: A Poem* (London: William Miller, 1809), 135.

19. Penny, 80.

20. Mary Wollstonecraft Shelley, *Letters.* 3 vols., ed. Betty T. Bennett (Baltimore: Johns Hopkins University Press, 1980), 1: 150. 105.

21. *Shelley: The Pursuit* (New York: E. P. Dutton, 1975), 657.

22. James Stevens Curl, *A Celebration of Death* (London: Constable, 1980), 50. Curl is quoting Augustus J. C. Hare, *Walks in Rome* (1897).

23. Blunden, 189.

24. For eighteenth- and nineteenth-century interest in mausolea, see Curl, Ch. 6.

10. KEATS'S TEMPLES AND SHRINES

1. *The Poems of John Keats,* ed. Jack Stillinger (Cambridge: Belknap Press, Harvard University Press, 1978).

2. Jack Stillinger, "The Order of Poems in Keats's First Volume," in *The Hoodwinking of Madeline and Other Essays on Keats's Poems* (Urbana: University of Illinois Press, 1971), 5; and Martin Aske, *Keats and Hellenism: An Essay* (Cambridge: Cambridge University Press, 1985), 50. My chapter on Keats is much indebted to Aske, particularly his observations on floral and vernal imagery in the poems.

3. Jean Hagstrum traces the ancient legend that Phidias was inspired to his most famous statue of Zeus by a description in the *Iliad. The Sister Arts,* 17–18.

4. *Liberty, The Castle of Indolence, and Other Poems,* ed. James Sambrook (Oxford: Clarendon Press, 1986).

5. London: J. Dodsley, 1755; repr. (New York: Garland, 1971).

6. Like the sculpted figure, the mythological one played a crucial role in romantic ideas of the symbol. It was the prime example of the image whose meaning lies in its own form, not elsewhere. As Schelling put it, "Every figure in mythology is to be taken for what it is, for it is precisely in this way that it will be taken for what it signifies. The signifying here is at the same time the being itself, it has passed into the object, being one with it" (quoted by Todorov, 210). In his revealing chapter on the Romantic symbol, Todorov's other authorities—Creuzer, Goethe, Heinrich Meyer—all seem to conceive of myth as exemplifying an inherent symbolic power to be lost in later, allegorical representation of ideas.

7. *John Keats: Selected Poems and Letters,* ed. Douglas Bush (Boston: Houghton Mifflin, 1959), 317, 318.

8. Edward Baldwin [pseud. William Godwin], *The Pantheon: Or Ancient History of the Gods of Greece and Rome,* 4th ed. (London: Juvenile Library, 1814; repr. New York: Garland, 1984), 135–6.

9. *The Keats Circle: Letters and Papers and More Letters and Poems of the Keats Circle,* ed. Hyder Edward Rollins, 2nd ed. 2 vols. (Cambridge: Harvard University Press, 1988), 1: 58.

10. In the same manner Browning's Bishop of St. Praxed's imagines himself as sleeper, dead person, and effigy. His bedclothes will change into a mortcloth that drops "into great laps and folds of sculptor's-work," and his feet will stretch "forth straight as stone can point."

11. See Clare Gittings, *Death, Burial, and the Individual in Early Modern England* (London: Croom Helm, 1984). Also Paul S. Fritz, "From 'Public' to 'Private': The Royal Funerals in England, 1500–1830," in *Mirrors of Mortality: Studies in the Social History of Death,* ed. Joachim Whaley (London: Europa, 1981), 61–79. In his "Canonization" Donne surmises that his "legend" might be "unfit for tombes and hearse." And Cowley, "On the Death of Mr. William Hervey": "Be this my latest verse/ With which I now adorn his Herse."

12. D. E. L. Haynes, *The Portland Vase,* 2nd ed. (London: British Museum Publications, 1975), 7.

13. Wolf Mankowitz, *The Portland Vase and the Wedgwood Copies* (London: Deutsche, 1952), 43–4.

14. Haynes, 7.

15. See for example [James Christie], *A Disquisition upon Etruscan Vases* (London: Wm. Bulmer, 1806); and James Dallaway, *Of Statuary and Sculpture Among the Ancients* (London: T. Bensley, 1816).

16. See his *Description of the Portland Vase, formerly the Barberini* (1790); repr. (London: Pickering, 1845).

17. *Keats,* 4th ed. (London: Cape, 1955), 219.

18. Kenneth Lindley, *Of Graves and Epitaphs* (London: Hutchinson, 1965), 100.

19. *The Well Wrought Urn: Studies in the Structure of Poetry* (San Diego: Harcourt Brace Jovanovich, 1975), 164.

20. *Art and Existence: A Phenomenological Aesthetics* (Lewisburg: Bucknell University Press, 1970), 154.

21. *Memorials of Coleorton,* ed. William Knight. 2 vols. (Edinburgh, 1887), 2: 207.

22. *A Biographical and Critical Dictionary of Painters and Engravers.* 2 vols. (London: Carpenter & Son, 1816), 1: xlii.

23. E.g., see David Perkins, *English Romantic Writers* (Fort Worth: Harcourt Brace, 1995), 1254.

24. Donald H. Reiman, "Keats and the Humanistic Paradox: Mythological History in *Lamia,*" in *Romantic Texts and Contexts* (Columbia: University of Missouri Press, 1987), 333.

25. Ovid, *Metamorphosis,* trans. Rolfe Humphries (Bloomington: Indiana University Press, 1955), 6: 307–17.

26. Hagstrum, *The Sister Arts,* 118. He quotes Milton's sonnet on Shakespeare and Dryden's "Threnodia Augustalis": "Like Niobe we marble grow,/ And petrify with grief" (ll. 7–8).

27. *John Keats* (Cambridge: Harvard University Press, 1963), 591–2.

28. *The Language of Sculpture* (London: Thames and Hudson, 1974), 107.

29. "Poem and Ideology: A Study of Keats's 'To Autumn,'" in *The Fate of Reading* (Chicago: University of Chicago Press, 1975), 130.

30. *John Keats,* ed. Elizabeth Cook. The Oxford Authors. (Oxford: Oxford University Press, 1990), 344.

31. See Edward B. Hungerford, *Shores of Darkness* (1941), repr. (New York: World Publishing Co., 1963), 28, 38–9.

CONCLUSION

1. *The Order of Things: An Archaeology of the Human Sciences* (New York: Vintage Books, 1973), 369.

2. "The History of Art as a Humanistic Discipline," *Meaning in the Visual Arts: Papers in and on Art History* (Garden City, N.Y.: Doubleday Anchor, 1955), 5.

3. Herbert Read, *The Origins of Form in Art* (New York: Horizon, 1965), 66.

4. Krieger, *Theory,* 99, 103.

5. "The Content of Form: A Commentary," *NLH* 2 (1971): 354.

6. *Problems of Art,* (New York: Scribner's, 1957), 58.

7. *Problems,* 98.

Works Cited

Addison, Joseph. "Dialogues on Medals." In *The Works of Joseph Addison*, edited by George Washington Greene, Vol. 2, pp. 1–130. Philadelphia: Lippincott, 1870.

——. *The Spectator*. Edited by Donald F. Bond. 5 vols. Oxford: Clarendon Press, 1965.

Adolphus, John. *British Cabinet*. 2 vols. London: Harding, 1799, 1800.

Alison, Sir Archibald, and P. F. Tyler. *Travels in France, during the Years 1814–15*, 2 vols. 2nd ed. Edinburgh: Macredie, Skelly, and Muckersy, 1816.

Alsop, Joseph. *The Rare Art Traditions: The History of Art Collecting, etc.* New York: Harper & Row, 1982.

Annals of the Fine Arts, 5 vols. London: Sherwood, Neely, and Jones, 1817–20.

Anon. "Arrangement of the Elgin Marbles in the British Museum." *Examiner* 9 (1816): 399.

——. "Belzoni's Exhibition of Egyptian Antiquities." *Magazine of the Fine Arts* 1 (1821): 40.

——. "Definitions and Reflections." *Magazine of the Fine Arts* 1 (1821): 1–10.

——. *A Descriptive Catalogue of the Ancient Statues, Paintings, and Other Productions, etc.* Edinburgh: Francis Pillans, 1816.

——. "Francis Chantrey, Sculptor." *Blackwood's* 7 (1820): 3–10.

——. "Greek and English Tragedy." *The Reflector* 2 (1812): 127–39.

Ariès, Philippe. *Images of Man and Death*. Translated by Janet Lloyd. Cambridge, Mass.: Harvard University Press, 1985.

Aristotle. *The Poetics*. Translated by S. H. Butcher. 4th ed. London: Macmillan, 1911.

Arnheim, Rudolf. "Gestalt Psychology and Artistic Form." In *Aspects of Form: A Symposium on Form in Nature and Art*, edited by Lancelot Lawe Whyte, pp. 196–224. New York: Pellegrini and Cudahy, 1951.

Aske, Martin. *Keats and Hellenism: An Essay.* Cambridge: Cambridge University Press, 1985.

Bacon, Francis. *The Works of Francis Bacon.* 1857–1874, 14 vols. Edited by James Spedding et al. New York: Garrett Press, 1968.

"Baldwin, Edward." [See Godwin, William].

Bate, Walter Jackson. *John Keats.* Cambridge: Belknap-Harvard University Press, 1963.

Bazin, Germain. *The Museum Age,* translated by Jane van Nuis Cahill. New York: Universe Books, 1967.

Bell, John. *Observations on Italy.* 2nd ed. Naples: Fibreno, 1834.

Bell's New Pantheon; or, Historical Dictionary of the Gods, Demi-gods, Heroes, and Fabulous Personages of Antiquity. 2 vols. London: J. Bell, 1790.

Belzoni, G[iovanni]. *Narrative of the Operations and Recent Discoveries within the Pyramids, Temples, Tombs, and Excavations in Egypt and Nubia.* 3rd ed. London: John Murray, 1822.

Benjamin, Walter. *The Origin of Greek Tragic Drama,* translated by John Osborne. London: NLB, 1977.

The Biographical Magazine. 2 vols. London: Wilson, 1819.

Blackstone, Bernard. *Byron,* Pt. I: *Lyric and Romance, Writers and Their Work,* No. 215. Harlow, Essex: Longman, 1970.

Blair, Robert. *The Grave: A Poem.* Los Angeles: Augustan Reprint Society, 1973.

Blake, William. *Complete Poetry and Prose,* edited by David V. Erdman. Berkeley: University of California Press, 1982.

Blessington, Countess [M. Gardiner]. *The Idler in Italy,* 2 vols. Philadelphia: Carey & Hart, 1839.

Blundell, Henry. *An Account of the Statues, Busts, Bass-relieves, Cinerary Urns, and Other Ancient Marbles, and Paintings, at Ince.* Liverpool: John McCreery, 1803.

Blunden, Edmund. *Shelley: A Life Story.* 1946. Reprint, London: Oxford University Press, 1965.

Boydell's Heads of Illustrious Persons. London: Boydell, 1811.

Bradley, A. C. *Shakespearean Tragedy.* 1904. Reprint, New York: Meridian Books, 1955.

[British Institution]. *An Historical Catalogue of Portraits.* London: W. Bulmer, 1820.

Brooks, Cleanth. *The Well Wrought Urn: Studies in the Structure of Poetry.* San Diego: Harcourt Brace Jovanovich, 1975.

Brown, John. *A Dissertation on the rise, union, and power, the progressions, separations, and corruptions, of poetry and music.* 1763. Reprint, New York: Garland, 1971.

Brown, Nathaniel. *Sexuality and Feminism in Shelley.* Cambridge: Harvard University Press, 1979.

Bryan, Michael. *A Biographical and Critical Dictionary of Painters and Engravers.* 2 vols. London: Carpenter & Son, 1816.

Buchanan, W. *Memoirs of Painting.* 2 vols. London: Ackermann, 1824.

Burwick, Frederick. "Ekphrasis and the Mimetic Crisis of Romanticism." In *Icons—Texts—Iconotexts: Essays on Ekphrasis and Intermediality,* edited by Peter Wagner, pp. 78–104. Berlin: De Gruyter, 1996.

———. "The Language of Causality in *Prometheus Unbound.*" *K-SJ* 31 (1982): 136–58.

Butler, Marilyn. *Peacock Displayed: A Satirist in His Context.* London: Routledge and Kegan Paul, 1979.

Byron, George Gordon. *The Complete Poetical Works,* 7 vols. Edited by Jerome J. McGann. Oxford: Clarendon Press, 1980–93.

———. *Byron's Letters and Journals,* 12 vols. Edited by Leslie A. Marchand. Cambridge: Belknap-Harvard University Press, 1973–82.

———. *The Works of Lord Byron: Letters and Journals,* 6 vols. Edited by Rowland E. Prothero. London: John Murray, 1898–1901.

Cadell, W. A. *A Journey in Carniola, Italy, and France, in the Years 1817, 1818,* 2 vols. Edinburgh: Constable, 1820.

Cameron, Kenneth Neill. *Shelley: The Golden Years.* Cambridge: Harvard University Press, 1974.

———, and Donald H. Reiman, eds. *Shelley and His Circle 1773–1822.* 8 vols. Cambridge: Harvard University Press, 1961–86.

Campbell, George. *The Philosophy of Rhetoric.* 1776. Edited by Lloyd Bitzer. Reprint, Carbondale: Southern Illinois University Press, 1963.

Campbell, Thomas. *Poetical Works.* London: George Bell, 1903.

Canova, Antonio. *A Letter from the Chevalier Antonio Canova . . . on the Sculptures in the Collection of the Earl of Elgin.* London: John Murray, 1816.

Cassirer, Ernst. *An Essay on Man: An Introduction to a Philosophy of Human Culture.* New York: Anchor-Doubleday, 1944.

———. *The Individual and the Cosmos in Renaissance Philosophy,* translated by Mario Domandi. New York: Barnes and Noble, 1963.

———. *The Logic of the Humanities,* translated by Clarence Smith Howe. New Haven: Yale University Press, 1961.

Chancellor, E. Beresford. *The Lives of the British Sculptors*. London: Chapman and Hall, 1911.

Christie, James. *A Disquisition upon Etruscan Vases*. London: William Bulmer, 1806.

Cicero, Marcus Tullius. *Ad C. Herrenium de Ratione Dicendi*, translated and edited by Harry Caplan. Cambridge: Harvard University Press, 1931.

Clarke, Edward Daniel. *The Tomb of Alexander: A Dissertation on the Sarcophagus Brought from Alexandria and Now in the British Museum*. Cambridge: J. Mawman, 1805.

———. *Travels in Various Countries of Europe, Asia and Africa*. 8 vols. London: T. Cadell & Davies, 1810–23.

Coleridge, Samuel Taylor. *Aids to Reflection*, edited by John Beer. Vol. 9 of *Collected Works of Samuel Taylor Coleridge*. Princeton: Princeton University Press, 1993.

———. *Biographia Literaria*, edited by James Engell and W. Jackson Bate. 2 vols. Vol. 7 of *Collected Works*. Princeton: Princeton University Press, 1983.

———. *Coleridge's Miscellaneous Criticism*. 1936. Edited by Thomas Middleton Raysor. Reprint, Folcroft, Pa: Folcroft Press, 1969.

———. "Confessions of an Inquiring Spirit." In *Shorter Works and Fragments*, edited by H. J. Jackson and J. R. De J. Jackson, 2 vols., pp. 1111–1171. Vol. 11 of *Collected Works*. Princeton: Princeton University Press, 1995.

———. "Essays on the Principles of Genial Criticism." In *Shorter Works and Fragments*, 2 vols., pp. 353–86. Vol. 11 of *Collected Works*. Princeton: Princeton University Press, 1995.

———. "Formation of a More Comprehensive Theory of Life." In *The Selected Poetry and Prose of Samuel Taylor Coleridge*, edited by Donald A. Stauffer, pp. 558–606. New York: Random House, 1951.

———. *The Friend*, edited by Barbara E. Rooke, 2 vols. Vol. 4 of *Collected Works*. Princeton: Princeton University Press, 1969.

———. *Lectures 1808–1819 on Literature*, edited by R. A. Foakes, 2 vols. Vol. 5 of *Collected Works*. Princeton: Princeton University Press, 1995.

———. *Letters of Samuel Taylor Coleridge*, edited by Earl Leslie Griggs, 6 vols. Oxford: Clarendon Press, 1956–71.

———. *Logic*, edited by J. R. de J. Jackson. Vol. 13 of *Collected Works*. Princeton: Princeton University Press, 1981.

———. *The Notebooks of Samuel Taylor Coleridge*, edited by Kathleen Coburn et al., 5 vols. New York: Pantheon, 1957–.

———. *On the Constitution of Church and State*, edited by John Colmer. Vol. 10 of *Collected Works*. Princeton: Princeton University Press, 1976.

————. "On Poesy or Art." In *Biographia Literaria . . . with His Aesthetical Essays,* edited by J. Shawcross, pp. 253–63. London: Oxford University Press, 1958.

————. *Poetical Works.* 1912. Edited by Ernest Hartley Coleridge. Reprint, Oxford: Oxford University Press, 1991.

————. *Shakespearean Criticism,* edited by Thomas Middleton Raysor, 2 vols. London: Dent, 1960.

————. *The Statesman's Manual. Lay Sermons,* edited by R. J. White. Vol. 6 of *Collected Works.* Princeton: Princeton University Press, 1972.

————. *Table Talk,* edited by Carl Woodring, 2 vols. Vol. 14 of *Collected Works.* Princeton: Princeton, University Press, 1990.

Collingwood, R. G. *The Idea of History.* Oxford: Clarendon Press, 1946.

Cook, B. F. *The Townley Marbles.* London: British Museum Publications, 1985.

Cooper, Anthony, Earl of Shaftesbury. *Second Characters or the Language of Forms,* edited by Benjamin Rand. Reprint, New York: Greenwood Press, 1969.

Coulmann, J. J. *Reminiscences.* Paris: Michel Levy, 1862.

Cowper, William. *Poetical Works,* edited by H. S. Milford, 4th ed. Revised by Norma Russell. London: Oxford University Press, 1967.

Coxe, Henry. *Picture of Italy.* London: Sherwood, Neely, and Jones, 1815.

Croly, George. *Paris in 1815 with Other Poems.* London: John Warren, 1821.

Cunningham, J. V. *The Collected Essays of J. V. Cunningham.* Chicago: Swallow Press, 1976.

Curl, James Stevens. *A Celebration of Death.* London: Constable, 1980.

Curran, Stuart. *Poetic Form and British Romanticism.* New York: Oxford University Press, 1986.

Dallaway, James. *Of Statuary and Sculpture Among the Ancients.* London: T. Bensley, 1816.

Darwin, Erasmus. *Poetical Works,* 3 vols. London: J. Johnson, 1806.

Davenant, William. "Author's Preface." In *Gondibert,* edited by David F. Gladish, pp. 3–44. Oxford: Clarendon Press, 1971.

De Man, Paul. *Rhetoric of Romanticism.* New York: Columbia University Press, 1984.

————. "The Rhetoric of Temporality." In *Blindness and Insight,* pp. 187–228. 2nd ed. Minneapolis: University of Minnesota Press, 1983.

Denon, Vivant. *Travels in Upper and Lower Egypt,* translated by Arthur Aiken, 3 vols. London: Longman and Rees, 1803.

De Quincey, Thomas. *Works.* 12 vols. Boston: Houghton, Mifflin, 1876–77.

Dewey, John. *Art as Experience.* New York: Putnam's, 1958.

Dickens, Charles. *American Notes and Pictures from Italy.* London: Oxford University Press, 1957.

Donoghue, Denis. "The Political Turn in Criticism." *Salmagundi* 81 (1989): 104–22.

Duppa, Richard. *The Life of M. A. Buonarroti,* 2nd ed. London: Murray, 1807.

[———]. *Miscellaneous Observations and Opinions on the Continent.* London: Longman, Hurst, 1825.

Elmes, James. *A General and Biographical Dictionary of the Fine Arts.* London: Thomas Tegg, 1826.

Escarpit, Robert. *Lord Byron: un tempérament littéraire.* Paris: Le Cercle du Livre, 1955–57.

Eustace, John Chetwoode. *A Classical Tour through Italy and Sicily,* 4th ed., revised. 4 vols. London: Mawman, 1817.

———. *A Letter from Paris to George Petre, Esq.* London: Mawman, 1814.

Fehl, Philipp. *The Classical Monument; Reflections on the Connection between Morality and Art in Greek and Roman Sculpture.* New York: New York University Press, 1972.

Flaxman, John. *Lectures on Sculpture.* London: John Murray, 1829.

Flindall, John Morris. *The Amateur's Pocket Companion; or, A Description of Scarce and Valuable Engraved British Portraits.* London: privately printed, 1813.

Focillon, Henri. *The Life of Forms in Art,* translated by Charles Beecher Hogan, et al. 2nd English ed. New York: Wittenborn, Schiltz, 1948.

Forbes, James. *Letters from France Written in the Years 1803 & 1804.* 2 vols. London: J. White, 1806.

Forbin, Count de. *Travels in Egypt in 1817–18.* London: Phillips, n.d.

Forsyth, John. *Remarks on Antiquities, Arts, and Letters during an Excursion in Italy, in the Years 1802 and 1803.* 2nd ed. London: John Murray, 1816.

Foucault, Michel. *The Archaeology of Knowledge and the Discourse on Language,* translated by A. M. Sheridan Smith. New York: Pantheon, 1972.

———. "Nietzsche, Genealogy, History," translated by Donald F. Bouchard and Sherry Simon. In *Language, Counter-Memory, Practice: Selected Essays and Interviews,* edited by Donald F. Bouchard, pp. 139–64. Ithaca: Cornell University Press, 1977.

———. *The Order of Things: An Archaeology of the Human Sciences.* New York: Vintage Books, 1973.

Fowler, Alastair. "Periodization and Interart Analogies." *NLH* 3, No. 3 (1972): 487–509.

Fragments: Incompletion and Discontinuity, edited by Lawrence D. Kritzman. New York: New York Literary Forum, 1981.

Freud, Sigmund. *Five Lectures on Psycho-Analysis,* translated and edited by James Strachey. New York: Norton, 1977.

——. "Mourning and Melancholia." In Vol. 14 of *The Complete Psychological Works of Sigmund Freud,* edited by James Strachey et al., pp. 243–58. London: Hogarth, 1957.

Fried, Michael. *Absorption and Theatricality: Painting and Beholder in the Age of Diderot.* Berkeley: University of California Press, 1980.

——. "Art and Objecthood." In *Minimal Art: A Critical Anthology,* edited by Gregory Battcock, pp. 116–47. New York: Dutton, 1968.

Friedman, Winifred H. *Boydell's Shakespeare Gallery.* New York: Garland, 1976.

Fritz, Paul S. "From 'Public' to 'Private': The Royal Funerals in England, 1500–1830." In *Mirrors of Mortality: Studies in the Social History of Death,* edited by Joachim Whaley, pp. 61–79. London: Europa, 1981.

Fuseli, Henry. *The Mind of Henry Fuseli,* edited by Eudo C. Mason. [London]: Routledge & Paul [1951].

Galiffe, James A. *Italy and Its Inhabitants.* 2 vols. London: John Murray, 1820.

Galignani, A. and W. *Traveller's Guide through Italy.* Paris, Galignani, 1819.

Gallagher, Catherine. *The Industrial Reformation of English Fiction: Social Discourse and Narrative Form 1832–1867.* Chicago: University of Chicago Press, 1985.

Gibbon, Edward. *Gibbon's Journey from Geneva to Rome,* edited by Georges A. Bonnard. London: Thomas Nelson, [1961].

——. *The History of the Decline and Fall of the Roman Empire,* edited by David Womersley. 6 vols. in 3. London: Allen Lane, 1994.

Gittings, Clare. *Death, Burial, and the Individual in Early Modern England.* London: Croom Helm, 1984.

Godwin, William ["Edward Baldwin"]. *Essay on Sepulchres: or, a proposal for erecting some memorials of the illustrious dead in all ages on the spot where their remains have been interred.* London: Miller, 1809.

——. *The Pantheon: Or Ancient History of the Gods of Greece and Rome.* 4th ed. 1814. Reprint, New York: Garland, 1984.

Goethe, Johann Wolfgang von. *Italian Journey, 1786–1788,* translated by W. H. Auden and Elizabeth Mayer. San Francisco: North Point Press, 1982.

——. "Upon the Laocoon" (1798). In *Goethe's Literary Essays,* edited by J. E. Spingarn, pp. 2–35. 1921. Reprint, Freeport, N.Y.: Books for Libraries Press, 1967.

——. "Winckelmann" (1805). *German Aesthetic and Literary Criticism: Winckelmann, Lessing, Hamann, Herder, Schiller, Goethe,* edited by H. B. Nisbet, pp. 236–58. Cambridge: Cambridge University Press, 1985.

Gombrich, E. H. *Meditations on a Hobby Horse and Other Essays on the Theory of Art*. London: Phaidon, 1963.

———. *Symbolic Images: Studies in the Art of the Renaissance*. Chicago: University of Chicago Press, 1985.

Goslee, Nancy Moore. *Uriel's Eye: Miltonic Stationing and Statuary in Blake, Keats, and Shelley*. University, Ala.: University of Alabama Press, 1985.

Gould, Cecil. *Trophy of Conquest: The Musée Napoléon and the Creation of the Louvre*. London: Faber and Faber, 1965.

Green, Valentine. *A Review of the Polite Arts in France*. London: Cadell, 1782.

Guillén, Claudio. "The Aesthetics of Literary Influence." In *Literature as System*, pp. 17–52. Princeton: Princeton University Press, 1971.

Hagstrum, Jean. *The Sister Arts: The Tradition of Literary Pictorialism and English Poetry from Dryden to Gray*. 1958. Reprint, Chicago: University of Chicago Press, 1987.

Harris, Ann Sutherland, and Linda Nochlin. *Women Artists: 1550–1950*. New York: Knopf, 1976.

Hartman, Geoffrey. "Poem and Ideology: A Study of Keats's 'To Autumn.'" In *The Fate of Reading*, pp. 124–46. Chicago: University of Chicago Press, 1975.

———. "Spectral Symbolism and the Authorial Self: An Approach to Keats's *Hyperion*." *Essays in Criticism* 24 (1974): 1–19.

Haskell, Francis. *History and Its Images*. New Haven: Yale University Press, 1993.

Haskell, Francis, and Nicholas Penny. *Taste and the Antique: The Lure of Classical Sculpture, 1500–1900*. New Haven: Yale University Press, 1981.

Haydon, Benjamin. *Life of Benjamin Robert Haydon, Historical Painter*, edited by Tom Taylor, 2nd ed. 3 vols. London: Longman, Brown, Green, 1853.

———, and William Hazlitt. *Painting, and the Fine Arts*. Edinburgh: A. & C. Black, 1838.

Hayley, William. *An Essay on Sculpture*. London: T. Cadell, 1800.

Haynes, D. E. L. *The Portland Vase*. 2nd ed. London: British Museum Publications, 1975.

Hazlitt, William. *The Complete Works*, edited by P. P. Howe. 21 vols. London: J. M. Dent and Sons, 1930–34.

———. *Conversations of James Northcote, R. A.*, edited by Edmund Gosse. London: Richard Bentley, 1894.

Heffernan, James A. W. *Museum of Words: The Poetics of Ekphrasis from Homer to Ashbery*. Chicago: University of Chicago Press, 1993.

Hegel, G. W. F. *Aesthetics: Lectures on Fine Art*, edited by T. M. Knox. 2 vols. Oxford: Clarendon Press, 1975.

———. *Introductory Letters on Aesthetics,* translated by Bernard Bosanquet. Edited by Michael Inwood. London: Penguin, 1993.

———. *The Philosophy of History,* translated by J. Sibree. New York: Dover, 1956.

Hemans, Felicia. *The Domestic Affections; The Restoration of the Works of Art to Italy; Wallace's Invocation to Bruce; The Sceptic.* 1812–20. Edited by Donald Reiman. Reprint, New York: Garland, 1978.

———. *Poems; England and Spain; Modern Greece,* edited by Donald H. Reiman. Reprint, New York: Garland, 1978.

———. *The Poetical Works of Felicia Dorothea Hemans.* Philadelphia: Porter & Coates, [1907].

———. *Records of Woman: With Other Poems.* 1828. Edited by Donald Reiman. Reprint, New York: Garland, 1978.

———. *Songs of the Affections.* 1830. Edited by Donald H. Reiman. Reprint, New York: Garland, 1978.

Herder, Johann Gottfried von. *Outlines of a Philosophy of the History of Man.* 1800. Translated by T. Churchill. Reprint, New York: Bergman, 1966.

———. "Shakespeare." *German Aesthetic and Literary Criticism: Winckelmann, Lessing, Hamann, Herder, Schiller, Goethe,* edited by H. B. Nisbet, pp. 161–76. Cambridge: Cambridge University Press, 1985.

Hibbard, Howard. *Michelangelo.* New York: Harper & Row, 1974.

Hoare, Prince. *Epochs of the Arts.* London: Murray, 1813.

Hogg, Thomas Jefferson. *Two Hundred and Nine Days; or, The Journal of a Traveller on the Continent.* 2 vols. London: Hunt and Clark, 1827.

Hollander, John. "The Gazer's Spirit: Romantic and Later Poetry on Painting and Sculpture." In *The Romantics and Us: Essays on Literature and Culture,* edited by Gene W. Ruoff, pp. 130–67. New Brunswick: Rutgers University Press, 1990.

Holmes, Richard. *Shelley: The Pursuit.* New York: E. P. Dutton, 1975.

Horne, Donald. *The Great Museum: The Re-presentation of History.* Leichhardt, Australia: Pluto Press, 1984.

Hudson, Kenneth. *Museums of Influence.* Cambridge: Cambridge University Press, 1987.

Hume, David. "Of the Rise and Progress of the Arts and Sciences." In *Essays: Moral, Political, and Literary,* edited by Eugene F. Miller, pp. 111–37. Indianapolis: Liberty Classics, 1985. 111–37.

Hungerford, Edward B. *Shores of Darkness.* 1941. Reprint, New York: World Publishing, 1963.

Hunt, Leigh. "On the Connection and the Mutual Assistance of the Arts and Sciences, and the Relation of Poetry to Them All." In *The Reflector, A Col-*

lection of Essays on Miscellaneous Subjects of Literature and Politics, 2 vols., pp. 346–60. London: J. Hunt, [1812].

Hutcheson, Francis. *An Inquiry into the Origin of Our Ideas of Beauty and Virtue*. 4th ed. 1738. Reprint, Westmead: Gregg International, 1969.

Irwin, David. *John Flaxman 1755–1826: Sculptor Illustrator Designer*. New York: Rizzoli, 1979.

——. "Sentiment and Antiquity: European Tombs 1750–1830." In *Mirrors of Mortality: Studies in the Social History of Death*, edited by Joachim Whaley, pp. 131–53. London: Europa, 1981.

Jauss, Hans Robert. "Literary History as a Challenge to Literary Theory." In *New Directions in Literary History*, edited by Ralph Cohen, pp. 11–41. Baltimore: Johns Hopkins University Press, 1974.

Kaelin, Eugene. *Art and Existence: A Phenomenological Aesthetics*. Lewisburg: Bucknell University Press, 1970.

Kaminsky, Jack. *Hegel on Art: An Interpretation of Hegel's Aesthetics*. New York: State University of New York Press, 1962.

Kant, Immanuel. *Kant's Critique of Judgement*, translated and edited by J. H. Bernard. 2nd ed., revised, London: Macmillan, 1931.

Keats, John. *John Keats*, edited by Elizabeth Cook. Oxford: Oxford University Press, 1990.

——. *The Letters of John Keats*, edited by Hyder Edward Rollins. 2 vols. Cambridge: Harvard University Press, 1958.

——. *The Poems of John Keats*, edited by Jack Stillinger. Cambridge: Belknap Press, Harvard University Press, 1978.

——. *Selected Poems and Letters*, edited by Douglas Bush. Boston: Houghton Mifflin, 1959.

The Keats Circle: Letters and Papers and More Letters and Poems of the Keats Circle, edited by Hyder Edward Rollins. 2nd ed. 2 vols. Cambridge: Harvard University Press, 1988.

Kemp, Brian. *English Church Monuments*. London: Batsford, 1980.

Kinnaird, John. *William Hazlitt: Critic of Power*. New York: Columbia University Press, 1978.

Krieger, Murray. *Theory of Criticism: A Tradition and Its System*. Baltimore: Johns Hopkins University Press, 1976.

——. "'A Waking Dream': The Symbolic Alternative to Allegory." In *Allegory, Myth, and Symbol*, edited by Morton W. Bloomfield, pp. 1–22. Cambridge: Harvard University Press, 1981.

Langer, Susanne. *Feeling and Form: A Theory of Art*. New York: Scribner's, 1953.

——. *Philosophy in a New Key*. Cambridge: Harvard University Press, 1957.

———. *Problems of Art*. New York: Scribner's, 1957.

Larrabee, Stephen A. *English Bards and Grecian Marbles: The Relationship between Sculpture and Poetry, Especially in the Romantic Period*. New York: Columbia University Press, 1943.

Lectures on Painting, by the Royal Academicians: Barrie, Opie, and Fuseli, edited by Ralph N. Wornum. London: Bohn, 1848.

Leppmann, Wolfgang. *Winckelmann*. New York: Knopf, 1970.

Lessing, Gotthold Ephraim. "Laocoon or On the Limits of Painting and Poetry." Translated by W. A. Steel. *German Aesthetic and Literary Criticism: Winckelmann, Lessing, Hamann, Herder, Schiller, Goethe*, edited by H. B. Nisbet, pp. 59–133. Cambridge: Cambridge University Press, 1985.

Levine, Alice. "T. S. Eliot and Byron." *ELH* 45 (1978): 522–41.

Levy, Michael. *Sir Thomas Lawrence 1769–1830*. London: National Portrait Gallery, 1979.

Lewis, C. S. *The Allegory of Love*. London: Oxford University Press, 1938.

Lindley, Kenneth. *Of Graves and Epitaphs*. London: Hutchinson, 1965.

Lipman, Matthew. *What Happens in Art*. New York: Appleton-Century-Crofts, 1967.

Locke, John. *An Essay Concerning Human Understanding*, edited by P. H. Nidditch. 3rd ed. Oxford: Clarendon Press, 1975.

Macpherson, Jay. *The Spirit of Solitude: Conventions and Continuities*. New Haven: Yale University Press, 1982.

Malraux, André. *Museum without Walls (Le musée imaginaire)*, translated by Stuart Gilbert and Francis Price. New York: Doubleday, 1967.

Mankowitz, Wolf. *The Portland Vase and the Wedgwood Copies*. London: Deutsche, 1952.

Manzoni, Alessandro. *On the Historical Novel [Del romanzo storico]*, translated and edited by Sandra Bermann. Lincoln: University of Nebraska Press, 1984.

Margolis, Joseph. *Art and Philosophy*. Atlantic Highlands, N.J.: Humanities Press, 1980.

McManners, John. *Death and the Enlightenment*. London: Oxford University Press, 1985.

Memorials of Coleorton, edited by William Knight. 2 vols. Edinburgh: n.p., 1887.

Miller, J. Hillis. "The Still Heart: Poetic Form in Wordsworth." *NLH* 2 (1971): 297–310.

Milman, Henry Hart. *A Comparative Estimate of Sculpture and Painting*. Privately printed [1816].

Milton, Henry. *Letters on the Fine Arts, Written from Paris in the Year 1815.* London: Longman, Hurst, 1816.

Mitchell, W. J. T. *Iconology: Image, Text, Ideology.* Chicago: University of Chicago Press, 1986.

Montfaucon, Bernard de. *L'Antiquite expliquée et representée en figures.* 2nd ed. Paris: Delaulne, 1722.

Morgan, Lady [S.] *Italy.* 3 vols. Paris: Galignani, 1821.

Morgann, Maurice. *Shakespearean Criticism,* edited by Daniel A. Fineman. Oxford: Clarendon Press, 1972.

Murry, John Middleton. *Keats.* 4th ed. London: Cape, 1955.

Nietzsche, Friedrich. *The Use and Abuse of History,* translated by Adrian Collins. Indianapolis: Bobbs-Merrill, 1957.

Nisbet, H. B., ed. *German Aesthetic and Literary Criticism: Winckelmann, Lessing, Hamann, Herder, Schiller, Goethe.* Cambridge: Cambridge University Press, 1985.

North, Michael. *The Final Sculpture: Public Monuments and Modern Poets.* Ithaca: Cornell University Press, 1985.

Norton, Robert E. *Herder's Aesthetics and the European Enlightenment.* Ithaca: Cornell University Press, 1991.

Ovid. *Metamorphosis,* translated by Rolfe Humphries. Bloomington: Indiana University Press, 1955.

Panofsky, Erwin. "The History of Art as a Humanistic Discipline." In *Meaning in the Visual Arts: Papers in and on Art History,* pp. 1–25. Garden City, N.Y.: Doubleday Anchor, 1955.

————. *Tomb Sculpture: Its Changing Aspects from Ancient Egypt to Bernini.* London: Thames & Hudson, 1964.

Pater, Walter. *The Renaissance: Studies in Art and Poetry.* London, Macmillan, 1910.

Patmore, P. G. *British Galleries of Art.* London: Whittaker, 1824.

Peacock, Thomas Love. *The Works of Thomas Love Peacock,* edited by Herbert Francis Brett-Smith and Clifford Ernest Jones. 10 vols. New York: Constable, 1924–34.

Penny, Nicholas. *Church Monuments in Romantic England.* New Haven: Yale University Press, 1977.

Perkins, David, ed. *English Romantic Writers.* Fort Worth: Harcourt Brace, 1995.

Piper, David. *The Image of the Poet: British Poets and Their Portraits.* Oxford: Clarendon Press, 1982.

[Quincy, Quatremère de] *The Destination of Works of Art and the Use to which They Are Applied,* translated by Henry Thomson. London: John Murray. 1821.

Raffles, Thomas. *Letters during a Tour of Some Parts of France . . . in the Summer of 1817.* 3rd ed. Liverpool: Thomas Taylor, 1820.

Read, Herbert. *The Art of Sculpture.* 2nd ed. Princeton: Princeton University Press, 1961.

———. *The Origins of Form in Art.* New York: Horizon, 1965.

Reiman, Donald H. "Keats and the Humanistic Paradox: Mythological History in *Lamia.*" In *Romantic Texts and Contexts,* pp. 321–33. Columbia: University of Missouri Press, 1987.

———. *The Romantics Reviewed: Contemporary Reviews of British Romantic Writers.* 3 pts. in 9 vols. New York: Garland, 1972.

Richardson, William. *A Philosophical Analysis and Illustration of Some of Shakespeare's Remarkable Characters.* 1780. Reprint, New York: AMS Press, 1966.

Riffaterre, Michael. "Prosopopoeia." *Yale French Studies* 69 (1985): 107–23.

Robertson, William. *The History of the Reign of the Emperor Charles V.* 7th ed. 4 vols. London: Strahan, Cadell, and Balfour, 1792.

Rogers, Samuel. *Italy: A Poem.* London: T. Cadell, 1830.

———. *Poetical Works.* New York: Leavitt and Allen, 1857.

[Rose, W. S.] *Letters from the North of Italy.* 2 vols. London: Murray, 1819.

Salaman, Malcolm C. *Shakespeare in Pictorial Art.* New York: Benjamin Blom, 1971.

s'Jacob, Henriette. *Idealism and Realism: A Study of Sepulchral Symbolism.* Leiden: E. J. Brill, 1954.

Sass, Henry. *A Journey to Rome and Naples.* London: Longman, Hurst, 1818.

Schelling, Friedrich Wilhelm Joseph von. "Concerning the Relation of the Plastic Arts to Nature." 1807. Translated by Michael Bullock. In *The True Voice of Feeling: Studies in English Romantic Poetry,* edited by Herbert Read, pp. 323–58. New York: Pantheon, 1953.

Schiller, Friedrich. *On the Aesthetic Education of Man,* edited and translated by Elizabeth M. Wilkinson and L. A. Willoughby. Oxford: Clarendon Press, 1967.

———. *On Naive and Sentimental Poetry,* translated by Julius A. Elias. *German Aesthetic and Literary Criticism: Winckelmann, Lessing, Hamann, Herder, Schiller, Goethe,* edited by H. B. Nisbet, pp. 180–232. Cambridge: Cambridge University Press, 1985.

Schlegel, August Wilhelm von. *Lectures on Dramatic Art and Literature,* translated by John Black. 2nd ed. London: George Bell, 1894.

Schlegel, Friedrich von. *Lectures on the History of Literature.* London: George Bell, 1909.

Scott, John. *A Visit to Paris in 1814.* 4th ed. London: Longman, 1816.

Sharp, William. *The Life and Letters of Joseph Severn*. London: Sampson, Low, Marston, 1892.

Shawe-Taylor, Desmond. *The Georgians: Eighteenth-Century Portraiture and Society*. London: Barrie & Jenkins, 1990.

Shee, Martin Archer. *The Commemoration of Reynolds . . . and Other Poems*. London: Murray, 1814.

———. *Elements of Art: A Poem*. London: William Miller, 1809.

Shelley, Mary. *The Journals of Mary Shelley*, edited by Paula R. Feldman and Diana Scott-Kilvert. Oxford: Clarendon Press, 1987.

———. *Letters*, edited by Betty T. Bennett. 3 vols. Baltimore: Johns Hopkins University Press, 1980.

Shelley, Percy Bysshe. *The Complete Poetical Works*, edited by Thomas Hutchinson. London: Oxford University Press, 1905.

———. *The Complete Works of Percy Bysshe Shelley*. 1926–30. Edited by Roger Ingpen and Walter E. Peck. 10 vols. Reprint, New York: Gordian Press, 1965.

———. *Letters*, edited by Frederick L. Jones. 2 vols. Oxford: Clarendon Press, 1964.

———. *Shelley's Poetry and Prose*, edited by Donald H. Reiman and Sharon B. Powers. New York: Norton, 1977.

———. *Shelley's Prose; or, The Trumpet of a Prophecy*, edited by David Lee Clark. New York: New Amsterdam Books, 1988.

Simpson, James. *Paris after Waterloo*. Edinburgh: Blackwood, 1853.

Sircello, Guy. *Mind and Art: An Essay on the Varieties of Expression*. Princeton: Princeton University Press, 1972.

Smith, Eric. *By Mourning Tongues: Studies in English Elegy*. Ipswich: Boydell Press, 1977.

Society of Dilettanti. *Specimens of Antient Sculpture, Aegyptian, Etruscan, Greek, and Roman*. 2 vols. London: Payne and White, 1809, 1835.

Spence, Joseph. *Polymetis: or, An Enquiry Concerning the Agreement Between the Works of the Roman Poets, and the Remains of Ancient Artists*. 1747. Reprint, New York: Garland, 1971.

Springer, Carolyn. *The Marble Wilderness: Ruins and Representation in Italian Romanticism 1775–1850*. Cambridge: Cambridge University Press, 1987.

Staël, Madame de (Ann Louise Germaine). *Corinne, or Italy*, translated by Avriel H. Goldberger. New Brunswick: Rutgers University Press, 1987.

Starobinski, Jean. *1789: The Emblems of Reason*, translated by Barbara Bray. Charlottesville: University of Virginia Press, 1982.

Stendhal (Henri Beyle). *Chroniques italiennes*. Paris: Librarie Gallimard, [1936].

Stillinger, Jack. "The Order of Poems in Keats's First Volume." In *The Hood-winking of Madeline and Other Essays on Keats's Poems,* pp. 1–13. Urbana: University of Illinois Press, 1971.

Strong, Roy. *The English Icon. Elizabethan and Jacobean Portraiture.* London: Routledge and Kegan Paul, 1969.

———. *Recreating the Past: British History and the Victorian Painter.* New York: Thames & Hudson, 1978.

Taine, H[ippolyte] A[dolphe]. *History of English Literature,* translated by H. Van Laun. 2 vols. New York: Holt, 1889.

Thomson, James. *Liberty, The Castle of Indolence and Other Poems,* edited by James Sambrook. Oxford: Clarendon Press, 1986.

———. *The Seasons,* edited by James Sambrook. Oxford: Clarendon Press, 1981.

Todorov, Tzvetan. *Theories of the Symbol,* translated by Catherine Porter. Ithaca: Cornell University Press, 1982.

Tomas, Vincent. "The Concept of Expression in Art." In *Philosophy Looks at the Arts,* edited by Joseph Margolis, pp. 30–45. New York: Scribner's, 1962.

Tormey, Alan. *The Concept of Expression: A Study in Philosophical Psychology and Aesthetics.* Princeton: Princeton University Press, 1971.

Tucker, William. *The Language of Sculpture.* London: Thames and Hudson, 1974.

Volney, Constantin-François. *The Ruins, or Meditations [on] the Revolutions of Empires.* 1795. Reprint, New York: ECA Associates, 1990.

———. *Travels through Syria and Egypt in the Years 1783, 1784, and 1785.* 2 vols. London: Robinson, 1788.

Waite, Eugene M. "Ozymandias: Shelley, Horace Smith, and Denon." *K-SJ* 44 (1995): 22–8.

[Waldie, Charlotte, later Eaton]. *Rome in the Nineteenth Century.* 3 vols. Edinburgh, Constable, 1820.

Warner, Malcolm. *Portrait Painting.* Oxford: Phaidon, 1979.

Warton, Thomas, the Younger. "The Pleasures of Melancholy." In *The Three Wartons: A Choice of Their Verse,* edited by Eric Partridge, pp. 101–12. London: The Scholartis Press, 1927.

Wasserman, Earl R. "The Inherent Values of Eighteenth-Century Personification." *PMLA* 65 (1950): 435–63.

Webster, Mary. "Flaxman as Sculptor." In *John Flaxman,* edited by David Bindman, pp. 100–19. London: Thames & Hudson, 1979.

Wedgwood, Josiah. *Description of the Portland Vase, formerly the Barberini.* 1790. Reprint, London: Pickering, 1845.

Weever, John. *Ancient Funerall Monuments*. 1631. Reprint, Norwood, N.J.: W. J. Johnson, 1979.

Weitz, Morris. "The Content of Form: A Commentary." *NLH* 2 (1971): 351–6.

Wellbery, David E. *Lessing's Laocoon: Semiotics and Aesthetics in the Age of Reason*. Cambridge: Cambridge University Press, 1984.

Wheelock, Arthur K., et al. *Anthony Van Dyck*. New York: Abrams, 1990.

Whittle, James. "Beatrice Cenci, the Parricide." *Bentley's Miscellany* 2 (1847): 105–18.

Willsher, Betty, and Doreen Hunter. *Stones: A Guide to Some Remarkable Eighteenth Century Gravestones*. New York: Taplinger, 1979.

[Wilson, John]. "Childe Harold's Pilgrimage. Canto the Fourth." *Edinburgh Review* 30 (1818), 87–120.

Winckelmann, Johann Joachim. *History of Ancient Art*. 4 vols. in 2. New York: Frederick Unger, 1968.

———. "Thoughts on the Imitation of the Painting and Sculpture of the Greeks." Translated by H. B. Nisbet. *German Aesthetic and Literary Criticism: Winckelmann, Lessing, Hamann, Herder, Schiller, Goethe*, edited by H. B. Nisbet, pp. 31–54. Cambridge: Cambridge University Press, 1985.

———. *Winckelmann: Writings on Art*, edited by David Irwin. London: Phaidon, 1972.

Wölfflin, Heinrich. *The Sense of Form in Art: A Comparative Psychological Study*, translated by Alice Muehsam and Norma A. Shatan. New York: Chelsea, 1958.

Woodburn's Gallery of Rare Portraits 2 vols. London: George Jones, 1816.

Woodman, Ross Grieg. *The Apocalyptic Vision in the Poetry of Shelley*. Toronto: University of Toronto Press, 1964.

Wordsworth, Dorothy. *Journals of Dorothy Wordsworth*, edited by Ernest de Sélincourt. 2 vols. New York: Macmillan, 1941.

Wordsworth, William. *The Borderers*, edited by Robert Osborn. Ithaca: Cornell University Press, 1982.

———. *Descriptive Sketches*, edited by Eric Birdsall. Ithaca: Cornell University Press, 1984.

———. *The Fenwick Notes of William Wordsworth*, edited by Jared Curtis. London and Bristol: Classical Press, 1993.

———. *Guide to the Lakes: The Fifth Edition (1835)*, edited by Ernest de Sélincourt. 1906. Reprint, Oxford: Oxford University Press, 1977.

———. *Lyrical Ballads, and Other Poems, 1797–1800*, edited by James Butler and Karen Green. Ithaca: Cornell University Press, 1992.

———. *Poems, in Two Volumes, and Other Poems*, edited by Jared Curtis. Ithaca: Cornell University Press, 1983.

———. *The Poetical Works of William Wordsworth,* edited by Ernest de Sélincourt and Helen Darbishire. 5 vols. Oxford: Clarendon Press, 1940–49.

———. *The Prelude: 1799, 1805, 1850,* edited by Jonathan Wordsworth, M. H. Abrams, and Stephen Gill. New York: Norton, 1979.

———. *The Prose Works of William Wordsworth,* edited by W. J. B. Owen and Jane Worthington Smyser. 3 vols. Oxford: Clarendon Press, 1974.

———. *The Salisbury Plain Poems,* edited by Stephen Gill. Ithaca: Cornell University Press, 1975.

Worton, Michael. "Speech and Silence in *The Cenci.*" In *Essays on Shelley,* edited by Miriam Allott, pp. 105–21. Liverpool: Liverpool University Press, 1982.

Index